RODIN

Raphaël Masson - Véronique Mattiussi

Translated from the French by Deke Dusinberre

musée
RODIN

Flammarion

The authors wish to thank:

Helen Adedotun, Christian Baraja, Philippe Bijon, Jean de Calan,
Anne-Marie Chabot, Muriel Chatelais, Guillaume Czerw, Dominique de Coninck,
Marie-Pierre Delclaux, Annie-Claude Demagny, Mathilde Deprez, Antoine du Payrat,
Deke Dusinberre, Elda, Sylvester Engbrox, Adrien Goetz, Dominique Jacquot,
Benoit Jeay, Antoinette Le Normand-Romain, Yves Lacasse, Laurence Lacroix,
Frédérique Leseur, Luc Mandraud, Enzo and Hélène Mattiussi,
Jérôme Manoukian, Hélène Marraud, Laurence Nicod, Sylvie Patry, Hélène Pinet,
Marie Poulain, Poupi, Gautier Prinlin, Edwige Ridel, Jane Riordan, Hélène Rouvier,
Anne Schmauch, Simone Schmickl, Françoise Schwarz, Renaud Temperini,
Vincent Tessier, Sophy Thompson, Valérie Tomasi, Corinne Trovarelli, Diane Tytgat,
and Côme and Marc Guyot.

Copyediting: Chrisoula Petridis

Typesetting: Thomas Gravemaker, Studio X-Act

Proofreading: Jennifer Ladonne

Index: Jennifer Ladonne and Mark Simpson

Color Separation: Quat'Coul, Toulouse

Distributed in North America by Rizzoli International Publications, Inc.

Simultaneously published in French as *Rodin*
© Éditions Flammarion, Paris–Musée Rodin, 2004
English-language edition
© Éditions Flammarion, Paris–Musée Rodin, 2004

www.editions.flammarion.com

04 05 06 4 3 2 1

FC0445-04-X
ISBN (Musée Rodin): 2-9014-2858-1
ISBN (Éditions Flammarion): 2-0803-0445-3
Dépôt légal: 10/2004

Printed in Italy by Errestampa

CONTENTS

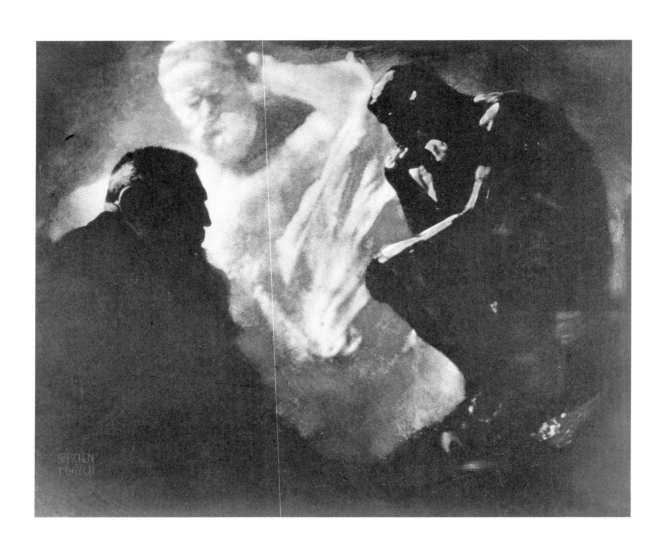

Given the numerous books on Rodin, published everywhere from Japan and Korea to the United States and Brazil, why the need for a new monograph? Things have evolved considerably in the eighty-seven years since the sculptor died and the eighty-five years since the Musée Rodin opened, notably thanks to a spectacular increase in the number of exhibitions and publications over the past fifteen years, predominantly in French. Alongside the artist's unflagging fame, we enjoy the fruit of an established museum where an ever-increasing number of specialists can devote their time to combing the archives, examining private collections, exploring the art market, and restoring the works in a constantly growing collection. All this effort has steadily filled-in gaps and deepened our understanding of Rodin. The Musée Rodin—the institution Rodin stubbornly fought for, devoted solely to his own oeuvre—is today a veritable study center where information converges and new research inquiries are conducted.

The basic study material has now been filed, inventoried, and categorized—we have arrived at a period of analytical synthesis. This analysis has shown that Rodin far transcends the limited framework of the sculptures that made him famous. His oeuvre, however well-known it may be, cannot be summed up by *The Kiss* or *The Thinker* alone—the conventional image of those universal icons is greatly surpassed by the unseen part of the iceberg.

Ranging from monumental sculptures to early sketches, maquettes in plaster (along with systematic casts made of every stage of research), and from inclusions of leaves, branches, and newspapers to drawings that were cut up, reworked, and glued together, there are now many thousands of items that provide the examples selected for analysis here (6,734 sculptures, over 7,000 drawings, and nearly 16,000 photographs, in addition to thousands of Egyptian and Greco-Roman antiquities). These works are cited in this monograph, chapter after chapter, in order to define Rodin's ideas and oeuvre. Also taken into consideration is an enormous volume of correspondence, which is a crucial source in any attempt to grasp the artist's personality and daily life. Abundant new illustrations place classic pieces alongside rougher, and often little-known, sketches.

Rodin was a strange character. The demiurge-like artist who forged *The Gates of Hell* was a titan of creativity equal to the composer of the *Ring* cycle, the builder of the Eiffel Tower, and the painter of *Burial at Ornans*.

A short, near-sighted man of modest background, Rodin did not seek honors. Endowed with only a brief education, he rose to the heights of sculpture thanks to his own determination alone. He was a long way from educated, bourgeois artists such as Manet and Degas. He elaborated his oeuvre alone, deliberately aloof from an artistic environment that he either didn't want to confront or failed to understand—the end of his life, after all, chronologically overlapped with cubism. Although no true connection has been attested, Rodin, alone in the privacy of his studios, pursued a work of fragmentation and recomposition identical and anterior to cubism. It remained totally unknown at the time.

So perhaps we should picture the sculptor of *Balzac*—which in 1898 created a scandal that, in hindsight, we can perfectly appreciate—sitting on a pleasant evening at his property in Meudon, enjoying an apple pie made from the fruit in his garden, washed down with a glass of wine. The very simplicity of the man is perhaps a key to the grandeur of a sculptor whose thundering convictions were nevertheless accompanied by moments of doubt.

Jacques Vilain
Director, Musée Rodin
Senior Curator, National Heritage

RODIN

"My own pleasure is my only guide"

R odin has been dubbed the "titan of sculpture," the "god Pan," and a "demiurge," to mention just a few of the superlatives. Today, we might be inclined to call him an "uncivilized genius"—the cost of his highly personal and extremely bold explorations into plastic form was a recurring series of scandals that landed him with a fiendish reputation. "When he sculpted," recalled Antoine Bourdelle, "Rodin seemed like a great goat leading a flock of ideas. This god Pan could also make flocks of lines thrill to his touch—he seemed to drink in the very the soul of the clay while working, the way one wins a kiss with a never-faltering gaze. . . . While working, Rodin never looked far off; his vision weakened in the distance—he saw everything close up, penetratingly."

Rodin's world was populated by truncated torsos, decapitated heads, visible genitalia, drawings and figures that had been cut up and reassembled, photographs that had been retouched, plinths that had been revamped, and assemblages that were endlessly recombined. "Rodin is a man of talent," wrote the Goncourt brothers, "a sensual molder of the human body's lewd and impassioned writhings, although with errors of proportion and almost never with limbs that are fully executed. In the midst of today's infatuation with Impressionism, where every painting remains in a sketchy state, Rodin is the first artist to establish his name and fame in sculpture through sketches."

The thousands of items now catalogued, from the smallest fragment of a limb to the monumental *Balzac*, testify to his artistic heritage and his lifelong quest. Rodin saved everything, with no concern for sorting or selecting. Perfectly accomplished pieces coexist with experimental sketches. It all adds up to a peerless, powerful, outlandish oeuvre lacking a specific subject and flaunting an unfinished or fragmentary quality that represented a permanent break with official sculpture. Rodin's admiration for old masters did not stem from timid academicism, for it spurred him to create ceaselessly, to address contemporary issues. Through his research Rodin devised forms and poses that he constantly reinterpreted—to the extent of unsettling and surprising beholders even today. Thanks to newly accessible preparatory studies, viewers are now offered keys to the artist's private world, providing information on Rodin's working methods and intellectual evolution.

Rodin's insatiable curiosity made him a pioneer as he kneaded clay into swift models. "Theses sketches, done all in one go, fascinated him," reported Paul Gsell, "because they allowed him to grasp, on the fly, wonderful movements whose fleeting truth might get lost through deeper, but slower, study." When Rodin would return to such works, sometimes years later, tirelessly combining them and creating new masterpieces that often left tool marks visible, he seemed more than ever the visionary artist.

As well as the solitary, taciturn artist, we have tried to present the man in all his complexity and contradictions. Of modest background and limited education, Rodin was a simple craftsman who achieved true grandeur. Yet he could prove to be indifferent, indeed cruelly selfish, to the tireless devotion of faithful friends. His simple, hard-working if often contemplative life was followed later by a social whirlwind and a powerfully sensual life that continues to be the subject of debate. Did Rodin represent the end of an era or the start of a new one? His genius, his rare gift for hard work, and his instinctive originality bequeathed later generations more than an oeuvre; he left us a concept, a heritage, an education to which—like Rodin himself—we can continually return for new inspiration.

The goal of the authors of this book is to help readers discover—or rediscover—August Rodin and his oeuvre, based on a comment he made to Paul Gsell back in 1906. "I follow no working rule. My own pleasure is my only guide. I do only what interests me, and only when it suits me. Art is pleasurable: it can and must require effort, but not constraint. If a work is to turn out fine, the artist, when undertaking it, must feel a joyous and pressing need to create it."

"You know that I'm not clear, that writing and speaking put me in a muddle; my natural resources are clay and pencil."

Auguste Rodin to Hélène Wahl, after October 25, 1895

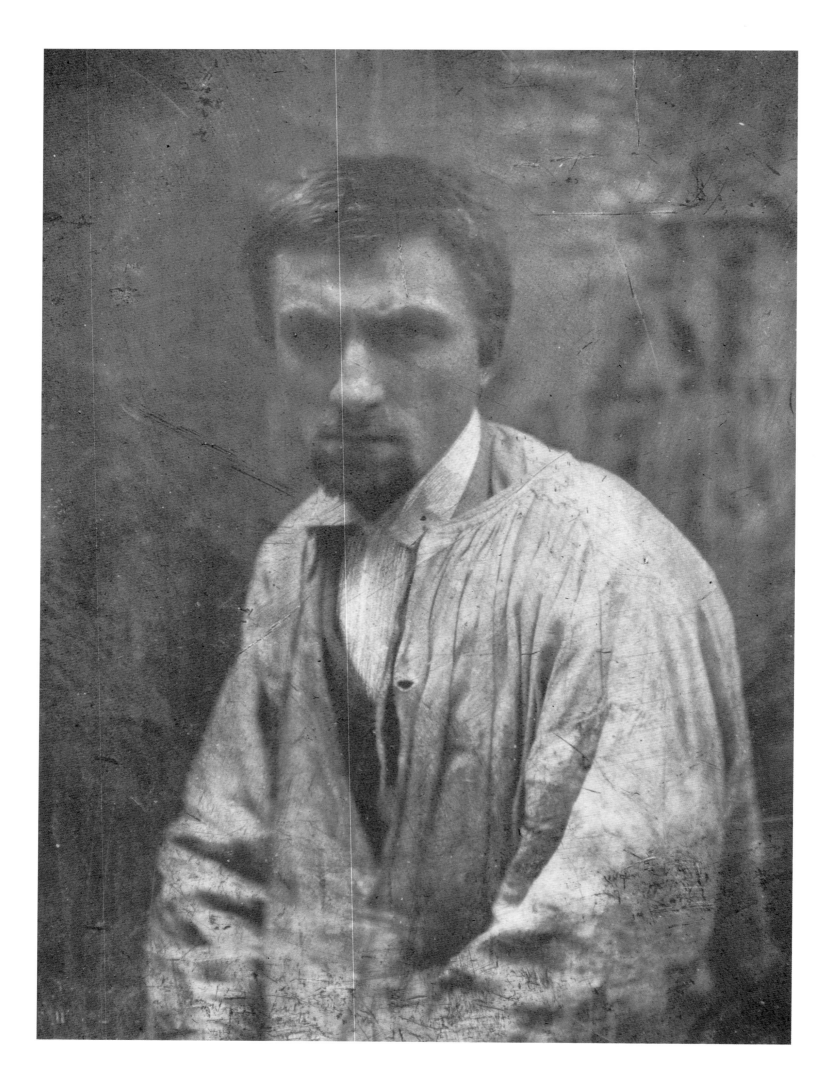

YOUTH
AND EDUCATION

In 1840, just two days apart—November 12 and 14—Auguste Rodin and Claude Monet were born, two pioneers "who, in this century, most gloriously and most permanently incarnate the two arts of painting and sculpture," as described by Octave Mirbeau in an issue of *Écho de Paris* dated June 25, 1889. It was "a vintage year," commented Frederic V. Grunfeld, given that 1840 also saw the birth of Émile Zola, Pyotr Ilich Tchaikovsky, Alphonse Daudet, Giovanni Verga, and Thomas Hardy.

Rodin was born on rue de l'Arbalète, in a poor but lively neighborhood of what was then the twelfth arrondissement of Paris (today's fifth arrondissement). Rodin's father Jean-Baptiste, of Normandy, had taken Marie Cheffer, of Lorraine, as his second wife. He worked as a minor civil servant at police headquarters, while his highly devout wife spent all her time at home and made sure her children received religious instruction. The young Auguste grew up in modest surroundings, with the reassuring complicity of an older sister who was as loving as she was bossy.

Due to his poor grades at the school on rue du Val-de-Grâce, in 1851 Auguste was handed over to an uncle in Beauvais who ran a private school. Incapable of sticking to his books, Auguste's grades failed to improve, so he returned to Paris in 1853. "After all, spelling mistakes are no worse than the drawing mistakes that everyone else makes," retorted the "famous innocent"—as Léon Cladel dubbed Rodin—to anyone who pointed out his failings.

"I maintain that before drawing on plaster, you must begin by drawing on paper; I myself was a draftsmen before I was a sculptor."
"Rodin par lui-même," *Je sais tout,* **March 1910**

Rodin's very real talent for drawing soon convinced his father to let him enroll in the École Impériale Spéciale de Dessin et Mathématiques, generally known as the "Petite École" to distinguish this "lesser" school from the grander École des Beaux-Arts. The four years Rodin spent there, 1854 to 1857, were crucial to his development. As he acquired traditional skills, he refined his powers of observation and practice by drawing from memory under the aegis of painter Horace Lecoq de Boisbaudran. "I started drawing very young, as far back as I can remember," confided Rodin to Étienne Dujardin-Beaumetz. "A grocer patronized by my mother used to wrap his prunes in paper torn from the pages of illustrated books and even in engravings, which I would copy. They were my earliest models." At the Louvre, where all artists of the day studied, Rodin religiously copied old masters, endlessly sketching drapery. In the evenings, meanwhile, he would work from life models in decorative-art studios at the Gobelins factory.

Far left
ANONYMOUS,
AUGUSTE RODIN WITH HIS SISTER MARIA,
C. 1859.
ALBUMEN PRINT,
4 ¼ × 3 ¼ IN. (11 × 8.5 CM).

Left
BOY WRITING ON HIS LAP,
PENCIL HIGHLIGHTED WITH PEN AND BLACK INK
ON BEIGE PAPER,
5 ¼ × 2 ¼ IN. (13.2 × 6.2 CM).

Facing page
CHARLES HIPPOLYTE AUBRY,
PORTRAIT OF RODIN IN A SMOCK,
C. 1862.
GELATIN SILVER PRINT,
4 ¼ × 3 IN. (11.1 × 7.5 CM).

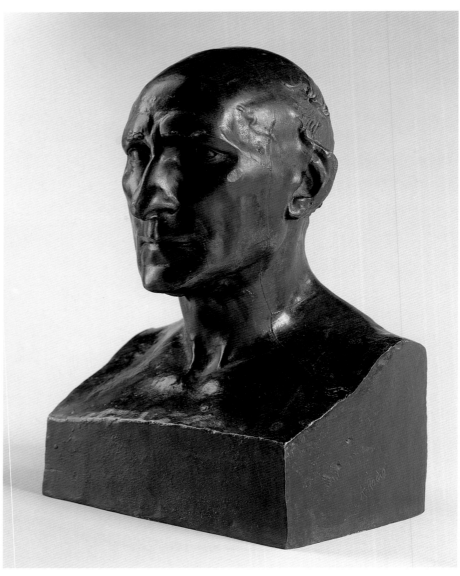

That was the period when Rodin first began sculpting. His earliest surviving work dates from 1860—a bust of his father, Jean-Baptiste Rodin, in the guise of a Roman senator. Unlike the painted portrait that Rodin would execute a little later, this clean-shaven bust seems severe. The very careful modeling emphasizes the almost bald head, the intense, concentrated gaze, prominent cheekbones, straight, even nose, pursed lips, and strong chin. The bust was never exhibited during Rodin's lifetime.

The young man felt the time had come to try for a place at the École des Beaux-Arts. But despite attentive support from his father—who must surely have worried about his son's choice of an artistic career—Rodin failed on three occasions to pass the entrance exam. He had to give up the idea of ever winning the glorious Prix de Rome. As he set off on his career, the official path was closed to him.

These setbacks were compounded by the death of his sister Maria on December 8, 1862. Having entered a convent and taken the name Sister Euphémia after a purportedly unhappy love affair, she succumbed to smallpox. Her demise—following the deaths of two younger sisters and a brother of whom all traces were quickly lost—meant that Rodin became the only child of a hard-pressed family on the brink of poverty. Literally overwhelmed by grief, Rodin joined the Order of the Blessed Sacrament as a novice, adopting the name of Brother Augustin. In a crisis of faith, he vowed to give up sculpture. But very soon the Reverend Father Eymard, who had founded the order, recognized the temporary effects of grief and encouraged Rodin to return to his true calling—the priest even agreed to model for his own bust, one that also bears the partial inscription of a eucharistic prayer. Rodin's handling of the priest's fine nostrils, powerful bone structure, and lively, intelligent gaze portrays, despite a stiff expression, a young, dynamic, insightful, and austere man. The thick, almost wild hair emphasizes the effect of the tonsure at the back of his head, while at his temples a mass of hair lends him an air not so much lofty as diabolical. Father Eymard thus became the first in a long line of sitters to express his dissatisfaction to Rodin. As the sculptor explained to Paul Gsell, "The biggest difficulties for an artist who models a bust or paints a portrait come not from the work he's doing, but from the client who has given him that work. By some strange, inevitable law, a person who commissions his image always struggles against the talent of the artist he's chosen. It's very rare for a man to see himself as he really is, and even if he truly knows himself he finds it unpleasant for an artist to depict him authentically. He wants to be seen in a more neutral and ordinary light."

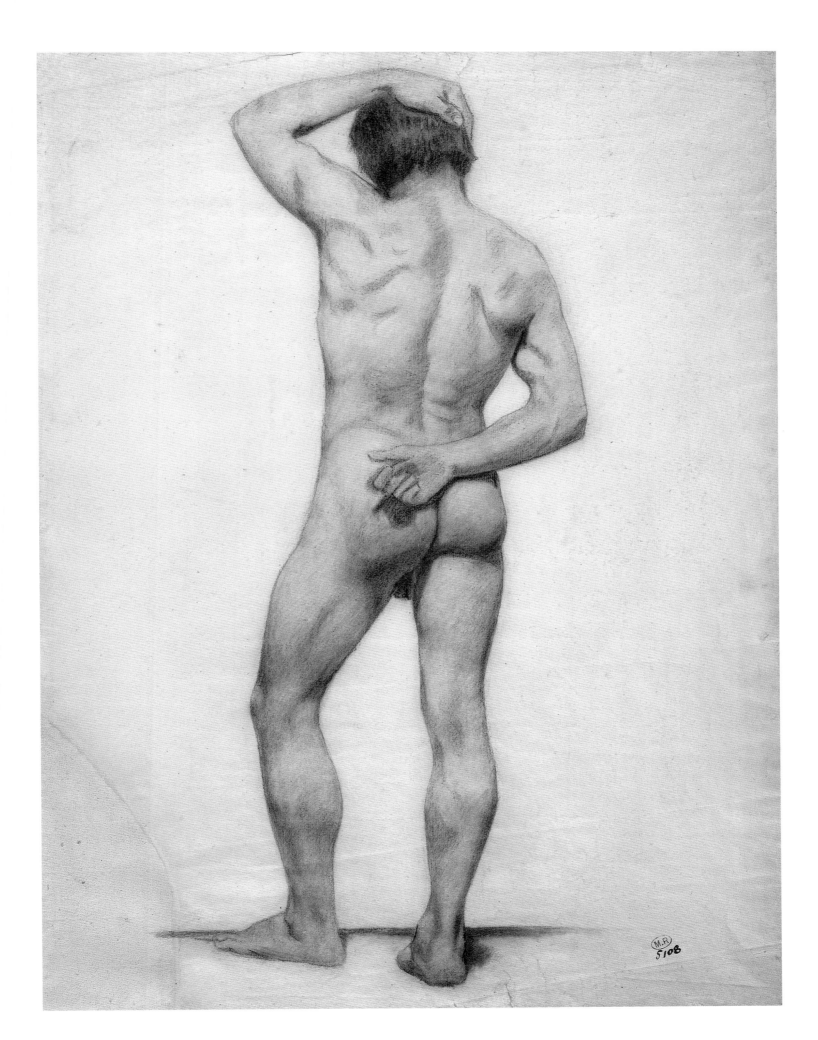

M.R
5108

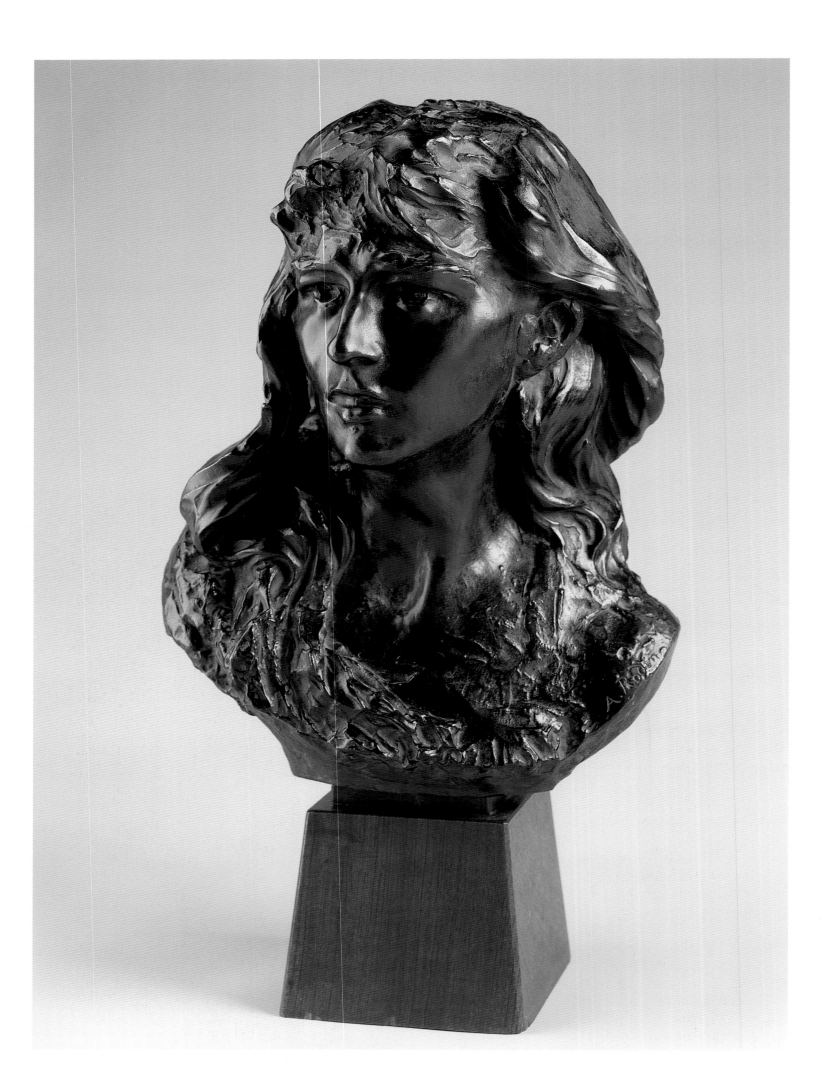

M.R 132

Above
**TWO DRAY HORSES,
THE LATTER STUMBLING.**
GRAPHITE ON BROWN PAPER,
3 ½ × 6 ½ IN. (8.8 × 16.8 CM).

Right
SKELETON, PRIOR TO 1870.
PENCIL ON BEIGE PAPER,
7 ¾ × 4 ½ IN. (19.9 × 11.5 CM).

Facing page
MIGNON,
C. 1870.
BRONZE,
16 × 12 ¼ × 10 ½ IN. (41 × 31 × 27 CM).

"Up to the age of fifty, I experienced all the problems
of poverty; I've always lived like a laborer, but
the joy of laboring made it all bearable. . . . Rest is
monotonous, and has the sadness of everything
that comes to an end."

Rodin, quoted in Dujardin-Beaumetz, *Entretiens avec Rodin*, 1913

Paris was then undergoing a major transformation. The vast urban
development begun by Baron Haussmann included decorative ambi-
tions that resulted in the hiring of many small contractors and labor-
ers. Rodin, more a sculptor's assistant than a full-fledged artist, earned
his living by working for ornamental and decorative carvers. Shy and
quiet, but combative, he also managed to devote several hours a day
to his own work. At a horse market on boulevard Saint-Marcel, near
his lodgings, he completed his education not only by painting horses
but also by observing life. In an unflagging desire to understand
things by observing them, he remained attentive and searching. At
the Natural History Museum, for instance, he struggled to master
anatomy and render animal forms under the vigilant eye of the great
animal sculptor Antoine-Louis Barye—yet he seems to have retained
few traces of his former master's influence.

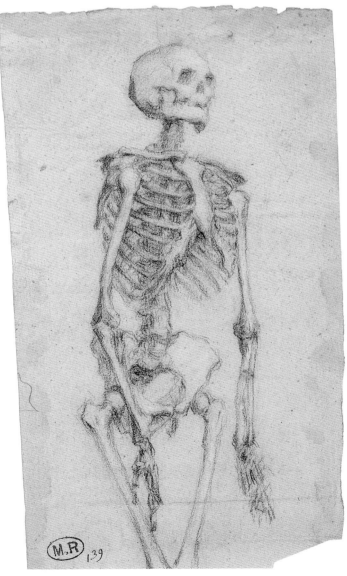

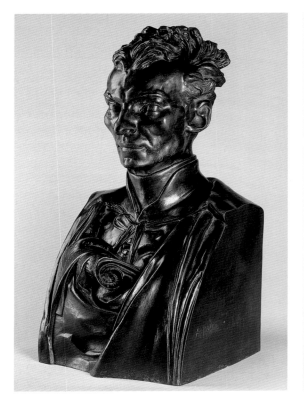

Far left
Father Eymard,
1863.
Bronze,
23 ¼ × 11 ¼ × 11 ½ in (59.3 × 29 × 29.2 cm).

Left
Albert Carrier-Belleuse,
1882.
Bronze,
19 ¼ × 17 × 12 ¾ in.
(49 × 43.2 × 30.4 cm).

Facing page, top left
Idyll (or Idyll in Ixelles),
1885.
Bronze,
20 ¾ × 16 × 16 ¼ in. (53 × 41 × 41.5 cm).

Facing page, top right
Venus and Cupid,
c. 1876.
Terracotta,
14 ¼ × 5 ½ × 6 in. (36.2 × 14.2 × 14.9 cm).

Facing page, bottom left
Young Mother,
1885.
Bronze,
15 ¼ × 14 ½ × 10 in. (39 × 36.9 × 25.5 cm).

Facing page, bottom right
Seated Child, Profile.
Graphite, pen, and black
ink on cream paper,
2 ¼ × 1 ½ in. (6.2 × 3.8 cm).

In many respects, 1864 represented a key date in Rodin's life. It was not only the year that Camille Claudel was born in northern France, but the year Rodin met—in Paris—Marie-Rose Beuret, who would become his lifelong companion. "At twenty," wrote Judith Cladel, "Marie-Rose Beuret was more than just a pretty woman. Her somewhat masculine features, her big, golden brown eyes that flared up at the least emotion, the abundant brown hair that she would curl and wear in an original manner, and a style of dress that, simple as it was, she graced with wide hats and her own personal cachet, all made her what was then called *a character*." Rose, of course, served as the artist's model, and Rodin's first sculpted portrait of her bears the name of Goethe's heroine, *Mignon*. The harsh but lively gaze, the pupils hollowed with a crown saw, and the parted lips make it a particularly expressive face. The wavy, wild hair falls over the sitter's shoulders as it delicately reveals her neck. Rodin's meticulous, thorough handling of his subject is a legacy of classicism yet in no way undermines the psychological dimension—the young woman appears to be fierce, shy, and sensual all at once.

Rose, originally from Champagne, was practically illiterate and worked in Paris as a seamstress. Her rural simplicity and devotion fully accorded with the requirements of a solitary, ambitious sculptor. Their affair led to the birth of an illegitimate son, Auguste Beuret, on January 18, 1866—the only name he ever received from his father was his first one. The birth of Auguste inspired Rodin to do drawings of infants, of mother and child, and of affectionate scenes in which the tightly knit pair make a charming group even if these subjects sometimes sink into mawkishness. Nothing in this early stage pointed to Rodin's later career.

He nevertheless labored intensely, coldly ignoring everything that did not serve his professional ambitions. Completely wrapped up in his work, he usually seemed anxious and absent, to the point of appearing unavailable, demanding, and irascible to his immediate entourage: "You're reading Balzac," he wrote one day to Hélène de Nostitz, "a man who should have had a wife that loved and cared for him. But men like him don't have what it takes to please. Their constant preoccupation with their art prevents them from being graceful and elegantly clean, and even makes them coarse despite their intelligence, because you only do well what you do every day."

Rodin had just rented a studio on rue Lebrun in the Gobelins district—but it was a studio in name only. The shabbiness and coldness of this former stable did not inhibit the young artist at work, his hands full of damp clay. Yet few traces survive of those years of work. Rodin was too poor to have casts made of the clay models, and almost all were lost to drastic changes in temperature and weather, as was the case of a *Bacchante* for which Rose posed: "My model didn't have the grace of a city lady, but all the physical vigor and firm flesh of a country girl, with that lively, frank, determined, masculine air that makes a woman's body even more beautiful." In those formative years, Rodin's sitters for paintings and sculptures were recruited almost exclusively from his family and friends. In the 1880s, when he became a real portraitist, he would execute for free—and in complete freedom—busts of friends such as Jean-Paul Laurens, Alphonse Legros, Albert-Ernest Carrier-Belleuse, and Jules Dalou.

Still in 1864, in search of greater financial security, Rodin accepted a job as an assistant in the workshop of Carrier-Belleuse, then a highly fashionable sculptor. "He always spoke of his master with respect and even a little admiration," recalled Sigismond Jeanès, "for he felt [Carrier-Belleuse] was skilled in his craft and sensitive to nature." On behalf of his boss, and with newly recognized virtuosity, Rodin shaped

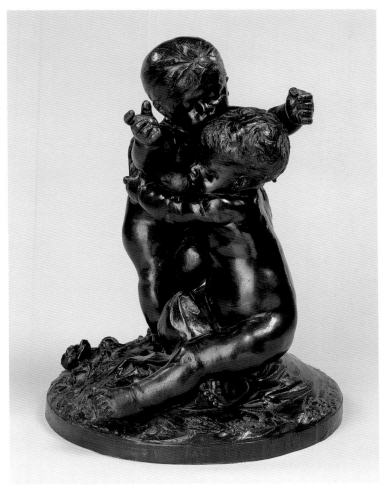

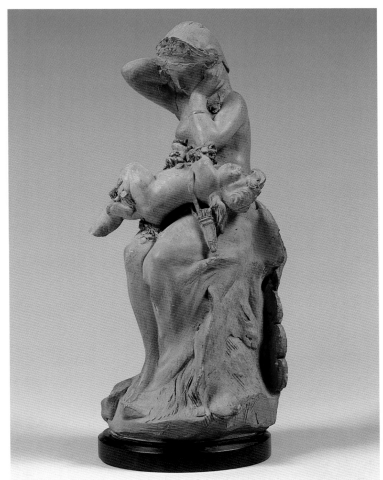

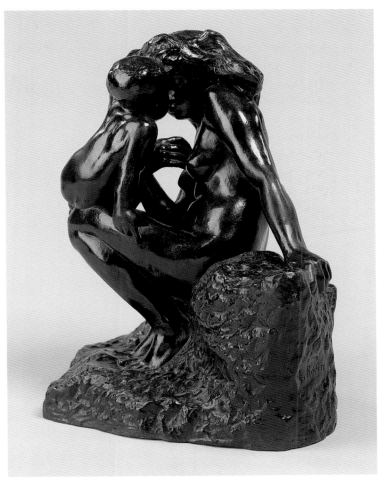

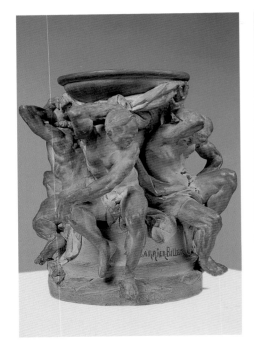
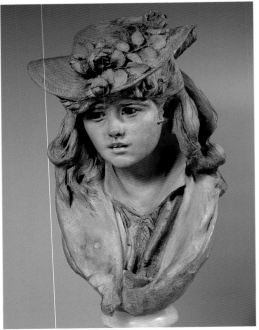

clay into elegant and sometimes frivolous sculpted groups, which Carrier-Belleuse signed and sold as his own. The *Vase des Titans,* with four figures inspired by Michelangelo's nudes in the Sistine Chapel, thus bears the signature of Rodin's employer. The employee, meanwhile, quietly familiarized himself with the workings of a large studio.

Even if he later renounced his "potboiling" sculptures, Rodin's swift success explains his prolific output of pleasant items designed for instant sale. The most representative of these charming figures is the *Young Girl with Roses on Her Hat,* whose handling and careful detailing demonstrate the modeler's skill. The light, graceful character, the perfection of the youthful face, the rendering of the finely woven, rose-adorned straw hat, and the accurate drapery of the bust all reveal a taste for detail typical of the bourgeoisie of the day.

"The most beautiful and happiest days of our lives."
Rodin on his stay in Belgium, quoted by Truman H. Bartlett

After France lost the Franco-Prussian war of 1870, Carrier-Belleuse transferred his workshop to Brussels, which was then enjoying an economic boom. Soon freed from military duties, Rodin joined his master early in 1871, leaving his parents, Rose, and young Auguste back in Paris. He worked on the ornamentation of the new Brussels stock exchange, or Bourse de Commerce, until Carrier-Belleuse discovered that his young assistant was also exhibiting works under his own name. Rodin was fired. A partnership contract signed on February 12, 1873 with Antoine-Joseph van Rasbourgh, another former Carrier-Belleuse employee, once again made Rodin eligible for monumental projects even as it allowed him to continue his own creative work. The partners' main commissions were for the decoration of public buildings in Brussels. Although the terms of the contract favored van Rasbourgh, Rodin also managed to produce, entirely on his own, a series of atlantes and caryatids on boulevard Anspach. Furthermore, the sculpted groups in terracotta that he turned out en masse under his own name sold well.

After seven years in Belgium, Rodin had made solid friendships with Belgian artists, who considered him a fellow countryman by adoption. Once he acquired a certain financial security, he allowed Rose to join him. Sunday strolls in a forest in Soignes just outside Brussels satisfied his need for meditation and passive contemplation. He wandered among all the wild spots, painting the woods in a very free manner that yielded some thirty small landscapes glued onto board, plus ten red-chalk drawings. "Dear forest of Groenendael!" he exclaimed later, a fan of nature in the manner of Gustave Coquiot. "Maybe that's where I found my wild Muse!"

"And all the time he was speaking to me, I sensed that he was observing, studying, drawing, sculpting, and etching me in his head."
Rodin described by Edmond de Goncourt in his diary

In 1875, Rodin's *The Man with a Broken Nose* was accepted for the Salon in Paris. Produced back in 1864, the work reflected the world-weary face of a poor man, nicknamed "Bibi," who lived in Rodin's neighborhood. But that year the winter had been harsh; the head of clay froze, split, and the entire back part shattered. Reduced to a facial mask, it was judged fragmentary—even though it prefigured a major aspect of Rodin's mature work—and was rejected by the Salon of 1865. Rodin nevertheless remained attached to this exceptionally fine portrait, which he considered to be his "first good sculpture." Once the head was completed anew, the hair redone in the manner of Greek philosophers, the work was carved in marble and assumed the air of a Socrates with the impact of an antique bust. Its exhibition at the Salon of 1875 constituted Rodin's first real victory.

He nevertheless remained unknown to the public. That same year, he decided to travel to Italy; the voyage—a powerful, youthful dream—was a mandatory stage in any artistic career at that time. In Florence, Rodin studied Michelangelo enthusiastically, paying him tribute on

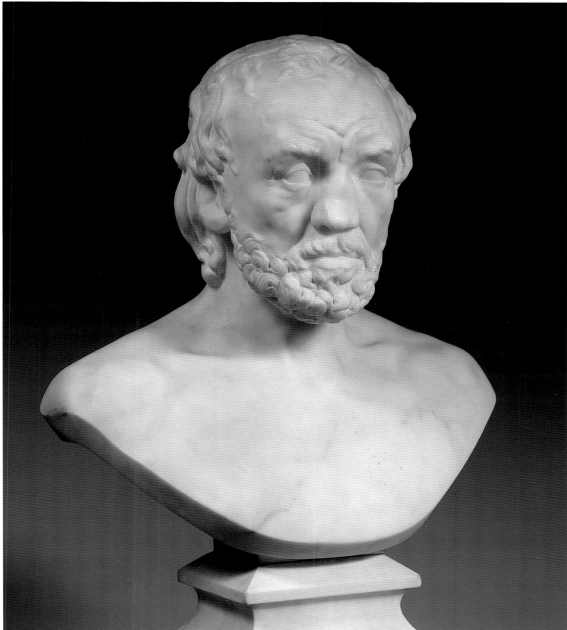

his return to Paris by completing a study of a life-sized nude. Initially exhibited without a title, later dubbed *The Vanquished One* and still later *Man Awakening to Nature,* it ultimately became known as *The Age of Bronze,* in reference to the third age of humanity as described by the Greek poet Hesiod. The figure represents the painful awakening of individual consciousness. Rodin breathed life into it through his perfect mastery of the human form, handled with particular sensitivity to modeling and the subtle play of light and shadow. But the absence of subject matter and the bold handling immediately provoked suspicions: Rodin was accused of having made a life mold. Misconceptions remained stubborn, envy sparked hostility, and critics sought to cast the piece as a pretentious failure. Deeply affected, Rodin vainly mobilized a solid defense by calling upon witnesses, photographs of the model (a young Belgian soldier named Auguste Neyt), and molds taken from the model. It was finally thanks to the support and enthusiastic efforts of friends, outraged by the damaging scandal, that *The Age of Bronze* was purchased by the French government

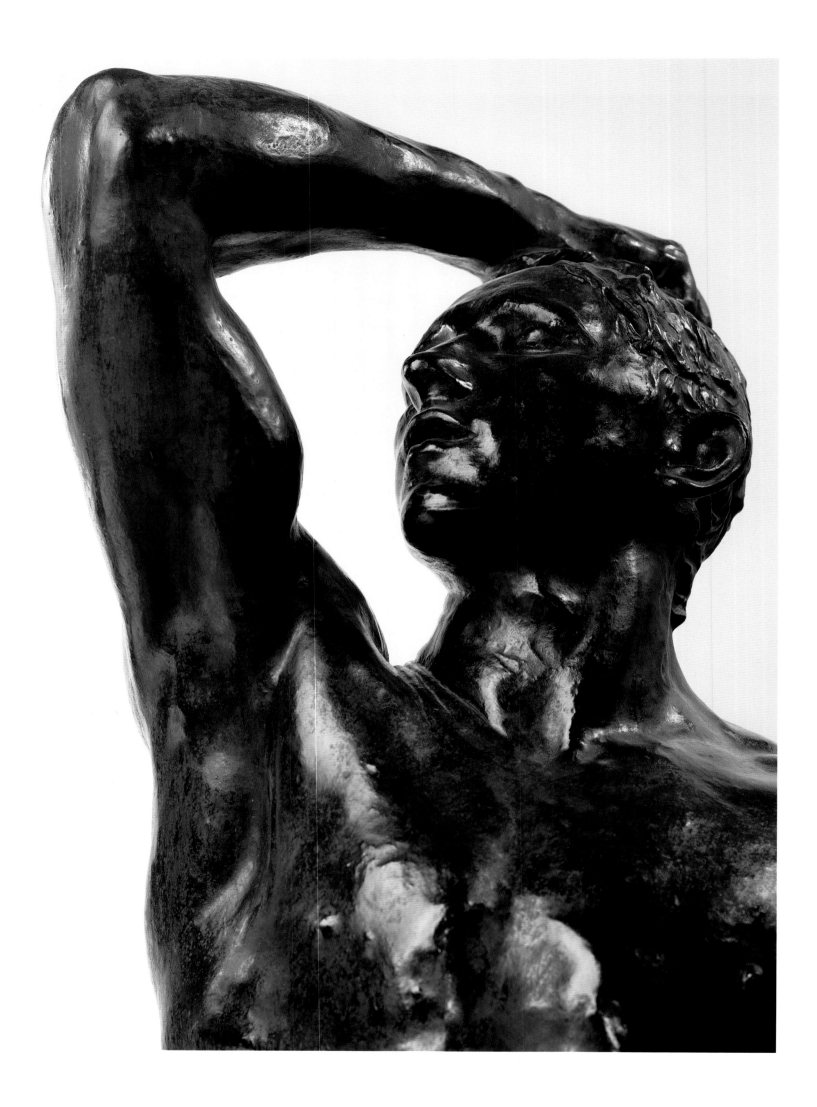

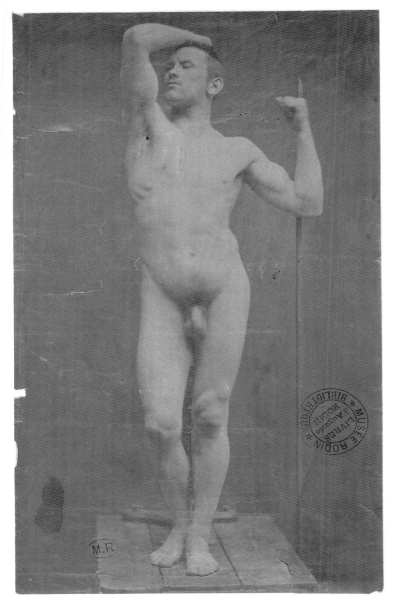

in 1880 at the cost of two thousand francs. This first major scandal, and first masterpiece, brought Rodin to the threshold of fame.

In the spring of 1877, he decided to return permanently to Paris. He was therefore obliged to find decorative work once again, notably modeling two large decorative masks (*Fair Weather* and *Foul Weather*) for a fountain at the Palais du Trocadéro, built for the Universal Exposition of 1878. From 1879 to 1882, Rodin executed a variety of ornamental vases on the behalf of the Sèvres porcelain factory, to which Carrier-Belleuse had just been appointed director. At the same time, the etcher Alphonse Legros taught Rodin to engrave. Encouraged by Legros, Rodin produced several drypoint engravings such as *Putti Guiding the Earth*. All those years of anxiety and poverty, of apprenticeship and hard work, taught Rodin patience and enabled him to fully master his craft. His now skillful hand, combined with his powers of execution and tenacity, would finally allow him to emancipate himself. The foundations of his art had firmly been laid.

Facing page
THE AGE OF BRONZE,
1877.
BRONZE, 71 × 27 × 21 ½ IN. (180.5 × 68.5 × 54.5 CM).

Left
GAUDENZIO MARCONI,
AUGUSTE NEYT, THE MODEL FOR THE AGE OF BRONZE.
ALBUMEN PRINT,
9 ½ × 5 ¾ IN. (24 × 14.8 CM).

Left
FOUL WEATHER,
1878.
DECORATIVE MASK FOR
A FOUNTAIN AT THE PALAIS
DU TROCADÉRO.
PLASTER,
49 ½ × 32 ¼ × 21 ½ IN.
(125.7 × 82.2 × 55 CM).

Far left, bottom
SAIGON VASE.
HARD-PASTE SÈVRES
PORCELAIN,
9 ¾ × 5 ¼ × 5 ¼ IN.
(24.7 × 13.3 × 13.3 CM).

Below
PUTTI GUIDING THE EARTH,
1881.
DRYPOINT,
12 ¼ × 14 ½ IN. (31 × 37 CM).

Through me you pass into the city of woe:
Through me you pass into eternal pain:
Through me among the people lost for aye.
Justice the founder of my fabric moved:
To rear me was the task of Power divine,
Supremest Wisdom, and primeval Love.
Before me things created were none, save things
Eternal, and eternal I endure.
All hope abandon, ye who enter here.

Dante, *The Divine Comedy*, Hell, Canto III, line 9, translated by Henry F. Cary, 1888

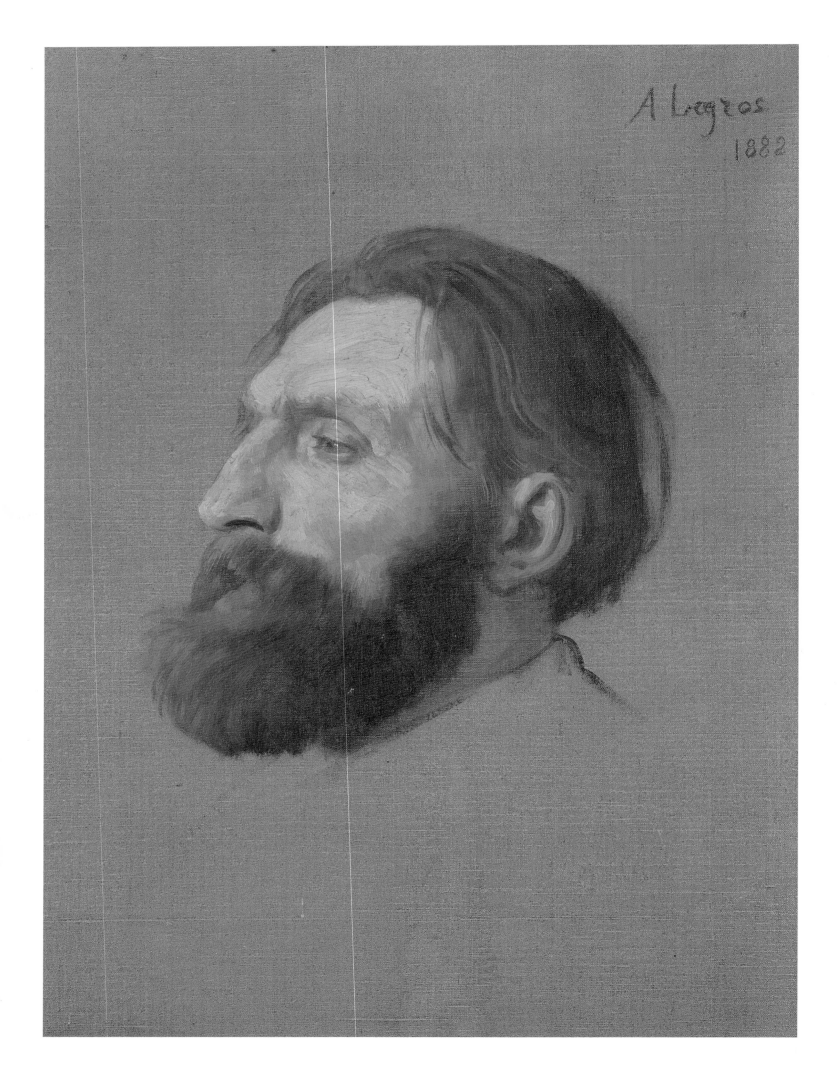

A Legros
1882

THE GATES
OF HELL

The official commission for what would become the pivotal work in Rodin's oeuvre was largely the result of the interest and influence of a politician, Edmond Turquet. Rodin probably met Turquet in 1877, when the latter was an elected representative for the Aisne region; he was a liberal who liked to surround himself with artists, entertaining them in his private residence in Neuilly, just outside Paris. When Turquet was named undersecretary of state for fine arts in 1879, the press applauded the government's choice. Rodin, too, was pleased by the appointment, and immediately took advantage of the connection to ask Turquet to reopen the inquiry over *The Age of Bronze,* to prove once and for all that it had not been cast from life. Following an initial, disappointing, report, a new official opinion notably signed by Carrier-Belleuse and Alexandre Falguière concluded: "Our unanimous and sincere assessment is designed to demolish the accusations of duplicate casting, which are absolutely erroneous." Although the polemic was finally put to rest, Rodin remained deeply affected by the slander that impugned not only his talent but also his honesty. As he would confide later, when speaking of *The Gates of Hell,* "Accused of having cast forms from life to produce my works, I created my *St. John* to prove that opinion false. But I was only half successful. Naive, simple, and innocent as I was, I then decided to model the figures on the *Gates* smaller than life-size, in order to prove once and for all that I was able to model from nature just as well as other sculptors."

On January 11, 1880, Rodin went to see Turquet, who discussed a commission for a bronze door to a building still in the planning stages, designed to house a museum of decorative arts. On July 1, the chief secretary of the fine arts ministry, Georges Hecq, wrote to Rodin to announce that a workshop had been placed at his disposal in the Dépôt des Marbres, a government marble warehouse located at 182 rue de l'Université; the workshop would remain available for the duration of the commission. In fact, Rodin managed to hold onto a studio at the Dépôt until his death, which was where most of his oeuvre was produced. On August 16, 1880, France's President Jules Ferry signed the order commissioning Rodin to produce a model of a "bas-relief depicting Dante's *Divine Comedy.*" The sum of eight thousand francs accorded Rodin was modest compared to what would have been offered—for less ambitious projects—to well-known artists such as Chapu, Falguière, and even Dalou. But here Rodin was being recognized for the first time by the government, which was making an official commission. The very nature of the commission was of

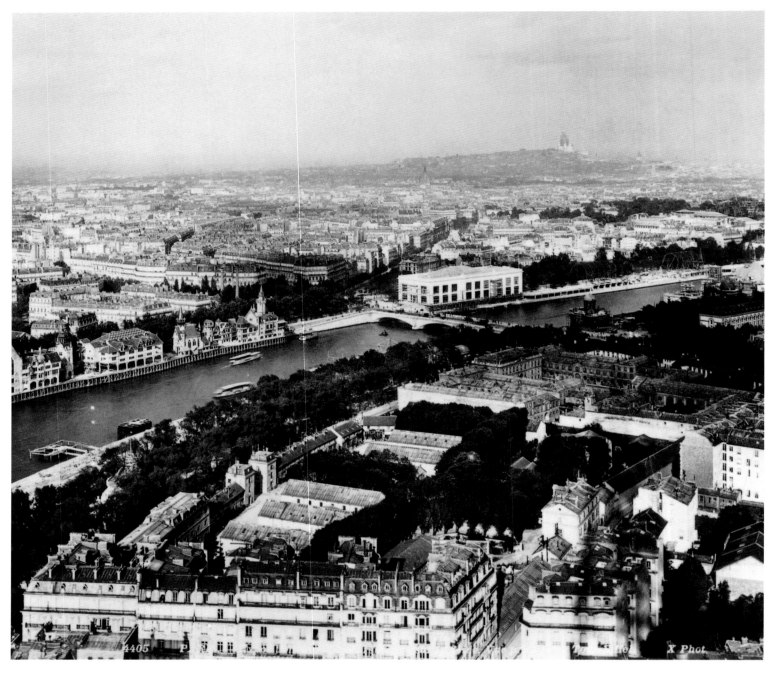

Above
NEURDEIN BROTHERS,
THE DÉPÔT DES MARBRES,
SEEN FROM THE EIFFEL TOWER, C. 1908.
ALBUMEN PRINT,
8 ¼ × 10 ¾ (21.1 × 27.4 CM).

Facing page
LORENZO GHIBERTI,
BAPTISTERY DOORS, FLORENCE, 1425–52.
BRONZE.

capital importance to the sculptor: like equestrian statues, monumental doors were considered prestigious projects that could be awarded only to well-known artists.

One of the uncontested models for such doors were those done by Lorenzo Ghiberti from 1425 to 1542 for the baptistery in Florence, whose panels depicted scenes from the Old Testament. An admiring Michelangelo dubbed them the "Gates of Paradise." Rodin, during his trip to Italy in 1875, spent a long time admiring the bronze masterpiece. "In Florence," he later told René Chéruy, "I saw Ghiberti's gates, the ones Michelangelo studied. On returning home, I couldn't stop

thinking of Florence. And then I read Dante's *Divina Commedia*—it was always in my pocket. I read it every time I had a free moment. In fact, I'd begun the *Ugolino* group before seeing Monsieur Turquet. My head was like an egg ready to hatch. Turquet broke the shell."

The influence of the Florentine Renaissance in general and Ghiberti's doors in particular had been shared by other artists in the nineteenth-century: during the reign of Philippe Auguste (1830–1848), sculptor Henri de Triqueti completed the monumental doors of the church of La Madeleine in Paris, showing the Ten Commandments in the form of bas-reliefs of biblical scenes. Here again, the debt to

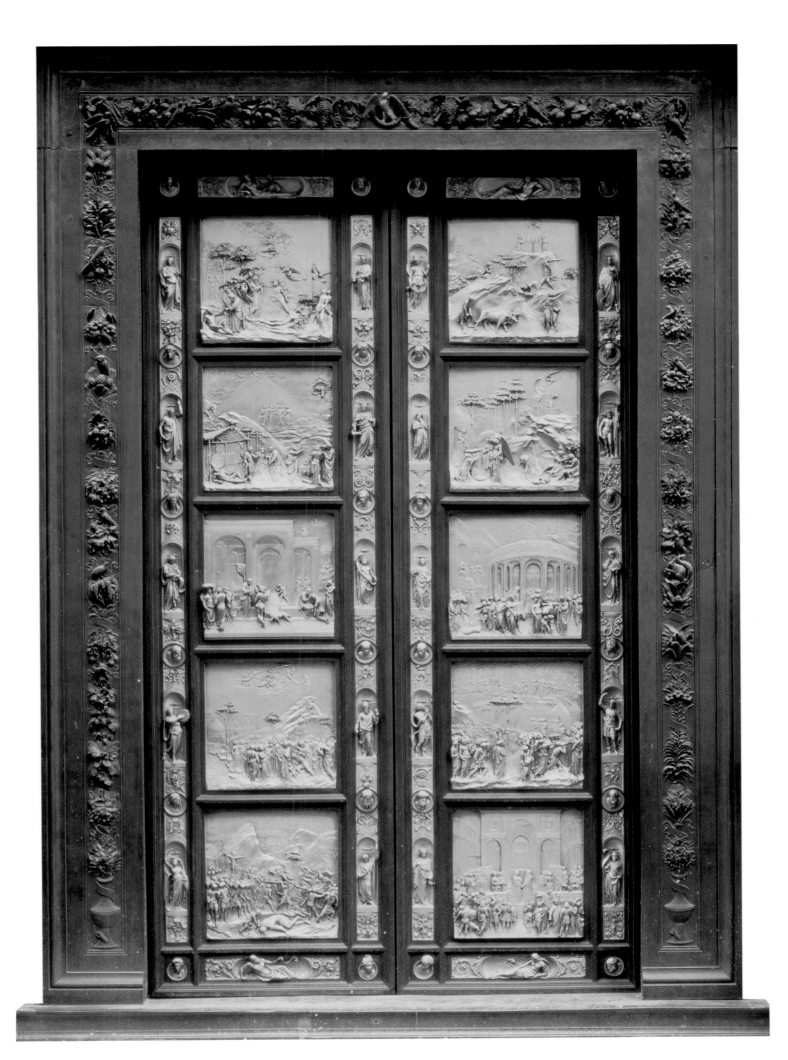

PLANNING A MUSEUM OF DECORATIVE ARTS

In 1857, Londoners inaugurated the South Kensington Museum (later renamed the Victoria and Albert Museum), an institution devoted to the decorative arts. In France, curators and other administrators of imperial museums, headed by Emilien de Nieuwerkerke, superintendent of fine arts under Napoleon III, immediately stressed the importance of establishing a similar institution. This idea had been dismissed by François de Neufchâteau back at the turn of the nineteenth century. Finally, it was artists and craftsmen, rather than political administrators, who in 1864 founded the applied arts association known as the Union Centrale des Beaux-Arts Appliqués à l'Industrie.

After the Franco-Prussian war of 1870, the idea of a museum was taken up by major collectors. Thus in 1876 a national subscription was launched to finance the building of the future museum. The following year, the Société pour le Musée des Arts Décoratifs was established under the aegis of Duc d'Audiffret-Pasquier. Philippe de Chennevières, who had worked in Napoleon III's fine arts administration and then headed the department from 1874 to 1877, joined the society's executive committee in 1878; he thereby strongly rivaled Edmond Turquet in developing the planned museum, to the extent of organizing a high-profile exhibition of drawings by French ornamental artists at the same time as Turquet's Salon of 1880 was being held. One year later, the Union Centrale and the Société merged, becoming the Union Centrale des Arts Décoratifs.

Against this background of political maneuvering, the rivalry seems to have spurred Turquet to commission Rodin to produce the doors for the future museum, as a way of demonstrating the government's determination to regain control of the project. As though stressing his administration's role in cultural policies even further, in 1881 Prime Minister Léon Gambetta even set up a ministry of fine art completely independent of the ministry of education. Antonin Proust, who was appointed minister, left the government the following year and became president of the Union Centrale des Arts Décoratifs. Plans for the museum slowly advanced. In February 1885, the Union Centrale and the government signed an agreement that anticipated installing the new museum in a restored Palais d'Orsay, which had been burned during the events of the Paris Commune in 1871.

The Universal Exposition of 1889—timed to celebrate the hundredth anniversary of the French Revolution—was a driving force behind the project, but ministerial instability and financial crises continued to delay the opening of the museum; instead, the government put its energy behind insuring the solemn inauguration of Dalou's monument to the French Republic on place de la Nation. Meanwhile, the land on which the Palais d'Orsay had stood was sold to the Paris–Orléans railway company, which hired architect Victor Laloux to build a new train station on the site. The collection of the Union Centrale, which had been formed in 1882, was housed in the Palais de l'Industrie for a time, and later transferred to the Marsan wing of the Louvre, where the Musée des Arts Décoratifs finally opened in 1905.

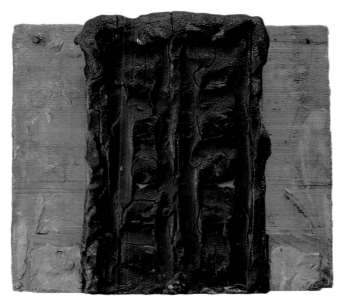

Ghiberti was obvious, if only through the division of the overall composition into ten historical panels. The influence was equally obvious on Rodin when he sketched his early ideas for *The Gates of Hell*. They reflect the compartmentalized structure of the Florentine panels, each compartment depicting a specific incident. The subdivision of Dante's poem into cantos made such division easy, perfectly conforming with a breakdown into independent narrative scenes. Nevertheless, Rodin soon abandoned this initial idea in favor of a single overall panel on each of the double doors, providing scope for an astounding fall of the damned from top to bottom, thus echoing the impact of Dante's text.

In 1881, Rodin was awarded an additional commission for two statues, representing Adam and Eve, designed to flank the *Gates*. Michelangelo's influence on *Adam* is very clear: the position of the

right hand strikingly recalls the hand of God in Michelangelo's fresco on the Sistine Chapel of the creation of Adam. Yet Rodin decided to abandon the combined staging of statues and doors, despite a few surviving sketches—it was only after his death and the inauguration of the Musée Rodin that the two statues were placed on either side of the *Gates*. *Adam* directly inspired the group of three *Shades* installed above the doors around 1886, as though underscoring the lines from canto III of the *Inferno*, where Dante reads above the entranceway to the dark passage: "All hope abandon, ye who enter here."

"It is not a translation, it's a conjuration!"

Henri Turat

While preparing this work, Rodin spent nearly a year on a series of sketches—the famous "black" drawings—which he explained to Léon Gauchez in 1883: "Before beginning the work itself, I had to try to transform myself, to get into the spirit of this wonderful poet. That's why these drawings are groping efforts. I circled around Dante's ideas a good deal, and if my drawings were not used, if they did not all become part of the work, at least they served as preparation. I can't assume that all my drawings will be modeled, because the overall harmony occasionally requires something different than what I had been working on from the standpoint of pure expression. So at this time my drawings are more an illustration of Dante at moments of sculptural expressiveness, of which there are very many."

Subsequently realizing that he couldn't go as far as he wished, and aware of the overly narrative character of his drawings, Rodin soon began to model his subjects from life. His thinking thus became steadily clearer. As he wrote to Turquet, "This door will be at least 4.5 meters [fifteen feet] high and 3.5 meters [twelve feet] wide, and will include, in addition to the bas-reliefs, many figures almost in the round. Plus two colossal figures on each side. . . . I'll need at least three years to complete the work."

At regular intervals Rodin asked for advances from the government, which were promptly paid. In 1883, following yet another request, the fine arts ministry sent an inspector, Roger Ballu, to report

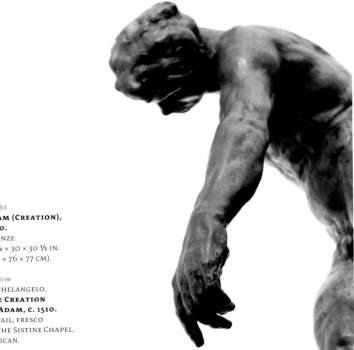

Right
**ADAM (CREATION),
1880.**
BRONZE.
77 ½ × 30 × 30 ½ IN.
(197 × 76 × 77 CM).

Below
MICHELANGELO,
**THE CREATION
OF ADAM, C. 1510.**
DETAIL, FRESCO
IN THE SISTINE CHAPEL,
VATICAN.

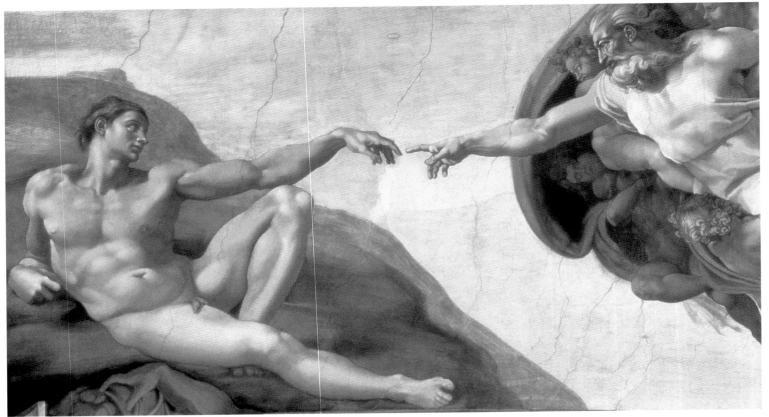

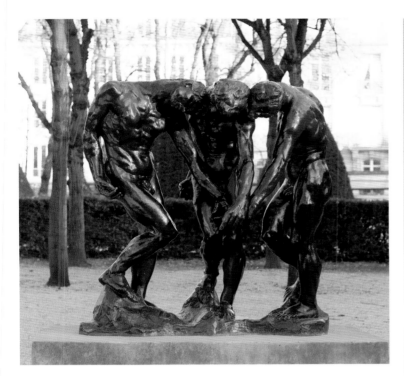

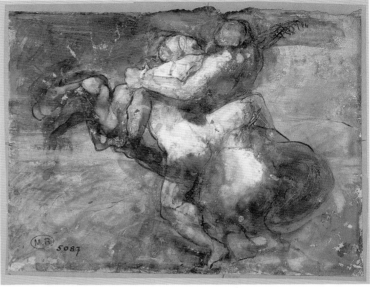

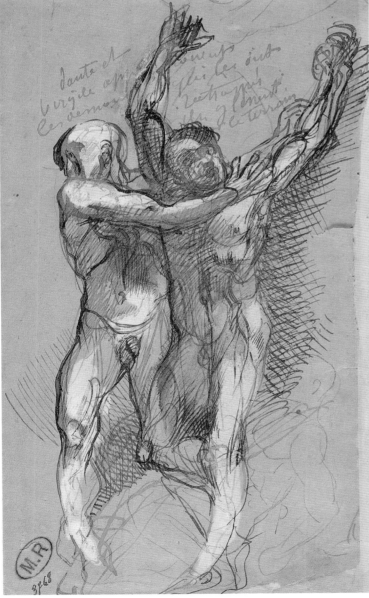

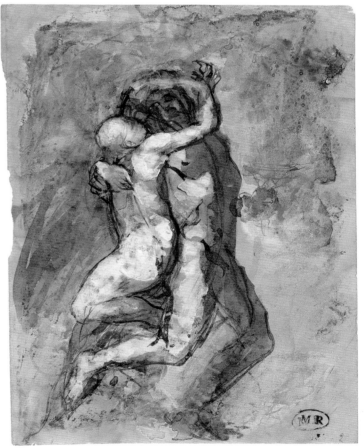

Left, top

THE THREE SHADES, 1902–04.
BRONZE (COUBERTIN FOUNDRY),
79 ¼ × 79 ½ × 45 ¼ IN. (191.5 × 191.8 × 115 CM).

Left, bottom

DANTE AND VIRGIL, C. 1880.
GRAPHITE, PEN AND BROWN INK, WASH,
AND GOUACHE HIGHLIGHTS ON BEIGE PAPER
GLUED TO A SUPPORT.
ANNOTATED, TOP, IN PEN AND BROWN INK: DANTE
ET VIRGILE APPERÇOIVENT LES DÉMONS QUI LES
ONT RATTRAPÉS. ILS GLISSENT SUR LE TERRAIN.
(DANTE AND VIRGIL SEE THE DEMONS WHO HAVE
CAUGHT UP TO THEM—THEY STUMBLE ON THE
GROUND.)
7 ½ × 4 IN. (19 × 10.5 CM).

Above, top

**A GALLOPING CENTAUR CARRIES OFF
A WOMAN, C. 1880.**
PEN AND INK, WASH, AND GOUACHE
ON PAPER GLUED TO A PAPER SUPPORT,
ITSELF GLUED TO CARDBOARD,
6 × 7 ½ IN. (15.5 × 19.2 CM).

Above, bottom

THE CIRCLE OF LUST, C. 1880.
GRAPHITE, PEN AND BROWN INK,
WASH, AND GOUACHE,
7 ½ × 6 IN. (19.5 × 15.1 CM).

on progress. Ballu ended his report with the affirmation that the *Gates* "will stand out for their originality. They will be criticized in the name of traditional principles and standard rules. They will be acclaimed for their determined energy and the style that governs their execution. They will truly be, in the full sense of word, a work of art."

In 1884, sculptor Jules Dalou even defended a new request for money by writing directly to Armand Fallières, the minister of education and fine arts. "My friend Rodin tells me that you would like my opinion on the decorative doors that he is doing for the Ministry of Fine Arts. Let me just say that in my view, I am deeply convinced that it will be one of this century's finest pieces of art, and perhaps its most original. As to the sum allocated for this work, you know as well as I do that it is *very modest* not only given the considerable expenses involved, but also given the great artistic value of this fine work."

These various reports confirm the fact that government art administrators were following Rodin's work with interest, as they did all official projects. Curiosity was also steadily aroused by the press of the day—the archives of the Musée Rodin abound with press clippings saved by the artist himself, including articles and accounts of visits to his studio at the Dépôt des Marbres. As an official

government commission, the *Gates*—"always talked of, never seen" according to Jean Wilfrid—were frequently mentioned in various contexts relating to their subject matter, their originality, and obviously their cost. In 1882, Henri Turat was the first journalist to describe a visit to the workshop.

This ascetic's hovel instills respect and superstitious fright in the visitor. You are brought in with an air of mystery, and are immediately assaulted by fantastic sights—what are those veiled shadows standing along the walls? What masterpieces crouch beneath those damp cloths? And what about the enormous wood chest that rises to the ceiling and takes up the entire floor, what is that? Rodin replies calmly, "That's my Gates of Hell!" Fame will pass through this triumphal arch. Despite my promise to the artist to remain discreet, I can't help telling him, and him alone, that this colossal conception will survive as an age-old monument. . . . All of Dante's genius can be found there, on that one page of sculpture. It is not a translation, it's a conjuration!

In late 1884, casts of various parts of the *Gates* were assembled, enabling Octave Mirbeau to provide one of the earliest detailed descriptions of them in the February 18, 1885 issue of *La France*.

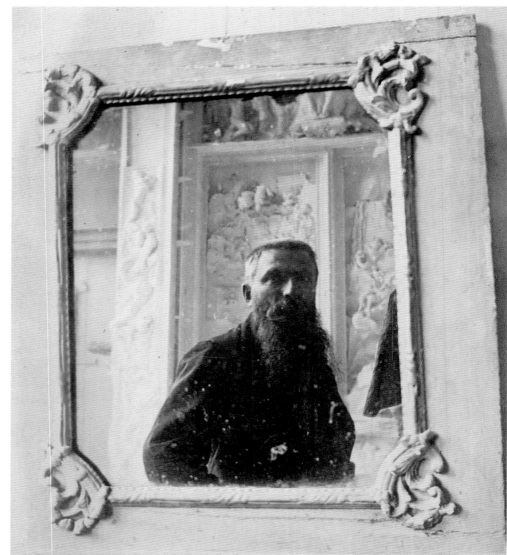

Right
WILLIAM ELBORNE,
**RODIN REFLECTED
IN A MIRROR, IN FRONT
OF THE GATES
OF HELL, 1887.**
ALBUMEN PRINT
FROM THE LIPSCOMB ALBUM.
5 × 4 ¼ IN. (12.9 × 11.1 CM).

Page 34
**THE GATES
OF HELL, 1900.**
PLASTER,
236 ¼ × 152 ¾ × 38 ½ IN.
(600 × 388× 97.5 CM).

Page 35
**THE GATES
OF HELL, 1880/1889–1890.**
PLASTER, EXECUTED IN 1917,
236 ¼ × 157 ½ × 37 IN.
(600 × 400× 94 CM).
PARIS, MUSÉE D'ORSAY.

The two parts of the door are divided into two panels, each separated by a group that forms a kind of knocker. On the right door are Ugolino and his sons; on the left, Paolo and Francesca da Rimini. Above these groups Rodin has composed figures in the round and scenes in high relief, which gives this work extraordinary perspective. Each door is crowned by tragic masks, heads of furies, dreadful and graceful allegories, and illicit passions. Below these groups are more bas-reliefs, from which surge masks of sorrow. Centaurs gallop along the river of mud, carrying off women who struggle, writhe, and twist on their rearing backs; other centaurs unleash arrows at the wretched people trying to escape; we see women, prostitutes, carried away in swift falls, tumbling precipitously, head first, into the flaming mire.

"What about cathedrals, are *they* ever finished?"
Rodin

That same year, Rodin considered making a bronze cast, as confirmed by an official order dated August 20, 1885. But he could not resign himself to the idea that the work was finished, so he continually altered it. Things dragged on—construction of the new museum of

**PROPOSAL FOR INSTALLING THE GATES OF HELL
IN THE CHAPEL OF THE SAINT-SULPICE SEMINARY,
1908–10.**
GRAPHITE ON CREAM PAPER,
4 ¾ × 3 ½ IN. (12.4 × 8.9 CM).

decorative arts was postponed indefinitely, and Rodin had begun to work on other commissioned projects, such as *The Burghers of Calais*. In 1888, the government paid him yet another advance, though the bronze doors had not yet been cast. Neither the upcoming Salon of 1888 nor the Universal Exposition of 1889 were enough to compel Rodin. Meanwhile, independent works based on the *Gates* were steadily making their way in the world, as witnessed, for example, by the government commission for *The Kiss* in 1888 and the *Monet–Rodin* exhibition of 1889, which featured many fragments including *The Thinker* (an allegorical depiction of Dante).

Years went by, but the final cast was still put off. Was this from lack of complete mastery of the subject? Or from the angst of putting an end to a work that was a constant topic of conversation? A note from Rodin to the journalist Mathias Morhardt, dated 1888, would tend to suggest the latter. "I ask you as a friend, since we are already [friends], that if you write about visiting the sculptors' studios you will not mention [the *Gates*]; a brief word about my sculpture, if you like, about its spirit, but the word *Gates* has appeared too frequently and may ultimately lead to disappointment when they are exhibited." Whatever the case, given all the indecisiveness, the *Gates* steadily lost their utilitarian goal, becoming an autonomous artwork independent of practical consideration.

For the Universal Exposition of 1900, a fuss was nevertheless made over finding a site for the *Gates*. A number of places were suggested, or rather mentioned, such as the Palais des Beaux-Arts. Rodin made sketches that show his musings over various potential sites. Ultimately, it was for his one-man show in the pavilion on place de l'Alma that a plaster cast of *The Gates of Hell* was first exhibited in public. Rodin had decided at the last minute to remove most of the figures he had sculpted for it, leaving only a kind of simplified sketch, topped by the group of three *Shades*. This decision went unnoticed by the public, which paid scant attention to the doors; but some critics, such as André Fontainas, were drawn to the spareness and symbolism of the *Gates*. "Here we see only the outline of the intended work; the figures that will detail the meaning, one by one, are not placed, and yet already we are impressed by the thrilling splendor of the composition, by the heavily worked surface of hollows and swellings that generate a sophisticated play of light." Rodin's deliberately radical approach testifies to his modernity, as rightly stressed by Antoinette Le Normand-Romain. "By stripping the *Gates* . . . of everything that made them comprehensible . . . Rodin crossed the threshold of representation to become the first person to enter the realm of pure abstraction." After the show, the *Gates* returned to the Dépôt des Marbres while awaiting a potential use. Around 1908–10, one plan suggested installing a bronze and marble version of the *Gates* at the seminary of Saint-Sulpice in Paris, in a setting of frescoes that illustrated the Creation; it came to nothing. Rodin seemed to have abandoned any idea of finishing his work.

At Rodin's death, Léonce Bénédite, the first curator of the Musée Rodin, had a complete model of the *Gates* assembled from the original molds. The first bronze cast was executed in 1926–28. Today there are seven casts of *The Gates of Hell* throughout the world, made between 1926 and 1997: Paris, Philadelphia, Tokyo, Zurich, Stanford, Shizuoka, and Seoul.

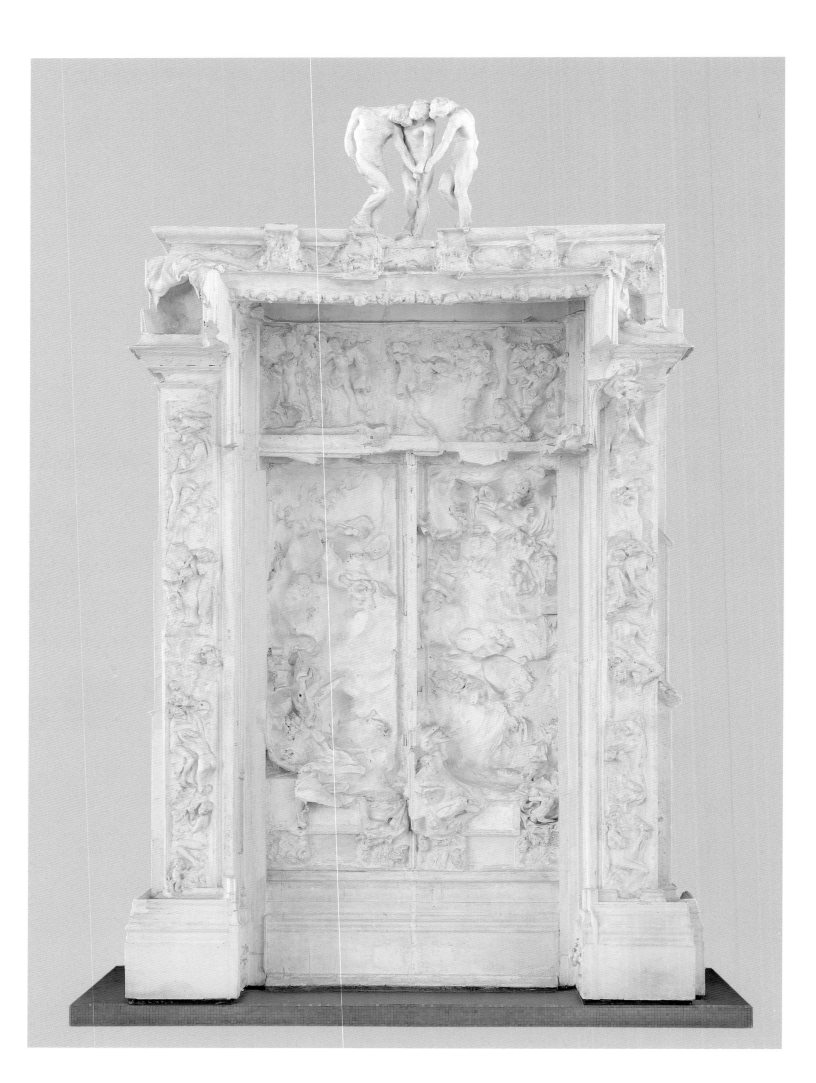

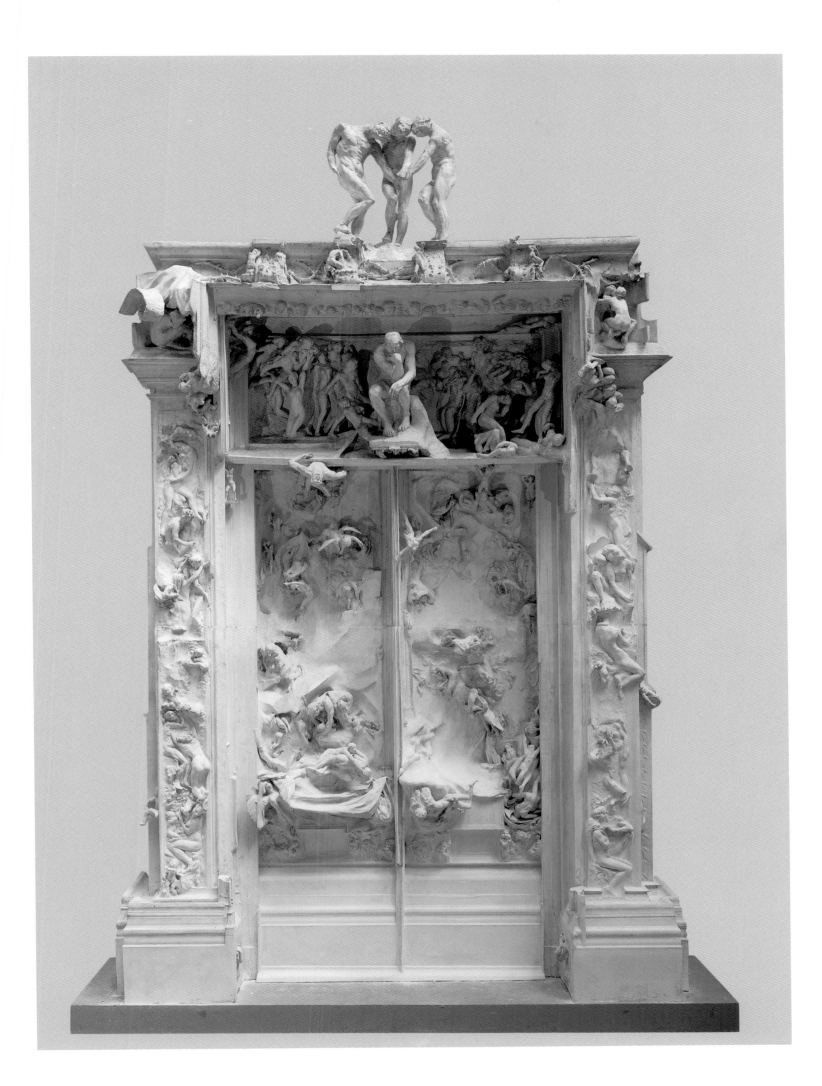

The Gates of Hell as a reservoir of forms

There are five sections to *The Gates of Hell:* two doors, two pilasters, and the tympanum. Rodin arrayed nearly two hundred figures across it, including many that would take on an independent life. Indeed, having decided early on to favor high relief for the decoration of various parts of the *Gates,* Rodin could draw on the main figures to create new subjects—which sometimes drew fire from critics.

[Rodin] has become fashionable and is selling isolated figures from his Gates, carved in marble, by the dozens. In his studio, you can always see five or six of his little groups entwined in every possible pose—and then some. And should you go visit any young sculptor known to be a skillful, sensitive carver of marble, it's a sure thing he'll be working on these figures: "It's for America, you know." The worst thing is, unrestrained subjects that are justifiable in the context of the Gates—Original Sin, Damnation, and the Last Judgment—often become indecent when taken separately. As one of these gentlemen rather coarsely but rightly told me, "Rodin now fashions nothing but fannies." Indeed, the common denominator of all these sinning little ladies is that they press their faces against or into the stone, while offering to the beholder's gaze another part of their body, one usually considered most unlikely to portray the torments of the soul.

This severe, even unfair, criticism in 1893 by Alfred Lichtwark, director of a museum in Hamburg, shows once again the modernity of an artist whose work went against the grain of the traditional ideas and habits of his day.

"The *Gates* [were] the source of almost everything that met with success."
Rodin

This book is not the place to provide a complete description of all the subjects seen on *The Gates of Hell*. It is nevertheless essential to discuss a few of the compositions that evolved into the masterpieces that still symbolize Rodin's genius today.

Eve

The statue of Eve was originally designed to flank the *Gates,* opposite Adam. Rodin's sitter was a young Italian woman, Adèle Abbruzzesi, who, along with her sister Anna, was one of his favorite models. A significant incident occurred during the modeling of *Eve*, one that provides a remarkable illustration of the importance of observation in Rodin's work. "I saw my model changing, without knowing why. I altered my profiles, naively following the successive changes in forms, which became ever greater. One day I learned that she was pregnant, and everything became clear. The profiles of her belly had barely changed, but you can see how authentically I copied nature by looking at the muscles of her loins and sides."

Adèle also posed for the *Caryatid* on the top left corner of the *Gates,* a figure that was moreover the first to acquire an independent life—a marble version of it was exhibited at the Cercle des Arts Libéraux in 1883.

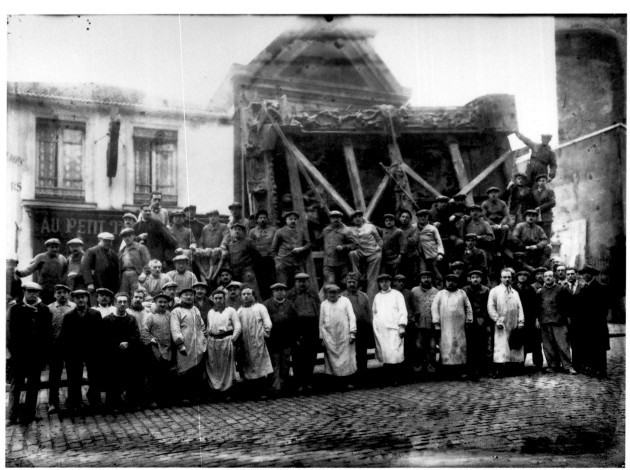

Right
JEAN-FRANÇOIS LIMET,
**TRANSPORTING
THE GATES OF HELL,
1928.**
GELATIN SILVER
PRINT,
3 ½ × 9 ½ IN.
(18 × 24 CM).

Facing page
ANONYMOUS
PHOTOGRAPHER,
**CASTING THE GATES
OF HELL AT THE
EUGÈNE RUDIER
FOUNDRY,
C. 1926.**
GELATIN SILVER
GLASS NEGATIVE,
3 ½ × 2 ½ IN.
(9 × 6.5 CM).

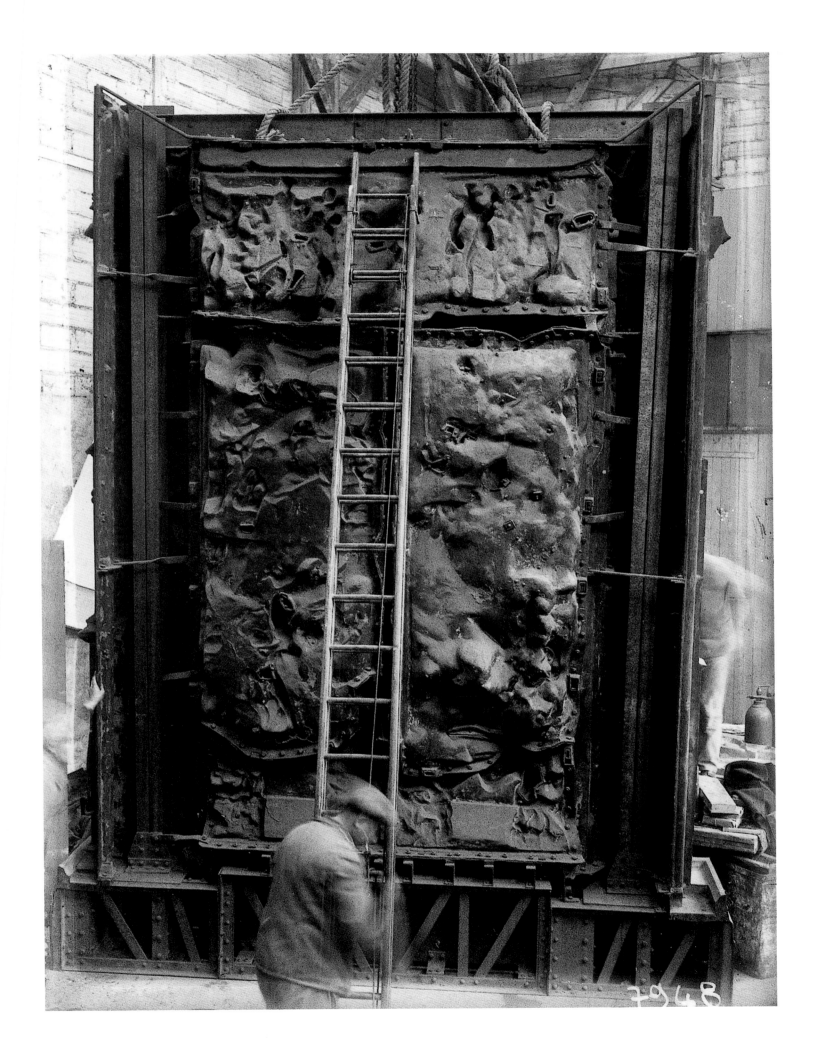

The Thinker

Le Penseur n'est pas homme, il est l'Homunculus,
Non né des alambics, mais de mains musicales,
En un bronze muet, cependant plus diffus
Et sonore, que les cloches des cathédrales.

Ce fougueux Penseur est le fœtus fabuleux
Et lourd de la Pensée, accroupi en équerre,
Palpitant et courbé dans un sein monstrueux
Fort et fécond, dans la matrice de la Terre.

The Thinker is not so much man as Homunculus,
Not of alembic born, but of musical hands
From mute bronze, a bronze that resounds
Farther and wider than cathedral bells.

This spirited Thinker is the mythical fetus
of Thought, so square in girth,
Crouched yet throbbing in a vast breast
so strong and fertile, in the womb of the Earth.

Valentine de Saint-Point, Poèmes de l'Orgueil (c. 1904)

Rodin's first attempts at male anatomy date from the time when he was working in Belgium. Thus in 1872 he incorporated a replica of the Belvedere Torso into the trophy of arts on the Palais des Académies in Brussels. Meanwhile, the vigorous bodies in his *Vase des Titans* (1878–80), and above all the *Seated Man*, seem to prefigure what would become his most famous sculpture.

Rodin originally considered depicting a cloaked, full-length Dante in the middle of the entablature of *The Gates of Hell,* but he soon replaced the poet with a figure of a seated nude man apparently gazing upon the figures of the damned at his feet. "Thin and ascetic in his straight gown, my Dante would have been meaningless once divorced from the overall work. Guided by my initial inspiration, I conceived another 'Thinker,' a nude man crouching on a rock, his feet tense. Fists tucked under his chin, he muses. Fertile thoughts slowly grow in his mind. He is no dreamer. He's a creator." Once again we see here Rodin's rejection of pointless anecdote, which constantly led him toward greater simplification and universality.

This figure was put in place very rapidly, and became the sole element of the *Gates* that underwent no further modification. Like *The Kiss,* it was exhibited on its own, notably in 1889 during the *Monet–Rodin* exhibition at the Georges Petit Gallery, where the work swapped its original title of *The Poet* for *The Thinker.*

It was in 1902 that Rodin decided to enlarge this piece, giving it a monumental scale that ran counter to the habits of the day; whereas it was common for sculptors such as Barye and Carpeaux to issue reductions of their work for commercial purposes, the enlargement of sculptures was rarely done (except in the case of monumental commissions). Rodin had nevertheless made an earlier, successful attempt in 1888 when the government commissioned a marble version of *The Kiss* based on the smaller one exhibited the previous year.

The first monumental version of *The Thinker* was thus enlarged by Henri Lebossé and cast by A. A. Hébrard in 1903. Critical reaction was both hostile and enthusiastic: from "a furious orangutan" to "a man of all epochs," the range of descriptions and attitudes to this work proved that once again Rodin had become an artist who was in direct touch with his times.

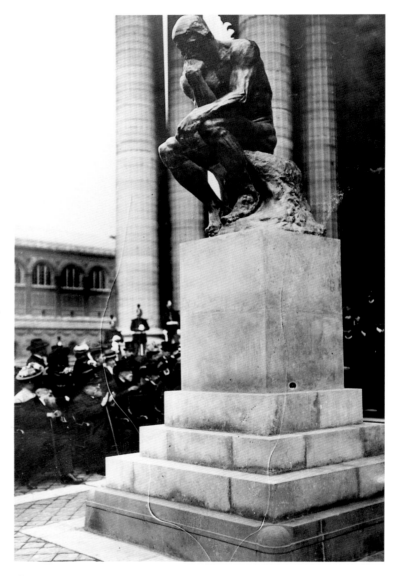

Above
MARCEL HUTIN,
UNVEILING THE THINKER IN FRONT OF THE PANTHEON, APRIL 21, 1906.
GELATIN SILVER PRINT,
6 ½ × 4 ½ IN. (16.8 × 11.4 CM).

Facing page, top left
EVE, 1880–81/1899.
BRONZE
(CAST BY ALEXIS RUDIER),
68 ½ × 22 ¾ × 26 IN.
(174 × 58 × 66 CM).

Facing page, top right
**CARYATID WITH STONE,
c. 1880–81.**
BRONZE,
17 ¼ × 12 ½ × 12 IN.
(44.2 × 32 × 30.5 CM).

Facing page, bottom left
THE THINKER, 1902–04.
BRONZE
(CAST BY ALEXIS RUDIER),
70 ¾ × 38 ½ × 57 IN.
(180 × 98 × 145 CM).

Facing page, bottom right
**STUDY FOR THE THINKER,
c. 1880.**
TERRACOTTA,
9 ½ × 7 ¾ × 4 IN.
(24.5 × 19.8 × 9.9 CM).

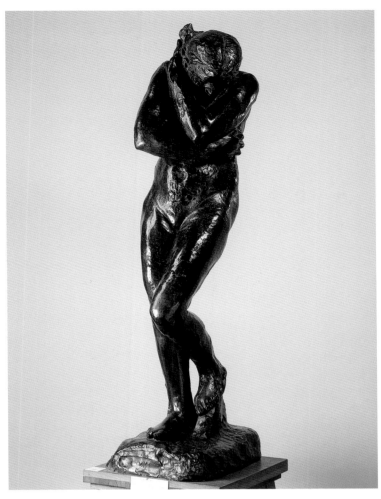

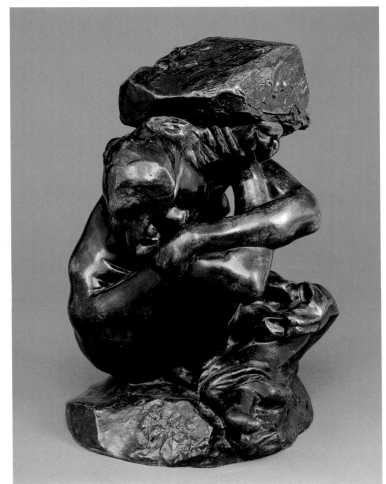

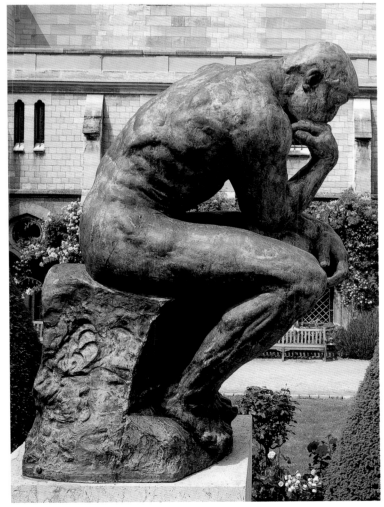

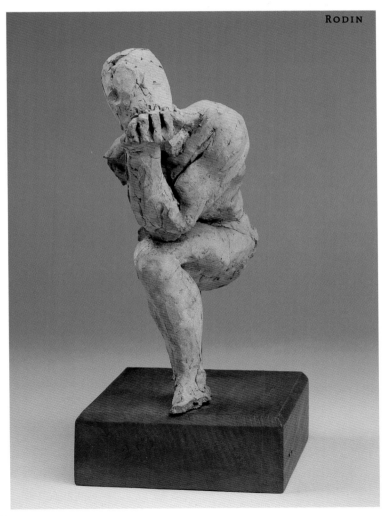

In June 1904 a campaign was launched to erect *The Thinker* in Paris. A subscription was organized under the lively aegis of Gabriel Mourey, editor of the magazine *Les Arts de la Vie*. After many delays and hesitations, a bronze cast by Alex Rudier was finally unveiled in front of the Pantheon on April 21, 1906. It remained there until 1923, when it was moved to the grounds of the Musée Rodin in the Hôtel Biron.

The image of *The Thinker,* one of the best-known sculptures of all time, was quickly disseminated and incorporated into collective culture through countless reproductions in all media (Léandre caricatured Rodin as a "Thinker" as early as 1907). The image has been appropriated in so many ways, from parody to advertising—a prospectus vaunting Onoto pens seems to have led the way in 1908—that it would impossible to count them all.

Simultaneously symbolizing Rodin and his sculpted oeuvre, *The Thinker* is now a part of universal culture. Its title alone is sufficient identification, even without the name of the sculptor. In total, there are twenty-one large-scale bronzes scattered across the planet, the most recent having been cast by the Musée Rodin in 1977 and now located in the City Museum of Nagoya, Japan. The first, 1903, cast of *The Thinker* is currently in Louisville, Kentucky, while the second (also 1903) is owned by the Detroit Institute of Art. The third—still 1903—is the one that was unveiled in front of the Pantheon and is now at the Musée Rodin in Paris. Meanwhile, the bronze version placed on Rodin's tomb in Meudon was cast in 1917.

Paolo and Francesca (*The Kiss*)

Paolo Malatesta and Francesca da Rimini figure in canto V of Dante's *Inferno*. The poet placed them in the second circle of hell, the one reserved for sinners condemned for lust, including great figures of antiquity and epic literature: Semiramis, Dido, Cleopatra, Helen, Achilles, Paris, Tristan, and so on. Francesca da Polenta, the first shade to speak to Dante, was a young woman from Ravenna who in 1275 married Gianciotto Malatesta, lord of Rimini and brother of Paolo. Having fallen madly in love with one another, Paolo and Francesca were caught by Gianciotto, who stabbed them to death. The event took place around 1285. Rodin decided to depict the couple at the moment when, surrendering to temptation, the two lovers embrace after reading of the love of Lancelot and Guinevere; in Rodin's plaster model of 1882, Paolo still holds the book in his hand, but this detail is scarcely visible in the marble version. The lovers' nudity shocked certain critics, who would have preferred to see them in period dress. The gentle sensuality emanating from the sculpture accorded poorly with the chaotic group of damned figures, leading Rodin to remove it from its planned location on the right door to another spot on the right pilaster. This work was soon being exhibited independently, acquiring its title of *The Kiss*.

The French government placed an order for an enlarged marble version in 1888, but it was only put on display ten years later, at the same time as the *Monument to Balzac*. After the Universal Exposition of 1900, the marble entered the Musée du Luxembourg in Paris; today it can be seen at the Musée Rodin.

Despite Rodin's own reservations—he was aware of the slightly academic classicism of this group—*The Kiss* still remains one of his most famous sculptures. It constitutes a kind of link between the dash of Bernini and the experiments of Brancusi.

Ugolino

Ugolino appears in cantos XXXII and XXXIII of Dante's poem (the Antenora ring of the ninth circle, for those who betrayed country or companions). Ugolino della Gherardesca, count of Donoratico, played an equivocal role in the wars that raged between Guelphs and Ghibellines among—and even within—Italian cities. In 1289, Ugolino was accused of treason and imprisoned with his sons and two grandsons in the Gualandi Tower in Pisa. There they all died of hunger. Legend has it that Ugolino ate the flesh of his dead children in an effort to survive, before succumbing to hunger himself. This subject had already been handled by Jean-Baptiste Carpeaux during his stay in Rome (1857–62, now in the Musée d'Orsay, Paris). Carpeaux depicted Ugolino in a seated pose not without similarities to the future *Thinker*. Rodin had also approached the subject at an earlier date, during his time in Brussels, employing a similar seated pose. Yet at the same

Right
CHARLES LEANDRE,
**"THE TINKER," COVER OF
LE RIRE, MAY 11, 1907.**
12 ¼ × 9 IN. (31 × 23.2 CM).

Facing page
**THE KISS,
c. 1881–82/1889.**
MARBLE,
71 ½ × 44 ¼ × 46 IN.
(181.5 × 112.5 × 117 CM).

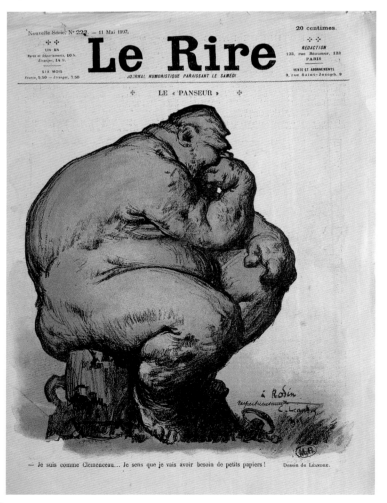

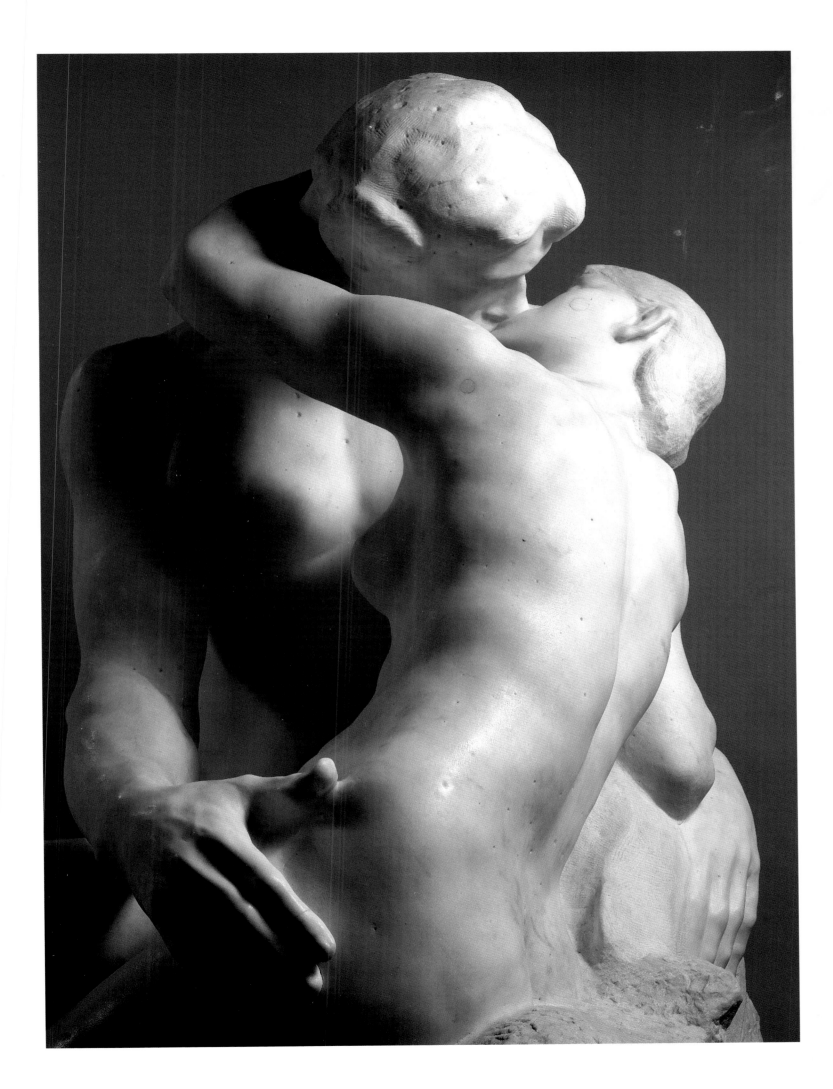

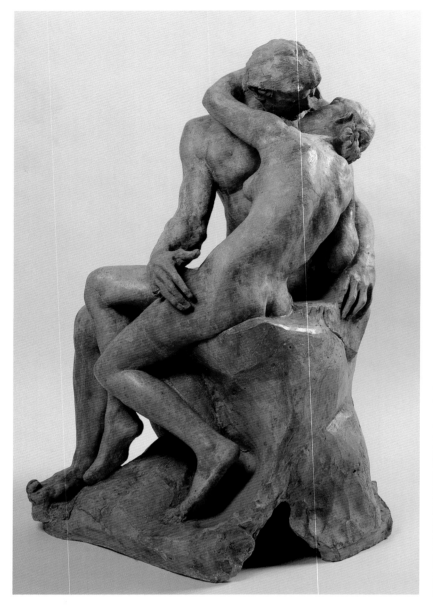

THE KISS, C. 1887.
TERRACOTTA,
31 × 20 ½ × 20 ¼ IN.
(78.7 × 52.5 × 51.8 CM).

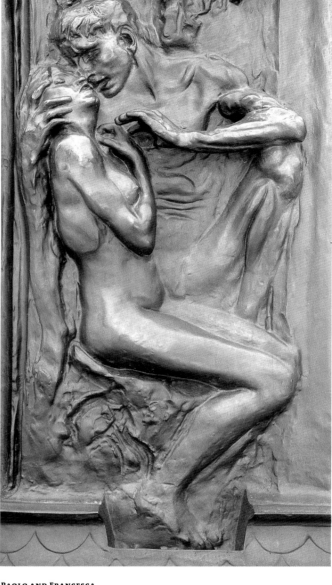

PAOLO AND FRANCESCA.
DETAIL FROM THE GATES
OF HELL.

time he sketched a version in which Ugolino was crouching, the one that would ultimately be seen on the left door of the *Gates*. This final pose spectacularly accentuates the horror described by Dante: "I threw myself, howling and crawling, on those lifeless bodies, calling to them two days after their deaths, calling them again until the hunger extinguished in me what sorrow had not." Enlarged by Lebossé between 1901 and 1904, the modified group was cast after Rodin died, around 1925, and placed in the middle of the ornamental pool on the grounds of hôtel Biron.

In addition to these major works, a few other figures populating *The Gates of Hell* deserve mention, such as the centaurs, mythological creatures that became demons, and who were charged with guarding and torturing looters, tyrants, and murderers (canto XII). Dante names three centaurs, Nessus, Pholus, and Chiron, with whom he

converses. Rodin also produced human figures that would in turn take on an independent life: one man was transformed into a free-standing figure known as *The Falling Man,* who was then combined with *The Crouching Woman* to become *I Am Beautiful,* while his enlarged torso would become *Marsyas* (or *Torso Louis XIV*). The group titled *Fugit Amor* would be elaborated in several variations, the man becoming, on his own, *The Prodigal Son.*

Alone, at the foot of the right pilaster, is the solitary image of a bearded old man, *The Creator,* a Rodin self-portrait that could be considered the artist's signature: like medieval masters, he has included himself in his work. For that matter, veneration for vestiges of the past can often be found in Rodin, combined with a love of fine workmanship. In Rodin's mind, *The Gates of Hell* wound up acquiring an almost sacred dimension, prompting him to reply, when questioned

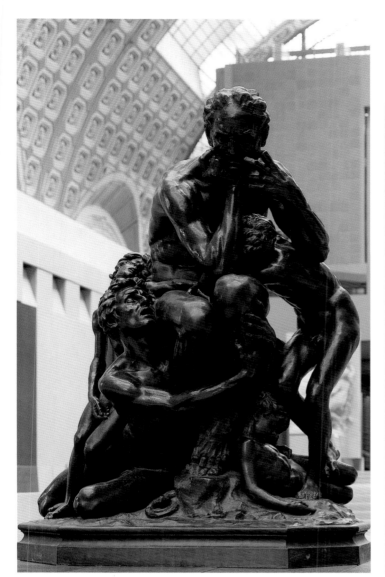

UGOLINO AND HIS CHILDREN, 1901–04.
BRONZE (CAST BY ALEXIS RUDIER),
52 ½ × 55 × 76 ¼ IN. (133.5 × 140 × 194 CM).

Above

UGOLINO, C. 1880.
GRAPHITE, PEN AND RED
AND BROWN INK, GRAY WASH,
GOUACHE HIGHLIGHTS.
ANNOTATED TOP RIGHT IN PEN
AND BROWN INK: UGOLIN,
6 ¾ × 5 ½ IN. (17.3 × 13.7 CM).

Left

UGOLINO.
DETAIL FROM THE GATES
OF HELL.

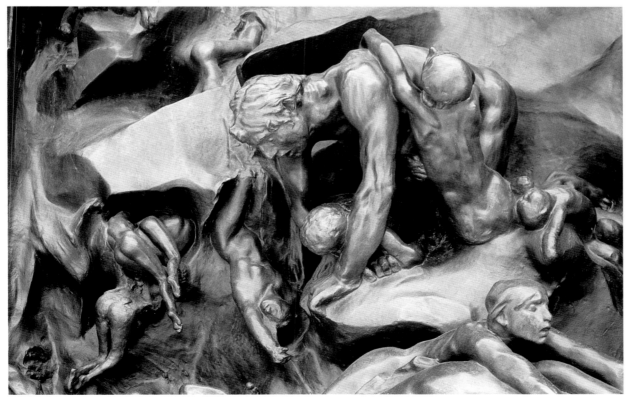

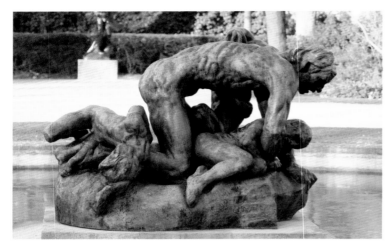

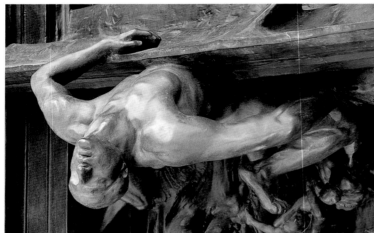

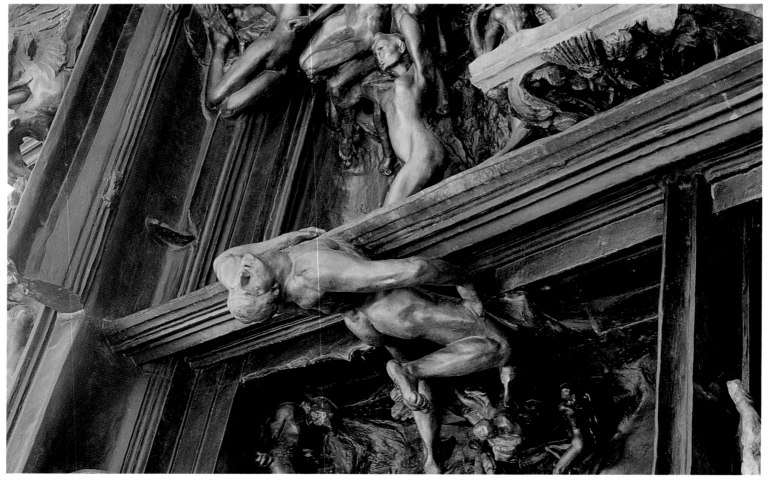

about the completion of the work. "What about cathedrals, are *they* ever finished?"

From whatever angle it is approached, *The Gates of Hell*—that unfinished masterpiece, that compendium of Rodin's genius, that extraordinary monument—is grand testimony to a lifetime of ceaseless aesthetic exploration and labor. Over time, Rodin became more and more aware of that fact, which is perhaps why he became indifferent to the completion of the entire ensemble. As he wrote to Turquet in 1904, nearly twenty-five years after he was awarded the initial commission: "What I still thank you for is the commission you gave me when everything seemed so impossible for me, namely the *Gates,* which was the source of almost everything that met with success—*The Kiss* and *The Thinker.* The confidence you showed in the artist gave me confidence; your true impartiality, such as a courageous government minister could permit himself, has given me ever-renewed gratitude. For at my age I can now judge things more easily, standing on the mountain that age and life have obliged me to climb."

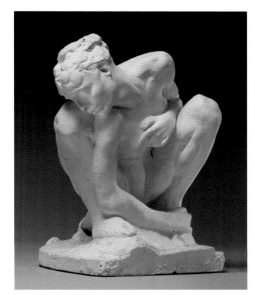

CROUCHING WOMAN,
1881–82.
PLASTER,
12 ½ × 11 ¼ × 8 ¼ IN.
(31.9 × 28.7 × 21.1 CM).

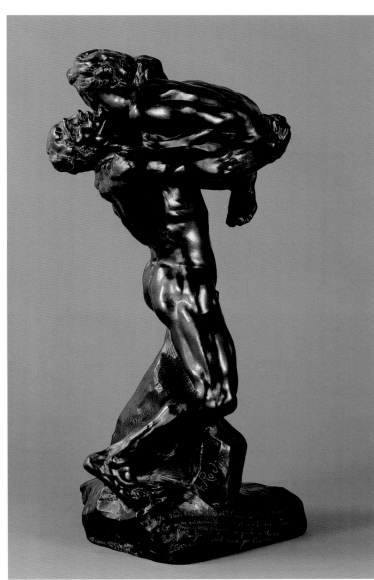

Facing page, top left
UGOLINO AND
HIS CHILDREN, 1901–04.
BRONZE (CAST BY ALEXIS RUDIER),
52 ½ × 55 × 76 ¼ IN.
(133.5 × 140 × 194 CM).

Facing page, top right
THE CREATOR (SELF-PORTRAIT
OF RODIN).
DETAIL FROM
THE GATES OF HELL.

Facing page, center and bottom
THE FALLING MAN.
DETAIL FROM
THE GATES OF HELL.

I AM BEAUTIFUL,
c. 1886.
BRONZE,
27 ¼ × 14 × 14 IN.
(69.4 × 36 × 36 CM).

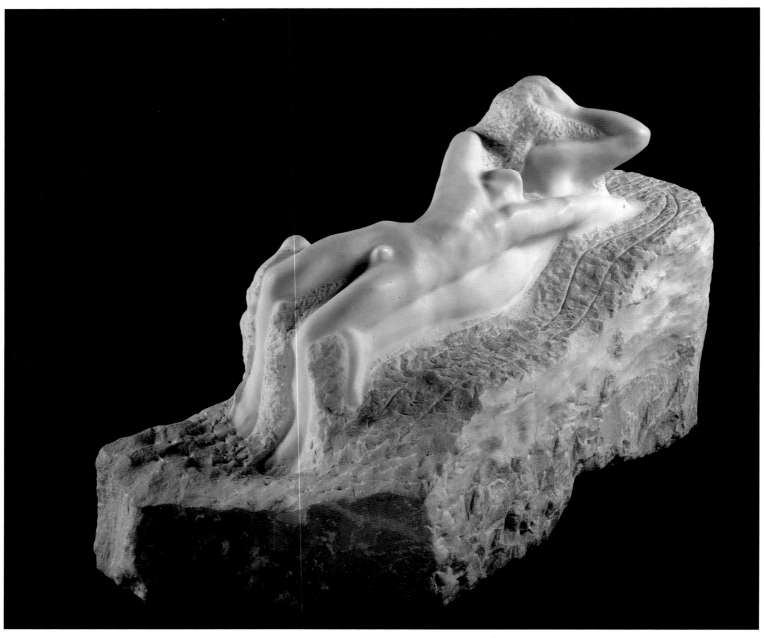

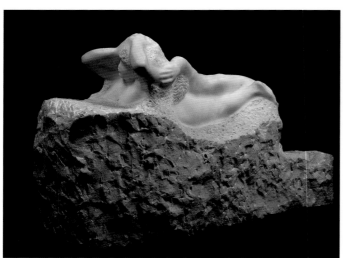

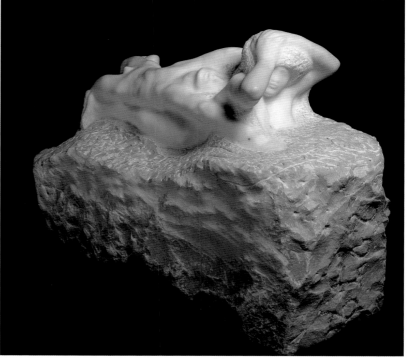

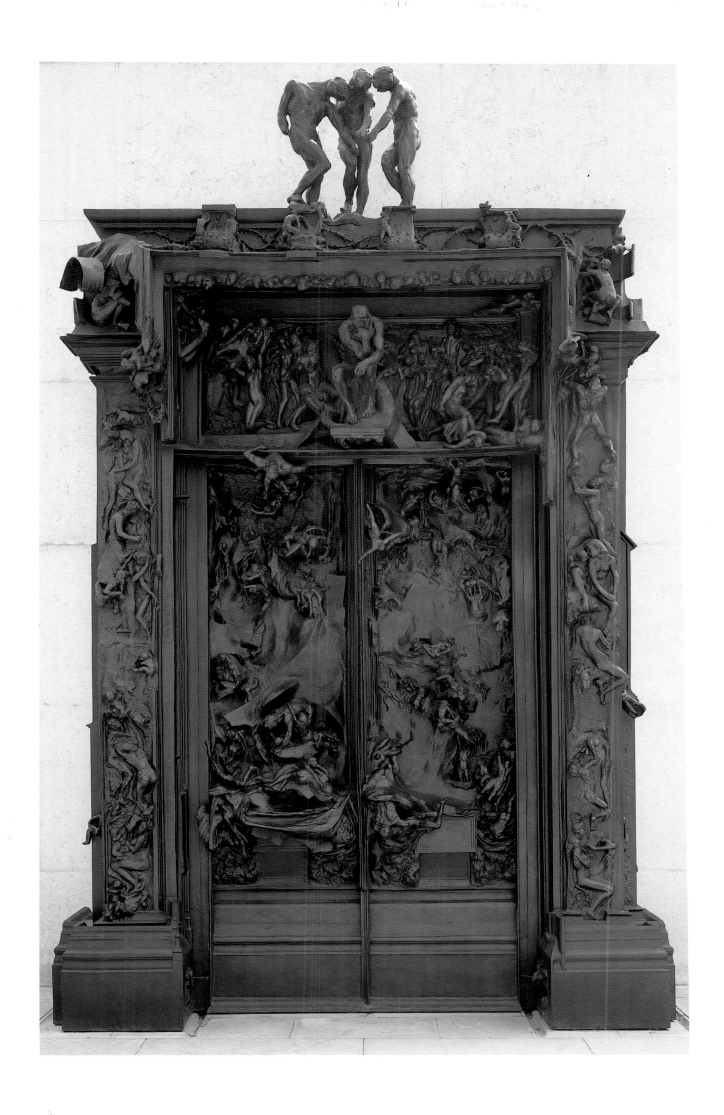

DANTE:
AN ETERNAL SOURCE OF INSPIRATION TO ARTISTS

Dante Alighieri's *The Divine Comedy,* with its description of Hell, Purgatory, and Heaven, has long provided a wellspring of inspiration for painters, illustrators, sculptors, and musicians. The vast poem, begun in 1306–07 and completed just before Dante's death in 1321, enjoyed immediate fame yet underwent a notable eclipse starting in the sixteenth century. It was largely thanks to Neapolitan scholar Giambattista Vico (1668–1744), and in particular to the publication of his *Discoverte del vero Dante, ovvero nuovi*

principi di critica dantesca (1728–29), that Dante enjoyed a revival in the first half of the eighteenth century. But it was above all in the nineteenth century that various episodes from *The Divine Comedy* were used by artists who found that the tormented imagery of hell offered an inexhaustible source of subject matter.

A few artists undertook a complete illustration of the poem. First among them was the painter Sandro Botticelli, who in 1481 began executing a hundred or so drawings, now held in Rome and Berlin, for a manuscript copy commissioned by a member of the Medici family. Much later, in England, John Flaxman (1755–1826) depicted several scenes from *The Divine Comedy* in a spare,

neoclassical style, followed by William Blake (1757–1827), who produced over one hundred drawings and watercolors between 1824 and 1827 with the intention of illustrating the entire poem. He died before the project was completed.

Like many artists who delved into *The Divine Comedy,* Blake devoted the most important part of his cycle to Dante's vision of hell. In the latter half of the nineteenth century, Gustave Doré produced engravings for a complete edition of the work (1861). A brief overview of illustrators should include Salvador Dalí, who in 1950 was commissioned by the Libreria dello Stato in Rome to paint one hundred watercolors depicting the poem's one hundred cantos; the book was finally

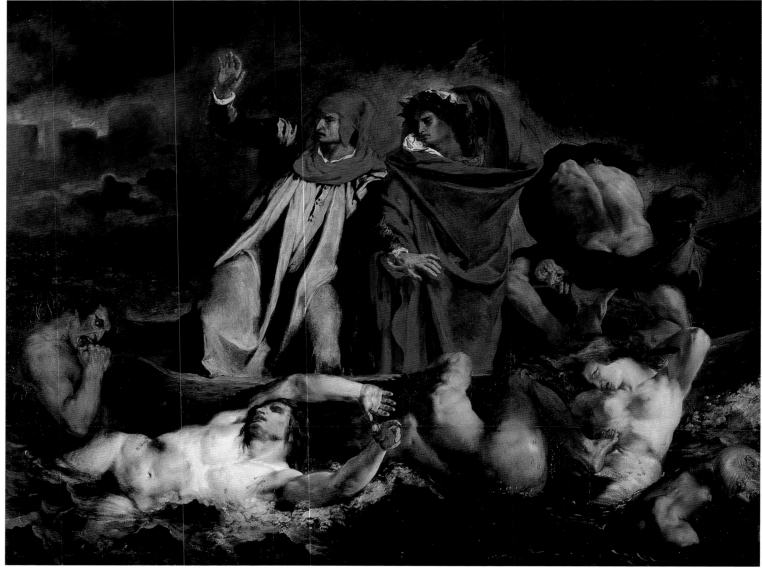

published ten years later by Les Éditions des Heures Claires.

Alongside complete illustrations of the entire poem, specific episodes have often inspired artists. Key masterpieces include *Francesca da Rimini* (1812) by Ingres, an 1822 canvas by Delacroix showing Phlegyas leading Dante and Virgil across the lake that surrounded the infernal city of Dis (*Inferno*, canto VIII), a painting of *Paolo and Francesca* by Ary Scheffer (1855), *Ugolino and His Children* by Charles Lobbedez (1856), and Jean-Baptiste Carpeaux's sculpted *Ugolino*.

The two famous subjects chosen by Rodin for his *Gates of Hell* also inspired many musicians. Ugolino's tragic fate was staged as early as the late eighteenth century in a *singspiel*

by Karl Ditters von Dittersdorf (*Ugolino*, 1796). A few years later, Italian composer Francesco Morlacchi (1784–1841) composed an operatic interlude for baritone, *Il lamento del conte Ugolino*. The Paolo and Francesca story, meanwhile, also inspired cantatas and operatic airs. The subject was set twice for composers competing for the Prix de Rome (in 1854 and again in 1868). It was also the theme of the last opera by Ambroise Thomas, *Françoise de Rimini*, which premiered in Paris in 1882. The libretto by Barbier and Carré even brought the characters of Virgil and Dante into the prologue and epilogue of the opera. In Russia, Tchaikovsky composed his symphonic fantasy *Francesca da Rimini* in 1876; his brother Modest, who was said to have suggested the

plot, was also the librettist for an opera of same name composed by Rachmaninoff (begun in 1898 but only completed in 1904 and performed at the Bolshoi in 1906). Then, in 1913 and 1914, two operas with the title of *Francesca da Rimini* were premiered, the first in Paris (by composer Francesco Leoni to a libretto by François Mario Crawford) and the second, a year later, in Turin (composed by Riccardo Zandonai to a libretto by Tito Ricordi). Nor should we overlook Puccini's lively *Gianni Schicchi*, with a libretto by Gioacchino Forzano (1918) based on canto XXX of Dante's *Inferno*, devoted to forgers.

Rodin's work itself served as inspiration for American composer Wilfred Josephs, who in 1959 completed a vast symphonic poem

Facing page
EUGÈNE DELACROIX,
DANTE AND VIRGIL, 1822.
OIL ON CANVAS,
74 ½ × 95 IN. (189 × 241.5 CM).
MUSÉE DU LOUVRE, PARIS.

Below
ARY SCHEFFER,
THE SHADES OF FRANCESCA DA RIMINI AND PAOLO MALATESTA APPEAR BEFORE DANTE AND VIRGIL, 1855.
OIL ON CANVAS,
67 ¼ × 94 IN. (171 × 239 CM).
MUSÉE DU LOUVRE, PARIS.

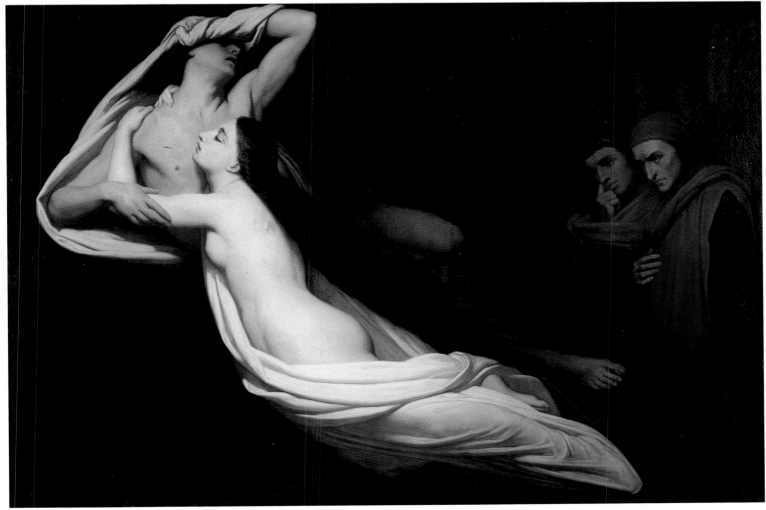

in seven movements, titled the *La Porte de l'Enfer* (*The Gates of Hell*), never performed in its entirety.

Franz Liszt, who in 1849 composed a piano sonata partly inspired by Victor Hugo's 1836 poem "Après une lecture du Dante," also composed a vast *Dante Symphony* (1857) that concluded with the angelic choirs of heaven,

making him one of the rare musicians to attack all three parts of *The Divine Comedy*. Liszt had envisaged staging the performance of his symphony with wind machines that would blow infernal gales across the audience, while a magic lantern would have projected images by painter and illustrator Bonaventura Genelli (1798–1868). But these

grandiose plans came to naught because of a lack of funds.

By deciding to illustrate Dante's *Inferno*, Rodin perfectly reflected the inspirational trends of the nineteenth century. Hence it was his special way of handling the subject that truly made his *Gates of Hell* a unique masterpiece.

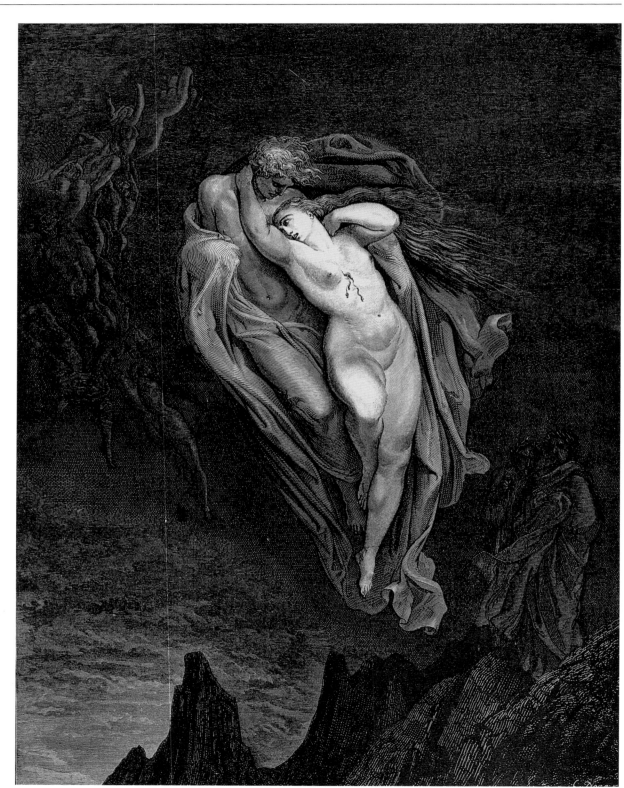

Right
GUSTAVE DORÉ,
PAOLO AND FRANCESCA,
ILLUSTRATION (ENGRAVED BY
PANNEMAKER) FOR A FRENCH
EDITION OF DANTE'S INFERNO
(PARIS: HACHETTE, 1891).
9 ½ × 7 ½ IN.
(24.3 × 19.3 CM).

Facing page
THE KISS (DETAIL),
C. 1881–82/1889.
MARBLE,
71 ½ × 44 ¼ × 46 IN.
(181.5 × 112.5 × 117 CM).

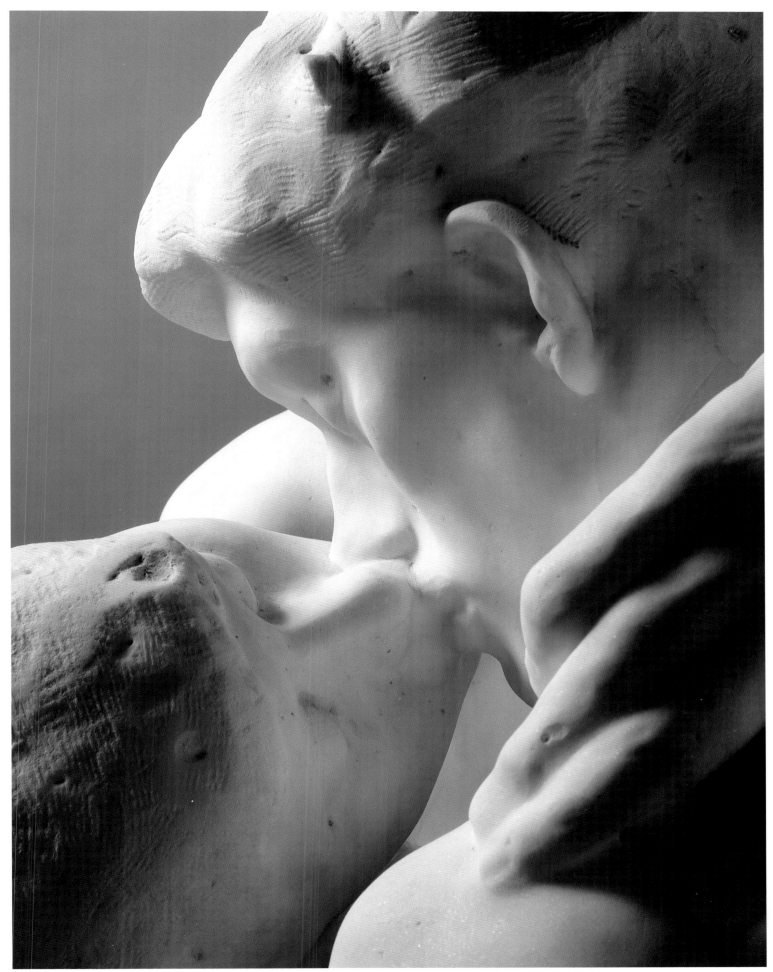

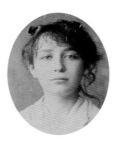

"I remember the glory we shared. . . . Your courage. CCC.
I think you're a divine woman. Would you rather I was unable to render
your extraordinary qualities, your sweetness? You're at my side, you hear!
Divine figure, you raised me up to your level."

Rodin on Camille Claudel, prior to 1913, notebook 42.

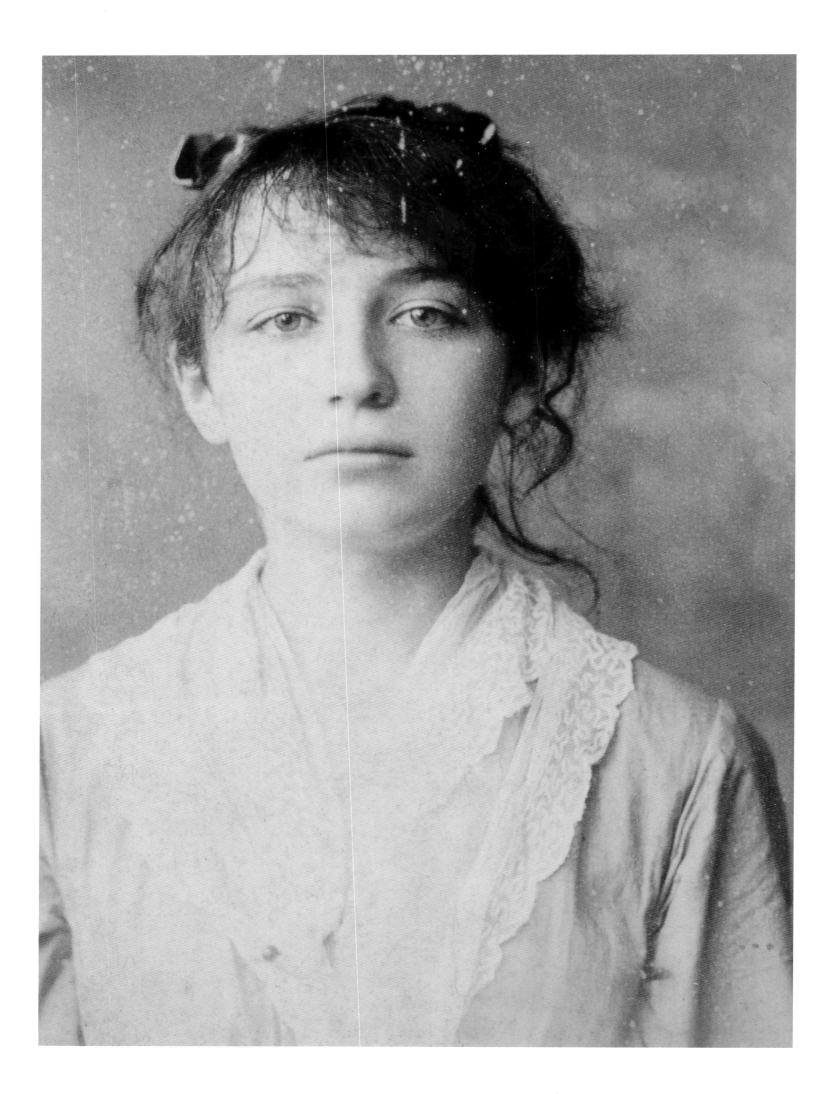

CAMILLE CLAUDEL

Camille Claudel was born on December 8, 1864 to Louis-Prosper Claudel and Louise-Athénaïse Cerveaux in a little village near Soissons, north of Paris. The very year, as fate would have it, that Rodin met Camille's main rival, Rose Beuret.

Camille, the eldest of three children in a modest family, "ruled as monarch" over her siblings. Free-spirited and stouthearted, she was a highly independent child whom Mathias Morhardt described as "extraordinarily willful and tenacious." At an early age, she decided to devote her life to sculpture. And although her brother Paul would describe, much later, her artistic calling as "a dreadful misfortune," Camille received crucial early support from a loving, devoted, and confident father, which countered—perhaps vainly—the cold indifference of her rigid and mercilessly moralizing mother.

As a child, Camille molded clay and painted remarkable portraits. Pursuing this calling, she had a dream for her life, and attempted to make this dream come true. As Morhardt lucidly reported, "The young artist [was] inflexible, somewhat despotic, and incapable of tolerating the least dishonesty. She never conceded a thing. She adopted a clear, straightforward idea of her rights and duties, as well as the rights and duties of others, on which she would not compromise." Thus, in order to pursue her training, she quite naturally obliged the entire family to move to Paris—mother, brother, and sister—first to 135 boulevard Montparnasse and later to 111 rue Notre-Dame des Champs. She took classes at the Académie Colarossi and studied anatomy, at the same time regularly visiting the Louvre's collections of ancient art. Among the rare early works, *Paul Claudel Aged 13* conveys the image of a young Roman with haughty head; it remains a promising work despite a certain awkwardness, most notably in Camille's handling of the hair.

By age eighteen, Claudel was already sharing the rent of a studio with several, mainly English, female friends, at 117 rue Notre-Dame des Champs. Sculptor Alfred Boucher would regularly go to the studio to offer the young ladies advice and correct their work. When about to leave for Italy, Boucher asked Rodin to replace him as the students' teacher. Rodin accepted.

From their very first encounter, Rodin realized that Claudel shared his passion for sculpture; that it was the sole love of their lives. Their first contact in 1882 was therefore eminently artistic and professional, even if Rodin would soon be seduced by the spirited temperament and exceptional talent of a "superb young woman in the triumphant bloom of beauty and genius."

Meanwhile, Paul Claudel would write of his sister's "lofty brow rising above magnificent eyes of a dark blue rarely encountered anywhere other than in novels, a nose which she later claimed to have

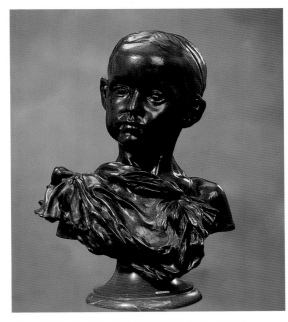

Above
CAMILLE CLAUDEL,
PAUL CLAUDEL AGED 13,
1881.
BRONZE,
15 ¾ 13 ¾ × 8 ½ IN.
(40 × 35 × 22 CM).
MUSÉE BERTRAND DE
CHÂTEAUROUX (INV. 3391).

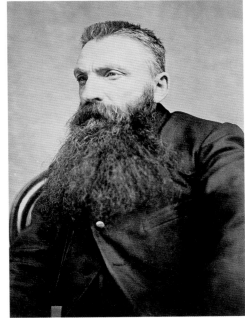

Above
HENRI MANUEL (PRINTED
BY ADOLPHE BRAUN),
**PORTRAIT OF RODIN
WITH A CREW CUT.**
CARBON PRINT,
8 ¾ × 6 ¼ IN. (22.2 × 16.2 CM).

Facing page
CÉSAR.
PORTRAIT OF CAMILLE CLAUDEL,
1884.
ALBUMEN PRINT,
2 ¼ × 4 IN. (5.5 × 10.3 CM).

inherited from the Virtues, a large mouth every bit as haughty as sensual, and the powerful thatch of dark brown hair—truly dark, which the English call auburn—that fell down to her waist. An impressive air of courage, frankness, superiority, and gaiety." Camille was certainly extraordinarily beautiful despite a hip problem that led to a slight limp. She turned her life into a constant combat, always asserting her independent spirit and determination through her appearance and comportment. Her brother shuddered at recollections of the "terrible forcefulness of her character" and her "fierce talent for mockery."

Camille was eighteen, Rodin forty-two. He already enjoyed controversial fame in the art world and had been officially commissioned to produce *The Gates of Hell* for the Musée des Arts Décoratifs, for which he required additional assistants. So, "at that pretentious age," as Jean Cocteau put it, "when nothing seems worthy of our genius, when no miracles startle us because we're convinced that fate owes them to us," the student Camille Claudel saw the door to the master's studio open wide for her. She inevitably became Rodin's assistant, mistress, and muse.

Below
WILLIAM ELBORNE,
**RODIN IN HIS STUDIO WITH JESSIE LIPSCOMB
AND CAMILLE CLAUDEL,**
1887.
ALBUMEN PRINT,
4 × 6 IN. (10.3 × 15.1 CM).

"My savage sweetheart. . ."
Letter from Rodin to Claudel [1886]

My savage sweetheart,

My poor head is truly unwell, I can no longer get out of bed in the morning. Yesterday evening I scoured our usual places (for hours) without finding you. How sweet death would be! How my death throes seem long! Why didn't you wait for me at the studio? Where are you going? Such pain is my fate. I have anemic moments when I suffer less, but today the harsh pain is back. Camille, my darling despite everything, despite the madness that's overtaking me, which will be your doing if this goes on. Why won't you believe me? I'm giving up the salon, my sculpture; if I could just go somewhere, some land where I could forget—but there isn't one. There are times, frankly, when I think I'll get over you. But then, in a blinding instant, I feel your terrible power. Have mercy on me, naughty girl. I can't take it any longer. I can't go another day without seeing you. Otherwise I'll go dreadfully mad. It's over, I can't work any longer, wicked goddess, and yet I love you furiously. Rest assured, dear Camille, that I have no liking for any other woman, that my entire soul belongs to you.

I cannot convince you, my proofs are powerless. You don't believe my suffering, I weep but you doubt. For a long time now I haven't laughed, I no longer sing. Everything seems bland and pointless. I'm already dead, I no longer understand why I took so much trouble over things

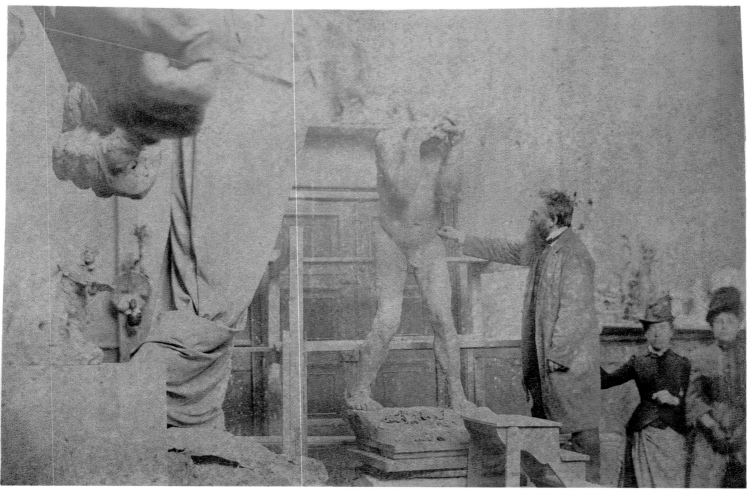

that now seem so pointless. Just let me see you every day, that would be a good deed; and maybe I'll even get better, because only you, in your generosity, can save me. Don't let this slow, hideous malady over-take my reason, the pure and ardent love that I have for you—have mercy, my beloved, and you yourself shall be rewarded.
Rodin

I kiss your hands, my sweetheart, you who have given me such exalted, ardent bliss—next to you my soul can exist powerfully, and even in its frenzy of love respect for you is always uppermost. The respect I have for your character, for you, Camille, is one cause of my violent passion. Don't treat me so mercilessly, I ask so little of you.

Don't threaten me, allow yourself to realize that your ever-so-gentle hand represents your kindness toward me, and leave it there some-times, that I may kiss it in my raptures.

I regret nothing. Not even the outcome, which seems grim—my life has plunged into an abyss. But my soul has flowered, if tardily, alas. I only had to meet you for everything to take on unknown life, for my gray existence to flare up in a bonfire. Thank you, for it's to you that I owe the entire measure of heaven that I've had in this life.

Leave them, your beloved hands, on my face, that my flesh may be happy, that my heart may feel your divine love flow once again. How intoxicating life is when I'm near you! Near you when I think I still have that joy, yet I complain. And in my cowardice I think my unhappiness is over, that I've come to the bitter end of it. No, for as long as there's a little hope—just a little, a drop—I must take advantage of it at night, and later, the next night.

Your hand, Camille—not the one you're withdrawing, there's no joy in touching it if it's not a little sign of a little of your affection.

Oh divine beauty, oh flower who speaks and who loves, intelligent flower, my darling. My dearest, down on both knees I embrace your fair body.
R.

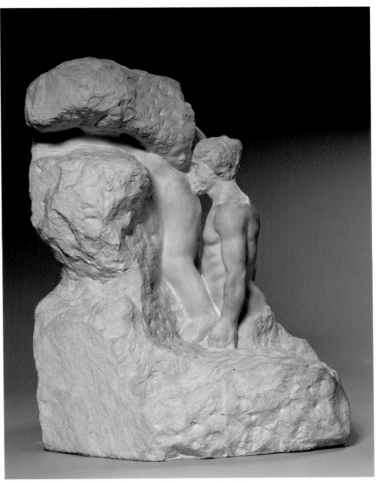

Above
MAN AND HIS THOUGHT,
c. 1895.
PLASTER,
30 × 18 ¾ × 23 ½ IN.
(76 × 47.8 × 59.3 CM).

Below
SIGNED LETTER FROM AUGUSTE RODIN TO CAMILLE CLAUDEL,
UNDATED.
8 ¼ × 10 ¼ IN. (21 × 26.9 CM).

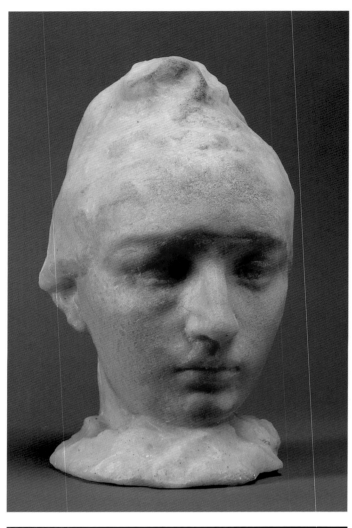

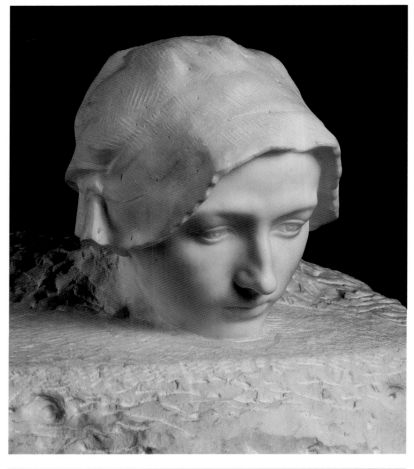

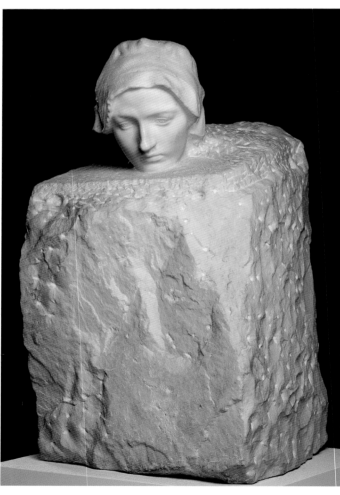

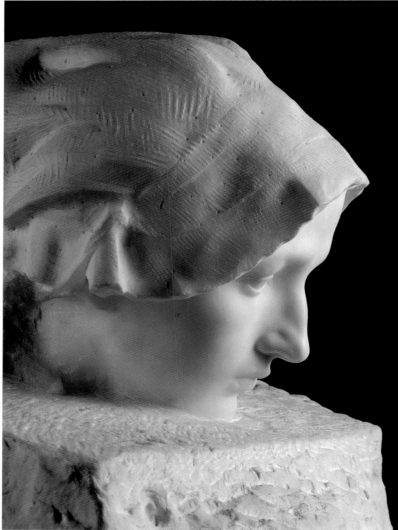

Rodin's private outpourings to the woman who offered him "the royal feast of her youth" show that he loved her to distraction. Suffocated by this obsessive love, he implores her on bended knee throughout the letter, in a confused style and uncertain spelling. Sculptural manifestations of this cry of love include *The Eternal Idol* and especially *Man and His Thought,* an assemblage based on two figures from the upper part of the tympanum of *The Gates of Hell*, dating from the 1890s. From a block of marble there emerges the broadly sketched body of a teenage girl who presents her beauty to an older man. Kneeling in an almost religious pose, the man gently approaches the figure he worships like a goddess.

Their union was like a waltz in three movements: the euphoria of an impassioned forty-year-old; the establishment of the lovers' complicated, tormented relationship; and the inevitable break, with the tragic outcome we now know.

At the start of the relationship, Rodin's attitude perhaps seemed surprising. He was literally a prisoner of his passion for his student, declaring a love as intense as it was sudden. He constantly solicited her, begging her to let him see her, even following her to Peterborough, England, where Camille was staying in the family home of her good friend Jessie Lipscomb. The young woman—authoritarian, irascible, capricious—excelled in her role of shrew, alternately sulking and flirting. Not fully aware of her own mad love for Rodin, she enjoyed the pleasure of tyrannizing the mature man he was supposed to be.

For many years, Claudel and Rodin had an intense affair. Right from the start, their relationship became inextricably linked to their artistic output. By 1888, Rodin had rented a studio for her on boulevard d'Italie; a little later he would rent, nearby, a crumbling eighteenth-century "pleasure house" on Clos Payen, where Alfred de Musset and George Sand enjoyed the idyll that inspired Musset's agonizing series of poems entitled *Nights*.

Above
ANONYMOUS,
TOWNHOUSE KNOWN AS LA FOLIE PAYEN,
1910.
GELATIN SILVER PRINT,
4 ½ × 3 ¼ IN.
(11.5 × 8.5 CM).

Below
ASSEMBLAGE: MASK OF CAMILLE CLAUDEL AND LEFT HAND OF PIERRE DE WIESSANT,
C. 1895 (?).
PLASTER,
12 ½ × 10 ½ × 10 ¾ IN.
(32.1 × 26.5 × 27.7 CM).

Facing page, top left
CAMILLE IN A CAP,
1911.
PÂTE DE VERRE,
9 ¾ × 5 ¾ × 7 IN. (24.9 × 14.9 × 17.9 CM).

Facing page, top right, bottom left and right
THOUGHT, 1895.
MARBLE, 29 ¼ × 17 × 18 IN.
(74.2 × 43.5 × 46.1 CM).
MUSÉE D'ORSAY, PARIS.

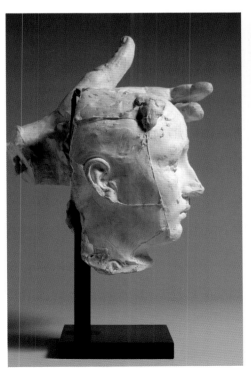
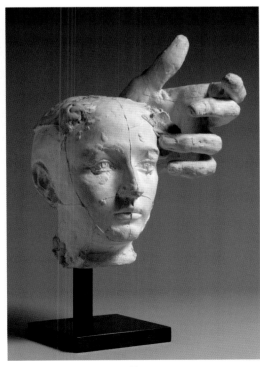
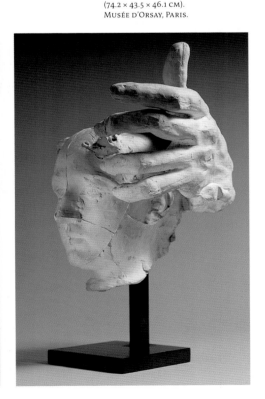

The two artists had scarcely begun their relationship when Claudel posed for Rodin, who was impassioned by the beauty of his sitter. Camille inspired many works, executed circa 1884, and her youthful face with its pure, innocent features and now short hair, would often be reused in later allegorical representations such as *Thought; Sleep; Dawn;* and *France.*

When later transposed into *pâte de verre*, Claudel's head—this time wearing a cap—acquired a softer, sensual, highly fragile effect thanks to the new medium of glass, ground and refired in a mold.

A dazzling if spare mask of Camille with bare forehead and pensive, lost gaze presents a visage of profound serenity and haunting radiance. The mouth is sensual, lines from the seams of the mold and drops of plaster left near the eyes and nose in no way alter the sense of perfection. Here we have the splendor of authentic beauty delivered in a raw state, with neither artifice nor falsehood. And yet, this work offers a hint of the sculptor's infinite sadness and especially nostalgia for the young, beautiful face. Later combined with the larger, powerful hand of Pierre de Wiessant, Camille's face assumed mysterious new dimensions.

In the studio, Rodin was entranced by the apparent ease with which his "assistant" stubbornly, assiduously, and feverishly handled clay. She wielded tools skillfully, always slightly bent under the weight of her own effort. Determined yet careful, her features were hard set by concentration and effort. Usually silent, Claudel would say nothing unless it arose from profound conviction. Together, in the routine life of the studio, they enjoyed an existence of exceptional unity, in deep and complete symbiosis. An atmosphere of mutual trust and industriousness filled the studio, creating an environment conducive to creativity. In fact, troubling similarities were soon noted between Claudel's *Young Girl with a Sheaf of Wheat* and Rodin's *Galatea.*

"Everyone who frequented the studio on rue de l'Université remembers her," wrote Morhardt. "Silent and diligent, she remained seated on her little chair. She barely listened to the lengthy chat of the idle. Concentrating solely on her task, she kneaded clay and modeled the foot or hand of the figurine set in front of her. Sometimes she'd raise her head. She'd look at the visitor with her big, bright eyes, whose light was so questioning and, I might say, so persistent. Then she would immediately return to the interrupted task."

Of all the women who became close to Rodin, Claudel was the only one who was an equal in work. "He consulted her on everything," continued Morhardt, "he discussed every decision with her, and only after they agreed would he make a final decision. . . . The delight of always being understood, of seeing his expectations exceeded, was, as he said himself, one of the greatest joys of his life."

But the sweet, peaceful moments inevitably gave way to anxious tension. Claudel's antisocial side, her profound aversion to playing to the gallery in any way, and her outlandish pride constantly sparked conflict. Furthermore, she was jealous and dreadfully possessive. A constant need to know the truth obsessively guided her thoughts. In a mood more playful than threatening, she one day dictated to Rodin the conditions of his commitment in the form of a pseudo-contract, which he penned without the least resistance:

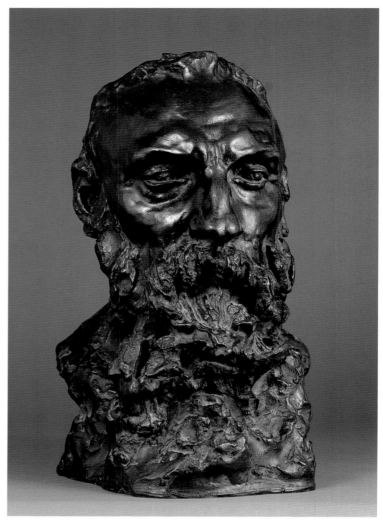

Above
CAMILLE CLAUDEL,
RODIN,
1892.
BRONZE,
16 × 9 ¾ × 11 IN. (40.4 × 24.6 × 28 CM).

Facing page
ANONYMOUS,
ÇAKOUNTALA IN CLAUDEL'S STUDIO,
C. 1887.
ALBUMEN PRINT,
6 × 4 ¼ IN. (15.5 × 10.6 CM).

In the future, starting from this day of October 12, 1886, I will have as my Student only Mademoiselle Camille Claudel, who will be my sole protégé through all the means at my disposal and through my friends, who will become hers, and especially my influential friends. I will accept no other students to avoid producing, by chance, rival talents, although I suppose that such naturally gifted artists occur very rarely.

For exhibitions, I will do my utmost in terms of placement and publicity. Under no excuse will I ever go to visit Madame X again, to whom I will no longer teach sculpture.

After the exhibition in May we will leave for Italy, remaining there at least six months together in an indissoluble union after which Mademoiselle Camille will be my wife.

This lone document, as flippant as it is solemn, offers a glimpse of the magical privacy of lovers who, as though legitimizing an unavowable relationship, put down on paper the terms of their union. Hence they were "officially" united in a game, a childish dream that would have a painful awakening.

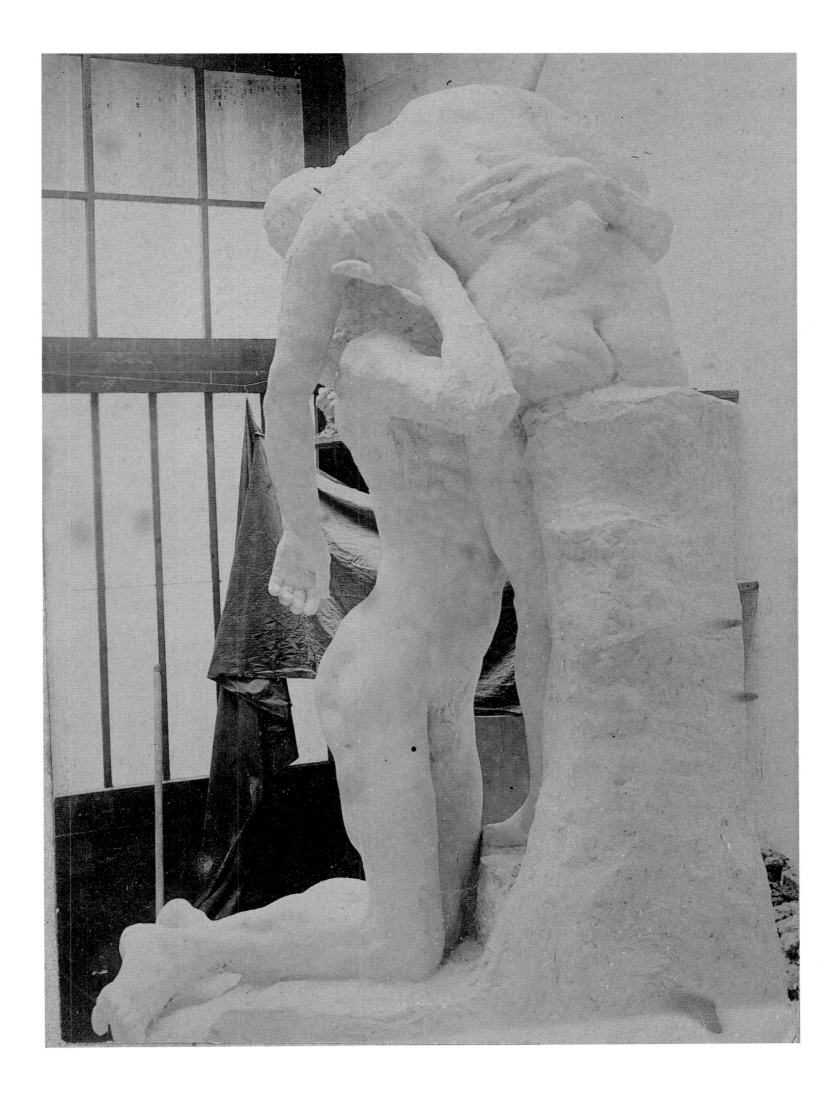

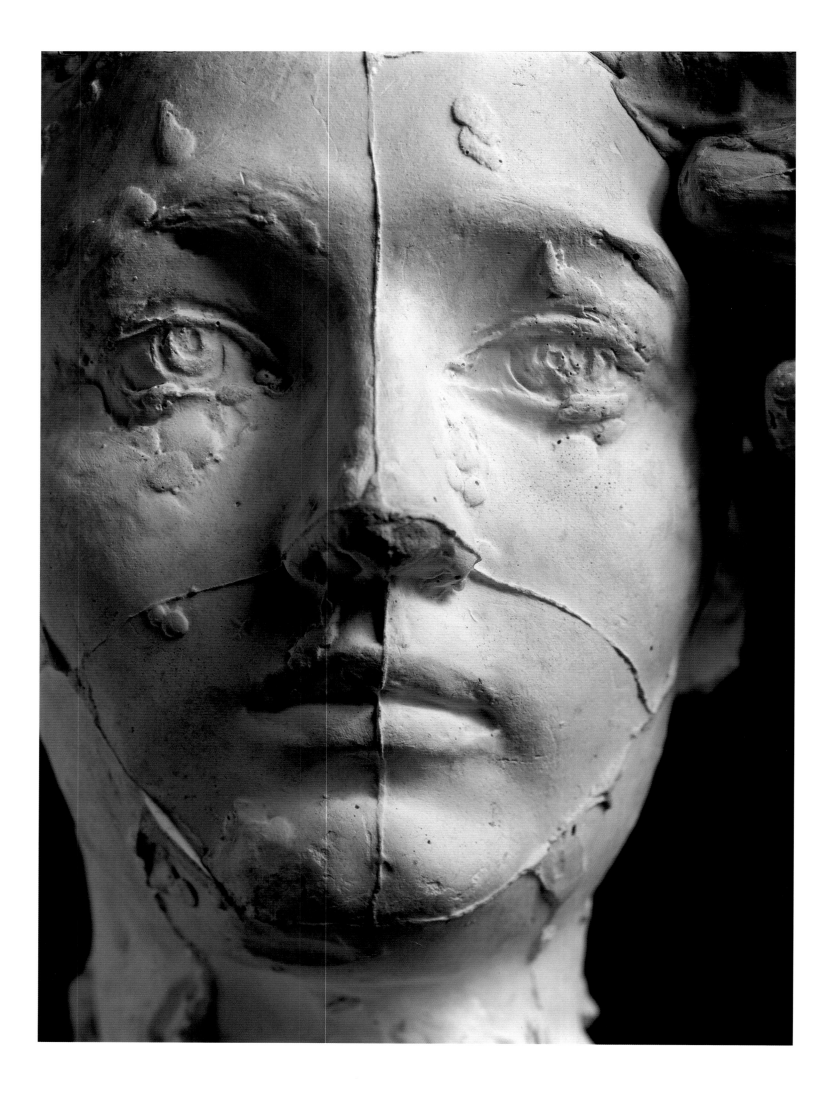

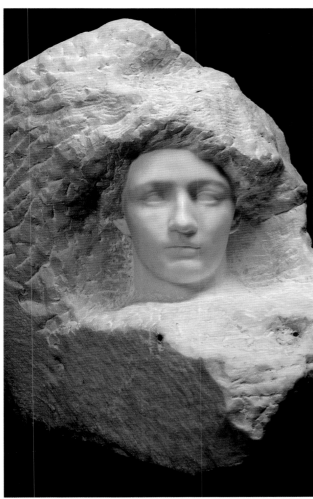

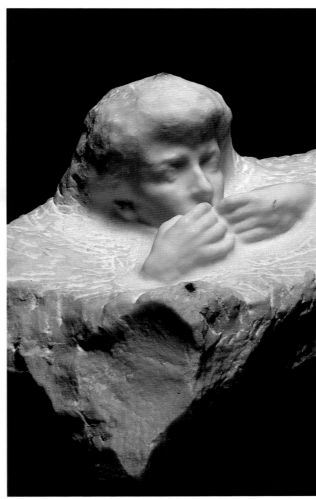

Facing page
ASSEMBLAGE: MASK OF CAMILLE CLAUDEL WITH LEFT HAND OF PIERRE DE WIESSANT,
C. 1895 (?).
PLASTER,
12 ½ × 10 ½ × 11 IN.
(32.1 × 26.5 × 27.7 CM).

Far left
DAWN,
C. 1895.
MARBLE,
22 × 22 ¾ × 19 ¾ IN.
(56 × 58 × 50 CM).

Left
CONVALESCENT,
C. 1909–10 (?).
MARBLE,
19 × 28 × 22 IN.
(48.5 × 71 × 56 CM).

Below, left
FAREWELL,
C. 1893–95.
PLASTER,
15 ¼ × 17 ¾ × 12 IN.
(38.8 × 45.2 × 30.6 CM).

Below, right
MASK OF CAMILLE CLAUDEL,
PRIOR TO 1887.
PLASTER,
9 × 6 ¾ × 6 ¼ IN.
(22.8 × 17 × 16 CM).

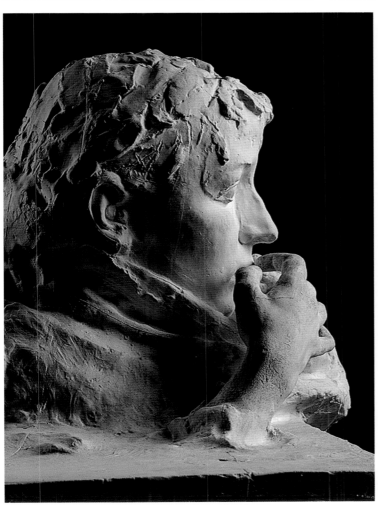

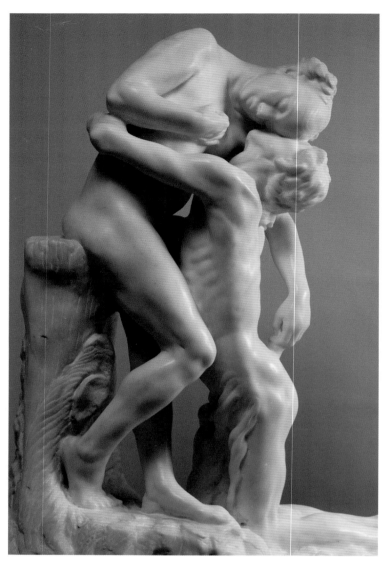
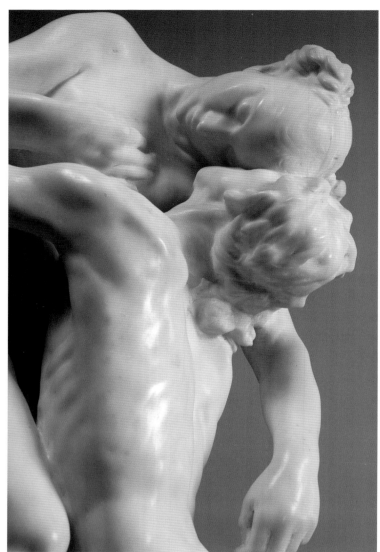
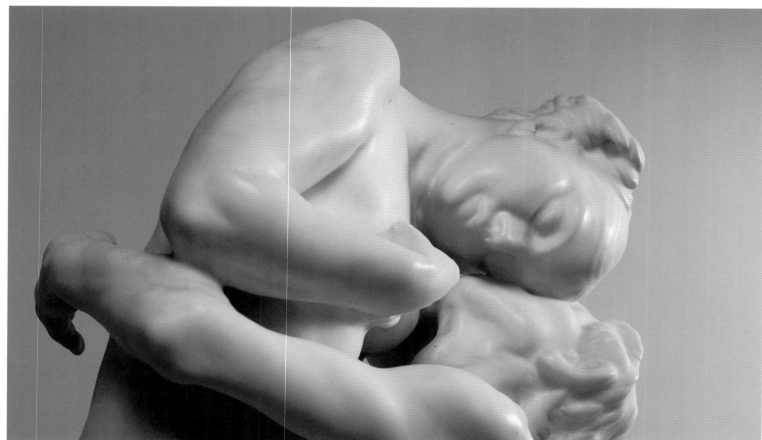

In 1888, Camille in turn modeled her lover's features into a perfectly balanced portrait that testified to the closeness of her relationship to her sitter and his teachings. The willful, wrinkled brow, prominent eyebrows, long straight nose, yet somewhat blank gaze, convey a head that is simultaneously pensive and energetic. A thick, heavy beard not only hides the mouth and chin but practically constitutes a plinth. Without the least pretension, the virile touch and confident, "energetic" handling result in what could almost be a Rodin self-portrait. The face is stiff with solemnity, but all the man's genius can be perceived in the noble execution and strong interpretation. Claudel's bust of Rodin was favorably received by critics.

Even as she collaborated on Rodin's major commissions in the studio, Claudel continued her own creative work, which the master supported and attempted to promote. Where others might have hesitated, Claudel decided that her first major project would be an ambitious piece celebrating the triumph of love. "Two big, larger-than-life figures," she explained to an English friend, would evoke a legendary Indian tale by the poet Kalidasa in which the heroine, Shakuntala (or Çakountala), after a long and harsh separation from her husband, Prince Dusyanta, who was cruelly bewitched to the point of forgetting his love for her, recovers and pardons him. "The kneeling man, with upturned face reflecting nothing but desire," wrote Paul Claudel to convey the prince's devotion and to allude to the ecstasy of prayer, "yearns for—embraces before he even dares grasp it—this marvelous being, this sacred flesh which, from a higher level, has fallen unto him. She surrenders blindly, silently, heavily to the weight of love; one of her arms hangs loosely, like a branch laden with fruit, the other covers her breasts and protects her heart, the ultimate refuge of virginity."

Full of intensity and emotion, this sculpted pair is a marvel of affection and modest sensuality. Passion and desire are expressed with propriety and restraint. Imbued with great classicism and perfect plastic equilibrium, the harmonious modeling of *Çakountala* combines both a debt to Rodin and her own autonomous style. The patinated plaster won Claudel an honorable mention at the Salon des Artistes Français.

Later, by changing only the characters' attributes, a carefully polished marble version that Claudel produced in 1905 would be rechristened *Vertumne et Pomone* (*Vertumnus and Pomona*), and a smaller bronze replica would be entitled *L'Abandon*.

"I go to bed naked to make me think you're here…"
Letter from Camille Claudel to Auguste Rodin, July 1891

At the height of their affair they shared the Château de l'Islette, a romantic spot in the Tours region kept jealously secret. The couple's best days were spent there, exchanging fertile ideas and talking of work. Their discovery of the area was due to Rodin's constant wanderings in search of "old stones." Fascinated by the beauty of the architecture and the region, in July 1889 they made their first visit to the Loire Valley with its châteaux of Amboise, Blois, Cheverny, Chambord, and Saint Aignan. Just over a mile from Azay-le-Rideau was the Château de l'Islette, then owned by Marie Courcelle. "This old château, flanked by turrets," had already delighted Beaumarchais back in the eighteenth century. Despite unfortunate alterations down through the years, the impressive dwelling retained its proud appearance. Its massive, fifteenth-century air, combined with the charms of the Indre Valley, spurred Rodin and Claudel to seek refuge there. They enjoyed several stays in the château in the spring and autumn of 1890 and 1891. Meanwhile Rodin's companion, Rose Beuret, was convalescing at the home of old friends, the Vivier family.

Facing page,
three perspectives
CAMILLE CLAUDEL,
VERTUMNE ET POMONE,
1905.
MARBLE,
36 ¼ × 31 ½ × 16 ¾ IN.
(92 × 80 × 42.5 CM).

Below, left
**SIGNED LETTER
FROM CAMILLE CLAUDEL
TO AUGUSTE RODIN,**
SUMMER 1890 OR 1891.
6 ¾ × 8 ½ IN.
(17.5 × 21.9 CM).

Below, right
L.L.,
**THE CHÂTEAU
DE L'ISLETTE.**
POSTCARD,
3 ½ × 5 ½ IN.
(9 × 13.8 CM).

24 ENVIRONS D'AZAY-le-RIDEAU. — Le Château de l'Islette. — LL.

Above
ANONYMOUS,
**MASK OF BALZAC
ON A COLUMN.**
ARISTOTYPE,
6 ½ × 4 IN. (16.5 × 10 CM).

Right
ANONYMOUS,
**MONSIEUR ESTAGER,
THE MODEL FOR BALZAC.**
ALBUMEN PRINT,
5 ¾ × 4 ½ IN. (14.4 × 11.2 CM).

Facing page
CAMILLE CLAUDEL,
LA PETITE CHÂTELAINE, 1895.
MARBLE,
13 ½ × 11 ¼ × 8 ½ IN.
(34.3 × 28.4 × 22 CM).

At Islette, the couple could share the pleasures of daily contact and private life. When Rodin was occasionally obligated to be absent, Claudel would affectionately remind him of the charms of the place.

Since I have nothing to do I'm writing to you again. You cannot imagine how fine it is here at Islette. Today I dined in the middle room (which serves as a greenhouse) where you can see the garden on both sides. Mme Courcelles [sic] suggested (without my mentioning the least thing) that if you pleased you could dine there from time to time, and even all the time (I think she'd truly like that), it's so pretty there! I strolled in the grounds, everything is mown—hay, wheat, oats—you can walk everywhere and it's charming. If you're kind, and keep your promise, we'll be in heaven here. You can have the room you want to work in. The old lady will be at our feet, I think. She told me that I [lacuna] bathe in the river, where her daughter and maid bathe, with absolutely no danger. With your permission, I will do just that, because it is a great delight and saves me from going to the hot baths at Azay. Would you be so kind as to buy me a little two-piece bathing costume, blouse and knickers (sized medium), dark blue with white braiding, that you can find at the Louvre or Bon Marché (in serge) or in Tours. I go to bed naked every night to make me think you're here, but when I wake up it's not at all the same thing.
All my love, Camille. Please don't be unfaithful to me anymore.

In the shelter of the turreted chateau, the two lovers enjoyed peaceful days far removed from the public sphere with its official events and social obligations. They stayed as paying guests at the château, and could devote themselves to work even as they immersed themselves in nature. In the fecundity of their creative work, both of them organized their lives with great simplicity. They were allotted several upstairs rooms, some of which served as studio space.

There Claudel executed a bust of *La Petite Châtelaine*, Marguerite Boyer, the owner's six-year-old granddaughter. The child was obliged to sit for nearly sixty-two hours of posing, in exchange for which Claudel bought her a doll. The motionless, studied pose of the figure fully conveys little Marguerite's concentration. Hypnotized, she watches the sculptor's every gesture. Her penetrating stare, parted lips, and "fluttering" nostrils are thoroughly expressive, while the vigorous modeling, youthful bust, and skein of braided hair add a particularly touching note. Several plasters were cast; in 1895 and 1896, Claudel sculpted four marbles whose nuances reside in the handling of the braid. Claude Debussy owned a copy that he considered to be "one of the most graceful evocations by an artist in marble of the inquisitive appeal of the face of a child confronting the unknown."

To this day, the pride of Château de l'Islette is its main hall, which has retained original decoration and architectural details from the sixteenth and seventeenth centuries. But it has acquired even more glamour by being the site of long sittings that Rodin inflicted on a coachman from Azay-le-Rideau—who happened to be the spitting image of Balzac.

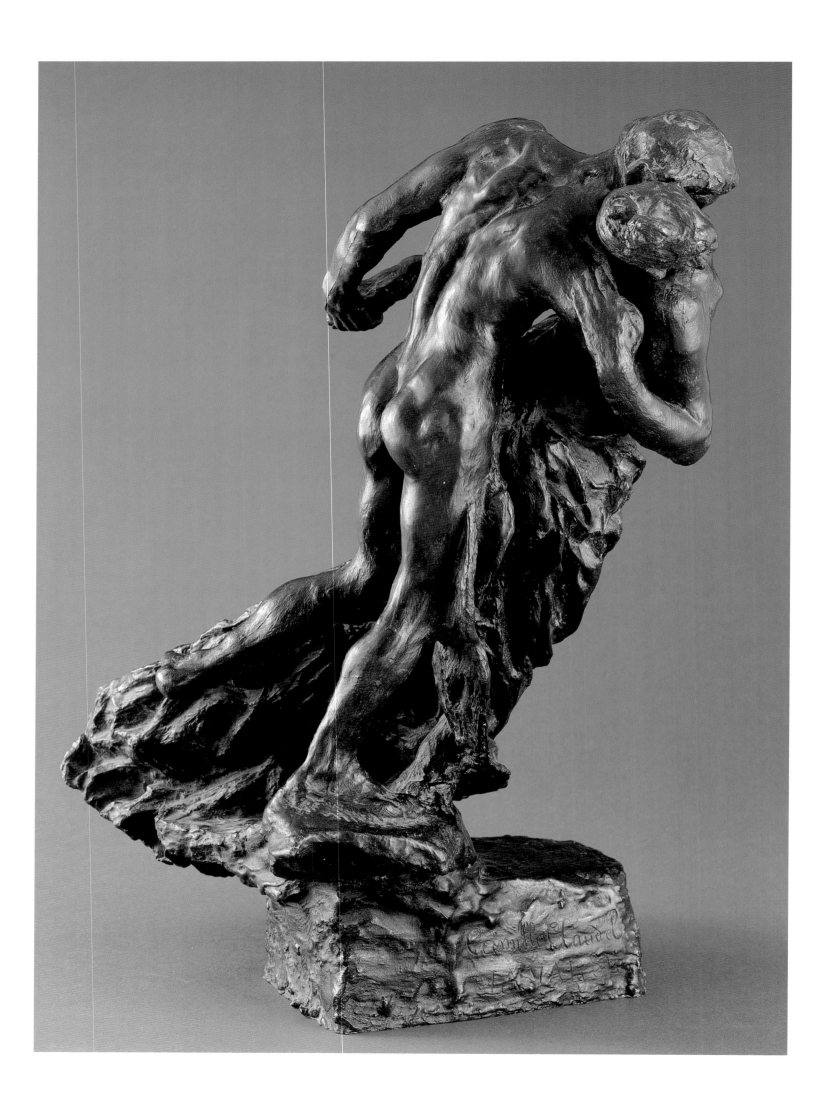

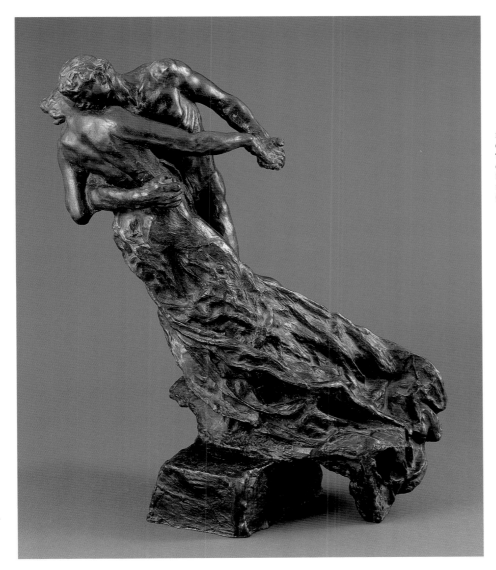

Facing page and left
CAMILLE CLAUDEL,
THE WALTZ,
C. 1895.
BRONZE,
17 × 9 × 13 ½ IN.
(43.2 × 23 × 34.3 CM).

When Rodin officially replaced Henri Chapu as the artist commissioned to produce a statue of Balzac for the Société des Gens de Lettres, he had already been carrying out some bold prospecting work in the Tours region. Anxious to get as close as possible to the novelist's physical presence, Rodin scoured the area, studying faces in a quest for a strong, colorful example of the men that he described as the "Touraine type."

In mid-summer 1891, with his usual enthusiasm for new projects and with the drive that leads a lover to his mistress, Rodin returned to the Tours region. He intended to devote himself to his study and to the woman without whom nothing had any meaning. His stay would last nearly three months.

Rodin finally met a man named Estager who bore a striking resemblance to Balzac. "He reminded me of the young Balzac," explained Rodin, "the way I envisaged him from drawings and lithographs." Estager was a 35-year-old Azay coachman who worked for a cooper from La-Chapelle-Saint-Blaise, when he met Rodin. The sculptor asked him to pose for a fee of one louis per sitting. Rodin studied his model with meticulous care. The interminable sittings thus yielded a major series of masks. Even once the work was completed, Rodin was still at an early, uncertain stage and knew that he was far from the powerful Balzac he envisaged.

He left Islette and the bucolic lanes of the Loire region one October morning. "I leave this fair countryside the way one looks longingly at his mistress before leaving her, the way one turns back several times to see her yet again, and again," wrote Rodin in *Les Cathédrales de France*, evoking with nostalgia but without explicitly naming the woman he had so loved in that place. "The way one takes leave of a beloved and loving heart, so I leave it in full glory!"

At the height of those passionate years, Claudel produced *The Waltz*, in which entwined dancers suggest the passionate embrace of a couple who, in Jules Renard's words, "seem ready to go to bed and end the dance by making love." The angle of the bodies, combined with the abundant drapery, accentuates the whirling dance as it creates a light, harmonious rhythm. Carried away by the intoxicating swirl, the shared elan, the caress of hands, the languid, interlocking bodies, and closeness of their faces, the two lovers are on the verge of surrender. The overly masculine anatomy of the female figure seems somewhat surprising in this work, which is incredibly sensual and almost Art Nouveau in style. But the fluidity of forms, the modernity of the bold composition, and the dynamism of the sculpted pair reveal great virtuosity of execution.

Critics enthusiastically greeted "the ambitious and skillful imbalance" of the work, which also met with commercial success. This was the beginning of official recognition for Claudel, who never stopped learning even as she diversified her work.

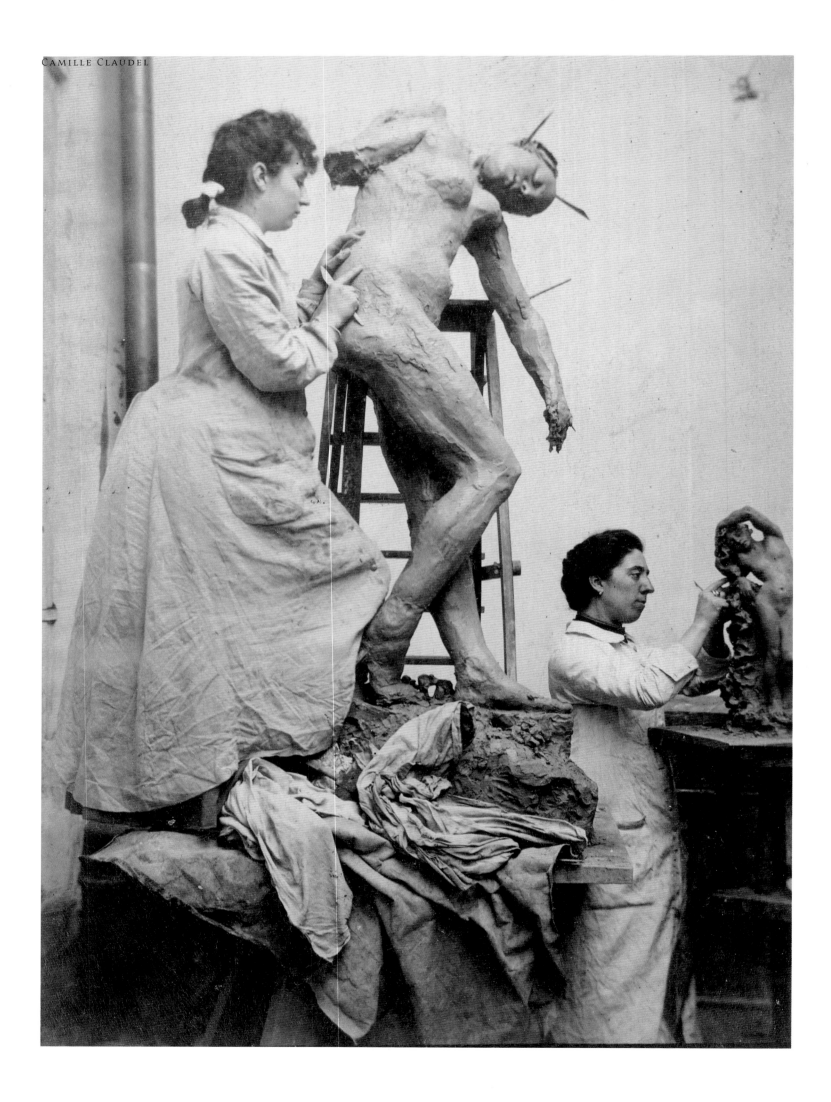

Facing page
WILLIAM ELBORNE
**CAMILLE CLAUDEL AND JESSIE LIPSCOMB
AT WORK,**
1887.
GELATIN SILVER PRINT,
1 ½ × 3 ¾ IN.
(4.2 × 9.8 CM).
ELBORNE COLLECTION.

Above
**CAMILLE CLAUDEL WITH SISTER LOUISE (LEFT)
AND JESSIE LIPSCOMB (RIGHT) SMOKING
A CIGARETTE,**
1887.
ELBORNE COLLECTION.

"I showed her where she would find gold; but the gold she found is all hers."

Rodin on Camille Claudel

Within this exceptionally close professional relationship, Claudel thought she had also found a man who would be supportive, whose affection would soothe her anxieties; in exchange, her presence at his side would redouble his powers and refine his education, making a great man of him. Rodin, however, never wanted to be forced to choose between the sincere affection he felt for Rose—his devoted companion—and the profound admiration he felt for his clever young mistress. While the lovers seemed madly passionate within their tormented relationship, one event suddenly and irreversibly altered the course of their story: Camille had an abortion. The date remains hard to pin down, but the fact was much later revealed in a letter written by her brother Paul to Marie Romain-Rolland, "You should know that someone to whom I am very close committed the same crime as you, and for twenty-six years she's been paying for it in the madhouse. Killing a child, killing an immortal soul, is horrible! Dreadful! How can you live and breathe with such a crime on your conscience?"

It is tempting to date this event to the summer of 1891, based on an enigmatic note from Rodin to Armand Dayot: "Dear friend, still no news concerning what I confided to you yesterday. Don't mention the name of Mlle Claudel. I saw the mother this morning and she doesn't even want me to go to M. Lozé's, the family doesn't want word to get out. Thank you, dear friend, it's lucky that I didn't run into anyone yesterday and that you're the only one who knows."

In an intense and passionate atmosphere, the fanciful games of the two lovers gave way to oppressive seriousness, deep wounds, and lasting scars. Claudel's descent into hell was about to begin. "Separation was inevitable," admitted Paul Claudel. "While divorce was a necessity for the man, for my sister it was a total, profound, definitive catastrophe. The sculptor's trade is already a kind of perpetual challenge to good sense for a man, so for a lone woman—a woman with my sister's temperament—it was a pure impossibility. She had wagered everything on Rodin, and she lost everything with him. That fine ship, briefly buffeted on bitter waves, finally went down with all hands."

In 1893, Camille began moving away from Rodin's sphere, then broke with the sculptor a first time in 1894, and permanently in 1898. Her dramatic imagination and her expressive mockery inspired four satiric drawings that she sent to Rodin. In one, a chained and enslaved Rodin is being guarded by Rose, depicted as an ugly old witch. In another, Rodin and Rose are glued together by their derrieres and are unable to separate despite strenuous efforts.

Rodin remained highly affected by the break and by the state of his young mistress. "I look at the sculptor Rodin, who is just opposite me," noted Edmond de Goncourt in his diary. "What a despondent head! He looks just like one of the Sarmatians, one of those barbarians seen circling Trajan's column." Camille's face continued to haunt Rodin, and in *Farewell,* executed in 1892, he movingly evoked his powerlessness to prevent the young woman from drifting away. The lower part of the face, as though wrapped in a scarf, seems to foretell the onset of illness particularly when linked with the striking contrast in handling of the dissimilar hands.

Rodin and Claudel exchanged no more than a few letters between that moment and 1900. Camille then decided to express her passion by executing a work closely related to her break with Rodin. A group of three figures is composed of a couple and a young woman. On the ground at their feet, off-balance, arms raised in a final effort, the young woman implores the man she loves. As Paul Claudel would write in the catalogue for an exhibition in 1951:

That naked soul, that young woman on her knees . . . is my sister! My sister Camille. Begging, humiliated, on her knees: that haughty, proud woman thus depicted herself begging, humiliated, naked, on her knees! It was over. That's what she is letting us see, forever! And you know what? What is being wrenched from her, at that very instant, before your eyes, is her soul! . . . What lends my sister's work its unique interest is that it is represents the entire story of her life.

Although an early plaster version of *Maturity* shows the three figures still linked, in the second version the die has been cast and the ties permanently cut. The mature man depicted by Claudel, initially hesitant, is now literally trapped, almost caged, by an alarming creature who carefully draws him to her side. So with resignation he follows this woman—who represents Rose Beuret—leaving his young mistress behind.

Below and facing page
FAREWELL,
C. 1893–95.
FIRST STATE (NO LONGER EXTANT)
AND SECOND STATE (FACING PAGE).
PLASTER,
15 14 × 17 ¾ × 12 IN.
(38.8 × 45.2 × 30.6 CM).

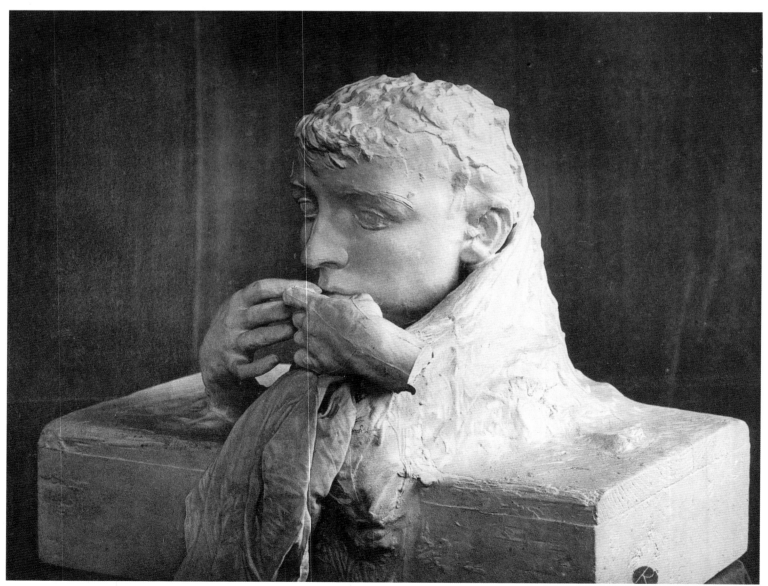

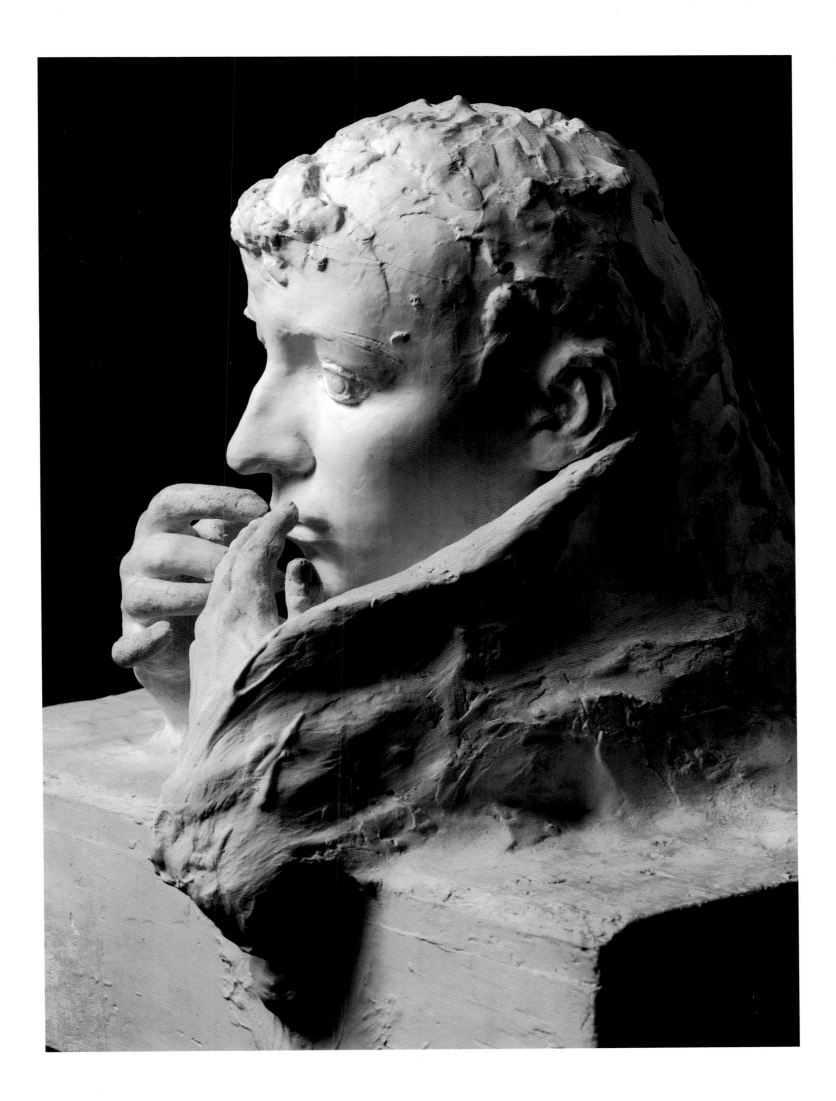

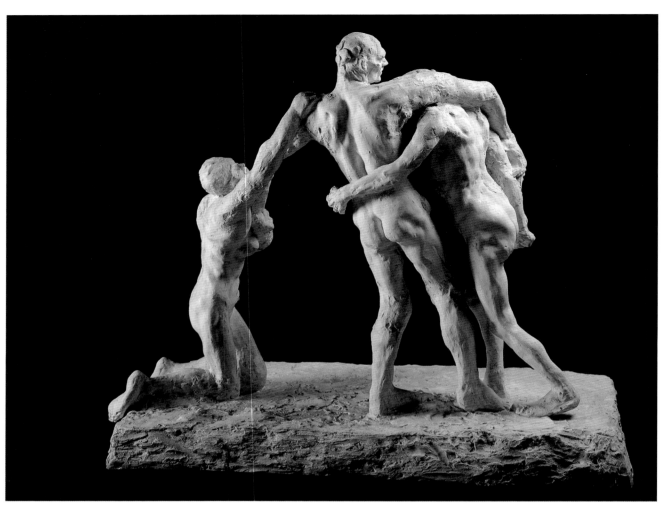

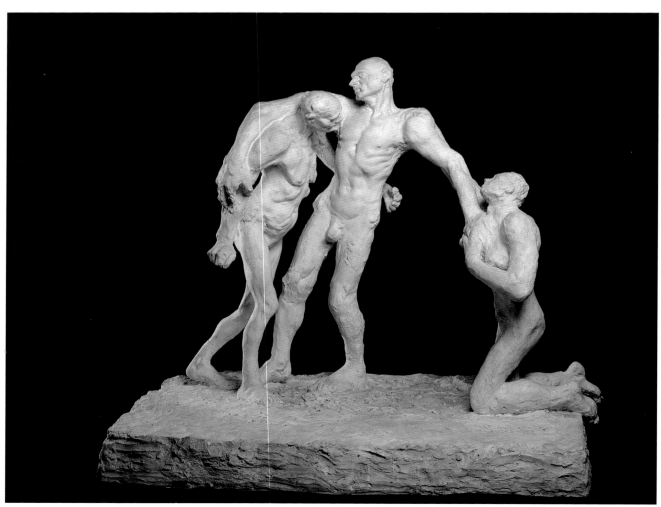

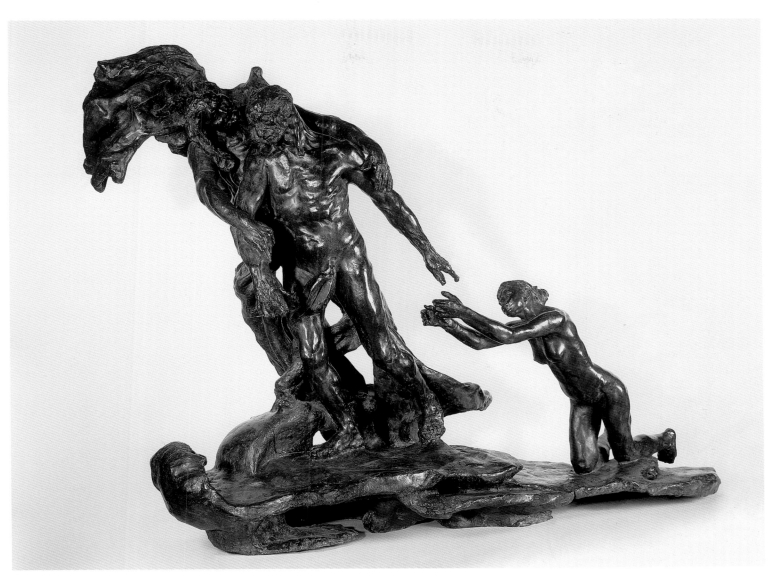

Facing page
CAMILLE CLAUDEL,
MATURITY (FIRST VERSION),
C. 1892.
PLASTER,
34 ¼ × 40 ¾ × 20 ¾ IN. (87 × 103.5 × 52.5 CM).

Above and following double page
CAMILLE CLAUDEL,
MATURITY (SECOND VERSION),
1899.
BRONZE,
47 ½ × 70 ¾ × 28 ¾ IN. (121 × 180 × 73 CM).

In the center of this harsh allegory of passing time is the rupture—the total void—between the hands of the lovers as they draw apart, lending the work its dramatic aspect. The particularly theatrical poses of the figures recall the greatest tragic operas, while the extreme naturalism and intensity of certain gestures confirm the influence of Rodin.

The play of diagonal lines, the fluttering drapery around the old woman, and the shifting, uneven ground of the wave all lend this sculpted group a striking dynamism that underscores the overall movement. In this outstandingly well-executed work, Claudel shamelessly exhibits her turmoil and takes a hard look at the tragedy of her fate. Given the autobiographical nature of the work, however, the French government declined to commission a cast of it.

Claudel tried to escape Rodin's hold over her by turning to her brother's literary friends. It is known that a true and solid friendship existed between her and the composer Claude Debussy, but nothing suggests their relationship was more intimate than that.

The aging Rodin was plagued by doubt. Wearied by the daily grind of commissions and their attendant financial commitments, he sought a quiet life. Claudel, tormented, rebellious, and hungry for recognition, decided to devote herself entirely to her career. She worked tirelessly, henceforth vehemently denying the influence of Rodin on her oeuvre—but preconceptions died hard. She moved into a studio at 113 boulevard d'Italie, in a lonely, deserted neighborhood, and didn't want anything to hinder or compromise her completely free development. That was when she began producing highly original "sketches from life." In a constant desire to observe, to grasp everything, she would remain attentive for hours on end before scenes of everyday life, thereby nurturing marvelous ideas.

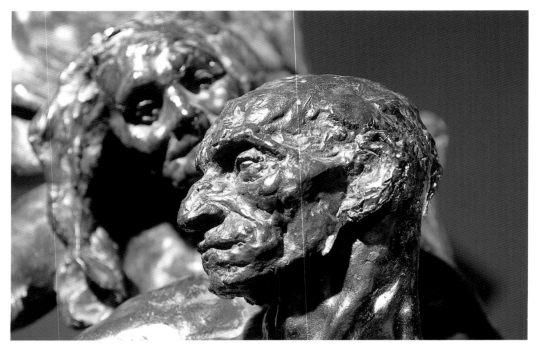

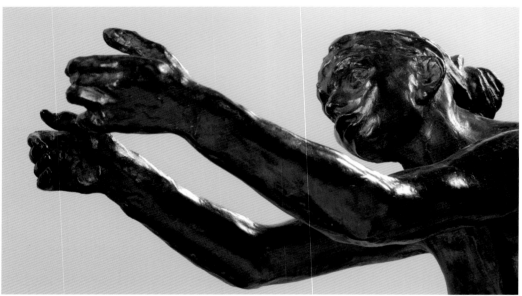

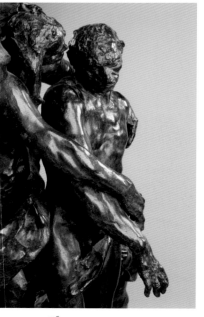

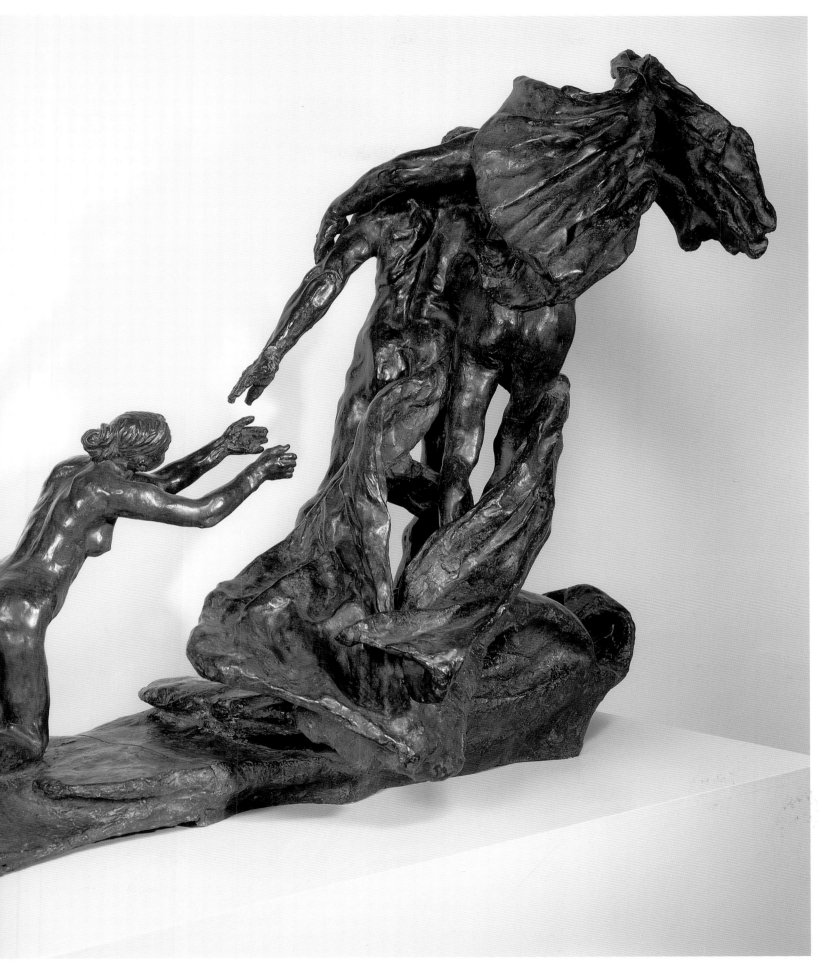

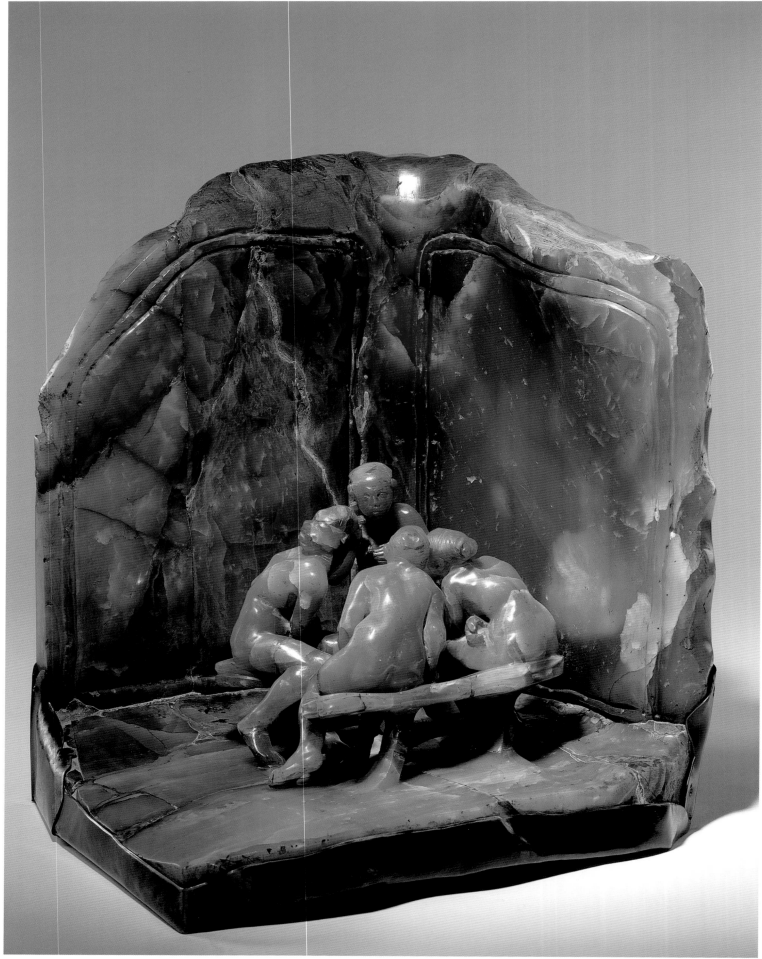

"Three characters listening to a fourth behind a screen," is how Camille described her work *Gossips* to her brother—an inspired, witty miniaturization of a shamelessly witnessed scene in the compartment of a train. Backs to the beholder, snuggled up against a screen, three nude gossips, sitting on two benches, lean in the direction of a fourth woman. Completely wrapped up in their confidential chat, their tilted heads, concentrated expressions, and wide eyes betray their curiosity over some priceless revelation. Claudel's intimate composition is conceived as a caricature that makes its point by plunging the beholder into the ambience of a live event. The high quality and realistic execution of this anecdotal subject make it a peerless work. Several versions exist, differing only in the handling of the screen and hair. One in onyx, a rare material that is difficult to work, was executed in 1897 and further stresses the strangeness as it signals the young Claudel's technical prowess and stylistic independence. The work was well received by critics, who praised its originality and great technical mastery.

In an Art Nouveau vein, Claudel once again asserted her originality by producing *The Wave,* directly influenced by Hokusai and Japanism. Three small, bronze female figures do a round dance, bending their bodies beneath the imminent threat of a giant wave breaking over their heads. The artist's style and virtuosity surface in the bold conception of the "light curl of water" and the innovative poses. Green onyx was successfully used again here, the veins of the stone—along with its varying shades, transparence, and translucence—suggesting the froth of the sea. The surface quality obtained by polishing the piece with a sheep bone, according to her brother's recollection, make it a powerful work whose modernity underscores the artist's inspired dexterity. Claudel was then at the peak of her art. François Pompon would complete the execution of the piece in 1902.

Despite the illness that had now become apparent, Claudel continued working and exhibiting until 1905. For Marie de Maigret she executed *Perseus and the Gorgon* in a traditional style that lacked

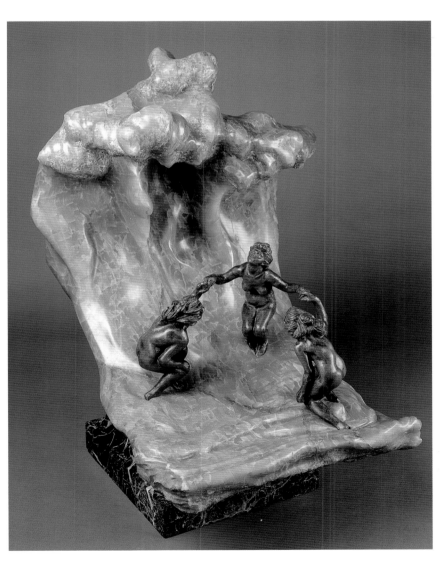

Above
HOKUSAI,
THE WAVE.
NISHIKI-E PRINT, JAPAN.
MUSÉE DES ARTS ASIATIQUES–GUIMET, PARIS.

Left
CAMILLE CLAUDEL,
THE WAVE,
1897–1902.
ONYX AND BRONZE,
24 ¼ × 22 × 19 ¾ IN. (62 × 56 × 50 CM).

Facing page
CAMILLE CLAUDEL,
GOSSIPS,
1897.
ONYX AND BRONZE,
19 ¾ × 16 ½ × 15 ¼ IN. (44.9 × 42.2 × 39 CM).

novelty and mostly harkened back to her apprenticeship—the work was barely noticed at the 1902 Salon de la Nationale.

Claudel's cupboards overflowed with "unbelievably beautiful" sculptures, which she destroyed with frenzied blows of the chisel during her darkest fits of delirium. A latent persecution complex strained her nerves and turned every negotiation into a battle. She was plagued by her sitters' lack of discipline and her assistants' dishonesty, encountering ever greater material difficulties and financial worries. Yet through all those years of isolated work, deprived of any family assistance, she nevertheless benefited from the tireless devotion of her friends, the valued support of her admirers, and the sometimes highly useful influence of critics and collectors such as Mathias Morhardt, Gustave Geffroy, Octave Mirbeau, Marcel Schoebe, and Armand Dayot. Behind the scenes, Rodin long continued making monthly payments—of between two hundred and five hundred francs—in total anonymity, thanks to the help of Joanny Peytel, an art lover who was a director of the Banque du Crédit Algérien.

As her pain and anguish steadily became an everyday affair, Camille's weariness was unrelieved, her tears uninterrupted. She found no way to protect herself from her madness, which gnawed at her own life and those of others. Ever fragile from the wounds of childhood and her break with Rodin, she replaced her authoritarianism with eccentric, odd behavior that made her unpredictable. By exorcising her demons through what Goncourt called "her eccentric comments, her peasant-like awkwardness of speech," she disrupted a family accustomed to the established principles of propriety. She greatly exasperated her younger brother Paul, who was evidently refined and sure of himself and his highly promising literary career.

Now over forty, nothing remained of Camille's legendary beauty. "She seemed older than she was," recalled Henry Asselin, "so much so that her ravaged face with its heavy features revealed the scars left by time and suffering. . . . She must have been beautiful once; she no longer was." Plagued by her demons, she practically never left her home and studio at 19 quai Bourbon, where she had moved in 1899. In her incurable madness, Claudel destroyed more than she created. Subjects dried up, and her tragic obsession prevented her from creating and thus reinvigorating herself. Her face—stiff with solemnity, lined by pain, ravaged by anxiety—expressed both sadness and hatred. She made threats in an undertone. As Paul noted coldly in his diary, "In Paris, Camille mad. Wallpaper torn into long shreds, the only armchair ripped and broken, terrible filth. She is huge, her face dirty, talking constantly in a metallic, monotonous tone."

Instead of calming down, Claudel's rancor toward Rodin grew ever more venomous. Yet the sculptor, haunted by bitter memories, never stopped coming to Camille's aid. "As to the Hôtel Biron, nothing has yet been concluded," wrote Rodin in 1914 to Morhardt, who had suggested that he display works by Claudel as well as his own in the future museum. "The principle of including some sculptures by Mlle Say [a pseudonym for Camille] would give me great pleasure. This residence is very small and I don't know how we will arrange the rooms. There will be some additional construction to do, for her and for me. But whatever the proportion, if the plan comes to fruition she shall have her place."

One week after her father died, on March 10, 1913, Claudel's family had her committed to an asylum at Ville-Evrard in northern France. She would never sculpt again. A few days later, the family issued instructions to forbid all visitors. When war broke out, Claudel was transferred, on September 9, 1914, to the asylum of Montdevergues, near Villeneuve-lès-Avignon in southern France, where she died on October 19, 1943, aged seventy-nine, in a solitude as weighty as it was unrelenting.

"Everything that's happened to me represents more than just a novel," she wrote to Eugène Blot from the Montdevergues asylum. "It's been an epic, the *Iliad* and the *Odyssey*, and it would take a Homer to recount it. I won't do that now, and I don't want to sadden you. I'm in an abyss. I live in a world so odd, so alien. My dream of a life has become a nightmare."

Below
CAMILLE CLAUDEL,
PERSEUS AND THE GORGON,
1902.
MARBLE,
20 ½ × 11 ½ × 7 ¾ IN. (52. 3 × 29.3 × 19.7 CM).

Facing page
WILLIAM ELBORNE,
CLAUDEL IN THE MONTDEVERGUES ASYLUM.
7 × 5 IN. (17.7 × 12.6 CM).
ELBORNE COLLECTION.

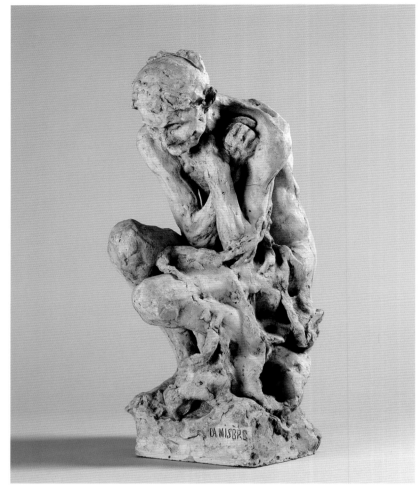

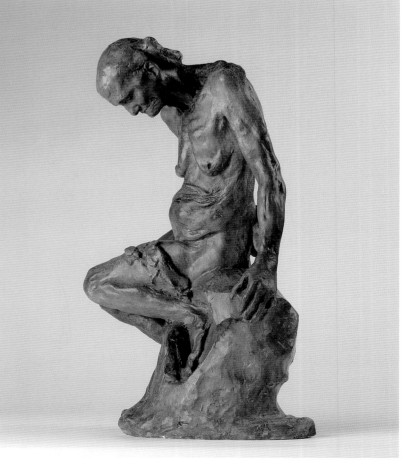

Above
DONATELLO,
SAINT MARY MAGDALENE,
1435–1455.
WOOD,
MUSEO DELL'OPERA
DEL DUOMO, FLORENCE

Above, right
JULES DESBOIS,
MISERY,
c. 1887–89.
TERRACOTTA,
14 ¾ × 7 × 9 ¾ IN.
(37.5 × 17.7 × 24.6 CM).

Right
THE HELMET-MAKER'S WIFE.
OCHER-PATINATED PLASTER,
20 × 12 × 10 ½ IN.
(50.5 × 30.5 × 26.5 CM).

Pages 84–85
CAMILLE CLAUDEL,
CLOTHO,
1893.
PLASTER,
35 ½ × 19 ½ × 17 IN.
(90 × 49.5 × 43.5 CM).

"UGLY," IN ART, MEANS ANYTHING FALSE

"'Ugly,' in Art, means anything false, anything artificial, anything that seeks to be pretty or nice instead of expressive, that is mawkish or affected, that is pointlessly rosy, inexplicably mannered, haphazardly curved or straight, all that is soulless or lacking in truth, all that is a mere show of beauty and grace, all that lies."

This declaration by Rodin to Paul Gsell sums up the sculptor's ambitious quest for truth, even at the cost of an occasionally extreme realism.

For instance, in the case of his model Maria Caira. Caira was an eighty-two-year-old Italian woman who traveled to France to see her son again before she died. At her son's urging, she became a model for Jules Desbois, Auguste Rodin, and Camille Claudel, three artists fascinated by the expressive power of a body ravaged by time and life. Under cover of allegorical, mythological, literary, and biblical themes—in a similar vein to Donatello's *Saint Mary Magdalen*—they stripped her skeletal body and exhibited it, each according to his or her own sensibility.

Desbois (1851–1935) was the first artist to have Caira pose for him, sometime around 1887. Originally from Anjou, Desbois was Rodin's employee, technical assistant, and faithful friend. He imbued his model with a great sense of pathos that helped him convey the idea of social wretchedness. The figure's closed eyes and carefully tilted head lend the face an expression of infinite sadness, while the strikingly withered body suggests illness. With great humility, the toothless old woman vainly attempts, in a reflexive gesture of modesty, to hide her shriveled body. Huddled, bereft of everything, with all her strength she clutches a kind of rag that is seen on her left leg in the sketch. Naturalism is taken here to an extreme. Under the allegorical title *Misery*, Desbois produced a poignant study of a body worn down by life, awaiting nothing more than death, yet he endowed it with infinite dignity and a painful beauty.

Literally fascinated by Desbois's sitter, Rodin hired her in turn. His initial quest was a form of beauty that he called "Character." As he explained to Gsell, "That's because, in Art, 'beautiful' means only that which has Character. Character is the intense truth behind any natural sight, whether beautiful or ugly." With Caira, however, Rodin was denouncing the vanity of fleeting beauty. Appalled and suddenly aware of this irony, the old woman emerges all the greater. Seated on a rock, completely naked, head bent, weary and resigned, she spreads her arms on both sides of her withered body, as though studying the ravages all the better. Jules Renard described the piece as "an old woman in bronze, something terribly beautiful, with her flat breasts, wrinkled belly, and still beautiful head." Free of all artifice, she owes her beauty to her truth. The magnificently handled anatomy seems cruelly accurate. The realistic rendering of tiny details testifies to Rodin's flawless observation.

Prior to executing the freestanding sculpture exhibited in 1889, Rodin depicted this figure in relief, at the bottom of the left pilaster of *The Gates of Hell*. Initially dubbed *Old Woman*, Rodin's literary friends prevailed upon him to retitle it *The Helmet-Maker's Wife*, based on François Villon's sixteenth-century ballad, "She Who was Once the Fair Helmet-Maker's Wife." Villon's verses describe a former courtesan, once beautiful and desired, who mourns the unsightliness of age:

When I think, alas! of times bygone,
Of what I was, what I've become,
When now I see myself all naked,
See how every part has changèd:
Poor, shriveled, thin, and sad,
'Tis fair enough to drive me mad.

Carved in marble by studio assistant Victor Peter, this figure was later given a sprig of holly and dubbed *Winter*. Finally, placed back-to-back in an assemblage of figures, Caira became *Dried–Up Springs*, a work appreciated by Octave Mirbeau.

Camille Claudel's Caira-derived piece is surely the boldest. Attracted by the ancient myth of the three Fates who spun, measured, and cut the lifelines of mortal humans, Claudel decided to depict the youngest of the three sisters, Clotho. It was Clotho who presided over an individual's birth, spinning the thread of fate from her distaff. Here the roguish spinner is apparently caught in her own trap: the standing figure's hair seems tangled in the skeins of thread with which she spins out every human life, making her a strange and evil creature. Her insanely tilted head, deformed chin, wild eyes, and hint of awful laughter captivate the beholder. This unforgettable figure incarnates, for everyone, the horrors encountered in nightmares. Although her breasts are shriveled and her flesh sags, her overall anatomy has been largely spared by Claudel, in no way rivaling the bodily decrepitude depicted by Desbois and Rodin. Claudel's skillful execution is clean and meticulous; her handling of the tentacular headdress reveals technical prowess and creates a striking, decorative effect.

Critics at the Salon of 1893, where the plaster was exhibited, were divided. Mathias Morhardt organized a subscription in the goal of commissioning the artist to produce a marble version for the Musée du Luxembourg; Rodin doubled the stakes by personally contributing one thousand francs. The final marble piece, completed in 1897 and exhibited on the Champs de Mars in Paris in 1899, received an equally mixed reception. Claudel was often misunderstood, and once again she was accused of plagiarizing Rodin. "I read with amazement your account of the Salon in which you accuse me of basing my *Clotho* on a drawing by Rodin," she replied to Maurice Guillemot in 1899. "I would have no difficulty in proving to you that *Clotho* is an absolutely original work; apart from the fact that I don't know Rodin's drawings, I might add that my works are based solely on my own ideas, of which I tend to have too many rather than too few." The marble *Clotho*, Claudel's most original work—a wicked nod at the evil spirits who haunted her—therefore remained in her former lover's studio for a long time. Then it vanished. Its whereabouts are still unknown.

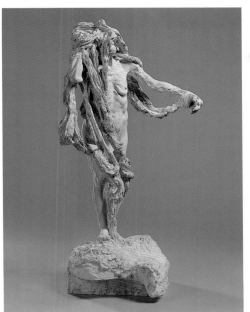
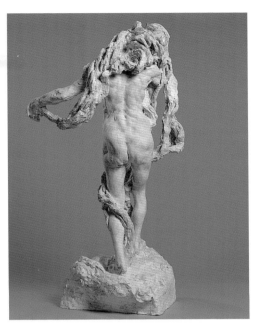
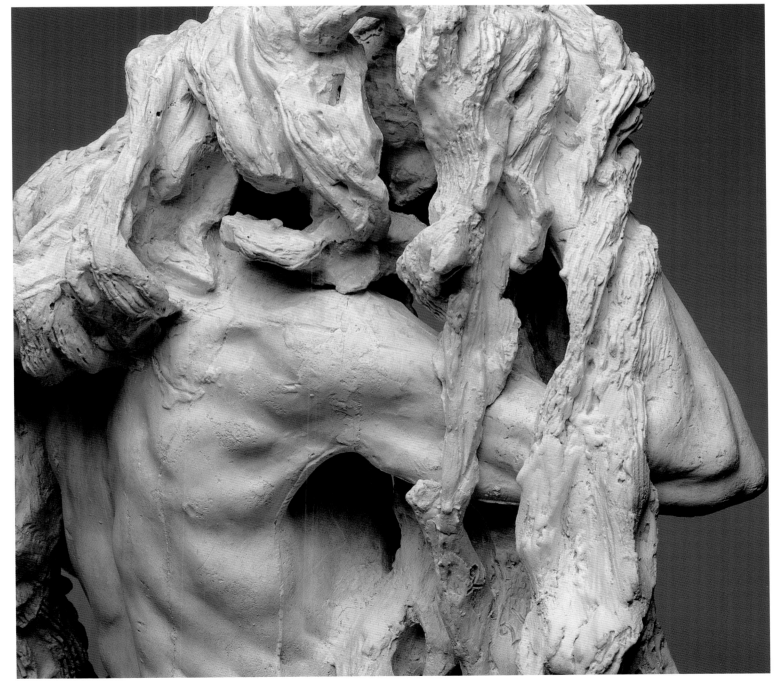

"I do not wish to follow people whose conventional art I despise."

Rodin to Omer Dewavrin, 1885

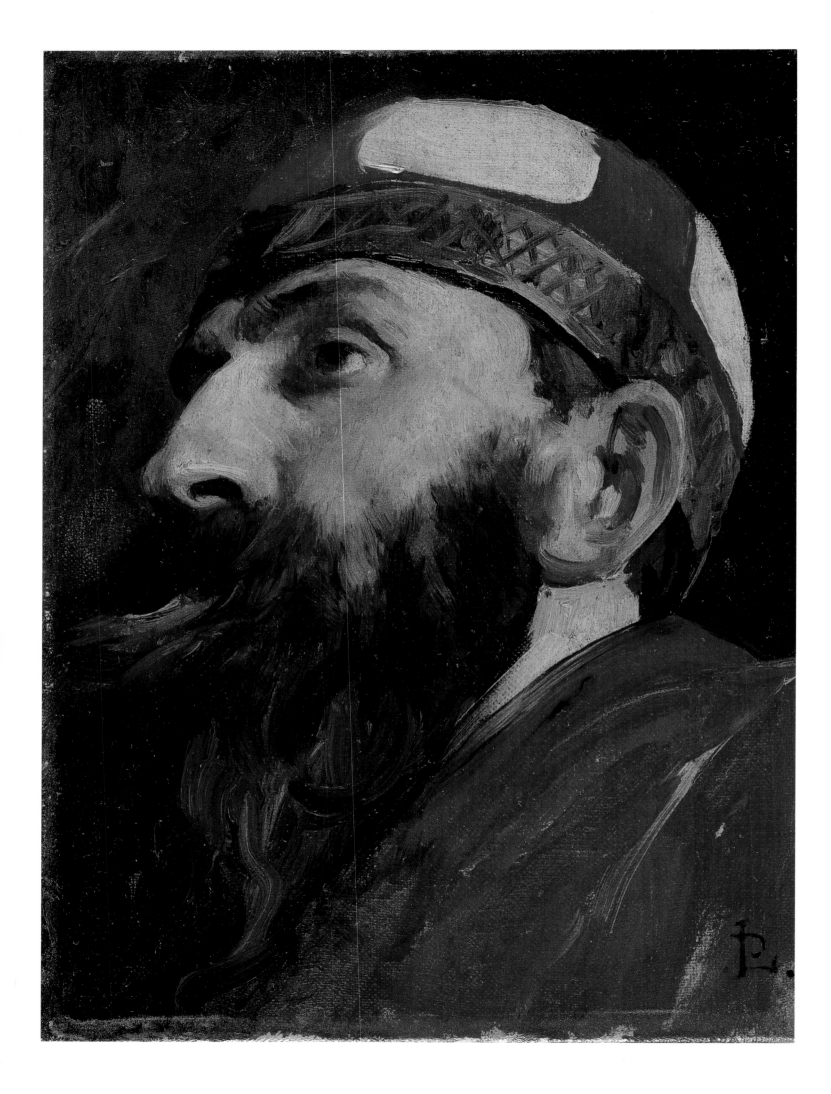

RODIN, SCULPTOR OF PUBLIC MONUMENTS

I t was not long before Rodin, like all artists of his day, began trying to obtain the official commissions that led to the renown required for his work to reach the general public. Two paths were possible at the time: open competition or direct commission. Since the latter tended to be reserved for experienced artists recognized by the cultural establishment, competitions such as the Prix de Rome, organized by the Institut de France, symbolized a first, crucial rung on the official ladder; but having already failed three times to gain admission to the École des Beaux-Arts, Rodin had no chance of winning the prestigious scholarship to Rome. He therefore had to submit to the process of open competition.

It is interesting to note that Rodin almost never won the competitions he entered. His commissions always came from the contacts he managed to cultivate right from the start of his career. These connections came from every sphere, not only artists such as Albert-Ernest Carrier-Belleuse, Alexandre Falguière, and Henri Chapu, but also politicians, notably including Edmond Turquet, the undersecretary of state for fine arts who was behind the official commission for *The Gates of Hell* in 1880.

Rodin had already worked on public monuments during his years in Belgium. In 1876, he helped Jules Pecher and Antoine (called Joseph) van Rasbourgh to design a *Monument to Loos* for the city of Antwerp. Similarly, still working with van Rasbourgh, he produced two monumental groups for the Bourse in Brussels. On returning to France, Rodin entered several official competitions for monuments to be erected by the national, regional, and municipal governments. His proposals for memorials to the Defense of Paris, the Republic, Jean-Jacques Rousseau, General Margueritte, and Lazare Carnot were all rejected. He only won a commission for a statue of *D'Alembert*—destined for the façade of the Hôtel de Ville in Paris—thanks to backing from Falguière and Carrier-Belleuse.

The reasons for Rodin's failures in public competitions stem above all from his obvious unwillingness to bow to official taste. But they also relate to an almost provocative determination to raise art above politics. This approach, at a time when the new French Republic was still seeking its way, was folly not only in the eyes of a jury—even the best disposed jury—but even more so in the eyes of political leaders who were less interested in art than in powerful, instantly understood symbols. For example, the rejection of Rodin's proposal for the Defense of Paris (now known as *La Défense* or *The Call to Arms*) was largely due

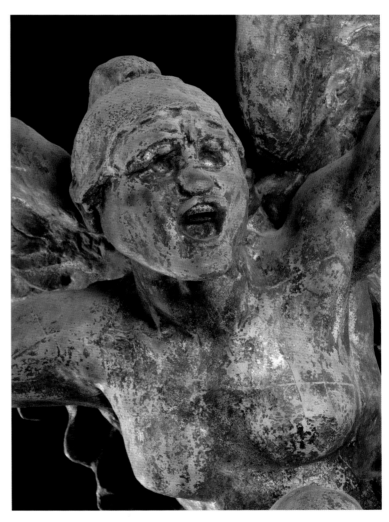

Above
LA DÉFENSE (OR THE CALL TO ARMS), 1906 (CAST 1917).
BRONZE,
90 ½ × 45 ¾ × 33 ¼ IN.
(230 × 116 × 84.5 CM).

Left
LOUIS-ERNEST BARRIAS,
LA DÉFENSE DE PARIS, 1883.
BRONZE.

Facing page
JEAN-PAUL LAURENS,
RODIN IN A TURBAN: STUDY FOR THE PANTHEON DECORATION.
OIL ON CANVAS,
9 ¾ × 7 ½ IN. (24 × 19 CM).

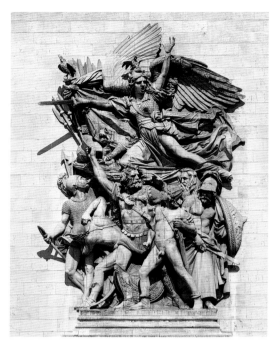

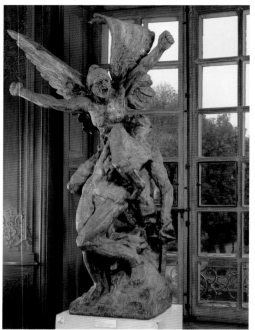

FRANÇOIS RUDE,
THE DEPARTURE OF THE VOLUNTEERS
OF 1792 (OR THE MARSEILLAISE), c. 1835.
ARC DE TRIOMPHE, PARIS.

LA DÉFENSE (OR THE CALL TO ARMS),
1906 (CAST 1917).
BRONZE,
90 ½ × 45 ¾ × 33 ¼ IN. (230 × 116 × 84.5 CM).

POSTER FOR THE SALE OF NATIONAL
REDEMPTION STAMPS, 1948.
PHOTOMECHANICAL REPRODUCTION.

to the very timelessness of a work that in no way addressed or even alluded to the specific event it was supposed to commemorate—Parisian resistance during the Prussian siege of 1870. Despite the expressive energy of a female figure incarnating the spirit of resistance, the highly powerful group proposed by Rodin was an allegory of an invaded nation making its last stand—which was obviously a lot more than the local council had bargained for. Whereas the official plan called for the depiction of a heroic but real and plausible incident, Rodin offered an absolute vision of almost unbearable pathos; the eye is drawn first to the dead warrior, whose pose is borrowed almost detail for detail from the Christ of Michelangelo's *Pietà* (Museo dell'opera del Duomo, Florence). An official jury could hardly accept this parallel between a secular, republican history and the Passion story, even if it is more than likely that the specific allusion to the *Pietà* went unnoticed at the time. To grasp the boldness and modernity of Rodin's piece, it needs to be compared to its antithesis—almost a reverse image—namely Antonin Mercié's *Gloria Victis*, so highly admired the previous year.

Eliminated in 1879, Rodin's entry would be better understood years later, when it was erected in Verdun to commemorate the bloody battle of the First World War. Still later, Gaullist propaganda would again recuperate the symbol of resistance conveyed by this group. Yet Rodin's approach to this monument clearly showed that he had thought about the specific site planned for it: the female figure was obviously inspired by François Rude's bas-relief on the Arc de Triomphe in Paris (titled *The Departure of the Volunteers* but more commonly known as *The Marseillaise*); he intended it as a deliberate echo rolling down the avenue de la Grande Armée and the avenue de Neuilly right up to the intersection in Courbevoie where the monument was supposed to be erected.

Despite these setbacks—his proposal for a statue of the Republic, to be erected in the Paris square of the same name, met with similar objections, and the commission went to Jules Dalou—Rodin continued to push himself. He exhibited regularly at the annual Salon, executed a number of busts of well-known figures, and made the social rounds of fashionable private salons, where he was able to meet influential men who soon became convinced of his talent. Rodin's true gift for striking up relationships that would enhance his reputation and promote his work soon bore fruit. On the heels of the official commission for *The Gates of Hell*, the mayor of the city of Calais, Omer Dewavrin, came to Rodin in 1884 to discuss a monument to celebrate an event in local history: in 1347, when the city surrendered to King Edward III, six heroic burghers were charged with offering the keys of the city to the victorious English monarch. Intrigued by the subject, Rodin read Froissart's *Chronicles* on the incident and presented an initial maquette to the city council in July 1885, with the following piece of advice: "Don't fret about making a useful expenditure because you don't always have such a fine idea and opportunity to spark patriotism and selflessness." Rebuffed by criticism that his maquette stressed the sorrowful expression and submissive poses of the figures—obstacles to the purported idea of national pride and heroism—Rodin revised his project to produce the final version. Despite delays due to problems both financial (the collapse of Calais banks in 1886) and political (Dewavrin's ousting and return, in 1892, to municipal leadership), *The Burghers of Calais*—the only monument of this kind ever truly completed by Rodin—was set up in front of the town hall and unveiled in 1895.

The sculpting of this group provided Rodin with an opportunity to set himself clearly apart from conventional ideas on the genre.

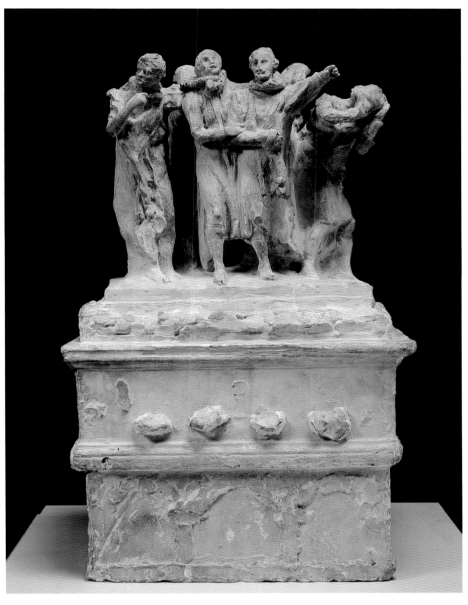

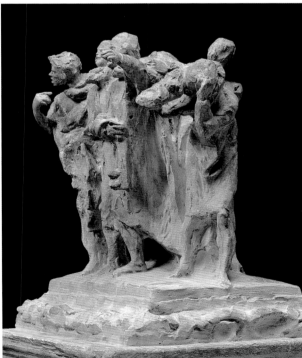

Above and right
THE BURGHERS OF CALAIS (FIRST MAQUETTE), 1884.
PLASTER,
24 × 15 × 12 ¾ IN.
(61 × 38 × 32.5 CM).

Below
LITERARY SUPPLEMENT TO LE PETIT PARISIAN,
"A PATRIOTIC EVENT: THE SIX BURGHERS OF CALAIS LEAVING THE CITY," 1895.
MUSÉE DES BEAUX-ARTS ET DE LA DENTELLE, CALAIS.

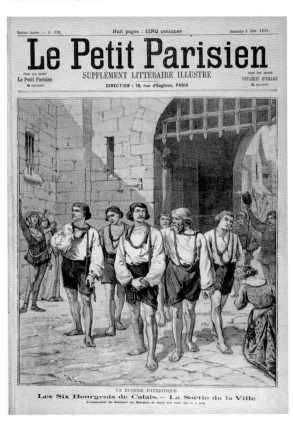

He notably rejected the traditional pyramidal composition, which disconcerted the critics. Rodin indirectly replied to them in a letter to Dewavrin. "It is quite simply the School that is laying down its laws; I am directly opposed to the principle that has pertained since the beginning of this century and that is contrary to all earlier periods of great art and that imparts coldness and lack of movement to all works conceived in its spirit." Rodin concerned himself with every detail, reflecting at length on how to enhance his *Burghers* as he conceived them, notably on the appearance and height of the base, which would play a crucial role in the way his group was perceived. Later, he even advocated displaying the sculpture without a base so that the beholder "could fully enter into the drama."

Rodin's preparatory work is further testimony to the originality of his creative approach—also reflected in his other monuments—which involved a concern for veracity and historical accuracy. He thus under-

took real research into the physical resemblance of his characters, notably Eustache de Saint-Pierre. He studied many types of faces from the Hainault region, even drawing inspiration from the actor Coquelin Cadet, originally from Boulogne, for the figure of Pierre de Wiessant. Similarly, for his *Balzac* Rodin went to the Tours region to uncover—or so he believed—models that might resemble the writer, as he worked from surviving portraits of Balzac. And when Rodin approached his *Victor Hugo,* he proceeded in the same manner, producing a considerable number of sketches done in the writer's presence.

With *The Burghers of Calais,* Rodin finally won official, institutional recognition. The national government commissioned a group to commemorate Victor Hugo, whom Rodin had met two years before the writer's death thanks to the intercession of his friend Edmond Bazire, while the city of Nancy chose Rodin in 1889 for a monument to the artist Claude Lorrain.

For the Lorrain piece, Rodin continued his creative exploration into pedestals, just as he had done for *The Burghers of Calais.* He elaborated a veritable allegorical scheme designed to enhance Lorraine's image. The surprisingly large base shows Apollo's horses emerging from the clouds, perhaps echoing the famous ones that were carved by Robert Le Lorrain over the courtyard of the Hôtel Rohan in Paris. This choice of subject was an explicit allusion to Lorraine's characteristic work on

Below
JACQUES-ERNEST BULLOZ,
THE BURGHERS OF CALAIS IN MEUDON, ON SCAFFOLDING, 1913.
GELATIN SILVER PRINT,
10 ¼ × 14 IN. (26.4 × 36 CM).

Facing page
JACQUES-ERNEST BULLOZ,
THE BURGHERS OF CALAIS ON SCAFFOLDING, UNDATED.
GELATIN SILVER PRINT,
15 ¾ × 11 ¾ IN. (39.8 × 29.9 CM).

Pages 94–95
THE BURGHERS OF CALAIS, 1889.
COATED PLASTER,
91 × 97 ½ × 78 ¾ IN. (231.5 × 248 × 200 CM).

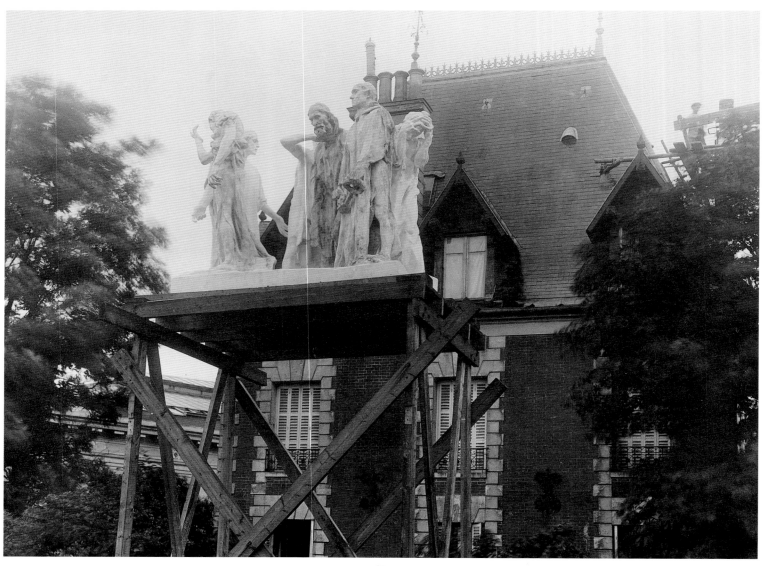

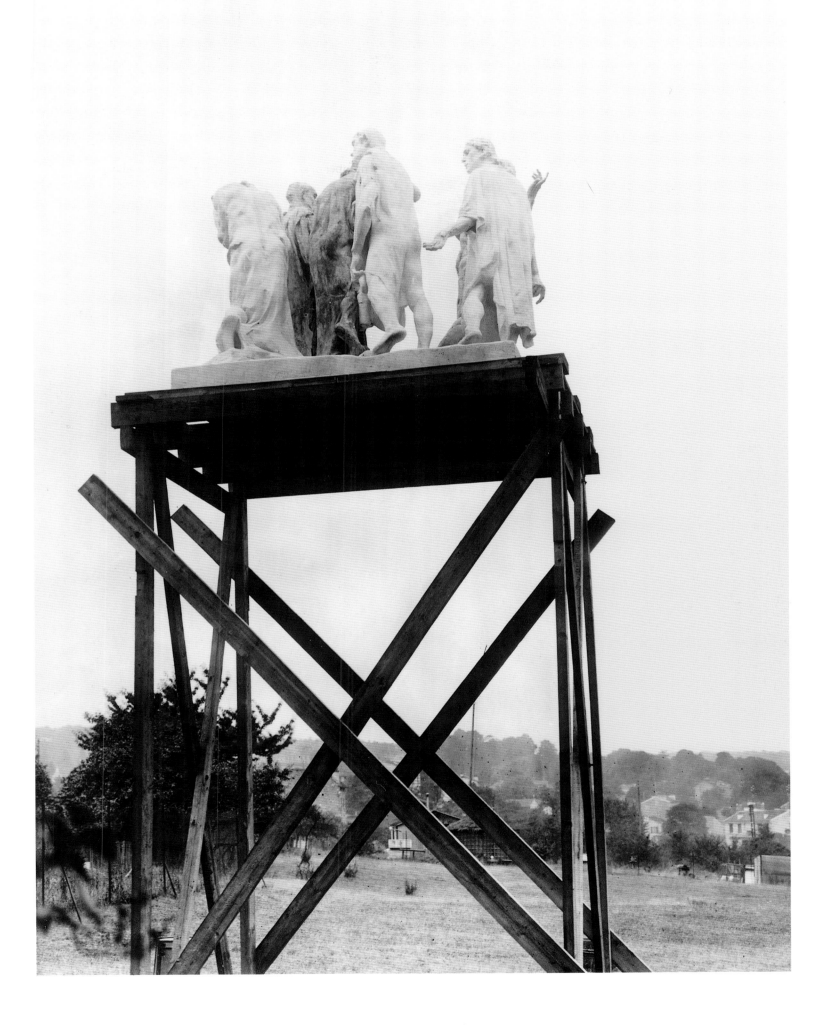

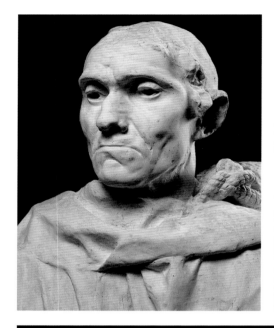
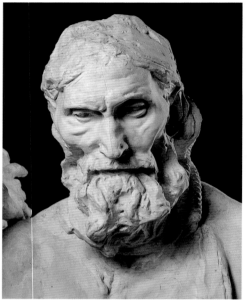
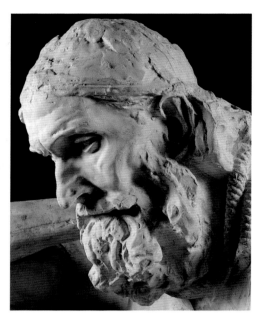

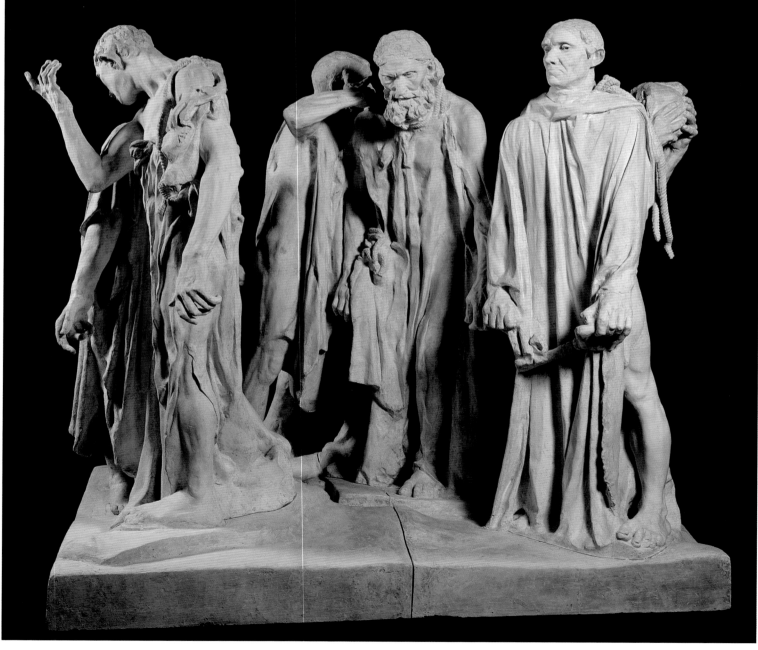

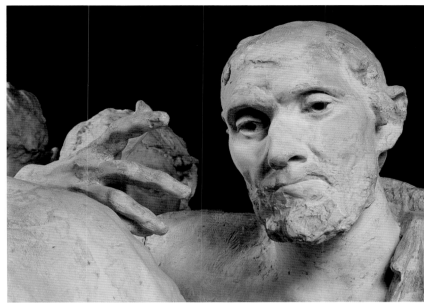
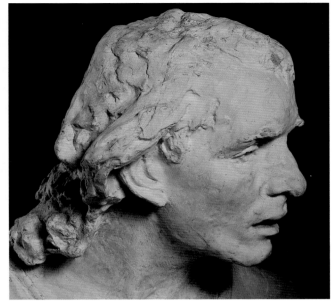
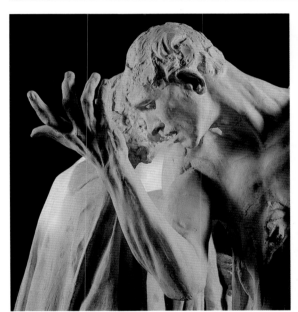
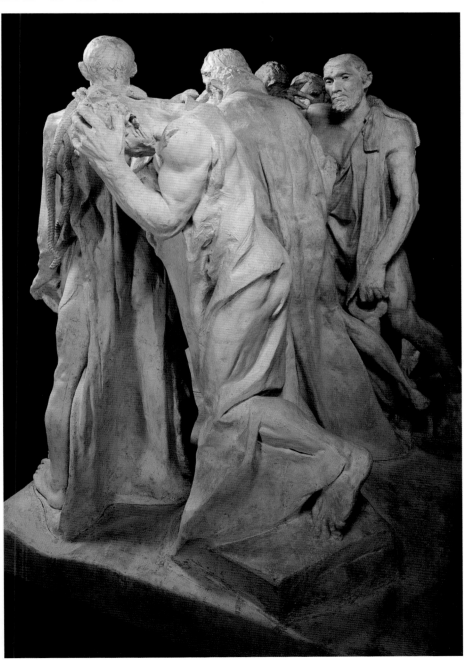
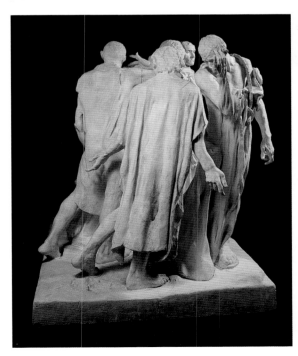

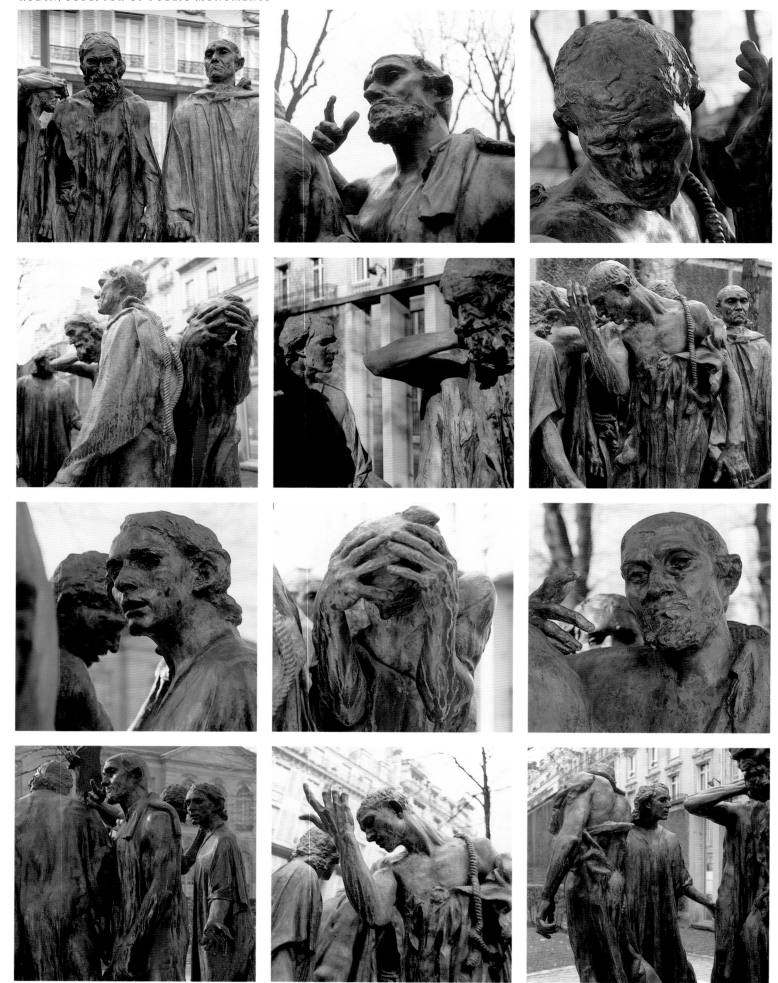

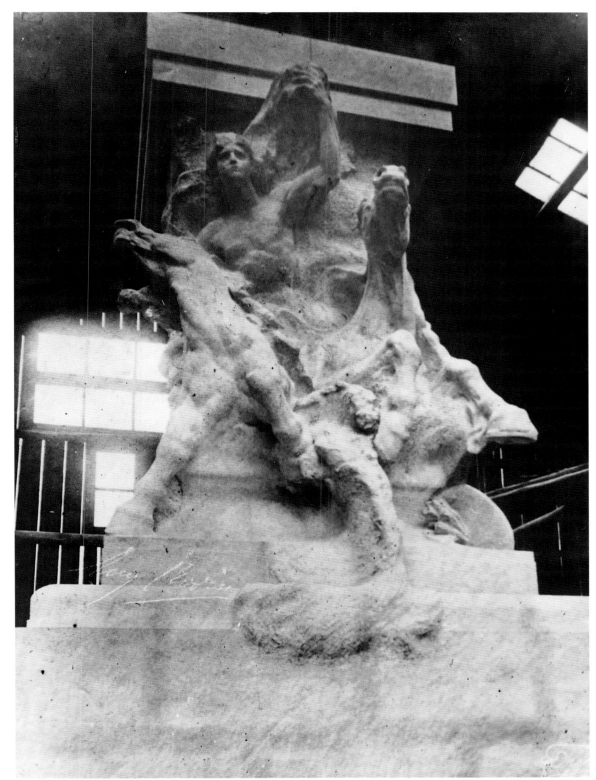

Facing page
**THE BURGHERS OF CALAIS,
1889.**
BRONZE (CAST BY RUDIER), 1926,
85 ½ × 100 ¼ × 77 ½ IN.
(217 × 255 × 197 CM).

Left
EUGÈNE DRUET,
**THE BASE OF THE MONUMENT
TO CLAUDE LORRAIN IN
A SHED IN NANCY, 1892.**
GELATIN SILVER PRINT,
15 × 11 ½ IN. (38.5 × 29.3 CM).

light in his paintings. Inaugurated in 1892 in the presence of Said Carnot, the French president, Rodin's group met with mixed critical reaction; he even had to make major changes to the pedestal and recarve the horses that had sparked dissatisfaction. Rodin later complained, "[The committee] made me kill my sculpture. They made me ruin my horses."

The 1890s marked the start of Rodin's major efforts to celebrate two of the country's greatest writers of all times, Honoré de Balzac and Victor Hugo.

"There is a little bit of Jupiter, Hercules, and Pan in Victor Hugo's face."
Rodin

Hugo had died on May 22, 1885, and after a grandiose funeral organized by the state, the government commissioned Rodin—on December 16, 1889—to sculpt a monument to the famous poet. It was to be set in Hugo's crypt in the Pantheon, the former church of Sainte-Geneviève converted into a mausoleum for great Frenchmen.

The government decided to launch a monumental project to redecorate the church by commissioning reputable sculptors to execute works such as *The Spirit of the Revolution* and *The Orators of 1830*. Rodin, who had already done a well-received bust of Hugo, told the selection committee that he had decided to depict "Victor Hugo in exile, the man who steadfastly held out for eighteen years against the despotism that drove him from his own country." The poet was thus shown sitting on a rock in Guernsey, flanked by three muses emerging from a wave and symbolizing the three ages of man and the sources of Hugo's inspiration. Despite the unflagging support Rodin received during this affair—notably from Octave Mirbeau—his proposed sculpture was felt to be unsuited to the scale of the Pantheon. The committee concluded, "However admirable they may be once finished, the three women tower over the poet's head, so when seen from a distance the group forms a confusing muddle." Gustave Larroumet, the ministry's director of fine arts, wanted to mollify Rodin and decided that the monument would be placed somewhere else; furthermore, Rodin would receive a commission for a new monument for the Pantheon, this time showing Hugo standing. Rodin therefore went back to work and on December 8, 1890, he wrote to Larroumet:

Right
JULES DALOU,
PROPOSAL FOR A MONUMENT TO VICTOR HUGO FOR THE PANTHEON, 1886.
PLASTER,
MUSÉE DU PETIT PALAIS, PARIS.

Top right
VICTOR HUGO IN THREE-QUARTER PROFILE, 1ST STATE, 1884.
DRYPOINT REWORKED WITH PEN AND BROWN INK,
9 × 7 IN. (22.7 × 17.8 CM).
ANNOTATED IN PEN AND BROWN INK,
RIGHT: V. HUGO L'IMMENSE / DONT
LE MASQUE A ÉTÉ SCULPTÉ /
PAR ANTICIPATION PAR MICHEL-ANGE /
AU TOMBEAU DES MÉDICIS SOUS LA /
FIGURE DU JOUR / MÉLANGE
DE L'HERCULE ANTIQUE / ET
DE LA PENSÉE MODERNE. A. RODIN;
ANNOTATED, LEFT:
A MON VÉRITABLE AMI. ED. BAZIRE.

Right
BUST OF VICTOR HUGO WITH MODELED BASE, 1883.
BRONZE,
19 × 11 ¼ × 12 IN.
(48.5 × 29 × 30.5 CM).

Facing page
MONUMENT TO VICTOR HUGO, FIRST PROPOSAL, FOURTH STUDY, 1895–96.
PLASTER,
41 × 52 ¾ × 32 ¼ IN.
(104 × 134 × 82 CM).

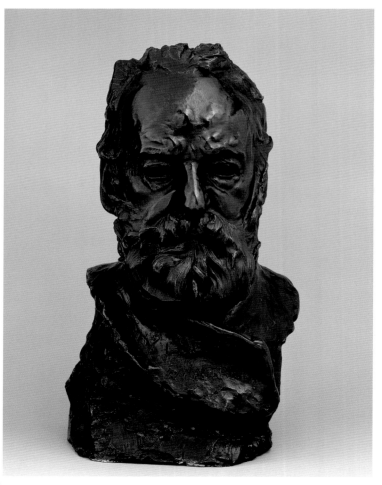

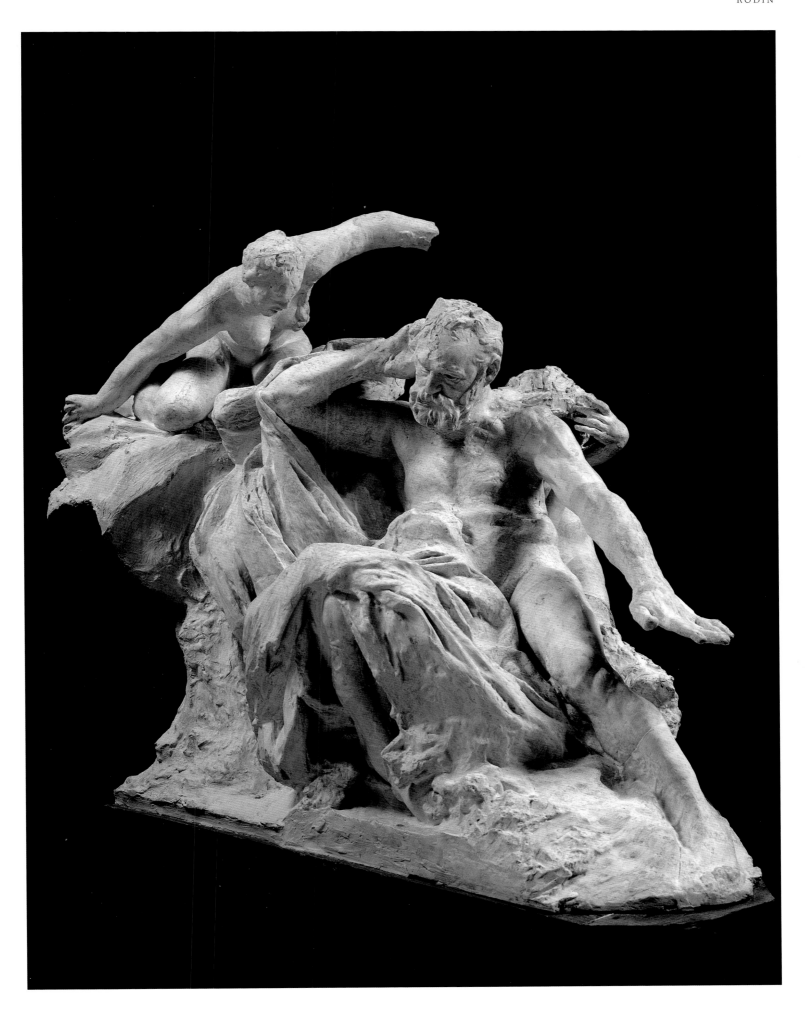

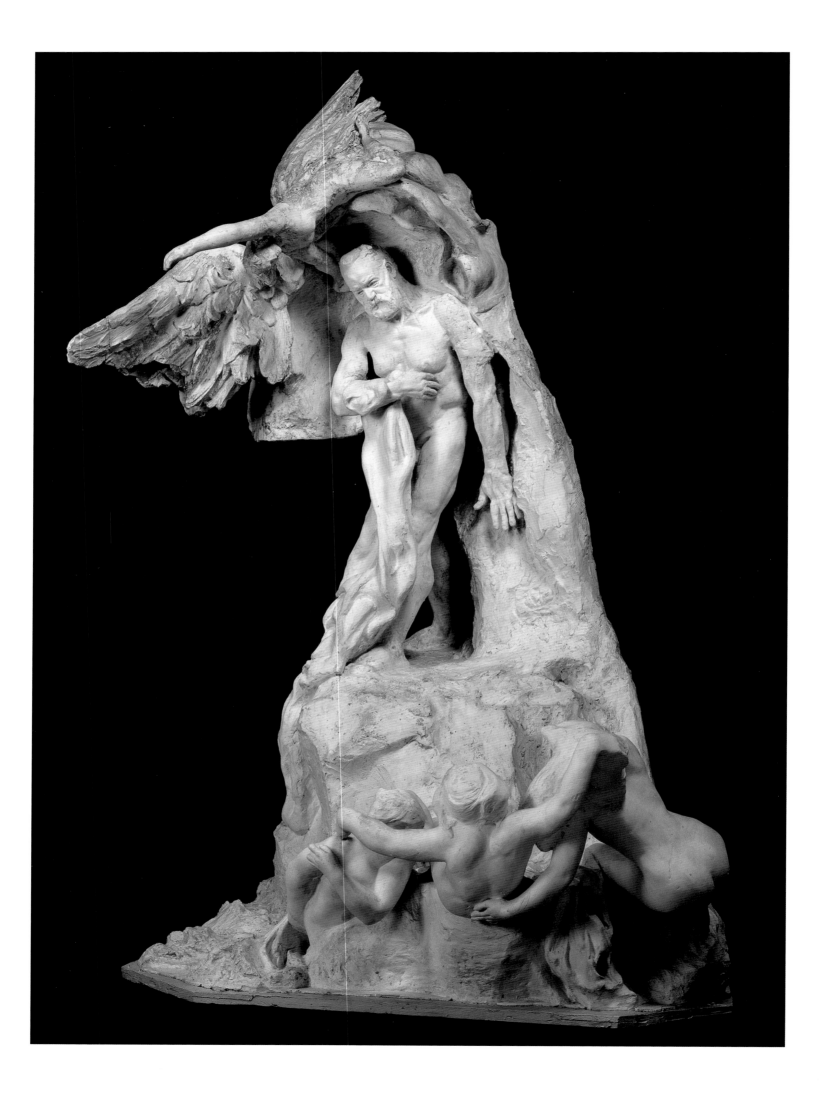

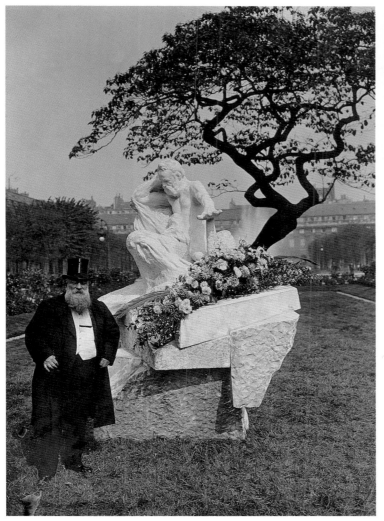

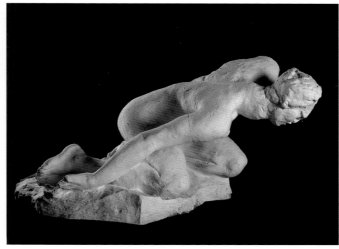

Above
THE TRAGIC MUSE, C. 1890.
PLASTER,
27 ½ × 32 ½ × 54 ¾ IN. (70.1 × 83.3 × 139.3 CM).

Left
HAWEIS AND COLES,
**BUST OF VICTOR HUGO AND TWO
MEDITATIONS, C. 1903.**
GUM BICHROMATE PRINT,
8 ½ × 6 ¼ IN. (22 × 16 CM).

Far left
**RODIN IN FRONT OF THE MONUMENT TO
VICTOR HUGO THE DAY IT WAS UNVEILED
IN THE GARDENS OF THE PALAIS ROYAL IN
PARIS, SEPTEMBER 30, 1909.**
GELATIN SILVER PRINT,
6 ½ × 4 ½ IN. (16.8 × 11.8 CM).

Facing page
**MONUMENT TO VICTOR HUGO, SECOND
PROPOSAL, SECOND STUDY, C. 1898.**
PLASTER,
85 ¾ × 57 ¾ × 43 ¼ IN. (218.5 × 146.5 × 110 CM).

Since the pediment [of the Pantheon] is inscribed "A Grateful Country to its Great Men," I'm doing an apotheosis. Victor Hugo is crowned by the spirit of the nineteenth century, while Iris descends [from the heavens] on a cloud and crowns him too, or rather their hands meet and hold flowers and laurels above him. Lower down I'm doing a powerful figure who raises his head to gaze at Hugo in his apotheosis—that's the crowds that made his funeral so unforgettable, that's us, vox populi. Victor Hugo is on a rock, with waves pounding against it, and a Nereid or the wave itself in female form hands him a lyre. Behind the monument, Envy flees down a hole below. It is not at all squat like the other one, my dear Sir, but is tall, silhouetting our program.

In all of Rodin's oeuvre, this dense allegorical program marks his greatest concession to official taste, which the sculptor had always viewed with wariness and even contempt. Perhaps that is why his monument to Hugo met with an embarrassed lack of comprehension, as though Rodin had clumsily wandered into the very academic art he had always resolutely rejected. As Frederic V. Grunfeld quite rightly stresses, the artist's failure to complete either of these two groups might be viewed as "a symptom of Rodin's increasing dislike of the whole genre of monumental sculpture, with its literalism and pomposity. He had come too far along the road to freedom to turn back now and appease an outworn aesthetic. His revolt took the tactile, physical form of cutting off heads, amputating limbs, slicing off backs. Iconoclasm was his intuitive way of breaking out of the tyranny of kitsch." Indeed, as with *The Gates of Hell*, Rodin would exploit these groups as inspiration for new, independent pieces such as *Iris, Messenger of the Gods* and *The Tragic Muse*. In the end, only a seated *Victor Hugo* was completed, rid of its female allegories and carved into marble for presentation at the Salon of 1901. (In 1909, once the concept of modern art had evolved in France and Rodin's work no longer sparked the same criticism it had just a few years earlier, the statue was placed in the gardens of the Palais Royal.) Rodin enjoyed a kind of revenge in 1906 when the large version of his *Thinker* was unveiled in front of the Pantheon, where his *Victor Hugo* had been denied a place a few years before.

"Balzac is the pivotal work of my aesthetics."
Rodin

In 1891, the French writers' association known as La Société des Gens de Lettres commissioned Rodin to execute a statue of its founder, Balzac. The job had already been given to Henri Chapu, a sculptor of statues of other authors such as Gustave Flaubert and Alexandre Dumas Père, but Chapu died before he could complete the work. At the urging of Léon Cladel and the Société's current president— who was none other than Émile Zola, a fervent admirer of Rodin—the

Right
LOUIS BOULANGER,
**HONORÉ DE
BALZAC, 1836–37.**
OIL ON CANVAS,
MUSÉE DES BEAUX-
ARTS, TOURS.

Far right
**BALZAC, AFTER
DEVÉRIA, 1893.**
PLASTER,
17 × 16 × 9 ¾ IN.
(43.5 × 40.6 × 25.1 CM).

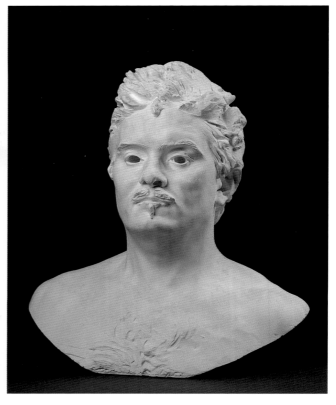

project was then entrusted directly to Rodin, who had refused to consider competing for the commission. "As soon as a few people, however intelligent or expert they may be, come together to judge artworks submitted to them, they will never agree on anything other than a totally neutral work. A work that is much superior and very personal, but showing some particularity, boldness, or defect, has no chance of winning. Therefore, unless the circumstances are highly special, I will not submit a proposal for this competition if it is open." This far-sighted comment suggests that Rodin was already considering an innovative work that would spark strong reactions. As it turned out, there was no competition. Rodin was simply named to take over the project. Since the statue was designed to be set up on place du Palais-Royal, official recognition of Rodin's talent was once again at stake.

Rodin thus undertook major preparatory work, consulting all the images of Balzac he could find—paintings, engravings, and sculptures, notably a bust by David d'Angers. He even traveled to Balzac's native Tours region in search of local people with features similar to those of the writer. Gustave Toudouze, vice president of the Société des Gens de Lettres, reported to Zola on Rodin's enthusiasm for the project. "I found Rodin full of joy and gratitude toward everyone, all excited about his *Balzac*. He's going to get down to work immediately, using vacation time to go to Tours and steep himself in Balzac's environment, to see the locals, rummage through the museum and the countryside; I think he'll produce a splendid work and that the Société will have no cause to regret having chosen this zealot."

During his stay in Tours, Rodin managed to find a man named Estager (dubbed "the driver from Tours") who somewhat resembled Balzac and who sat for a series of sketches. Rodin's concern for historical veracity and accuracy would go even further: he tracked down Balzac's former tailor and ordered a frock coat in the writer's size.

Rodin's countless and extremely meticulous studies led to a delay in delivery of the statue, which seriously inconvenienced the Société; Rodin had to do regular battle to have the deadline extended. From sketch to sketch, the project began to take shape in his mind. "I've understood," he said to Paul Gsell, "that the depicted character [needs] to be wreathed by a glimpse of his living environment, to be pictured with a halo of ideas that explain the character. The art is propagated in mysterious waves." Little by little, Rodin eliminated superfluous details, retaining only his subject's most typical features—the corpulence and the famous dressing gown that Balzac wore when writing. More than a physical portrait of Balzac, Rodin produced a veritable allegory that paid tribute to the author's creative power and immense literary oeuvre. According to Rilke, "It was creativity itself that was displayed in Balzac's form—haughty creativity with its pride, headlines, intoxication." This work had none of the complications that wound up smothering the *Monument to Victor Hugo*. Yet Rodin's novel approach, so alien to traditional statuary and to public expectations, ultimately triggered an outcry.

At the Salon of 1898 Rodin exhibited a plaster cast of *Balzac*, described by Georges Rodenbach as "less a statue than a kind of strange monolith, an age-old menhir, one of those rocks on which the caprice of some prehistoric volcanic explosion has etched a human face by chance." Disconcerted and even outraged by a statue so removed from the taste and expectations of most of its members, the Société's executive committee rejected the statue and passed the commission on to Falguière. Rodin, disappointed despite enthusiastic reactions from artists and writers such as Monet and Mallarmé, withdrew his work and erected it on his property in Meudon. The intense reactions to *Balzac*, extensively reported in the press, were typical of the reception Rodin's major works would henceforth receive.

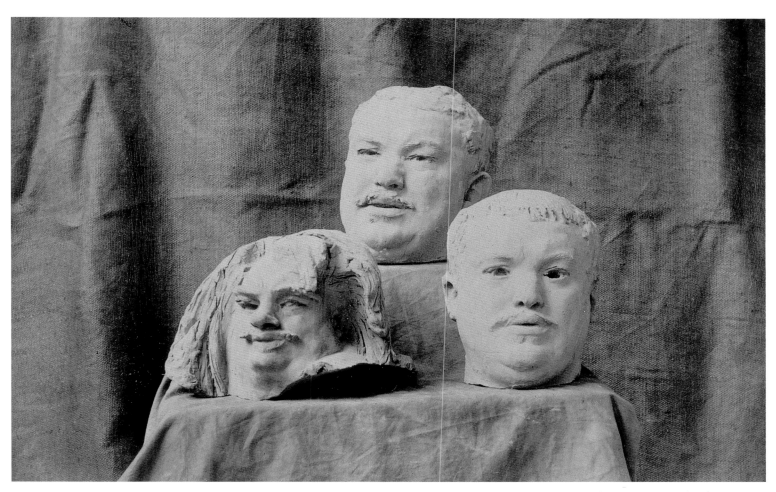

 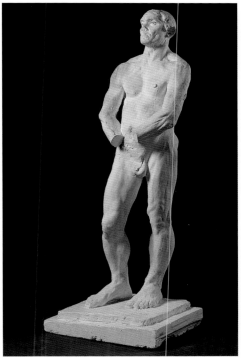

Top
ANONYMOUS,
**THREE STUDIES
OF BALZAC'S HEAD.**
ALBUMEN PRINT.

Bottom left
**STUDY FOR BALZAC'S
DRESSING GOWN, 1897.**
TERRACOTTA,
11 ¾ × 5 × 4 ½ IN.
(30.2 × 12.5 × 11.5 CM).

Bottom center
**BALZAC, NUDE STUDY
WITH HEAD OF JEAN
D'AIRE, 1894–95.**
PLASTER,
37 ½ × 11 × 8 ¼ IN.
(95.5 × 28 × 21.3 CM).

Bottom right
**BALZAC, TORSO IN MONK'S HABIT
WITH SMILING FACE, ON COLUMN
WITH SCROLL DECORATION, 1900.**
PLASTER,
65 ¾ × 16 ¼ × 19 ¾ IN.
(167 × 41.5 × 27.2 CM).

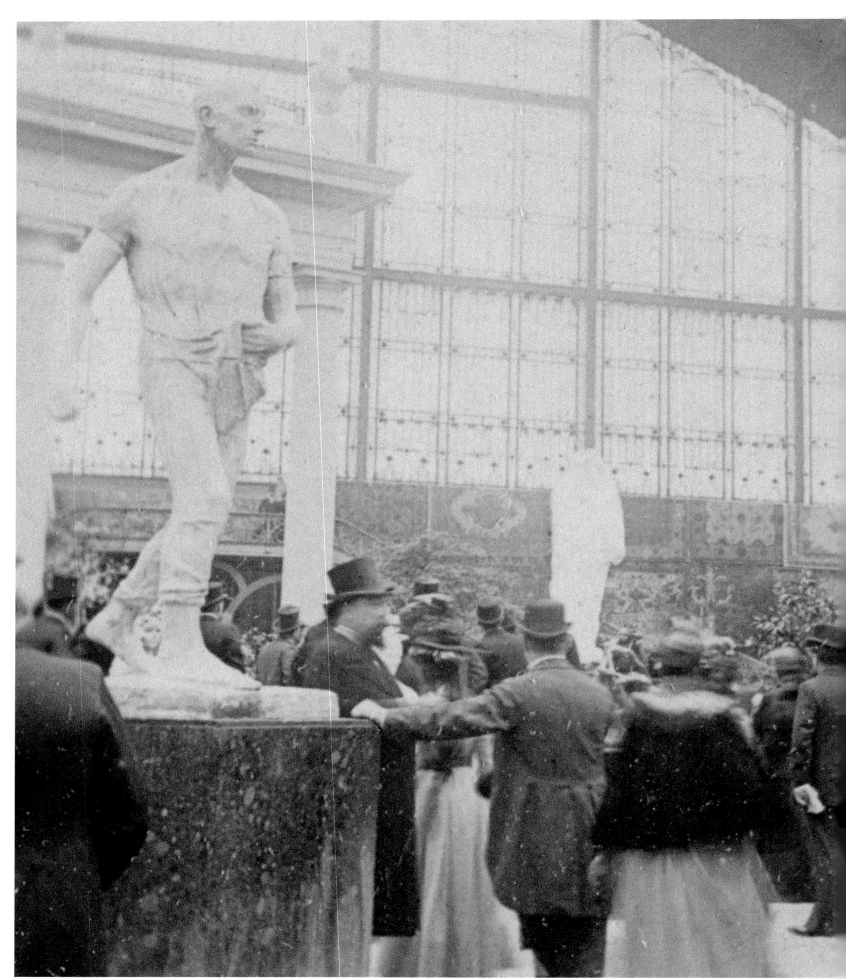

Whether castigated or acclaimed, Rodin now officially played a special role in the art of his day, thereby becoming one of the most famous artists of his time. It is worth mentioning that *Balzac* was unveiled at the height of the Dreyfus Affair that had divided France since 1894. It just so happened that almost all of the statue's admirers were pro-Dreyfus, while the loudest objectors were anti-Dreyfus. Thus, in addition to the astonished and intense reactions it provoked—whether delighted or shocked—*Balzac* became indirectly bound up in the greatest political affair to rock nineteenth-century France. Rodin had no desire to join a debate on which he had no particular opinion, and he was above all concerned to avoid any confusion that would turn his statue into a political symbol. As he stated to a journalist from *XIX^e Siècle,* "The truth is that I have always made art for art's sake, never trying to turn it to productive ends, the way so many others have done." Rodin was always careful to keep his opinions to himself during the Dreyfus Affair, even if certain clues suggest that he was closer to the anti-Dreyfus camp. Puvis de Chavannes, whom Rodin greatly admired, encouraged him to remain neutral. "I would regret any polemic over your famous name, because the independence of a creative artist must remain complete and sacred, and the same must apply to the public to whose judgment he subjects himself by exhibiting his work." Rodin therefore decided to halt the subscription his friends and admirers had launched with a view to setting up *Balzac* somewhere in Paris whatever the cost; he had the statue shipped to the grounds of the Villa des Brillants in Meudon, where Edward Steichen took magnificent photographs of it. Wisely, Rodin concluded, "It doesn't matter, *Balzac* will make its way, by force or persuasion, into people's minds." Indeed, forty years later, in July 1939, a bronze cast of *Balzac* was placed at the Raspail-Montparnasse intersection in Paris.

Wearied by this affair, Rodin slowly gave up sculpting public monuments. He never produced another completed proposal for commissions that nevertheless continued to pour in. The one exception concerned a project far from France, a monument in memory of Domingo Faustino Sarmiento, president of Argentina from 1868 to 1894. The *Monument to President Sarmiento* was commissioned by a committee in Buenos Aires. Rodin once again used the solar motif he had employed on the pedestal of *Claude Lorrain,* devising a magnificent bas-relief carved in a huge block of marble over eleven feet high. It showed Apollo battling the serpent Python, alluding to the battle led by Sarmiento against barbarity and illiteracy in Argentina. The statue of Sarmiento was not very favorably received at first, encountering the usual criticism from people who were shocked by Rodin's bold and novel style. But it was finally installed in Buenos Aires in the spring of 1900.

BALZAC AT THE SALON OF 1898, WITH CONSTANTIN MEUNIER'S SOWER IN THE FOREGROUND, 1898.
ARISTOTYPE,
1 ½ × 4 ¾ IN. (4.2 × 12.3 CM).

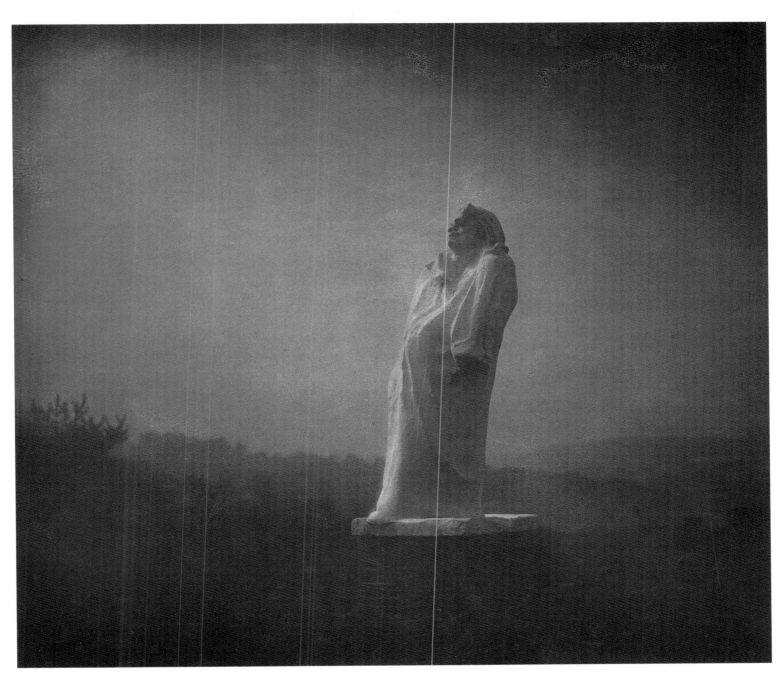

Facing page
BALZAC, 1898.
PATINATED PLASTER,
109 ¼ × 45 ½ × 49 ½ IN.
(277.5 × 116.2 × 125.5 CM).

Above
EDWARD STEICHEN,
**TOWARD THE LIGHT–MIDNIGHT
(BALZAC ON THE GROUNDS
OF MEUDON), C. 1908.**
GUM PLATINOTYPE,
7 ½ × 8 ¼ CM. (19.3 × 21.3 CM).

**THE SPIRIT OF ETERNAL REPOSE:
MONUMENT TO PUVIS DE CHAVANNES,
1899–1900.**
PLASTER,
73 ½ × 43 ¼ × 30 IN. (187 × 110 × 76.5 CM).

the Hôtel de Ville in Paris; his vast composition, titled *The Glorification of Labor,* depicted a whole range of trades. In a sign of the times, that same year Pope Leo XIII promulgated an encyclical titled *Rerum novarum,* on the condition of workers and on labor in general, thereby defining the Church's new social doctrine. "A man's labor necessarily bears two notes or characters. First of all, it is personal, inasmuch as the force which acts is bound up with the personality and is the exclusive property of him who acts, and, further, was given to him for his advantage. Secondly, man's labor is *necessary;* for without the result of labor a man cannot live, and self-preservation is a law of nature." Even if Rodin only followed these issues from afar, during his career he was able to forge his own conception of work. In answer to Rilke's question, "Sir, how should one live?" Rodin replied, "By working." (Letter to Rodin, September 11, 1902). He expressed this concept through his proposed monument.

Several other sculptors, including Dalou, were interested in the project, but the press naturally turned most readily to Rodin, from whom it expected an innovative, original proposal. Its expectations were met. "From a distance," he told Philippe Dubois from *L'Aurore,* "the monument I envisage would form an imposing, elegant, slender mass. It would be completely architectonic like the leaning tower of Pisa, with open arcades like you find in cloisters. This mass would surround a column in the style of Trajan's Column, up which would spiral a graceful series of bas-reliefs. Each bas-relief would correspond to a trade, separated from its neighbor by a high-relief figure or caryatid symbolizing that trade. A fairly wide space would separate the column from the tower. At just the right distance there will be a gently sloping indoor ramp, like the one in the clock tower in Venice that Napoleon allegedly rode up on horseback. People will pass below the tower through a gate guarded by figures of Day and Night, symbolizing the ceaselessness of work: a vast chamber will be reserved for the trades that extract raw materials from the bowels of the earth. Wide bas-reliefs . . . will depict the life of miners and divers, the dark and dangerous work beneath ground and sea. . . . Then the ascent begins. The spiral turns from right to left. The higher you go, the more refined the labor becomes, the less crude the trades are, [namely] those in which the mind plays the greatest role. . . . If you climb to the top, that's where pure thought resides, the noblest trades as represented by art, poetry, philosophy. Then, crowning the monument, set on the tip of the column in the open sky. . . are two spirits, two godsends, who bring love and joy to work." This description reveals Rodin's enthusiasm for Dayot's idea.

As with the start of every major project, Rodin began traveling, going to Pisa in the fall of 1898 to see the famous tower. He soon produced a plaster maquette of his monument, which combined the Pisan influence with allusions to large Renaissance staircases in châteaus such as Blois and Chambord, previously drawn by Rodin during his travels through central France. "The building will be in the French Renaissance style, whereas the structure will recall a honeycomb and the tower will evoke the Lighthouse [of Alexandria]." Despite Rodin's clear interest, the project went no further, and he stopped working on it once Dayot permanently dropped the idea in 1899. Yet Rodin had already chosen as his architect Henri-Paul Nénot

Meanwhile, Puvis de Chavannes, for whom Rodin had always had limitless admiration, died in 1898. The commission for a monument naturally went to Rodin, who produced an amazing maquette now held by the museum in Meudon. Wanting to pay tribute to the painter's Hellenistic inspiration, Rodin envisaged a group that combined a bust of Puvis de Chavannes with a full-length Greek youth (in fact, a reworking of *The Spirit of Eternal Repose*) and a symbolic tree of life cast from nature. The complexity and originality of this monument—almost a forerunner of contemporary "installation" work—partly explains why it never went past the planning stage.

The Tower of Labor

Early in 1898, writer and art critic Armand Dayot—a member of the government's arts administration—began reflecting on a monumental project to celebrate the upcoming Universal Exposition of 1900. Designed to symbolize the event—as the Eiffel Tower had done for the Exposition held in 1889—the planned monument would be erected to the glory of work and to modern arts and crafts. The chosen theme was nothing new—in the late nineteenth century the valorization of work and its social implications went beyond the political and economic spheres, even inspiring artists. Thus in 1891 Pierre-Victor Galland completed a decorative painting in one of galleries in

**MAQUETTE FOR THE TOWER
OF LABOR, 1898–99.**
PLASTER,
51 ½ × 25 ¼ × 26 ½ IN.
(131 × 64.5 × 67.5 CM).

PAUL NÉNOT (?),
THE TOWER OF LABOR, 1898–1900.
PEN AND WASH IN BLACK AND BROWN INK ON CREAM PAPER;
SKETCH IN GRAPHITE,
18 ½ × 11 IN. (47 × 28 CM).

(1853–1934), who had earlier executed the pedestal for *The Thinker* at the Pantheon. We might nevertheless question the effect produced by a hybrid construction whose design would have been a little like setting the Vendôme column in the middle of the Blois staircase.

Despite abandoning the project, Rodin apparently retained a lively interest in it, for he willingly mentioned it to friends and acquaintances. One of his many female friends and correspondents was the playwright and literary critic Valentine de Saint-Point, Lamartine's grandniece, who on July 5, 1906, informed him of her own idea for incorporating *The Gates of Hell* into the tower.

I've perceived the aesthetic and intellectual reasons for placing The Gates of Hell at the entrance to the monument to Labor. Don't you think it would be a fine thing if a depiction of basic human passions, Instinct, were found *at the very doorway to the struggles and victory of labor? Once past The Gates of Hell, that is to say the gate of all passions, one enters the realm of Labor, that is, of human civilization. Thus from wild, primitive instinct one arrives at the many manifestations of our society, as represented by work. Your monument would in fact be a new religious concept, in which Hell would be replaced by Instinct and Paradise by Labor.*

Two years before his death, as the Great War raged, Rodin could still write to Dayot: "Loie [Fuller] dazzled me with the idea that the monument to labor might be done in San Francisco. It's a magnificent idea that could counterbalance the barbarity that's ravaging Belgium and France." An international committee had even been formed in 1908, once again at Dayot's initiative, to promote the building of the monument. The call received the backing of many celebrities, artists,

politicians, writers, journalists, and critics who were enthusiastic about the tower, such as the Italian Ricciotto Canudo, who called it "the first really 'new' monument of the new era, worthy of the great epochs of creativity." Aleister Crowley, the British mystic, invoked the tower in a typewritten poem he sent to Rodin, entitled "The Tower of Toil."

The old Sun rolls; the old earth spins;
Incessant labor bends the stars.
Hath not enough of woes and sins
Passed? Who shall efface their senseless scars?
One makes, one mars. The eons foil
All purpose; rise, O Tower of Toil.

In 1906, Paul Adam suggested that the monument be erected in Courrières, northern France, as a memorial to the countless victims of a terrible mining accident. "To the glory of workers, a grateful nation would dedicate a work by its finest talent" (*Le Journal,* April 2, 1906). But then comments began to circulate not about the symbolic import of the monument, but about its aesthetic impact—the proposal was clearly not to the taste of everyone. Some felt it looked like "a corkscrew" (*La Liberté,* May 31, 1906), while others complained that, "It will merely take up space, alas, and will be ugly" (*L'Indiscret,* September 15, 1907). Just a few days later, *L'Indiscret* would joke, "You have to admit that *The Tower of Labor* will be a fine work, a work into which our good Mr. Rodin will be able to slip all the plasters so admired by his friends, because he never lets anything go to waste. His *Benedictions* and his *Gates of Hell* will be given their place in this crazy work. . . . There's only one thing that worries this genius: clutching his head in his hands, like his famous *Thinker,* he mutters, 'That's all very well, but where the h*** can I fit my *Balzac*?'"

It is nevertheless worth noting that the articles and archives almost never explicitly discuss a specific site; at most they make more or less felicitous suggestions. Only Courbevoie Circle (today the middle of the corporate neighborhood known as La Défense) was specifically cited, but at the rather late date of 1917, a few months before Rodin died. Ironically, the Courbevoie site had hosted, since 1883, *La Défense de Paris* by Louis-Ernest Barrias, who had bested Rodin in the competition for that monument. Some years earlier, various plans for construction were proposed, including one in The Hague, as part of a planned peace monument promoted by the Carnegie Foundation in 1905. Nothing came of any of these plans, and the project remained on the drawing board.

As Rodin's last truly monumental project, *The Tower of Labor* remained above all an allegorical concept. Critics and people of the day who discussed it were all concerned to praise its symbolic import, not dwelling on its baroque, incongruous appearance. The fact that no site was ever really designated suggests that the project was never taken entirely seriously, even though it helped to spread Rodin's fame. Nevertheless, compared to all the public monuments erected at the turn of the century, *The Tower of Labor* remains one of the most original; it was a chimerical work by an artist seeking to express his passion for his art in a grand, indeed grandiose, manner.

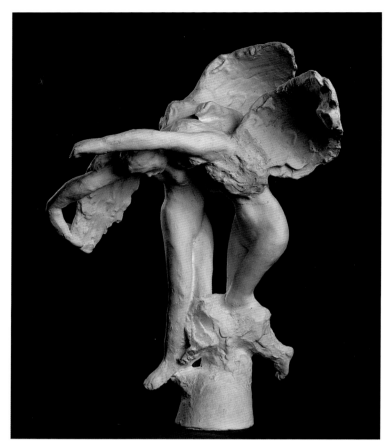

BENEDICTIONS, 1896(?)–1911.
MARBLE,
35 ¼ × 29 ¾ × 26 IN. (90 × 75.5 × 66.5 CM).

The Monument to Whistler

Rodin's last major work was his monument commemorating the American artist James McNeill Whistler (1834–1903). The commission came from London in 1905, during a retrospective exhibition of the late artist's paintings. As usual, Rodin quickly got down to work, but the many modifications he made to the model, plus sundry other concerns, induced him to drop it—equally quickly—for other works. He got so far behind that the monument was still unfinished at his death. In 1919, once the First World War had ended, representatives of the commissioning committee went to France to examine Rodin's proposal. Disappointed, they officially turned it down.

The composition proposed by Rodin may indeed seem surprising. It showed a figure of the Muse—for which Gwen John posed—scaling the mountain of Fame. At her feet was a medallion of Whistler. She held a garland of ivy in one hand. On her left knee Rodin intended to place a cast of an antique item from his own collection, the funerary altar of Aulus Ravius Epictetus. Thus, as in his monument to Puvis de Chavannes, Rodin adopted a method of collage and accumulation that produced something as admittedly disconcerting as it was extremely modern. The Whistler Memorial Committee's rejection of it therefore becomes understandable, as pointed out by Antoinette Romain—whereas the committee wanted a "memorial" monument, "Rodin was involved in a creating something drawn from his innermost self, which we now know would be his last great work."

Public monuments therefore occupy a special place in Rodin's oeuvre, marking a total rejection of the commonplace and of the prevailing academicism. Every project bears the sign of an inspiration that remained constantly alert, constantly refreshed, seeking to push the genre's potential ever further. To mention only a few, *La Défense, The Burghers of Calais,* his monuments to Balzac and Whistler, and *The Tower of Labor* each bear the stamp of the creative genius of an artist seeking to set himself apart from his contemporaries and to explore new possibilities. Some of them even point toward modern sculptural installations, as suggested by the proposed monument to Puvis de Chavannes. Rodin's courageous, uncompromising approach earned him, at best, a lack of comprehension; at worst, he drew the sarcasm and sometimes fierce criticism of a public not always ready or willing to follow him down the path he trod. Yet it is with these monuments that Rodin best affirmed his originality and creative power. As he himself predicted during the scandal over *Balzac,* some of his monuments have progressively impressed themselves on people's minds; the others, never completed, provide striking testimony to the work of a visionary artist.

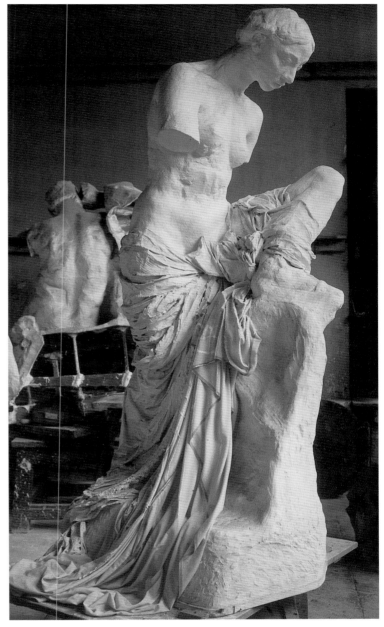

JACQUES-ERNEST BULLOZ,
**WHISTLER'S MUSE
IN RODIN'S STUDIO, C. 1908.**
CARBON PRINT,
14 ¼ × 10 ½ IN. (36.5 × 26.5 CM).

"It's the first time I've tried gathering all my work together to show to the public. . . .
People will probably find my pretension singularly proud,
but I'm convinced that by showing 'my sculpture' and what I mean by sculpture,
I will be doing the cause of art a service."

Rodin, quoted by Gustave Schneider, *Petit Bleu*, July 19, 1899

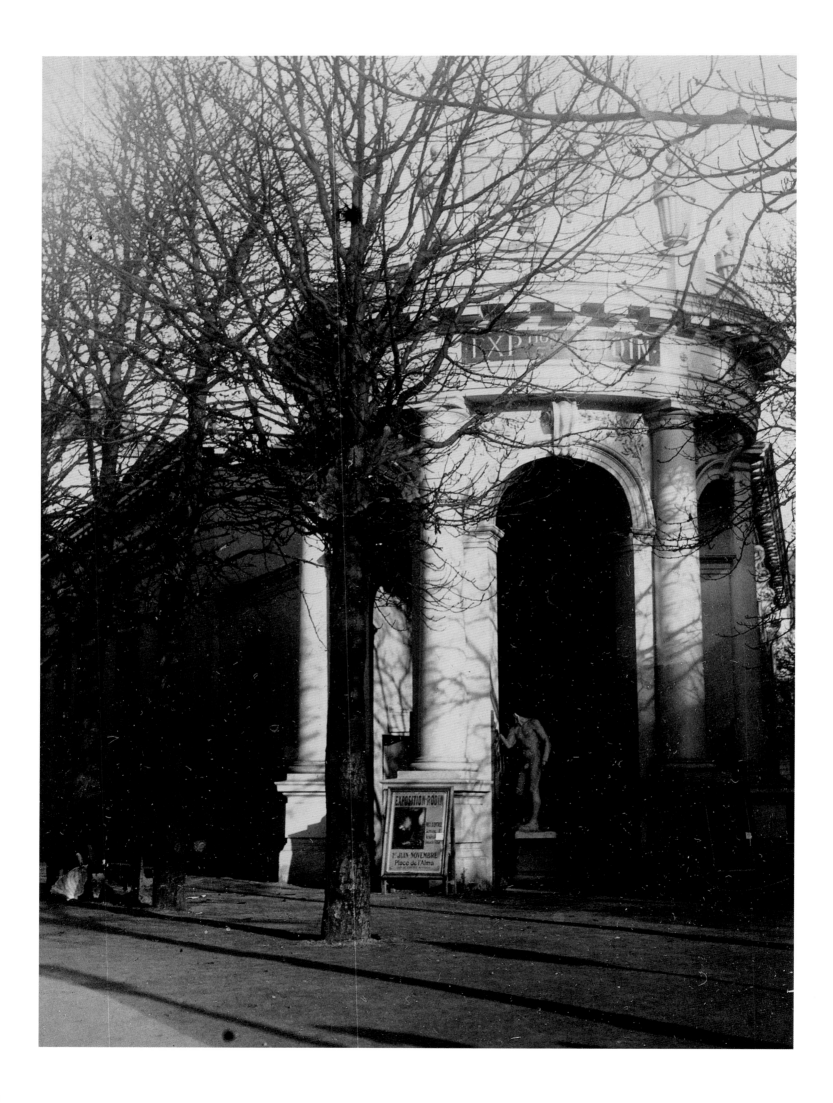

1900: THE WATERSHED YEAR

Around the year 1900, approaching sixty, Rodin decided to organize a one-man show of his work—his first in France. Designed to coincide with the Universal Exposition of 1900, it would be held in a specially built pavilion on place de l'Alma. After many months of administrative procedures, the Paris city council voted to grant him a concession on the corner of avenue Montaigne and rue Jean Goujon, where he could install his works. This strategic location was very near the official hall for the Universal Exposition, one of whose entrances gave onto the place de l'Alma. This was the very spot where Courbet (in 1855 and 1867) and Manet (in 1867) had tried similar personal ventures during previous Universal Expositions.

Overwhelmed by the logistics of this ambitious plan, Rodin realized the paramount importance of first finding the money to build his pavilion. A contract signed on October 27, 1899, sealed a partnership with three bankers, Louis Dorizon, Albert Kahn, and Joanny Peytel. Peytel, head of the Banque du Crédit Algérien and a great fan of Rodin's work, was the keenest of the three. Practically overnight, he began to coordinate the construction of an elegant and sober pavilion by architects Alexandre Marcel and Louis Sortais, the latter a relation of Peytel's through marriage.

The Universal Exposition officially opened on April 12, 1900—in the midst of a vast construction site. Most pavilions had not yet been completed, and it would be another three months until the new subway service—the Métropolitain—would begin operating. The opening of Rodin's pavilion was announced, and then postponed, on several occasions between April 15 and May 15. The last drawings were still being hung on the eve of the actual opening, which finally took place on June 1, 1900, nearly a month and a half after the Universal Exposition officially began. On a "horrid wet afternoon," Rodin inaugurated his pavilion in the presence of Georges Leygues, France's minister of public education and fine arts.

Facing page
E. BAUCHE,
THE ALMA PAVILION,
1900.
ARISTOTYPE,
4 ½ IN. × 3 ½ IN.
(11.1 × 8.7 CM).

Below, left
**ARCHIVE MATERIAL
RELATING TO THE RODIN
EXHIBITION IN
THE PAVILION ON PLACE
DE L'ALMA.**

Below, right
**BUILDING THE PARIS
MÉTRO,1900.**
PLACE SAINT-MICHEL,
SIXTH ARRONDISSEMENT.
(PHOTO COURTESY
ROGER-VIOLLET).

Rodin: Sculptor, set designer, director

Under the shade of tall chestnut trees, the blinding whiteness of the ground-level pavilion surprised passersby. According to Judith Cladel, it was "a Louis XVI-style pavilion, similar to the orangery of a château." Rodin had desired simple but not austere architecture, which would at any rate be masked by the leafy trees surrounding it. Opposite the extravagant decorative exuberance of the Universal Exposition, whose pavilions displayed an unfortunate tendency toward busy ornamentation, the elegant silhouette of Rodin's "palace" made a fine impact. The press lauded the building, for despite a certain lack of originality it conveyed a true sense of grandeur. The careful proportions successfully produced the effect of harmonious synthesis so dear to Rodin. "It is possible to create beautiful train carriages, beautiful rails, beautiful stations, and beautiful factories—everything useful should also be beautiful. You merely need to calculate their proportions harmoniously."

Visitors entered the pavilion through a round porch with columns, featuring three large archways framing elegant gates, topped by four flame ornaments. In the middle of the rotunda was a large plaster model of one of the burghers of Calais, Pierre de Wiessant—headless and armless, he confronted visitors as he drew them in. Once a narrow hall and velvet curtain had been traversed, visitors found themselves in an unforgettably serene atmosphere, an almost religious ambiance, a private, mysterious world steeped in emotion, inhabited by a "white population, a population of plaster and marble, characters straight out of Dante or mythology."

On show were sixty sculptures (mostly plasters), one hundred and twenty-eight drawings, and seventy-one photographs. Dating from the 1880s, thanks to the commission for *The Gates of Hell*, Rodin had built up an inexhaustible reservoir of forms from which he could draw fragments, enlargements, or multiple copies, according to his whim and his highly personal exploration into assemblage. This gave birth to many sculpted groups such as *Ecclesiastes,* whose themes were often racy. "Rodin is becoming a sculptor who is too original, too superior, too 'great an artist,'" wrote the Goncourt brothers. "His entwined lovers, given their invertebrate suppleness, their fluidity, and their liquidity, are no longer entwined men and women, but wriggling earthworms."

With his rich classical background based on a regular, enthusiastic study of nature, on the lessons of antiquity, and on old masters, Rodin possessed all the tools for establishing his own rules and forging a more fertile path. He suddenly ignored all the conventional approaches to form and subject matter, sacrificing anecdotal, superfluous details in order to focus on essentials that produced purified, partial, or fragmentary works; he could play on chance occurrences and exploit his own creative freedom, which might intervene and modify his work at any moment. Rodin was thus opening the doors to the twentieth century.

The interior of his pavilion, skillfully furnished to avoid pointless luxury, displayed profound refinement. "All that I claim for my exhibition," Rodin told the press, "is an overall tone similar to the soft effect of dead leaves casting their soothing reflections on the paleness of the marble." Beneath a glass ceiling supported by iron struts, the space was flooded with pale light created by filtering the sun through white awnings supplied by Liberty's, the famous department store. Elegant arched windows varied the lighting in an endlessly changing effect. Rodin wanted to "make the interior pleasant while extensively using the light flooding in from all sides; in fact I feel that sculpture is an outdoor art, and I find it unworthy of an artist to produce a work that can only be appreciated from one given angle of light." Fine gauze curtains of yellowish green covered the lower panes of the windows. The walls were covered in a plain straw-colored fabric, embellished with pleated bunting in a stronger tone that ran all around the pavilion, well above the windows. On both sides of the central aisle, two small salons with low walls and no ceiling were hung with a fabric "of soft, creamy green, dotted with crowns" that were barely perceptible. In these rooms, drawings and photographs were displayed in black or white frames hung very densely, and accompanied by a multitude of small sculptures. Side by side, the drawings and photographs sometimes descended all the way to the baseboard. The gouache-and-brown-ink drawings based

Below
INTERIOR VIEW OF THE ALMA PAVILION,
1900.
FROM "LE PAVILLON RODIN, AVENUE MONTAIGNE,"
LA VIE ILLUSTRÉE 114 (DECEMBER 21, 1900).

Facing page
ECCLESIASTES,
BEFORE 1899.
PLASTER,
10 ¼ × 11 × 10 ¼ IN. (26 × 28.3 × 26 CM).

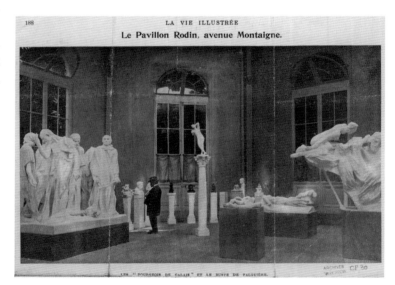

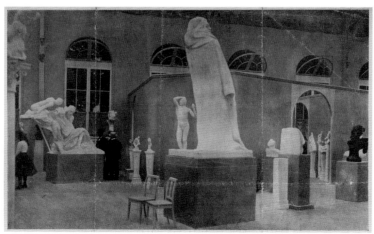

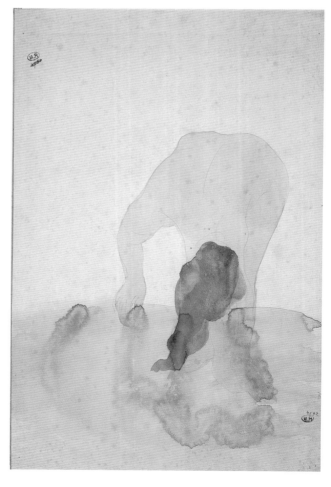

on Dante's *Inferno,* from the so-called "black period," were presented next to rapid sketches whose sole subject was the female body (sometimes highlighted with watercolor). As with his sculpted work, Rodin's drawings combined various techniques and recent experiments. Exploring on paper the creative processes of his sculpture, he would use tracings to multiply figures, which he could then alter and reorient at will. Dubbed with a new title, these collages and reconfigurations of recomposed figures and modified spatial relationships were then given new unity through the simple addition of color. Rodin educated the visitor's eye through photographs—often several of the same work taken in the authentic context of the studio,

from different angles and in changing light—thereby presenting a multifaceted vision of his oeuvre. "It will be a place of study," Rodin explained to reporters, "and not an industrial plant." Yet the show also attracted new buyers, who were offered advice by Eugène Druet, a café proprietor who became Rodin's official photographer and sales manager. Druet was the "one-man band and guardian of the temple" on whom Rodin unhesitatingly conferred the running of his pavilion. In exchange, Rodin allowed Druet to sell his own photographs free of royalties.

At the end of the main aisle, a place of honor was given to the plaster model of the monumental *Balzac,* rejected in 1898 by the Société

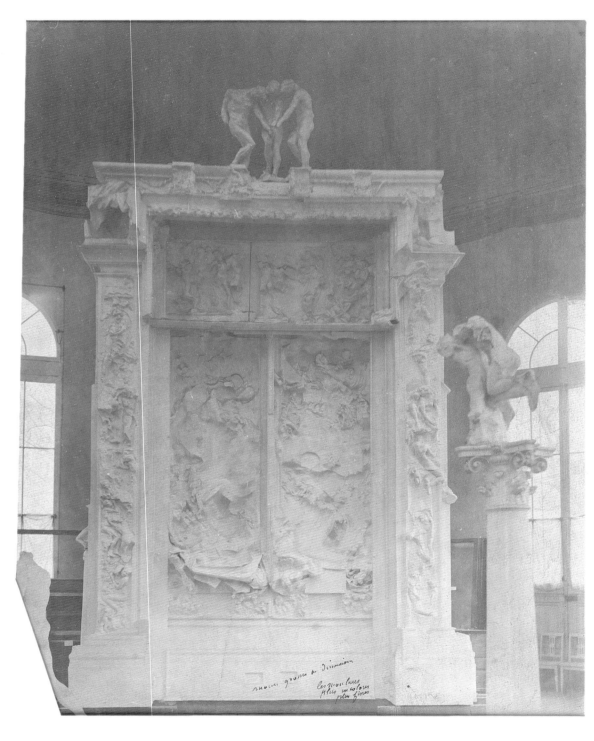

des Gens de Lettres at the height of the Dreyfus Affair. *The Gates of Hell* was shown stripped of its figures. Although he knew the work was long awaited, Rodin decided to display it bare. Inside the vast space, the ingenious stage director had assembled his monuments to *Victor Hugo* and *The Burghers of Calais,* conventionally placed on cubic bases, along with works of average or smaller dimension placed on more original plinths and columns. With or without Corinthian capitals, smooth or decorated with hearts, these plinths of various heights represented one of the most original aspects of the display. Quadrangular plinths from the Louvre's casting workshop were the most common. After 1900, Rodin systematically explored this approach, for example with his bust of Madame Fenaille, using higher and higher columns. Successors such as Brancusi and Giacometti were unmistakably influenced by these columns.

There was no chronological presentation or any special order, even though Rodin himself had supervised the "museum installation"

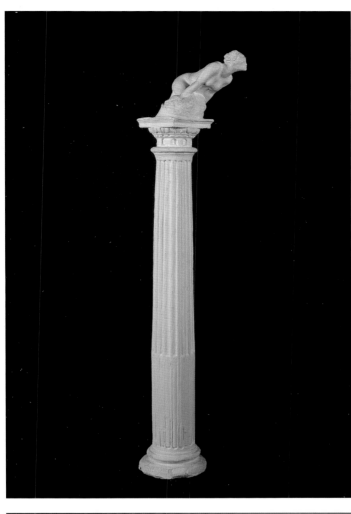

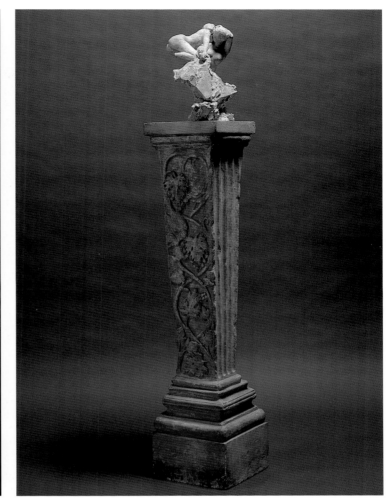

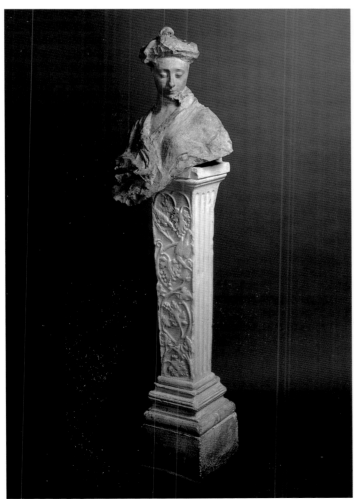

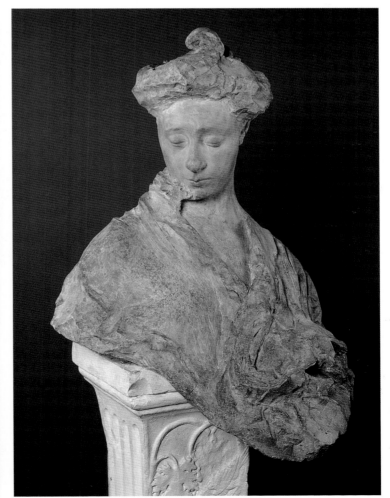

Right
Miss Eve Fairfax,
1904.
Marble,
20 ¾ × 22 ¾ × 18 in.
(53 × 57.7 × 45.5 cm).

Below, center
**Countess Hélène
von Hindenburg-Nostitz,**
1902.
Terracotta,
8 ¾ × 8 × 4 ½ in. (22.5 × 20.3 × 11.4 cm).

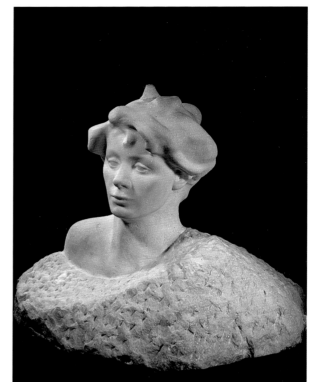

down to the tiniest detail. He was particularly demanding in the use of light and space around the sculptures. At a time when statues were usually packed together in a "blinding, dreadful jumble," Rodin felicitously insured that visitors had plenty of room to walk around. "I shall not pile my works one against the other in that appalling error made every year at the Salon," announced Rodin. "A sculpture must have around it an atmosphere, a certain zone of freedom that allows visitors to study it in all its various aspects."

Visitors to Rodin's show included Antoine Bourdelle, Eugène Carrière, Frederick Delius, Loie Fuller, Georges Leygues, Octave Mirbeau, Claude Monet, Pablo Picasso, Edward Steichen, and Oscar Wilde. Artists, politicians, art lovers and collectors, writers and journalists, musicians and dancers of every nationality attended the sculptor's demonstration. His recently acquired international fame brought in a new clientele, one that was rich and famous and would soon be commissioning works from him. Wealthy society ladies, mainly English and American—not only Mrs. Potter-Palmer, Lady Sackville, and Eve Fairfax, but also Madame Fenaille and Hélène de Nostitz—agreed to multiple sittings in order to have their bust done by the artist, now hailed as sculpture's latest great master. Whereas his male portraits were usually cast in bronze, for female sitters Rodin often preferred the elegance, finesse, and flattering effects of marble.

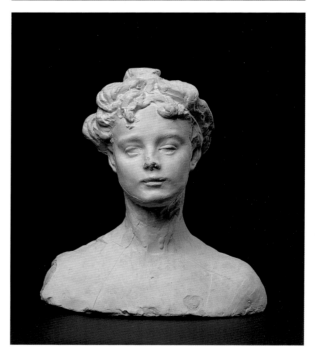

Rodin became a society figure. Previously welcomed at artistic and literary banquets, at a garden party at the presidential palace, and at the salons of Juliette Adam, Georgette Leblanc, and Aline Ménard-Dorian (where he made shy appearances), he now found himself invited to musical matinees given by Countess Greffulhe and to a tea given by Lady Pirbright, and was even asked to preside over a literary tea organized for Valentine de Saint-Point. His daily business was henceforth handled by a series of secretaries of every nationality. Attracted to the facile pleasures of society life, Rodin made many female conquests. It wasn't long before he became infatuated with the eccentric, impetuous Duchesse de Choiseul, whom he unresistingly allowed to redo his "look," abandoning his sculptor's smock for a perfect gentleman's appearance, including a sophisticated wave in hair and beard.

Right
Madame Fenaille,
1912–13.
Marble,
27 ½ × 31. ½ × 36 ½ in.
(70 × 80 × 92.5 cm).

Even after the Universal Exposition had officially closed, Rodin's exhibition was held over. He considered retaining the pavilion as a "museum–workshop." But despite negotiations with the city authorities, he was obliged to vacate the premises. In March 1901, his pavilion was dismantled then rebuilt—minus its rotunda and first bay—right next to the Villa des Brillants on his property in Meudon, outside Paris. On the façade, heavy columns flanked the arches of a rectangular portico that lent the structure the general appearance of a Greek temple. This became the first "Rodin museum," where celebrities including monarchs, ambassadors, politicians, and artists all hoped to be invited.

Alas, this "temple of beauty and life" was little suited to the torrential rains of autumn and the passing of time. Barely five years after Rodin died, just twenty years after the Universal Exposition, it was threatened with collapse. The cornice was crumbling, the floor was rotten, the metallic structure was rusting, and the glass panes were falling out of their grooves—restoration was impossible. Thanks to financial support from Jules Mastbaum, the founder of the Rodin Museum in Philadelphia, in 1926 the construction of a new building became feasible. And in September 1931 the plasters were transferred to the new "museum," which the curator Georges Grappe had built in a simple and classical eighteenth-century style, "sticking to Rodin's ideas as closely as possible." The old Alma pavilion was then demolished.

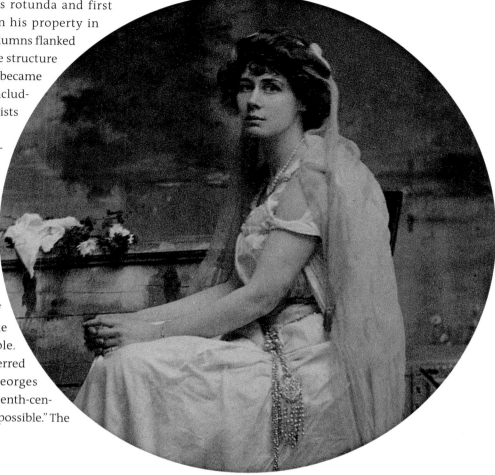

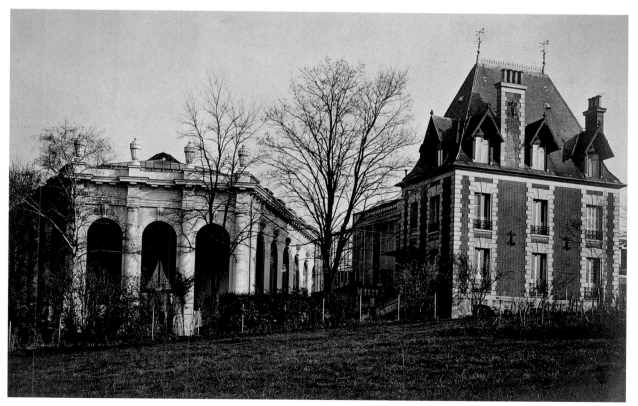

Above
H. LANE SMITH,
PORTRAIT OF MISS FAIRFAX.
MATTE COLLODION ARISTOTYPE,
3 ¼ × 3 IN. (8.1 × 7.6 CM).

Left
ANONYMOUS,
**THE ALMA PAVILION,
REBUILT IN MEUDON,**
AFTER 1901.
GELATIN SILVER PRINT,
3 ½ × 5 ½ IN. (9 × 14 CM).

"MY ELEVENTH-HOUR FRIENDS"

"Now I have a collection of mutilated gods in pieces, some of them masterpieces. I spend time with them, they educate me; I like their two- or three-thousand-year-old language, closer to nature than any other. I think I understand them, I constantly visit them, I adore their grandeur, they relate to everything I've ever loved . . . They're fragments of Neptune, of goddess-women . . . Nor are they dead, they're alive, I bring more life to them. I can easily complete them in my mind, they're my eleventh-hour friends."

Rodin to Hélène de Nostitz, October 10, 1905

Along with his sudden fame, Rodin's financial situation changed considerably. At the same time that he moved into Villa des Brillants in Meudon—which he would rent for two years before finally buying it in 1895—he began his collecting career. "A collector's life is full of surprises: bargains and foolish extravagances," he explained to a journalist. Enjoying his wealth, he amassed countless objects from all periods and all civilizations in record time, buying from dealers, auction houses, and even private individuals.

His heterogeneous collection numbered over eight thousand items including prehistoric flints, Coptic textiles, Egyptian bronzes, Japanese prints, Persian albums, sundry coins and medals, photographs, medieval tapestries, Cycladic idols, and ancient pottery. Nor were minor arts eschewed. When a dilapidated residence called Clos Payen, where he had once rented a studio, was about to be demolished, Rodin bought the woodwork, mirrors, a banister, a stone fireplace, and wrought-iron balcony railings.

Rodin was nevertheless a mediocre collector. With the notable exception of a mourner from the tomb of Jean de Berry in Bourges (bought just a few months before his own death) and van Gogh's notorious *Old Tanguy* (bought with little conviction, at the urging of his friend the enlightened art lover Octave Mirbeau), Rodin never unearthed a single masterpiece despite all his buying. Art historians and archaeologists have deplored the total lack of striking objects that might

have been collected by a man of genius, if not a scholar. Yet his collection is surprising. Although Rodin was unable to display reliable judgment or to assemble a collection of irreproachable pedigree, he still managed to fulfill his goal of taking pleasure in contemplating forms that inspired him. This permanent showcase, this "antique store," helped him—consciously or not—refine his formal vocabulary. During daily contemplation, he would scrutinize each object in hopes of receiving inspiration, emotion, or reassurance. He populated his garden with statues, and turned one of the outbuildings in Meudon into a museum of antiquities, whose total lack of organization remains exemplary. He would visit it again and again, sometimes reinventing objects in an imaginative whim, for example by populating Attic bowls with his dripping plaster figures. In Rodin's eyes, this emotionally charged Aladdin's cave was a storehouse of expressiveness that stimulated his ideas and enabled him to carry on a kind of imaginary dialogue with his peers.

Among all these items, in which casts mingled with originals, Rodin's own pantheon was composed of works from ancient Greece, many of which were in fact mere Roman copies.

In addition to a *Female Nude* by Renoir (bought from a dealer in 1910), Rodin collected numerous works from contemporary artists, many of whom were his friends, such as Albert Besnard, Antoine Bourdelle, Eugène Carrière, Charles Cottet, Aristide Maillol, Claude Monet, Medardo Rosso, and Fritz Thaulow. "He has a most original way of keeping paintings," recalled Paul Gsell. "He doesn't hang them in the normal way. He sets them at the base of the wall at random. When he wants to look at them, he picks them up And then puts them back in the corner."

Above
MEDIEVAL ART
MOURNER,
MID-15TH CENTURY.
ALABASTER,
16 × 5 × 4 ½ IN.
(41 × 12.8 × 11.4 CM).
FROM THE TOMB OF JEAN DE
BERRY IN THE SAINT-
CHAPELLE, BOURGES.

Facing page
VINCENT VAN GOGH,
OLD TANGUY,
LATE 1887.
OIL ON CANVAS,
36 ¼ × 28 ¾ IN. (92 × 73 CM).

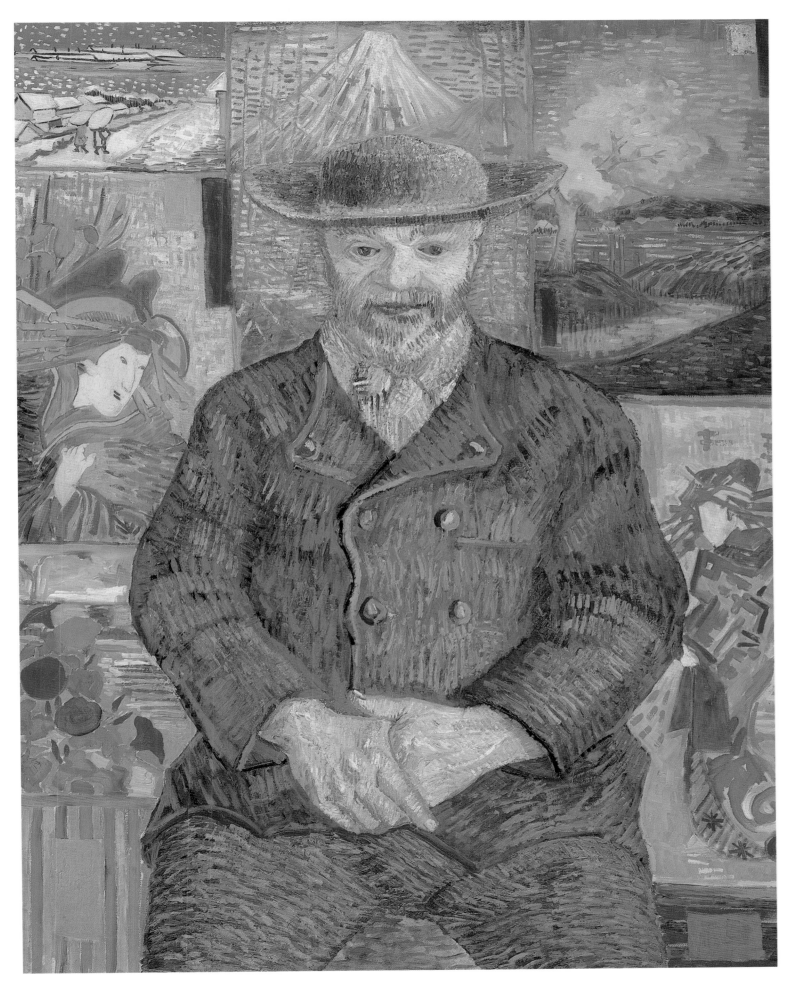

Right
JAPANESE ART
LAUGHING MASK,
19TH CENTURY.
LACQUERED WOOD, GLASS
EYES, HAIR,
7 ¼ × 5 ¾ × 3 ½ IN.
(18.5 × 14.5 × 9 CM).

Right
MEDARDO ROSSO,
LAUGHING WOMAN,
AFTER 1885.
BRONZE,
14 ½ × 7 ¾ × 10 ¼ IN.
(37 × 20 × 26 CM).

Right
HELLENISTIC ART
FROM EGYPT
**CROUCHING VENUS
ANADYOMENE (RISING
FROM THE SEA),**
2ND–1ST CENTURY B.C.E.
MARBLE,
9 ¾ × 7 ¾ × 8 ½ IN.
(25 × 20 × 22 CM).

Right
CHINESE ART (?)
GUANYIN,
15TH CENTURY (?).
BRONZE AND IRON,
19 × 13 ¼ × 7 ¾ IN. (48.6
× 30.8 × 19.5 CM).

Far right
HELLENISTIC ART
CAST OF A NYMPH.
PLASTER,
14 ¼ × 30 ½ × 23 IN.
(36.5 × 77.7 × 58.3 CM).
MADE FROM A MARBLE
ORIGINAL, 4TH–3RD
CENTURY B.C.E., NOW IN
THE PRADO, MADRID.

Right
ROMAN ART
KORE,
1ST CENTURY B.C.E.
MARBLE,
30 ¾ × 13 ¼ × 8 ½ IN.
(78 × 34 × 21.8 CM).

Right
**LITTLE WATER SPRITE
(SKETCH),**
C. 1900.
PLASTER AND POTTERY,
5 ¾ × 7 ¾ × 9 IN.
(14.3 × 19.9 × 23.2 CM).

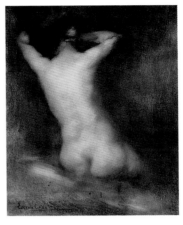

Left
CLAUDE MONET,
BELLE-ÎLE,
1886.
OIL ON CANVAS,
25 ½ × 33 ½ IN. (65 × 85 CM).

Below
SPANISH ART
MADONNA AND CHILD,
C. 1300.
POLYCHROME WOOD,
41 ¾ × 15 × 13 ¾ IN.
(106 × 38 × 35 CM).

Left
EUGÈNE CARRIÈRE,
**FIGURE COMBING
HER HAIR, SEEN
FROM THE BACK.**
OIL ON CANVAS,
22 × 18 ¼ IN.
(56 × 46.5 CM).

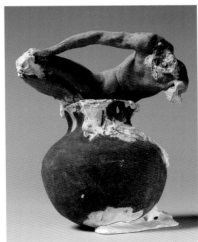

Left, center
EGYPTIAN ART
**FUNERARY MASK
OF YOUNG MAN,**
2ND CENTURY C.E.
PLASTER,
6 ½ × 5 × 4 IN.
(16.5 × 12.7 × 10.3 CM).

Left
GREEK ART (CORINTH)
ARYBALLOS,
FIRST QUARTER
OF 6TH CENTURY B.C.E.
CERAMIC,
6 × 5 ¾ IN. (15.1 × 14.4 CM).

Above
ASSEMBLAGE
OLD MAN IN URN.
TERRACOTTA, PLASTER,
AND POTTERY
8 × 7 × 5 IN. (20.8 × 18.2 × 13.1 CM).

Following double page
FRANK BAL,
**RODIN SEATED AMONG HIS
COLLECTION IN MEUDON,**
C. 1905.
GELATIN SILVER PRINT,
7 ½ × 11 IN. (19 × 27.8 CM).

"I'm a worker who enjoys the basest of tasks.
These rough hands that now work the block also mix the plaster.
From my apprentice days, I've retained a mason's habits.
I'm like those artists of the Renaissance: they were craftsmen and not fine gentlemen."

Rodin, quoted in *La Meuse*, February 1, 1911

IN THE SCULPTOR'S STUDIO

"He has several studios; some are better known, where visits and letters arrive, others are tucked away unknown to all. They are cells, empty, impoverished rooms full of dust and dinginess."

Rainer-Maria Rilke, *Auguste Rodin* **(Paris: Lapina, 1928)**

At 182 rue de l'Université in Paris' seventh arrondissement was the Dépôt des Marbres, or marble warehouse, containing workshops that the government allocated to the "new geniuses" it honored with state commissions. Rodin moved into a workshop there that would become his main studio in 1880, when he received the commission for *The Gates of Hell* intended for the Musée des Arts Décoratifs.

The larger workshops were reserved for the most glamorous, large-scale projects. Rodin was allocated studio M, which he shared with Joseph Osbach. A few years later, he was assigned H and J, near his friend Jean-Paul Laurens and the award-winning Eugène Guillaume. Rodin kept these studios until his death. "Some of them are famous, stylish, social," wrote Edouard Rod, "cluttered with artificial elegances, fabrics, knickknacks, vases, and trophies, with mysterious alcoves of canopy-sheltered ottomans—*buen-retiros* behind door hangings. Some of them are vast, as high as the nave of a cathedral, with galleries, where parties are given. Some are cute. Some are deliberately austere. Some of them are even sincerely austere."

There was nothing mysterious about Rodin's studio, but the presence of the artist among all his works-in-progress made it a place that stirred the imagination. The sculptor's heavy, bulky materials called for a great deal of space. The accumulation of what Léon Maillard called "pieces in preparation"—trials and sketches in clay resting underneath damp cloths, plaster casts of heads, arms, torsos and legs, groups of figures in marble being executed, and freshly patinated bronzes—set the stage for a resolutely industrious, noisy, and dusty place. Paintings and engravings by Rodin's friends were hung on the plaster-splattered walls. On one table near a window Rodin usually tossed letters and newspapers. Amenities were sparse—some worn chairs and armchairs, and a piano were the only furnishings. A legendary iron stove, common to all nineteenth-century studios, was insufficient to warm the air in the poorly insulated space that was always cold in winter. Rodin's student, the Czech sculptor Josef Maratka, always remembered the constant scrimping on coal; only Rodin's actual presence guaranteed that the studio would be heated.

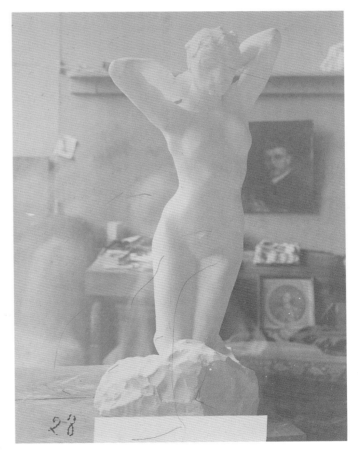

To reach the site—a workplace, exhibition space, and salon—visitors had to cross a vast, silent, treelined courtyard dotted with blocks of marble awaiting their fate. On Saturdays, collectors, politicians, art lovers, wealthy individuals from all over the world, and the merely curious followed this sacred path that led to the master. "He emerged, short but with sturdy shoulders and huge head, with the demeanor of a lion at rest," noted Camille Mauclair in 1904. He remembered:

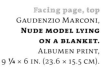

Right
Duchêne,
Rodin working from a life model.
Albumen print,
9 ¾ × 6 ¼ in. (24.5 × 16.3 cm).

Facing page, top
Gaudenzio Marconi,
**Nude model lying
on a blanket.**
Albumen print,
9 ¼ × 6 in. (23.6 × 15.5 cm).

Facing page, bottom
Gaudenzio Marconi,
**Nude model sitting
on a blanket.**
Albumen print,
5 ¼ × 7 ½ in. (13.5 × 19.2 cm).

Pages 136–137
**Letters from models
and assistants, bills
addressed to Rodin, and
address book.**

You saw only the top of the torso and the head with its strong nose, fluffy gray beard, and high forehead: two little, pale gray eyes—paler than the skin of the face—blinked at you. The first impression was of a truly leonine creature: all bust, squat, with short legs and powerful hands yet with a certain finesse. And this impression of power—reinforced by the rolling gait below the hips, the stony aspect of the rugged forehead under the roughly tousled hair, the bony thickness of the aquiline nose, and, finally, the massive twist of beard—was nevertheless contradicted by the ironic, reticent slit of the mouth, the myopic, shy, naive, yet penetrating and mischievous gaze (one of the most composite gazes I've ever seen), and finally the voice, soft, struggling to modulate itself, deep in the throat then suddenly returning to the front of the mouth, including certain highly special nods of the head that further modified meaning and intent while chatting. Unaffected: that is how he seemed—cordial without cheeriness, polite, precise, reserved. Little by little, the dominant impression, which was initially that of shyness, became that of a tranquil, unusual authority. Nothing about the man was grandiloquent, nor was anything awkward; on entering, you were inclined to deferential respect, given all you knew of his fame and work. This respect steadily accrued to the man himself, even though he never pontificated and seemed more drab than inspired. An immense latent energy arose from his sober movements, made manifest by all the measure that governed them. The very slowness of his speech, the absolute sobriety of his language, lent a special value to whatever

Rodin said. He was a man whose pauses in his explanations were highly significant. . . . And gradually you discovered, beneath Rodin's fundamental simplicity, the features that remained hidden at first: he is ironic, sensual, alert, anxious.

"I need a sitter in order to work. The sight of human forms nourishes and comforts me. I infinitely admire—I worship—the nude."
Rodin, quoted by Dujardin-Beaumetz, 1913

Models remained crucial players in the development of Rodin's work. He recruited them from everywhere, among professionals, from the large community of Italian peasants, and also from chance encounters. "Nymphs must have existed," he scribbled in his private notes, "we can still see their traces today, they're now studio models." On his own calling cards he would write their names phonetically, usually followed by a personal comment or physical detail that would help him visualize them later: "Mlle Octavie Lhonneur, pretty redhead"; "Jeanne Charlier, fat"; "Charles Colluci, very handsome"; "Octave Deriaz, handsome youth of antiquity"; Marguerite Leclerc, nice thighs." He also archived photos of elderly people of noble bearing, of women and children who solicited sittings by letter. All this information was carefully compiled by secretaries in long lists of addresses.

Like Carpeaux and Degas, Rodin wanted to avoid flattering poses.

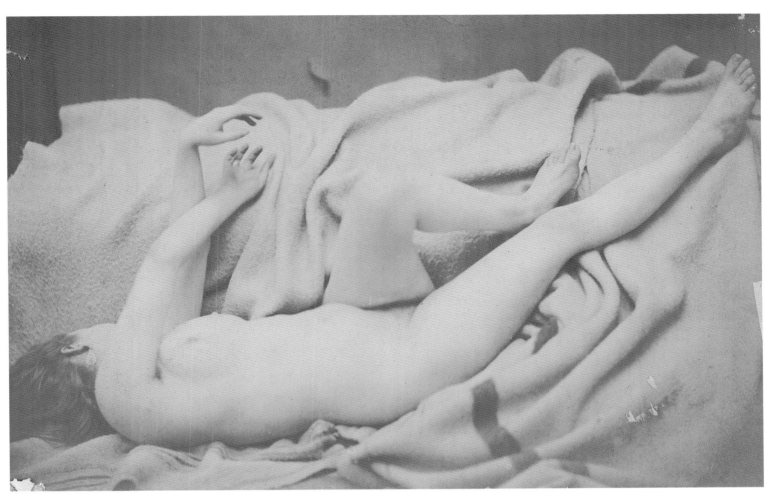

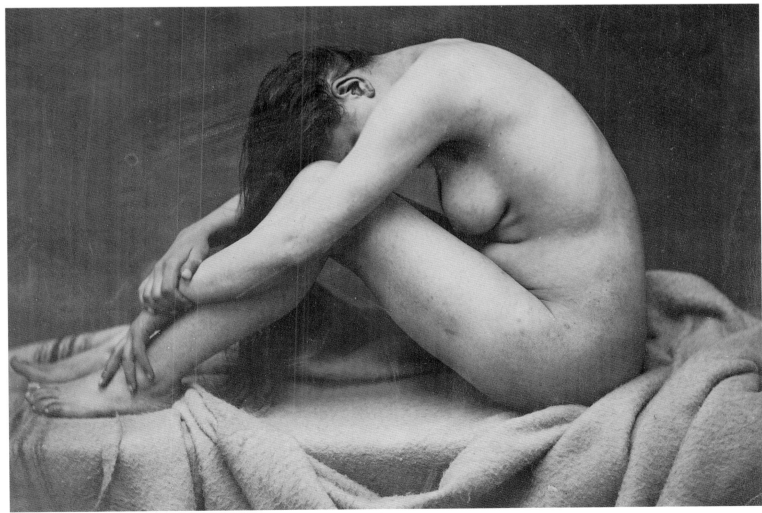

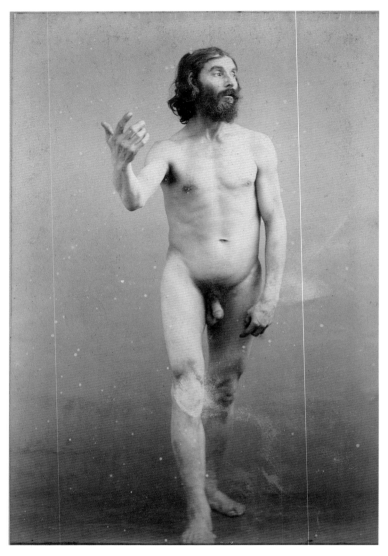

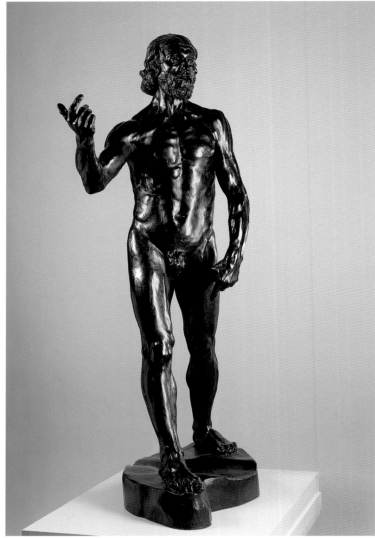

He sought to grasp the essence of things through authentic poses, and therefore encouraged his models to move freely. "I usually let my models wander around the studio undressed," he admitted to Paul Gsell. "They walk or rest. Seeing them live all around me, nude, I become familiar with all their movements." Rodin had his favorites: "There are above all two with whom I worked for a long time, who still seem to come to mind, two Italian women, one brunette the other blond. They were sisters [Anna and Adèle Abbruzzesi], and together they perfectly embodied absolutely opposed natures. One was magnificent in her wild strength. The other had that sovereign beauty all poets have sung." Rodin went on to describe his male model, Pignatelli:

One morning someone knocked at the studio. In came an Italian who had already posed for me accompanied by one of his compatriots. It was a peasant from Abruzzi, who had arrived the day before from his native land and who was offering to serve as a model. I was struck with admiration on seeing him: this crude, hirsute man expressed through his demeanor, features, and physical strength, all the intensity and mystery of his race.
I immediately thought of a John the Baptist, that is to say, a man of

nature; a visionary, a believer, a forerunner who came to announce someone greater than himself.
The peasant undressed, climbed on the turntable as though he had never posed; he stood squarely, head held high, torso straight, weight on both legs open like a compass. The movement was so right, so typical, and so authentic that I exclaimed, "Of course! That's a man walking!" And I immediately decided to sculpt what I had seen."

"He loves only his work, the rest he tolerates with polite boredom."

Camille Mauclair, *Idées Vivantes* (Paris: Librairie de l'Art ancien et moderne, 1904)

Numerous accounts by students, assistants, and journalists enable us to glimpse the private workings of this artistic community that functioned on the scale of a small business. It was far from a craft operation: Rodin employed nearly fifty people, from handymen to modelers, casters, pointers, marble masons, stampers, rough-hewers, ornamenters, and enlargers who bustled all day long at their specific tasks. He paid them by the hour, the day, the week, or the month. Then there were numerous subcontractors, including founders, patinators, and engravers, not to mention specialized

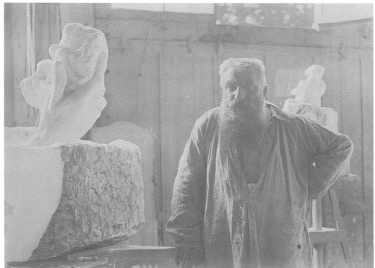

Facing page, left
ANONYMOUS,
THE BEAUX-ARTS MODEL PIGNATELLI POSING FOR SAINT JOHN THE BAPTIST.
ALBUMEN PRINT,
6 ¾ × 4 ¼ IN. (17.4 × 10.8 CM).
ÉCOLE NATIONALE SUPÉRIEURE
DES BEAUX-ARTS, PARIS.

Facing page, right
SAINT JOHN THE BAPTIST PREACHING,
1880.
BRONZE,
89 ½ × 40 ½ × 38 IN. (202 × 103 × 97 CM).

Above
EMBRACING COUPLE,
C. 1880 (?).
TERRACOTTA,
5 × 3 ¼ × 2 ¾ IN. (13.1 × 8.4 × 7.1 CM).

Above, right
ANONYMOUS,
RODIN AT THE DÉPÔT DES MARBRES, NEXT TO THE HAND OF GOD,
C. 1910.
ARISTOTYPE,
4 ¾ × 6 ¼ IN. (11.9 × 16 CM).

transportation firms that delivered maquettes, finished works, molds, and casts.

An early riser, Rodin worked nearly fourteen hours a day, "with the determination of steady, patient effort." He could spend entire days humming the same tune from a marching song—"Au jardin de mon père les lilas sont fleuris"—which on good days he would repeat ad infinitum. But the long working nights that resulted from daytime problems, combined with constant strain, would often put him in a nasty mood. Everyone dreaded his outbursts over delays or spoiled work, to the extent of fearing his presence.

His profiling method, which he inherited from his study of ancient artists, first took shape in clay. "When I begin a figure," he explained to Étienne Dujardin-Beaumetz, "I first look at the front, the back, and the two profiles, right and left, that is to say all the profiles from four angles; then, with clay, I get the basic mass in place, such as I see it. Then I do the intermediates, which means three-quarter profiles. And then I do it again, producing profiles that are tighter and tighter, cleaning them up. Since the human body has an infinite number of profiles, I do as many as I can and need to." Rodin made many corrections, and between working sessions the clay would be wrapped in damp cloth. "His hands were extraordinarily broad with very short fingers," recalled Paul Gsell. "He kneaded the clay furiously, rolling it into balls or pellets, using both the palm and fingernails, tapping away at the clay, making it leap under his fingers, sometimes brutally, sometimes caressingly, wringing out a leg or an arm in a single gesture, or lightly brushing the flesh of a lip. It was a delight to see him at work. His mesmeric passes brought the clay to life."

The artist's clay-fashioning hand was concretized in *The Hand of God*—the powerful hand of God the Creator who shaped two figures and gave life to Adam and Eve as an embracing, sensual couple. Rodin reused the hand of Pierre de Wiessant, one of the figures of *The Burghers of Calais,* this time making it emerge directly from the block, thereby radically changing its meaning. The play of shadow and light and the subtle combination of perfectly smooth sections with *non finito* passages, plus the deliberately apparent marks of the tools, make *The Hand of God* a particularly expressive work.

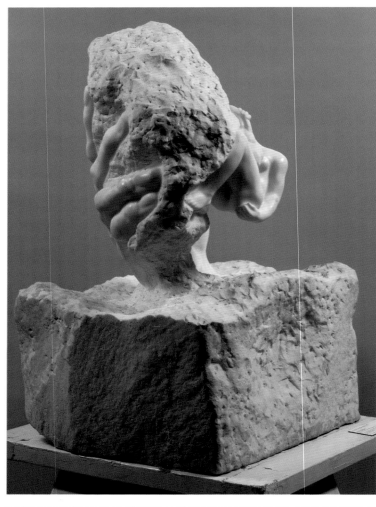
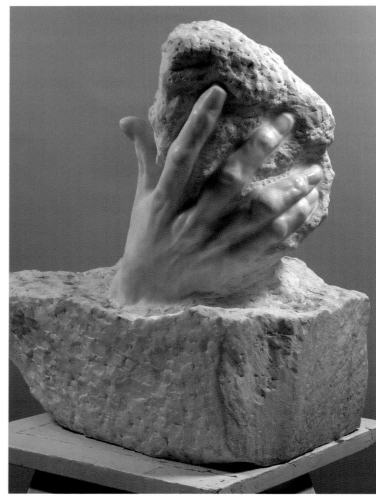
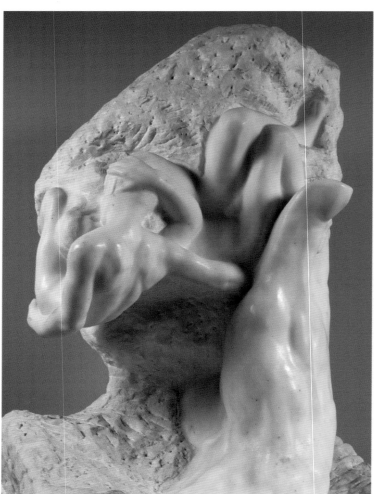
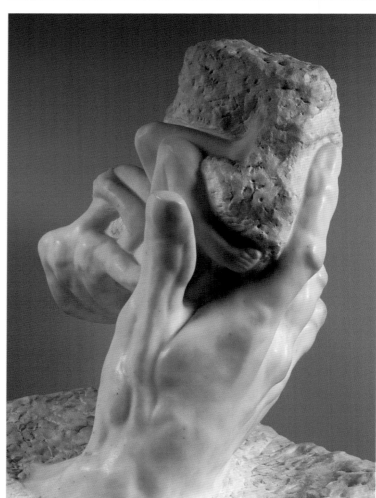

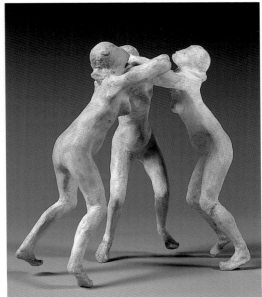

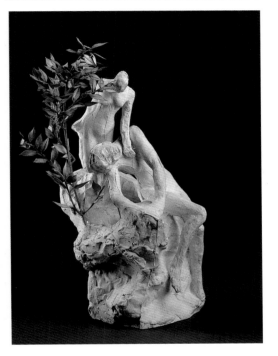

Facing page
THE HAND OF GOD,
1896.
MARBLE EXECUTED BY SÉRAPHIN
SOUDBININE BETWEEN 1916 AND 1918.
37 ½ × 29 ½ × 22 IN. (95.5 × 75 × 56 CM).

Above
ABATTIS (LIMBS).

Above, top right
THREE FAUNS,
BEFORE 1896 (?).
PLASTER,
9 ¾ × 10 × 5 ¾ IN.
(24.8 × 25.2 × 14.4 CM).

Above, bottom right
**ASSEMBLAGE: FEMALE NUDE OF THE ETERNAL IDOL,
FEMALE NUDE SITTING ON A ROCK, WITH PIECE
OF FOLIAGE.**
PLASTER AND FOLIATE ELEMENT,
11 × 7 ½ × 7 IN. (28 × 19 × 18 CM).

Once Rodin felt his wax or clay sketches were satisfactory, the next step involved casting the unfired clay in plaster, which on this occasion would become the original model. The form might even be reproduced to yield several proofs. Thus, in the 1880s, Rodin elaborated an entire repertoire of recurring forms, which he used as his visual idiom. Countless fragments of heads, hands, feet, arms, and legs—folded or outstretched—were reproduced in series. He called them his *abattis* (limbs), and they represent the hidden part of his artistic iceberg: the Meudon museum holds nearly six thousand items in plaster and terracotta, including hundreds of maquettes that now find increasing favor with visitors.

With instinctive ease, Rodin swiftly exploited all these previously created forms, figures, and gestural movements,

henceforth assembling them into original compositions. He excelled in this realm, giving free scope to his plastic imagination through bold rearrangements and mutations. Explorations typical of his mature period included couplings of identical forms, whether balanced or asymmetrical (*Three Fauns, Pas de Deux*), compositions that sometimes incorporated foliage (*Assemblage: Female Nude of the Eternal Idol, Female Nude Sitting on a Rock with Foliage*), and fragmentary figures combined with pieces of fabric dipped in liquid plaster (*The Age of Bronze, Draped Torso*). "[Rodin] will have been the first artist to make his name and fame in sculpture through sketches," wrote Edmond de Goncourt on July 11, 1889. Sometimes, by way of instruction, he penciled his desired modifications directly onto the plaster or marble. Corrections made

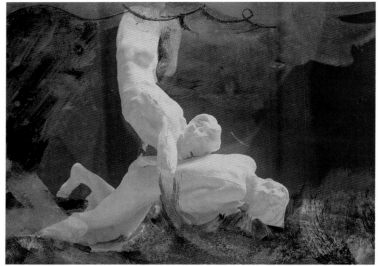

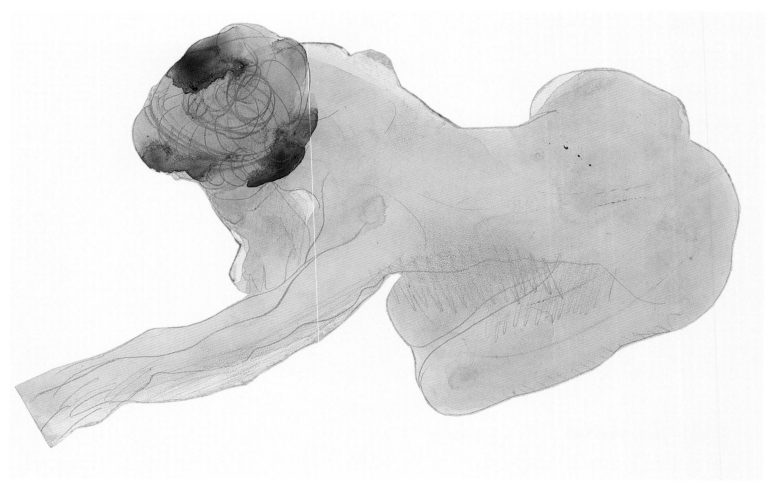

in pen, pencil, or brush on photographed works also helped Rodin to reinterpret and rethink his sculptures freely. The thrust of all this personal research was reinforced by his many cut ups and collages of drawn silhouettes, which he arranged and moved at will in a skillful play of transformations. Once Rodin decided to enlarge a work, it would be immediately executed by the loyal Henri Lebossé, piece by piece. The various elements, prepared separately, were then assembled.

For the sale and dissemination of his works, Rodin merely needed to translate them in a permanent medium, such as bronze or marble. Bronze casting offered numerous advantages, both artistic and economic. Starting with plaster originals, he had "piece molds"

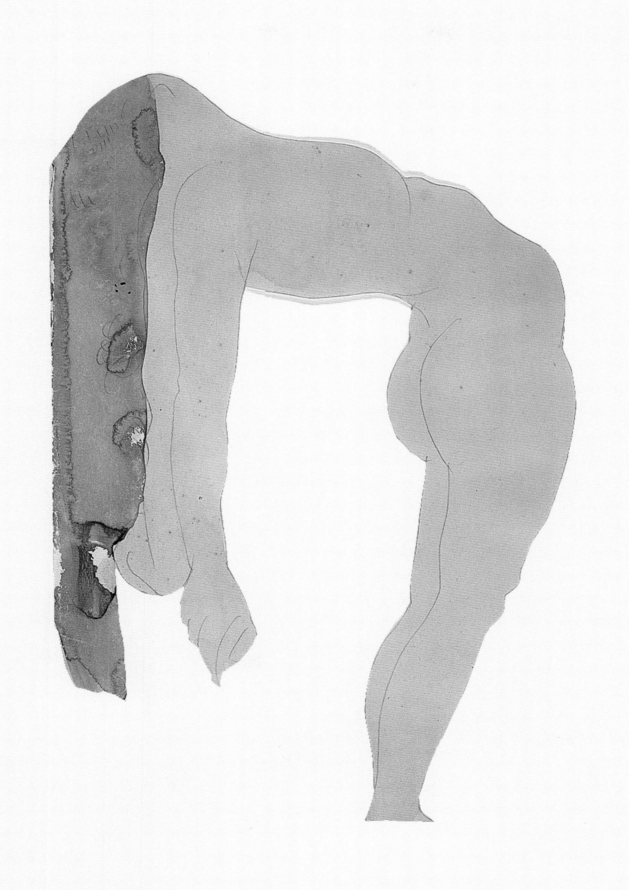

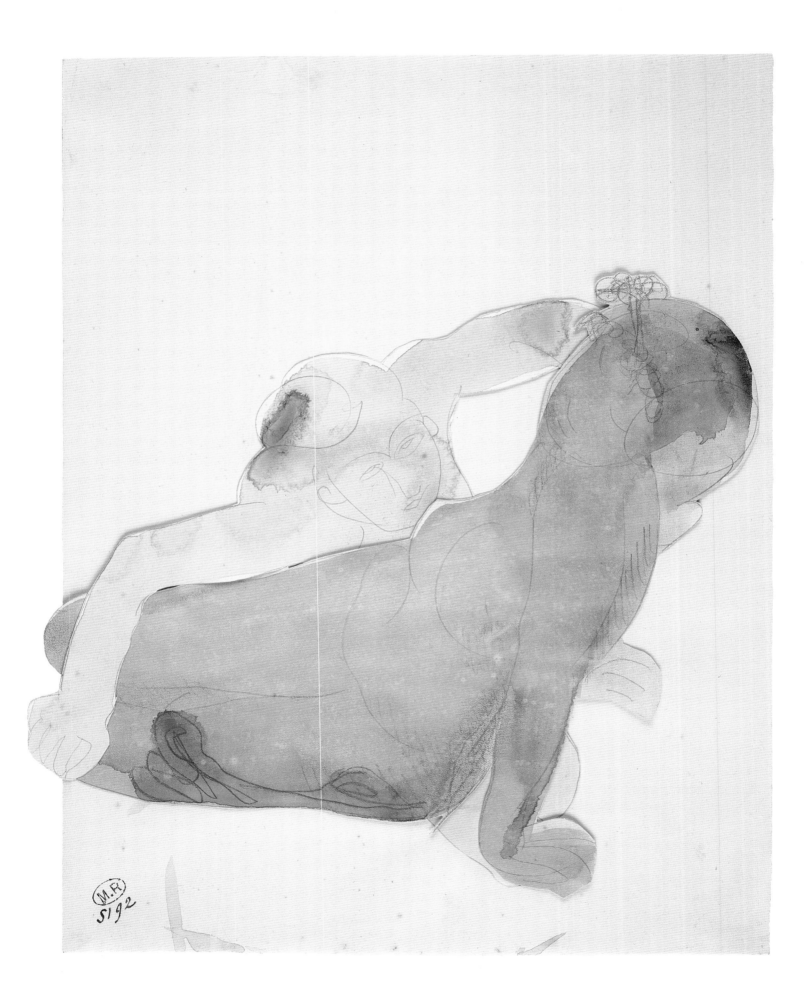

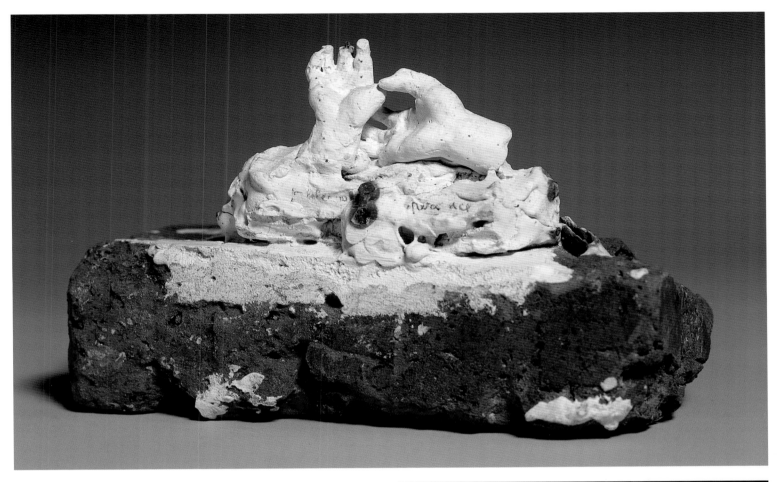

Facing page
TWO SEMI-RECLINING
NUDE WOMEN.
STUMPED GRAPHITE,
WATERCOLOR WITH GOUACHE
HIGHLIGHTS ON TWO PIECES
OF PAPER, CUT AND
ASSEMBLED,
9 × 11 ½ IN. (22.8 × 29 CM).

Above
LOVERS' HANDS,
BEFORE 1904.
PLASTER ON BRICK,
5 × 8 ½ × 4 ¼ IN.
(13 × 21.4 × 10.6 CM).

Right
LOVERS' HANDS,
1904.
MARBLE,
17 ¼ × 22 ¼ × 14 ¼ IN.
(44.3 × 56.9 × 36.5 CM).

made, yielding several plaster proofs that were then dispatched to the founders. Both the lost-wax process and especially the sand-casting method were heavy operations that required the expertise of specialized subcontractors such as founders, chasers, and patinators. In total, Rodin consigned his work to some twenty founders, the most important of whom was Alexis Rudier.

In his studio, the entrepreneurial Rodin was surrounded by assistants known in French as *praticiens,* skilled rough-hewers and finishers who could execute his marbles. Like most of his contemporaries, Rodin devoted himself entirely to the work of conception and creation, and thus did not himself carve. He handed his assistants a model, which was sometimes more of a sketch, a pointer would then rough out the block, after which a *praticien* could work by following the maquette. Thanks to a "three-compass" mechanism, accurate measurements of the volumes could be made on the original plaster and then transferred to the marble. This machine technique was a slow process that called for extreme rigor. Constant collaboration between the artist and the *praticiens* was also required, especially since Rodin's constant, dynamic analysis

meant that he followed each stage attentively, from the roughing all the way to the polishing via the execution of details and final chasing. Depending on his perception of the emerging work, Rodin might suddenly order a change of direction.

The terracotta version of *Sleep*—enigmatic and mysterious, gentle yet full of contrast—illustrates his methods in more than one respect. Rodin could be experimental yet still dwell meticulously on details. The variety of materials that went into this piece make it a surprising work, one that seems to violate the rules of art. The combination of different materials such as fired clay and plaster, wax in four colors, nails, and newspaper lend it a composite, lively appearance that seduces the viewer. The polychrome aspect was unprecedented in Rodin's output and, being a model of this

approach, makes the piece highly original. "Sculpture is sister to painting," Rodin told Paul Gsell, "and plays with light and shadow just like [painting]. . . . A sculptor who is not a colorist overlooks the main point of his craft."

Two marbles of *Sleep* exist, one made in 1889, the other in 1911. The loosened hair falling completely to the right underscores the gentle tilt of the head resting on one hand. Eyes closed, mouth parted, the young woman sleeps peacefully. The face is serene, the expression dreamy; the extremely smooth, careful finish contrasts with the rough block from which she emerges. The flattering effects of the marble reinforce the suave effect of the figure, which surely reflected the taste of the patrons who commissioned it. And yet the

marble versions are ultimately weaker and deprived of everything that made the work seem original.

Praticiens were often excellent sculptors who had to perform wearisome tasks in order to make a living. Discord could therefore be rife with Rodin, who was sometimes disrespectful, steadily demanding, and always very busy. In an apology to Dolivet, the master once wrote, "Henceforth when I give you something I'll leave you free to do it. I'm just tormenting myself and everyone else."

"They're ignoble; a museum is expensive; I'll get my revenge by bequeathing them an education."

Note by Rodin found by the museum's first archivist, Jean-Paul Hippeau, "in a humble notebook ordinarily used for keeping laundry accounts"

Below
SLEEP,
BETWEEN 1889 AND 1894.
MARBLE,
19 × 22 × 18 IN.
(48.4 × 56 × 47.7 CM).

Facing page
SLEEP,
1889.
TERRACOTTA, PLASTER, FIBERS,
WAX, NEWSPAPER, AND NAILS,
18 × 18 ½ × 15 ½ IN. (46 × 47 × 39.5 CM).

In 1900, Rodin, Desbois, and Bourdelle planned to open a Rodin Institute on boulevard de Montparnasse, but the project collapsed in a matter of months. Although he had no real teaching studio, as David

had, Rodin was constantly surrounded by students of all nationalities. Josef Maratka from Czechoslovakia, John Tweed and Berenice Langton from England, Auguste Zeller from the United States, Gustave Natorp from Germany, Moriye Ogihara from Japan, Nathalie de Golevsky from Russia, and many others respectfully followed his instructions. He taught them his profiling method and "would not tolerate approximations," reported Aristide Rousaud to Léonce Bénédite. Rodin generally had his apprentices do hands or feet. Every year, he awarded a bonus to the most capable among them. He took his task very seriously, and in the evening, by the light of a candle in the empty studio, he would scribble straight onto the stone to indicate the parts remaining to be carved. His assistants included the likes of Bourdelle, Claudel, Desbois, Despiau, Escoula, Millès, Peter, Pompon, Scheeg, and Turcan, for Rodin attracted young talent with bright futures. Other artists who did not pass via Rodin's studio but who were receptive to his lessons would later pay tribute to him; thus at the fourth Salon de la Jeune Sculpture, Condoy called him the "great pioneer of modern art, who revived a tradition forgotten since the Renaissance" and who could be considered the direct forebear of non-figurative artists. Gimond thought Rodin displayed "one of the most extraordinary sculpting temperaments the world has ever known" thanks to "his sense of solidly built construction and his dense, homogeneous, compact forms." Zadkine, meanwhile, argued that "during the pathetic decline of visual values, followed by the slow liberation and rediscovery of the life of forms, Rodin was the only passionate figure of the second half of the nineteenth century who still stands up. For generations to come he will remain the only one who delivered a liberating blow of the hammer to the wall that was slowly stifling the flickering life of sculpture."

Aware of Rodin's impact on contemporary art, Brancusi nevertheless decided not to join his studio. "Rodin's influence was and still is enormous," explained Brancusi, adding a few lines later that, "Rodin agreed to take me as a student. But I refused, because nothing grows in the shade of big trees." When faced with the artistic rebellion of the younger generation Rodin remained skeptical, rejecting the Cubist and Futurist movements en masse. Many younger artists envied him, and criticized his popularity, openly showing their disdain by trying to make him seem outmoded. In fact, Rodin participated very little in polemics, and only at the specific prodding of journalists. He led his own aesthetic battle, and his quest for perfection drove him toward the essential. By simplifying his works to the extreme, so that they became "fragmentary"—in appearance only—he had definitively eliminated subject matter, the better to give birth to form and thereby revolutionize sculpture. At the cost of constant experimental exploration, he elaborated a concept that he left as his testament to his successors. He certainly entertained little hope for future generations that did not share his cult of work, and he remained exclusively concerned with the life of his studio. According to his secretary, Anthony Ludovici, Rodin "regard[ed] himself as an *avant-dernier*" (one of the last).

Echoes of Permanence

His sculptures are flowers
of evil on heaven and earth.
His sculptures are troublingly bare,
sometimes even nude,
or wonderful, giant vines
with trimmed beards.
His sculptures are echoes of permanence,
dormant kisses
on dead men's hands,
Medusas with shiny buttoned
Ankle boots
from the era of waltzes.
It is a vast afterbirth of the
Renaissance,
a proposed erotomachia
to recover our roots,
far removed from the mechanical erotomachia
of our era.

Right
RUDOLF BRUNER-DVORAK,
**RODIN AND JOSEF
MARATKA,**
1902.
ARISTOTYPE,
5 × 2 ½ IN.
(12.7 × 6.5 CM).

Far right
LÉON ZANDER,
**RODIN IN HIS STUDIO
WITH A STUDENT,
NINA ZANDER,**
1908.
ARISTOTYPE,
5 × 3 ½ IN. (12.9 × 8.9 CM).

Facing page
D. FREULER,
**HAND HANGING
FROM A RACK IN THE
STUDIO.**
SALT PRINT,
4 ½ × 3 IN.
(11.5 × 7.9 CM).

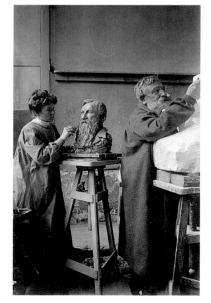

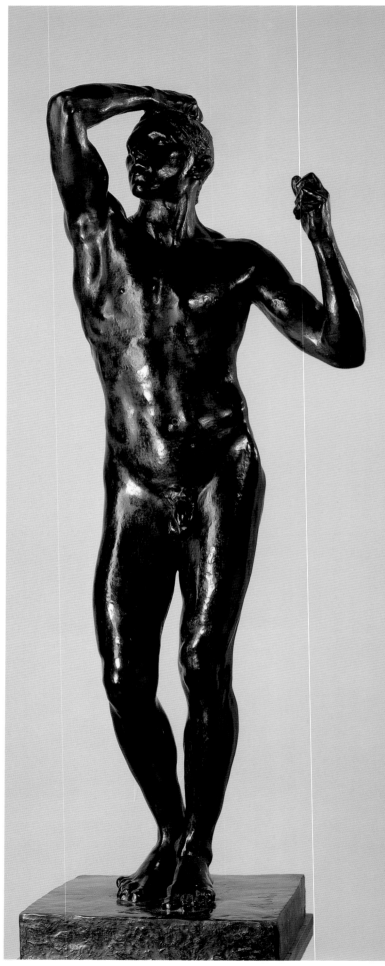

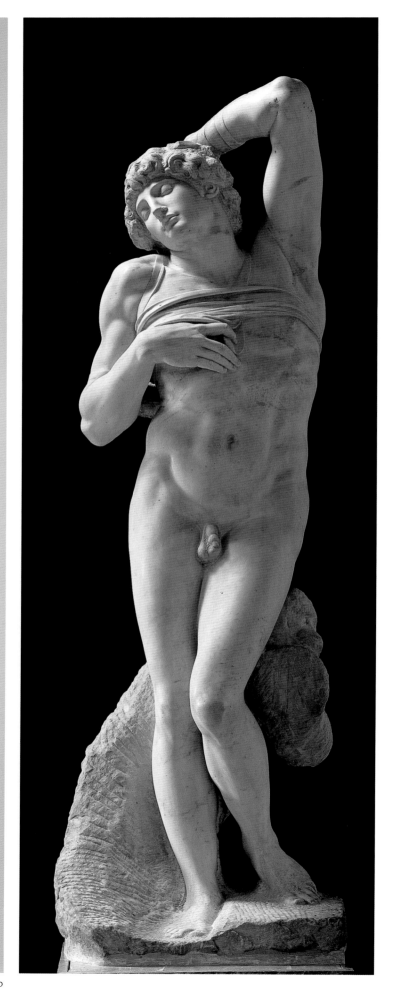

ITALIAN LESSONS

"I'm in Rome for my health, in a place where, even at my age, I'm still studying."

Rodin to Armand Dayot, January 25, 1915

Between 1876 and 1915, Rodin traveled across the Italian peninsula nearly fifteen times, exploring museums and ruins, ranging over the treasures of its churches and the beauties of its palaces, discovering the diversity of its landscapes, looking at absolutely everything. He never wearied of Italy. During these periods of study and pleasure, he would continue his research by exploring or reexploring not only Rome, Milan, Menaggio, Ardanza, Pisa, and Florence, but also Turin, Livorno, Seravezza, Genoa, and Venice.

"Michelangelo, who beckoned me to Italy, gave me valuable insights. I copied him in my mind, in some of my works, before understanding him."

Rodin to Antoine Bourdelle, July 18, 1907

The study of Italian masters was a necessary stage in the career of every artist, and Rodin cherished this dream long before he was able to make it come true. His first trip to Italy—home of his god, Michelangelo—took place in 1876, but it in no way resembled the traditional voyage made by young artists who had won a scholarship to the Académie de France in Rome. Rodin had failed three times to gain admission to the École des Beaux-Arts—luckily, we might almost say today—which irrevocably excluded him from an academic career. Rodin experienced this failure as a painful setback, not yet aware that, as Jean Cocteau put it, "There is a kind of success worse than failure, and a kind of failure worth all the success in the world."

Rodin's knowledge of old masters began at the Louvre, where he tirelessly drew and copied all that endlessly repeated imagery from the past. Once in Italy, he primarily sought a direct confrontation with Donatello, Michelangelo, and the other grand masters of the Italian Renaissance. "When I myself went to Italy, my brain full of Greek models that I had passionately studied at the Louvre, I was greatly disconcerted by the Michelangelos," he admitted to Paul Gsell. "They were always refuting all the truths I thought I'd permanently learned!" Rodin was in search of a formal vocabulary, and

the discovery of Michelangelo's work in its proper context was particularly unsettling. The emotional quality of the modeling, the tormented poses, and the throbbing power that stemmed directly from Michelangelo's *non finito* technique reassured Rodin, even as they revealed new paths to explore. Michelangelo, unlike his predecessor Donatello, urged the beholder to circle around a work, never privileging a single point of view.

The allusion to Michelangelo's *Dying Slave* in Rodin's *The Age of Bronze* is obvious. The arm raised behind the head, the slight contrapposto, and the closed eyes and languid expression on the face suggest a troubled awakening of consciousness. From the back, the play of light and shade that subtly enlivens the handling of the muscles even more strikingly echoes a Michelangelo drawing of a nude now in Florence.

"You'll hardly be surprised to learn that since the moment I arrived in Florence I've been doing a study of Michelangelo," he wrote from Italy to Rose Beuret, his companion. "And I think the great magician is revealing a few of his secrets to me. . . . I've done sketches back at my place in the evening, not based on his works but based on all the scaffoldings and systems I construct in my imagination to try to understand him, and I think I'm managing to give them a little of that indescribable something that only he could give." The countless drawings—in various sizes and various degrees of care in execution and

finish—that Rodin did of Donatello's *Gattamelata*, Michelangelo's *Moses* and Medici tombs, and other not always identifiable works were later collected and carefully arranged on large sheets of paper by Rodin himself. Their swift, spontaneous execution nevertheless reminds us that these were travel sketches, hastily scrawled in little notebooks, sometimes freely annotated with highly personal impressions and ideas in handwriting as capricious as it is illegible, with absolutely no concern for spelling or syntax. Some of the figures were occasionally reworked in ink or in washes.

Facing page, left and below, right
THE AGE OF BRONZE,
1877.
BRONZE,
71 × 27 × 21 ½ IN. (180.5 × 68.5 × 54.5 CM).

Facing page, right
MICHELANGELO,
DYING SLAVE,
1513.
MARBLE,
MUSÉE DU LOUVRE, PARIS.

Below, left
MICHELANGELO,
NUDE STUDY,
C. 1505.
PEN AND INK ON PAPER,
16 × 11 ¼ IN. (40.8 × 28.4 CM).
CASA BUONARROTI, FLORENCE.

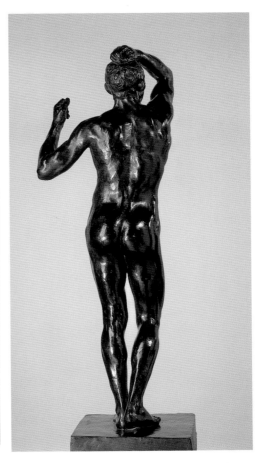

The *Adam* and *Eve* flanking *The Gates of Hell*, meanwhile, were more directly inspired by the lyrical power of Michelangelo's painted figures, as seen on the walls and ceiling of the Sistine Chapel. The powerful chest, twisting pose, and pointing index finger of *Adam* relate directly to Michelangelo's depiction of Creation. The ashamed *Eve*—her head bent toward one shoulder under the weight of guilt, her arms clasped around her body—appears wounded and humiliated; the general pose and the intensity she generates closely recall the sinning Eve who is hounded from Eden on the Sistine Chapel.

The impact of this Italian voyage and of Michelangelo—whom Rodin truly worshiped—can be seen everywhere in the countless figures Rodin modeled for *The Gates of Hell*.

"Rome means Bernini, an admirable man and an admirable sculptor, as fine as Michelangelo although not as subtle. It was Bernini who made Rome but nobody knows it."

Rodin quoted by Judith Cladel, 1936

Nearly thirty-five years later Rodin went back to the Eternal City, returning not only to the vestiges of antiquity that he considered his heritage, but also to the baroque city that had come as a revelation to him. At the time, Italian baroque sculpture remained completely misunderstood—compositional profusion and confusion led to systematic criticism from art lovers who saw it as a decadent art. All these hostile reactions, silly complaints, and negative reports perhaps spurred Rodin to examine baroque works more closely and subject them to a sharp gaze. Maybe the artist, who would tell Paul Gsell in 1906 that his "greatest joy is to feel internally free, that is to say freed from all artistic falsehood," found in Rome an opportunity to assert his independence. "There's a slander," noted Rodin among all his sketches and scribblings, "that gnaws at Rome: ancient Roman art is not beautiful, only ancient Greek art is. The baroco [sic] is no good. All Rome is contained in these two great periods—ancient and baroco. This stupid slander is repeated by minds that have been educated; fortunately, there are people who haven't been to school and who say it's beautiful."

Marcel Reymond had just dedicated his book on Bernini—part of a series on old masters—to Rodin. "To August Rodin, heir to the

Above
SHEET OF STUDIES,
C. 1875–76 (?).
GRAPHITE, PEN AND BROWN INK ON CREAM
PAPERS GLUED TO A BACKING,
10 ¼ × 13 IN.
(26.4 × 33.3 CM).

Right
MICHELANGELO,
ADAM AND EVE DRIVEN FROM EDEN,
1509–10.
DETAIL FROM THE SISTINE CHAPEL,
THE VATICAN, ROME.

Below
EVE,
1881–89.
BRONZE DETAIL,
68 ½ × 22 ¾ × 26 IN.
(174 × 58 × 66 CM).

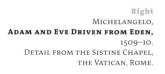

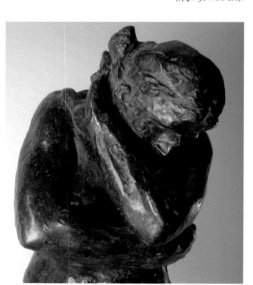

great geniuses of the past, who has managed to recover France's worldwide supremacy in the art of sculpture." The uneducated, self-taught sculptor was obviously infatuated. "In my presence he delighted in just one [book]," recalled Rodin's former secretary, Marcelle Tirel, "a study on Bernini by a young writer from Grenoble, Marcel Reymond. When Rodin was tired, he would hand me the book and I would begin reading it again, very slowly." Thanks to such anecdotal accounts, and above all to the notes and sketches in Rodin's notebooks, we now appreciate the powerful impact that Baroque art and Bernini made on Rodin. On Piazza di Trevi, he focused his attention on the fountain, which he mistakenly attributed to Bernini, and to the mass of roaring water that gushed among rocks and tritons. Where other people abhorred its excessiveness and outlandishness, Rodin enthusiastically noted the bold, exuberant composition, the sophisticated execution of lines that could be knotted, unknotted, then broken, and the astonishingly inventive poses and drapery.

He was also impressed by the Baroque style of the Barberini palace. He tirelessly took in Bernini's busts. "I can see what strikes him," explained Albert Besnard. "It's the skillful arrangement. He hovers around it like a man trying to discover a secret." Bernini's monumental power—the dynamic composition and theatrical vision of a work such as *The Ecstasy of Saint Theresa* in the church of Santa Maria della Vittoria—made a deep impression on Rodin. His enthusiasm inspired him to acquire a copy of Theresa's face in the form of a mask cast from the original. "Bernini's Virgin, like his Saint Theresa, is sensual profusion," scribbled Rodin in his notebook. He was certainly thinking of this when he executed his own *Martyr*, in which we no longer know where the expression of pain ends and that of pleasure begins.

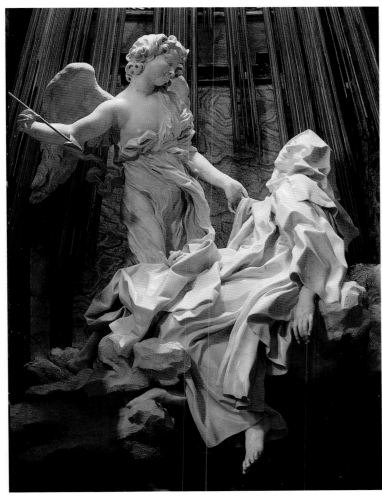

Above
BERNINI,
THE ECSTASY OF SAINT THERESA,
1645.
MARBLE.
CHURCH OF SANTA MARIA DELLA VITTORIA, ROME.

Above, right
MARTYR,
c. 1885.
LARGE VERSION, 1889.
BRONZE,
16 ½ × 60 × 39 ½ IN.
(42 × 152 × 100.5 CM).

Right
AFTER BERNINI,
FEMALE MASK BASED ON SAINT THERESA, 17TH–18TH CENTURY.
MARBLE,
13 ¾ × 8 ¼ × 45 ¼ IN. (35.1 × 21.1 × 115 CM).
CORNARO CHAPEL, CHURCH OF SANTA MARIA DELLA VITTORIA, ROME.

ROMA · Maderno · S. Cecilia (Chiesa della Santa)

241. Ernesto Richer. Roma

Above, top
ERNESTO RICHTER,
STEFANO MADERNO'S SAINT CECILIA.
PHOTOGRAPHIC POSTCARD,
3 ¼ × 5 ¼ IN.
(8.5 × 13.4 CM).

Above, center
FATIGUE,
1887.
BRONZE,
6 ¾ × 20 × 8 ½ IN.
(17 × 51 × 20.7 CM).

Right, facing page,
and pages 156–157
ARMLESS MEDITATION,
C. 1894.
PLASTER,
57 ¾ × 30 × 21 ¼ IN.
(147 × 76 × 55 CM).

In the church of Santa Maria in Trastevere, Stefano Maderno's *Saint Cecilia*—of which Rodin owned a reproduction on postcard—inspired the sculptor to note the perfection and purity of the curving line that combined, in ideal proportions, an inventive pose with a mastery of craft. Rodin would clearly recall this lesson in *Fatigue* and in an ink drawing done to illustrate Baudelaire's *The Flowers of Evil.* Thanks to an insatiable curiosity, Rodin was able to address highly contemporary concerns even as he increasingly explored the work of the past.

"Formerly, in the Louvre the Olympian gods told me—like saints to a monk in his cloister—everything a young man could usefully hear; later, they protected and inspired me; after an absence of twenty years, I have now met them again with indescribable joy, and I've understood them."

Rodin, Venus. "A la Vénus de Milo," Art et les Artistes, March 1910.

By the end of the great creative period of the 1880s, Rodin had produced a considerable set of figures. He could dip into this treasure trove for his technical explorations and his more personal research. "He could transform, fragment, and assemble at will figures drawn from his reservoir of forms," explained Antoinette Le Normand-Romain. "This represented considerable savings in time, especially since he didn't generally take the trouble to remove the marks of casting." Even as Rodin's work became more "intellectual," it still entailed a rediscovery of antiquity. He spent entire mornings musing at the Baths of Diocletian in Rome. "I'm happy here," he told a reporter in 1914, "because every day I learn something. I try to anchor inside myself the immutable beauty in which Rome is so rich." He admired a Venus recently discovered in the excavations at Cyrene. He had a four-month pass that allowed him to visit the papal museum and galleries in the Vatican as often as he wished. In the Villa Médicis, he enjoyed above all the gallery of casts where he could "lovingly stroke the Greek statues' admirable legs and torsos, so powerful yet so simple in shape," according to Albert Besnard. "Powerful yet so simple in shape" is what Rodin must have been saying to himself when, taking his cue from antiquity, he pushed his own sculpture in a direction that was more and more spare, rid

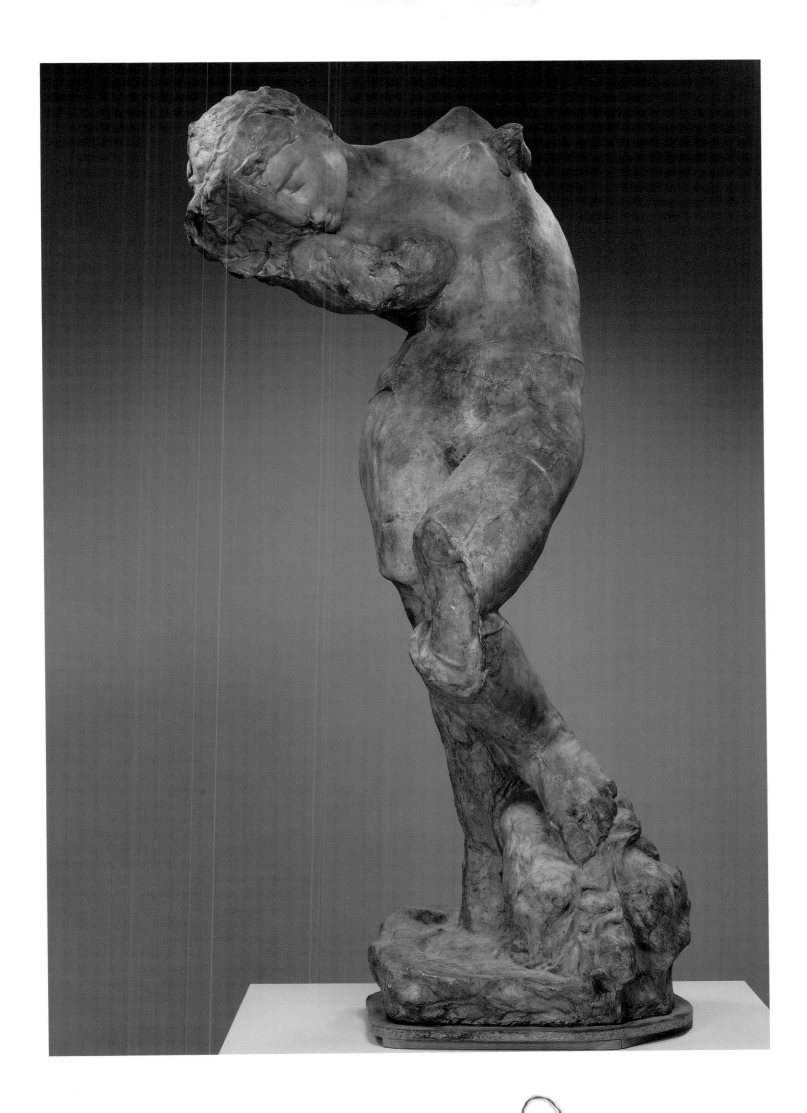

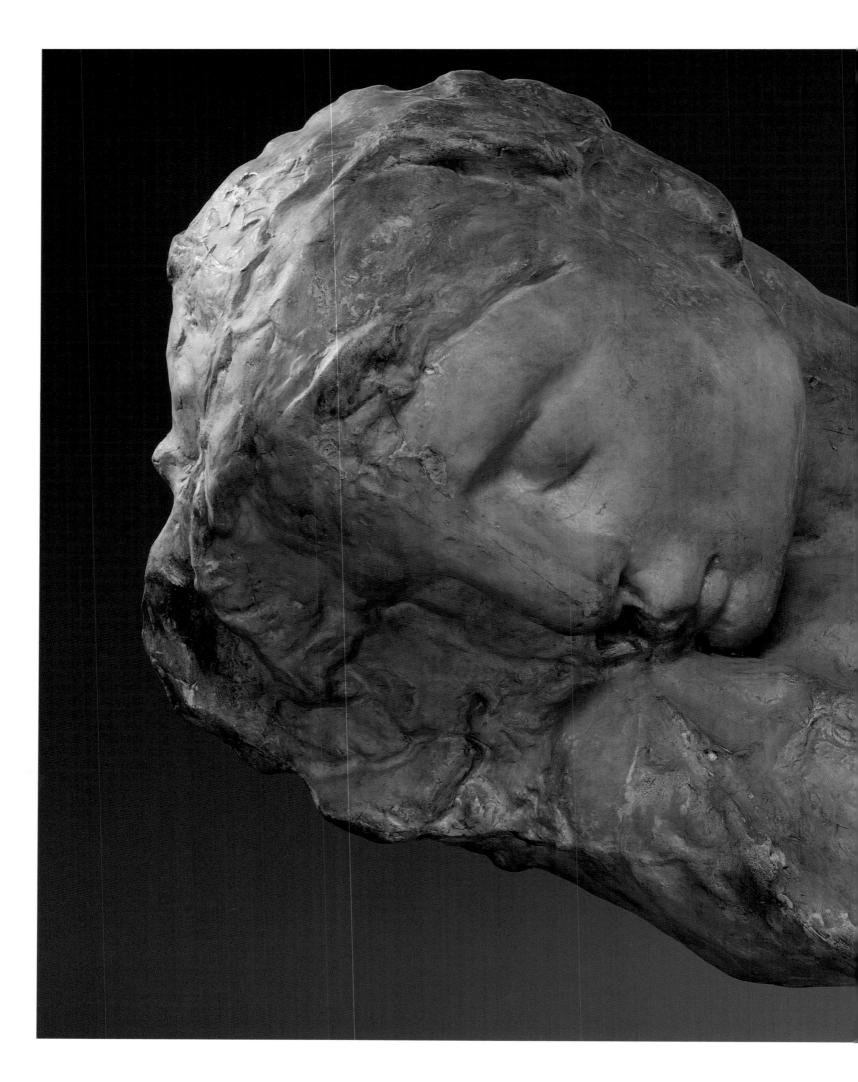

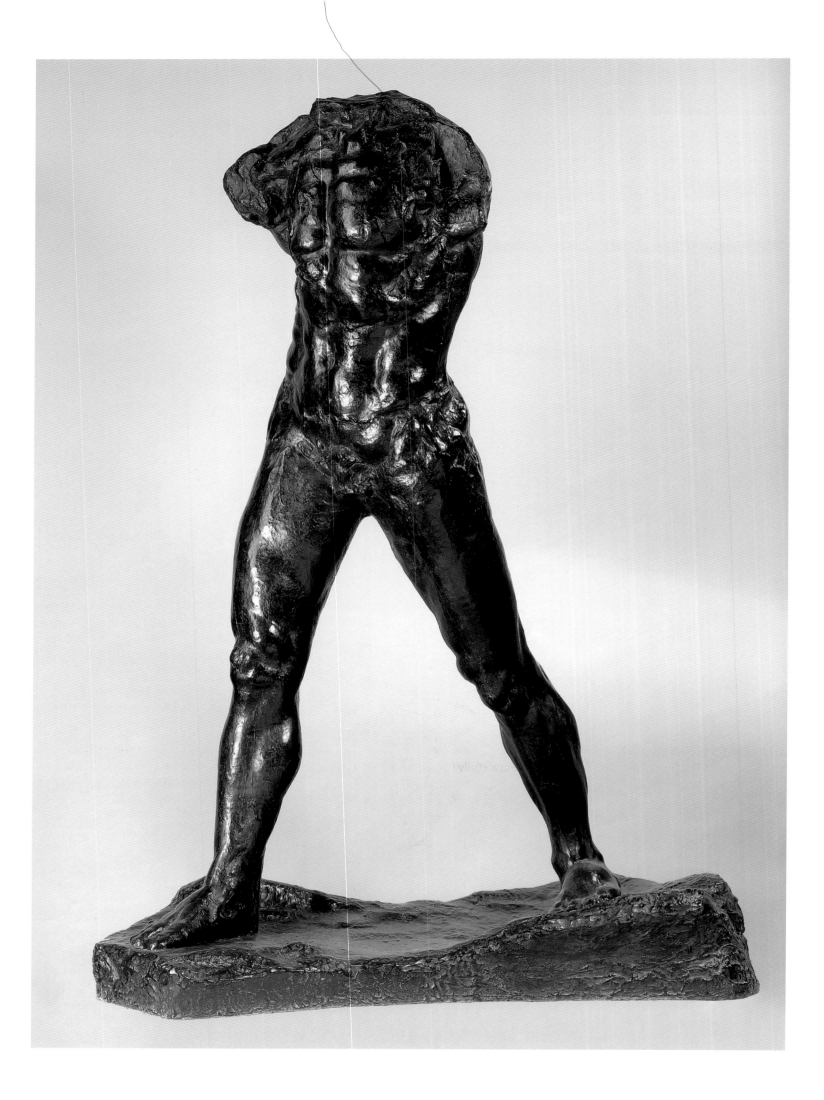

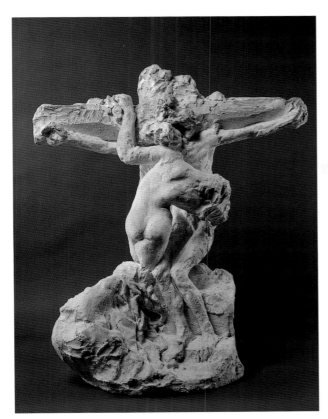

Facing page
THE WALKING MAN,
1907.
BRONZE,
84 × 28 ¼ × 61 ½ IN.
(213.5 × 71.7 × 156.5 CM).

Above
CHRIST AND THE MAGDALEN,
1894.
PLASTER,
33 ¼ × 29 × 17 ¼ IN.
(84.5 × 74 × 44.2 CM).

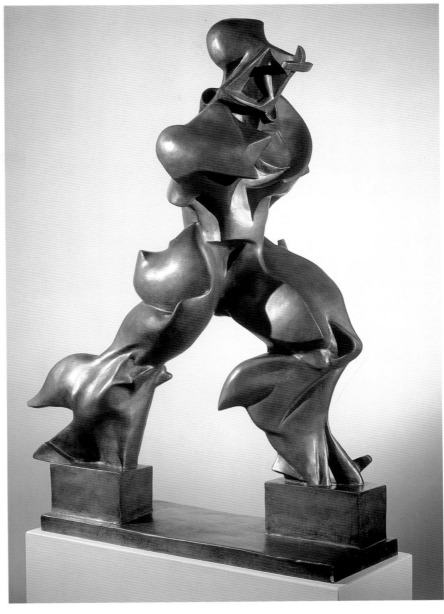

Right
UMBERTO BOCCIONI
**UNIQUE FORMS
OF CONTINUITY
IN SPACE,**
1913
BRONZE,
TATE MODERN, LONDON

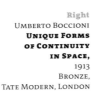

of everything superfluous and anecdotal. Around 1895–1900, this path had led to an extreme simplification of forms. "Familiar with Greek sculpture almost to the point of obsession, loving its spirit down to the letter, Rodin sought—and found—it in the incomplete forms pulled from excavations, which he recreated and fully imbued with modernity by retaining the incomplete, mysterious aspect that gives those few classical fragments so much grandeur," claimed Berthelot in *La Petite Gironde* of May 10, 1908.

A small figure of a damned woman originally designed for the tympanum of *The Gates of Hell* thus became, in an enlarged yet fragmentary version, *Meditation* or *Inner Voice*. "In it, the study from life is totally accomplished," wrote Rodin to Prince Eugene of Sweden, "and I put all my effort into rendering the art as fully

as possible. I consider this plaster to be one of my best finished pieces, the most advanced." The gracefully tilted head and serpentine twist lend this figure great elegance, while the emotion it conveys is reinforced by its fragmentary nature and the deliberately visible tool marks and traces of seams. "It is the epitome of art," explained Cladel, "a certificate that the sculptor bestowed on himself, the sum of his efforts and research, all concentrated into plastic expression." Although fragmentary, the figure of *Meditation* lacks no essential element—powerful, sensual, it incarnates absolute beauty. Rodin practically adopted it as his favorite form, the sum total of his aesthetics. He often incorporated this figure into various compositions such as *Christ and the Magdalen.*

With *The Walking Man,* Rodin pursued his quest for perfection by creating a work through

assemblage and elimination. In a bold innovation, he removed the head and arms from *Saint John the Baptist* so that only the impressive striding legs and overall vigor remained. This figure, built uniquely on diagonal lines, immediately conveys the idea of movement, even as the determination and tranquil strength of the work assumes symbolic power. The smooth handling of the massive legs contrasts with the rippled surface of the torso. This work would directly inspire later artists such as Giacometti and even Italian futurists like Boccioni to pursue the study of movement through successive moments, combining the notion of space with that of time.

Rodin thus permanently liberated himself from conventional practices, notably from the weightiness of a specific subject. Translating these figures onto a monumental scale

through the method of enlargement meant giving them a second birth, revealing their veritable power even as it multiplied their expressive possibilities.

Rodin—the man who would write to Hélène Porgès that "the great founder who made us all has certainly given you a finer patina than us"—paid his finest tribute to women and to antiquity through *Arched Torso of a Woman*. The extremely simple chest cage is inflated by its frontal presentation; the arched torso and proffered breast assert fullness and perfection. As though freshly pulled from an archaeological dig, the sculpture is reduced to the status of a human trunk by clean breaks at the limbs and head. Rodin realized that too many details would have weakened the work and disturbed the beholder. "This piece of pure sculpture," as Antoine Bourdelle called it, would mark the high point of Rodin's encounter with antiquity. But the supremacy that he granted to antiquity did not make him servile—his skillful regeneration never failed to surprise his entourage. In assemblages as bold as they are fanciful, he never hesitated to reappropriate objects, subvert their meaning, and freely reinterpret them, for instance by populating certain pieces of Attic pottery from his collection with his own plaster figures.

The lessons that Rodin learned in Italy would resurface throughout his artistic career, clearly helping to underpin his emerging aesthetic. Toward the end of his life, he still retained all the emotion, admiration, and wondrous gratitude that bound him to Italy and its eternally cherished artistic heritage.

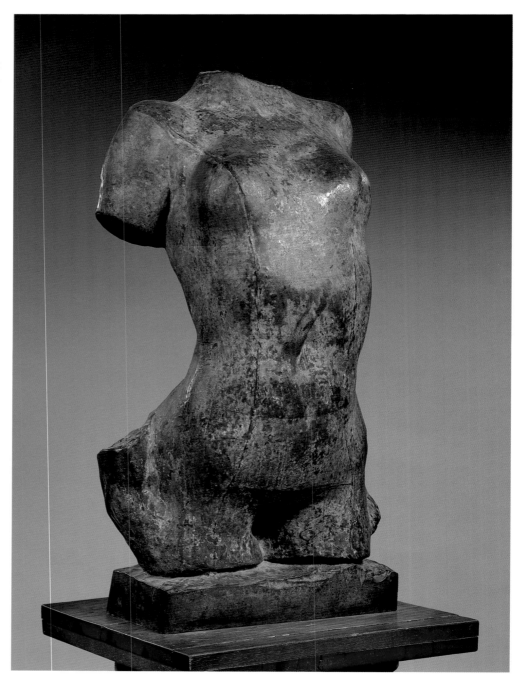

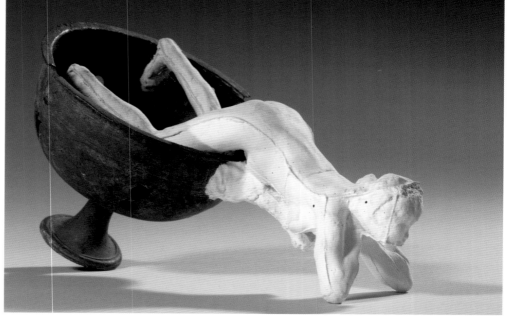

Top
ARCHED TORSO OF A WOMAN,
1910.
BRONZE,
33 ¾ × 19 × 12 ¾ IN.
(86 × 48.1 × 32.2 CM).

Right and facing page
ASSEMBLAGE: LITTLE FAUN WITH METAL CUP,
AFTER 1895.
PLASTER AND BRONZE,
7 × 6 × 10 ½ IN.
(17.6 × 15 × 26.6 CM).

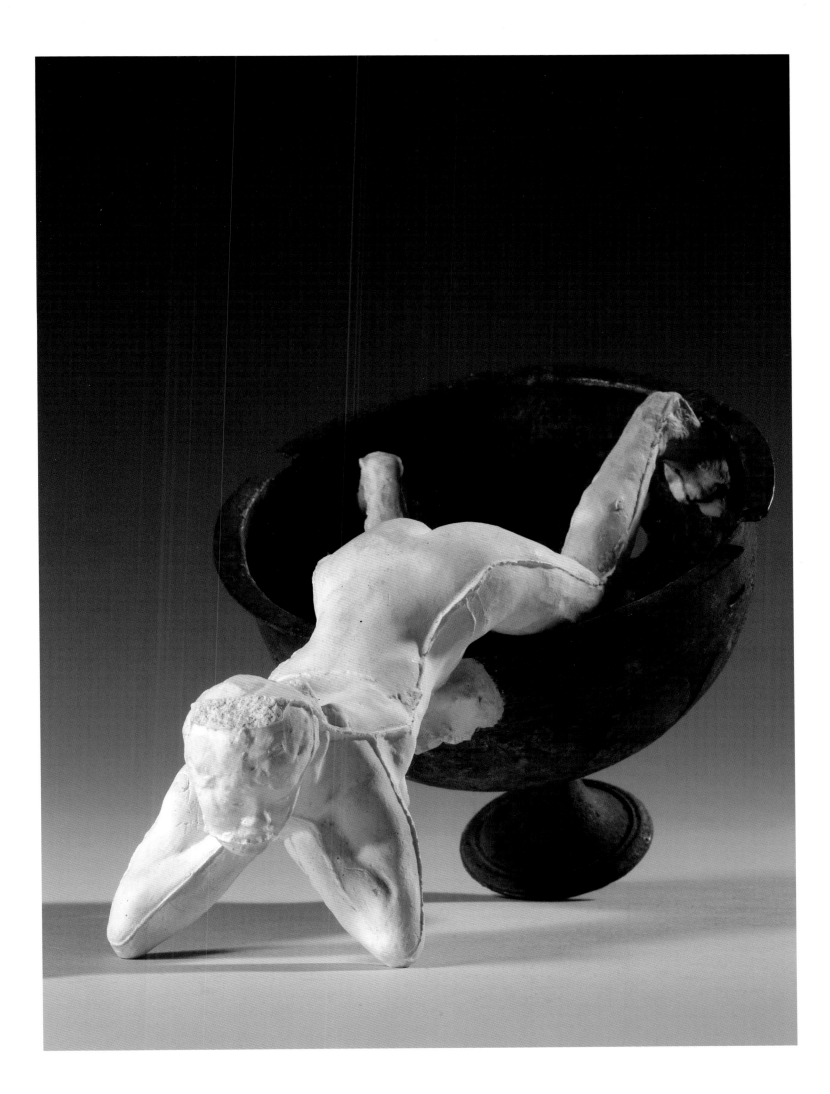

RODIN IN MEUDON AND THE HÔTEL BIRON

In Meudon

Eventide Visit
We climbed the hill's inspired lanes
to reach pale Temple's famed retreat.
On elbows perched, face pressed to panes,
we saw how Paris lapped our feet.

Having thus ascended hill at last,
we found the Master not at home.
We trod with fear among the grass,
as though some God dwelt in each stone.

Thus even in his home he acts like none;
"A rebel built this house," I had to say
as gaze moved far—yet farther still—
away: "Rodin with eagles dwells, in yon
setting sun."

Lucie Delarue-Mardrus, October 3, 1903

Above
ANONYMOUS,
**RODIN, ROSE BEURET, AND AUGUSTE CLOT
IN THE GROUNDS OF MEUDON,**
1899.
GELATIN SILVER PRINT,
7 ¼ × 9 ¼ IN. (18.5 × 23.7 CM).

The atmosphere of Rodin's studio, the artist himself, and, most often, his works have all inspired poets, writers, scholars, and simple admirers. These literary tributes betray great emotion, and the poems are touching even when anonymous, in a foreign language, more or less noble in style, or highly uneven in talent. A tribute by Lucie Delarue-Mardrus, a writer friend of Rodin, concerns Meudon, an ordinary, almost poor suburban town west of Paris, where Rodin moved in 1893. He would later turn Meudon into what Judith Cladel dubbed "the Bayreuth of sculpture."

For two years Rodin rented the Villa des Brillants, buying it when it finally came up for auction on December 19, 1895. Of recent construction, the contrasting colors of its brick and stone immediately set it apart from the others. "The villa, which he calls a 'little Louis XIII chateau,' is not pretty," asserted Rainer Maria Rilke. Yet set in the middle of a vast estate overlooking Val Fleury, it satisfied the sculptor's love of nature. In the turmoil of his waning relationship with Camille Claudel, he sought a quiet, peaceful life away from all official and social obligations. Even as he achieved solitude, however, he remained within easy striking distance of Paris and his workshops, which he could reach by boat or train.

In Meudon, Rose Beuret reigned as a "good farmwife" in all her "peasant coarse-ness," delighted at the mere thought of serving her master. "Madame Rodin was lively and bustling," recalled Cladel. "Her fine head with its characteristic features, its tousled gray hair, and its eyes with the alertness of a wild animal, contained the brain of a child." Assisted by Jean, the valet, and Madeleine, the Breton cook, Rose looked after household tasks and devotedly cared for the horses Moca, Quinola, and Rataplan, the dogs Dora and Lulu, and the cow Coquette, not to mention an old monkey, chickens, and swans.

The interior was plain, with neither luxury nor comfort. Rodin had assembled his entire collection of contemporary paintings there. Outside, antiquities were swallowed by lush vegetation. "A monumental Buddha preached wisdom to visitors with a sacred gesture," said Cladel. Steadily if chaotically, Rodin turned outbuildings into workshops where his staff could execute their special tasks—assistant sculptors, molders, laborers, and the secretaries whom he sometimes housed. To this sprawling shambles he added, in 1901, the reconstructed Alma pavilion (originally built in Paris for the Universal Exposition of 1900) and, between 1907 and 1910, the more whimsical reconstruction of the pediment and partial façade of the Château d'Issy-les-Moulineaux. There he installed his museum, where his own

Above
HARRY C. ELLIS,
**LOIE FULLER, ROSE BEURET, RODIN,
AND AN UNIDENTIFIED BOY ON THE GROUNDS
OF MEUDON.**
GELATIN SILVER NEGATIVE ON GLASS,
7 × 9 ½ IN. (18 × 24 CM).

Facing page, top
ANONYMOUS,
**GENERAL VIEW OF MEUDON WITH THE FAÇADE
OF THE CHÂTEAU D'ISSY-LES-MOULINEAUX,
THE ALMA PAVILION, AND THE VILLA DES BRILLANTS,**
1913.
GELATIN SILVER PRINT,
6 ¼ × 9 IN. (16.2 × 22.7 CM).

Facing page, bottom
ANONYMOUS,
**ROSE BEURET, GRIFFEULHE THE COACHMAN,
RATAPLAN THE HORSE, AND AN UNKNOWN WOMAN
ON THE GROUNDS IN MEUDON.**
GELATIN SILVER PRINT,
3 ½ × 5 ½ IN. (8.9 × 14 CM).

Above
HARRY C. ELLIS,
**RODIN IN FRONT OF THE FAÇADE
OF THE CHÂTEAU D'ISSY-LES-
MOULINEAUX AT MEUDON.**
GELATIN SILVER NEGATIVE ON GLASS,
7 × 9 ½ IN. (18 × 24 CM).

Right
CLAUDE GERSCHEL,
**RODIN STUDYING A HEADLESS
HERCULES IN HIS MUSEUM
OF ANTIQUITIES IN MEUDON.**
GELATIN SILVER PRINT,
8 ¾ × 6 ½ IN. (22.5 × 16.8 CM).

Facing page
JEAN LIMET,
**RODIN WORKING ON SMALL
SCULPTURES UNDER
THE PERISTYLE OF THE ALMA
PAVILION IN MEUDON,**
C. 1912.
ALBUMEN PRINT,
8 ¾ × 6 ¾ IN. (22.3 × 17 CM).

works were shown alongside antiquities. "You must come back here at night," Rodin suggested to Paul Gsell, "we'll shine a lamp over these forms and you'll see all the imperceptible undulations of the modeling, shuddering over the flesh that seems so apparently straightforward. It's fantastic! It's alive! When you feel it, you wonder, 'Say, why isn't it warm?'"

While Meudon was the place where Rodin could be most secluded, contemplative, and visionary, he also enjoyed receiving visitors there. On Sundays he would dine with his faithful friends Carrière, Desbois, Bourdelle, and his patinator, François Limet, who was also an inventor, photographer, chemist, and artist, and toward whom he felt a special warmth. Soon people were arriving from all over the world. Visitors included artists, musicians, writers, politicians, ambassadors and even monarchs, such as King Edward VII of England in 1908.

At the Hôtel Biron

"At the Hôtel Biron, Rodin spends almost all his time drawing. In this monastic retreat, he enjoys shutting himself up with the nudity of pretty young women, making countless pencil drawings of the supple poses they adopt in front of him."

L'Art, Interviews conducted by Paul Gsell, 1911

Every day, Rodin traveled from Meudon to Paris, first to his studio in the Dépôt des Marbres on rue de l'Université and then, from 1908 onward, to the Hôtel Biron, where nuns known as Les Dames du Sacré Coeur had set up a school for the education of young aristocratic girls. In 1904, however, the legal separation of church and state in France meant closure of the convent. Threatened with demolition, the old, disused residence and its outbuildings were rented out by the agent responsible for liquidation. The inner courtyard was flanked by buildings (no longer extant) inhabited by artists as low-cost studios or housing. Unknowns lived side-by-side with future celebrities such as the actor De Max, the writer Jean Cocteau, the dancer Isadora Duncan, the painter Henri Matisse, and the illustrious Austrian poet Rainer Maria Rilke. Rilke had formerly served as secretary to Rodin, with whom he had split and then reconciled. Rilke moved into a ground-floor studio originally occupied by his wife. He had barely moved in when he invited Rodin to pay a visit on August 31, 1908. "My dear friend, you should come see the fine room where I've been living since this morning. Its three windows magnificently overlook an abandoned garden, where from time to time you see wild rabbits hop through the trelliswork, straight out of some old tapestry."

Seduced by the unusual charm of the place, on October 15, 1908, Rodin rented several reception rooms on the ground floor. In a setting less designed for work than for society events, he received admirers, journalists, dealers, and collectors. "In fact, it is the finest dwelling an artist can imagine," wrote Paul Gsell. "Here the creator of *The Thinker* has several large, high-ceilinged halls with white woodwork, decorated with charming molding and gold filleting."

Rodin spent almost all of his time drawing. Installed in one of the rotundas that over-

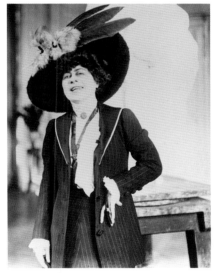

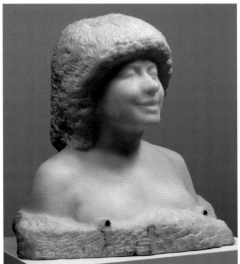

looked the gardens, he "shut himself up," in Gsell's words, "with his models, the way a lover locks an alcove." He henceforth preferred to draw nudes, occasionally in an erotic vein. Rejecting any sense of space, he threw swift, simple strokes down on paper to evoke exclusively female bodies; he would simply blend, or stump, the lines with his figures or highlight them with a little color to suggest flesh.

If the figure of Rose ruled at Meudon, that of Duchesse de Choiseul reigned at the Hôtel Biron. Rodin had bought a gramophone, and his secretary, Marcelle Tirel, who was assigned the task of winding it up, long remembered the Gregorian chants, church music, and airs from *Tosca* that would usually be followed by a dance called a bourée. At which point the

Top
Eugène Druet,
Rodin at his desk in the Hôtel Biron, wearing a beret, 1914.
Gelatin silver print,
8 ½ × 11 ¼ in. (21.5 × 28.3 cm).

Above, left
Anonymous,
The Duchesse de Choiseul in the Hôtel Biron,
c. 1910–12.
Gelatin silver print,
10 × 7 ¾ in. (25.8 × 19.7 cm).

Above, right
The Duchesse de Choiseul,
1911.
Marble,
19 ¼ × 19 ¾ × 12 ½ in. (49 × 50.3 × 31.9 cm).

Facing page
Henri Manuel,
Rodin and the Duchesse de Choiseul in the Hôtel Biron, c. 1911.
Gelatin silver print,
8 ¾ × 6 in. (22.8 × 15.1 cm).

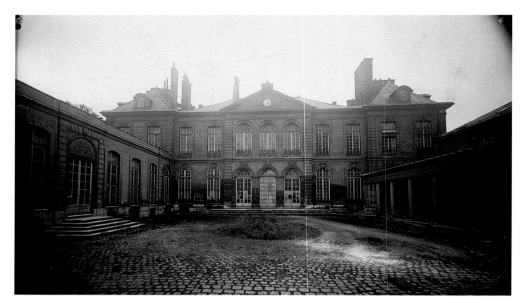

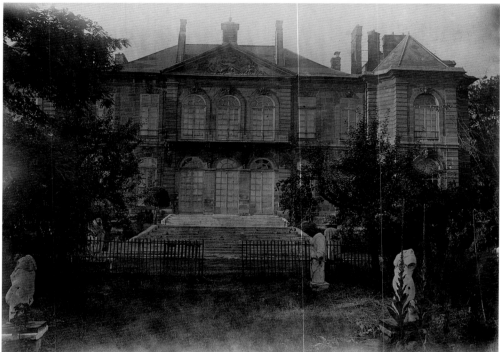

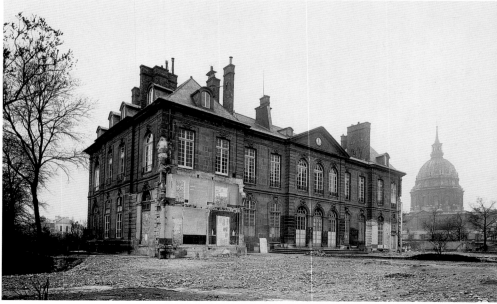

duchesse, thanks to the effects of alcohol, would seize a silk stole and parody—or massacre—the dance with great intensity and will. During the six years their relationship lasted, Rodin unscrupulously dropped his faithful friends to follow the various intrigues plotted by the woman he called his "little bacchante." The bust he made of her in 1908–11 revealed humor and irony in the way it retained the registration marks used during the pointing process, which, as chance would have it, corresponded to the tip of each breast.

Rodin's own works were displayed alongside those of his collection, and a few ancient pieces were placed for his personal pleasure in the garden, which he had let return to a wild state and where he liked to meditate. As Gsell recalled, "He would go into the grounds of Hôtel Biron with his bitch Dora, a German shepherd who growled constantly, showing her sharp fangs and black gums.... The sculptor, brow sheltered beneath a large, black-velvet beret, made his way through the thick vegetation that had invaded the huge garden and turned it into a kind of virgin forest—the lanes where the Dames du Sacré Coeur and their students used to stroll were lost in the wild grasses. The boxwood hedges were no longer trimmed and erupted into unruly growths."

When the state became the owner of the property in 1911, it allocated the southern part of the grounds to a neighboring high school, then threatened to evict Rodin and the other tenants. This sudden, harsh decision prompted the sculptor, then at the height of his international fame, to seriously consider the founding of a museum devoted to his own work. Thus began the long negotiations that eventually resulted in his bequest to the nation.

Top
CLAUDE LÉMERY,
MAIN COURTYARD OF THE HÔTEL BIRON,
C. 1912.
GELATIN SILVER PRINT,
7 × 9 ¼ IN. (18 × 23.8 CM).

Center
ANONYMOUS,
THE HÔTEL BIRON FROM THE GARDEN SIDE.
GELATIN SILVER PRINT,
6 ¾ × 9 IN. (17 × 22.6 CM).

Bottom
ANONYMOUS,
VIEW OF THE HÔTEL BIRON IN A DILAPIDATED STATE, 1913.
GELATIN SILVER PRINT,
6 ½ × 8 ¾ IN. (16.6 × 22.5 CM).

Top
ÉTIENNE CLEMENTEL,
**RODIN ON THE STEPS
OF THE HÔTEL BIRON.**
AUTOCHROME,
1 ½ × 4 IN. (4 × 10 CM).

Bottom
ÉTIENNE CLEMENTEL,
**RODIN IN THE GARDEN
OF THE HÔTEL BIRON,**
C. 1915.
AUTOCHROME,
1 ½ × 4 IN. (4 × 10 CM).

"Admiring things is a pleasure that begins each day anew...."

Rodin, quoted by Judith Cladel

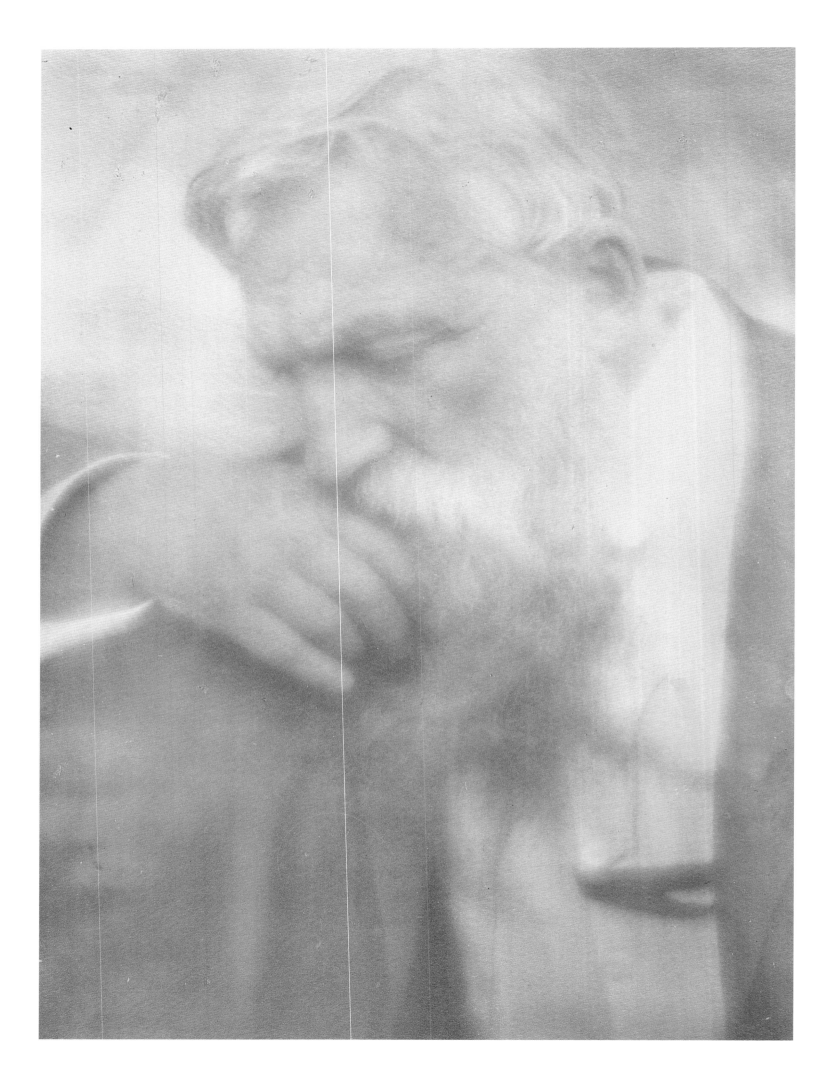

SOURCES OF INSPIRATION

In both work and life, Rodin always displayed a desire to explore all the possibilities triggered by his curiosity, drawing lessons from them in order to extend his mastery over his art. Direct observation, stimulated during his art-school training at the Petite École, assumed increasing importance over the years. Anything was potentially valid, as long as it provided inspiration and made him think about his work. Furthermore, a sense of infinite perfectibility never left him—which is one of the reasons he had so much difficulty completing specific works. More than just an artist in the conventional sense of the term, Rodin became, with age and the guarantee of success, a blazer of new trails. His felt that his art could not remain at a standstill, or else it would regress. During his career, he thus stumbled upon influences and genres that produced a kind of aesthetic shock, clearly seen in the development of his drawing as well as his sculpture. These confrontations were usually chance encounters, not governed by prevailing fashion or trends. That perhaps explains their intensity and sincerity; it certainly explains his freedom as an artist, even if that freedom did not go as far as the fierce independence of someone like Degas.

Dance

By its very nature, dance could hardly fail to offer Rodin a realm of observation and inspiration far exceeding conventional posing sessions with models. And yet, unlike Degas, Rodin was not very interested in classical ballet: "Seeing our opera ballets . . . I do not understand how the Greeks could have ranked dance above everything." Goncourt confirmed this comment: "[Rodin] finds our ballet too leaping, too fluttery." In contrast, he was enthusiastic about a performance by a Javanese dance troupe at the Universal Exposition of 1889, and immediately made several drawings of it. His fascination with Oriental dance was sparked again in 1906, when Rodin attended a performance by Cambodian dancers who came to Paris as part of the state visit of the young monarch of Cambodia, King Sisowath (of whom Rodin made several drawings). Fascinated by the show given at the Pré Catalan in the Bois de Boulogne on July 10, Rodin followed the Cambodian troupe to Marseille, where it was scheduled to perform at the Colonial Exposition there. "I watched them ecstatically," he told Louis Vauxcelles. "What a void they created in me when they left—I was in the dark and cold, I felt they'd

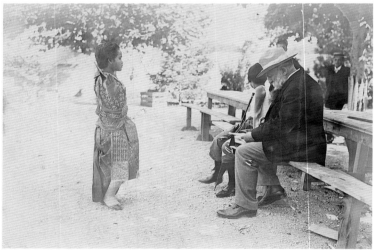

**THREE STUDIES OF CAMBODIAN
DANCERS' HANDS, 1906.**
GRAPHITE, WATERCOLOR,
AND GOUACHE ON CREAM PAPER,
13 × 7 ¼ IN. (33.3 × 18.7 CM).

**WOMAN (AFTER HANAKO),
C. 1906–07.**
GRAPHITE ON CREAM PAPER,
12 ¼ × 7 ¾ IN. (30.9 × 19.5 CM).

ÉMILE SANREMO,
**RODIN IN MARSEILLE, DRAWING
A CAMBODIAN DANCER, 1906.**
GELATIN SILVER PRINT,
4 ¾ × 6 ½ IN. (12 × 17 CM).

**CAMBODIAN DANCER, FRONT VIEW,
1906.**
STUMPED GRAPHITE, WATERCOLOR,
AND GOUACHE HEIGHTENED
WITH SOFT PENCIL ON CREAM PAPER,
13 ¾ × 10 ½ IN. (34.8 × 26.7 CM).

taken all the beauty of the world with them. . . . I followed them to Marseille; and would have followed them to Cairo!" In Marseille, Rodin produced approximately one hundred and fifty watercolors from life, including some remarkable studies of hands.

The following year, the American dancer Loie Fuller encouraged Rodin to attend a show by a Japanese troupe that featured a former geisha, Ota Hisa, rechristened Hanako. Fascinated by her, Rodin had Hanako pose on numerous occasions between 1907 and 1911, resulting in drawings and some fifty sculptures (the most extensive of all his series). He found Hanako's anatomy to be "completely different from European women, yet extremely beautiful, too, and uniquely powerful." Rodin was able to perceive in Hanako—and convey in his works—alternating expressions of anguish, sorrow, pain, and reverie; he even tried to glimpse in her the physiognomy of Beethoven, whom he greatly admired.

At the turn of the twentieth century, Western dance sought to recover its ancient roots, freeing the body of all artifice and giving it a certain freedom once again. Loie Fuller, Isadora Duncan, and later the Ballets Russes thus represented a new source of inspiration for Rodin. Fuller had wowed Paris audiences as early as 1892; her choreographic innovations earned her the admiration of Mallarmé and Toulouse-Lautrec, among others. With Rodin she conducted a voluminous correspondence, and on several occasions even undertook

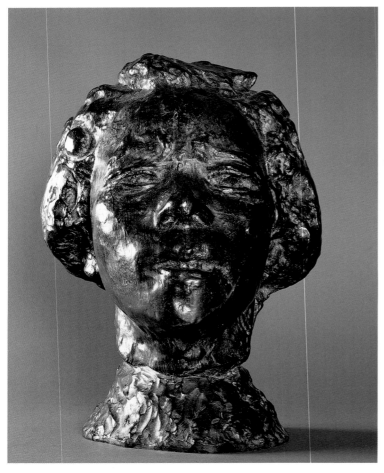

Above
HEAD OF HANAKO (TYPE D), ALSO CALLED
DREAD OF DEATH (LARGE MODEL)
OR LARGE MASK OF HANAKO, 1908–1912.
BRONZE (CAST 1969),
21 × 15 ¼ × 11 IN. (53.5 × 39 × 28 CM).

Right
HANAKO.
ARISTOTYPE,
4 × 2 ¾ IN.
(10.2 × 6.9 CM).

to promote him in the United States—although in dubious conditions that apparently aroused a certain wariness in him. Toward the end of Rodin's life, Fuller—muddleheaded and certainly self-interested—behaved in an equivocal fashion. Judith Cladel, who felt no affection for the dancer, condemned Fuller in her book on Rodin, castigating "the maze of [Fuller's] verbiage, an unheard-of blend of mercantilism, vanity, and extravagance bordering on madness," not to mention Fuller's "rage to possess."

In 1912, Rodin came into contact with another great dancer when Nijinsky posed for him. Rodin had particularly liked Nijinsky's performance in *L'Après-midi d'un faune*, choreographed to the music of Debussy by the dancer himself, which premiered that very year at the Théâtre du Châtelet in Paris. "It was youth in all its glory, as in the days of ancient Greece, when people knew the power and beauty of the human body and worshiped it. What grace, what suppleness!" Fully aware of what these innovations could offer him, Rodin told Mallarmé, on whose poem the ballet was based, "We like Loie Fuller, Isadora Duncan, and Nijinsky so much because they have recovered freedom of instinct and rediscovered the meaning of a tradition based on a respect for nature."

Above
LANGFIER,
LOIE FULLER DANCING,
UNDATED.
ALBUMEN PRINT,
4 × 5 ½ IN. (10.1 × 13.9 CM).

Drawn to an artist so clearly able to understand them, dancers flocked to Rodin. According to Cladel, "there wasn't a well-known dancer who didn't want to dance for him." Indeed, many photographs preserved by the Musée Rodin record performances or demonstrations given in Rodin's presence, notably dances by Isadora Duncan, sometimes flanked by her students (pictured on the grounds of the Hôtel Biron or during events such as the banquet organized for Rodin in Vélizy in 1902). The dance movements that Rodin sculpted—small figurines in which only the expressiveness of the body is at stake—suggest warming-up exercises more than veritable choreography, but they offer a remarkable illustration of what Terpischore's art could inspire in Rodin, and the way he incorporated it into his work.

It is therefore no coincidence that Rodin's oeuvre struck a chord in a great number of choreographers whose explorations of physical expressiveness responded closely to his own. It matters little whether this was a conscious choice or coincidence, for Rodin's genius was able to link sculpture and painting so closely that their shared exploration of the human body inevitably converged.

Rodin and the Far East

Rodin's enthusiasm for Cambodian dancers and for Hanako reflected his broader interest in Far Eastern art. Once he had become established, notably after setting up his workshop in Meudon, he began actively collecting objets d'art from India, Japan, and China, which he chose

Top
ARNOLD GENTHE,
ISADORA DUNCAN,
1916.
ARISTOTYPE,
7 × 7 ½ IN.
(17.8 × 19.2 CM).

Above
NIJINSKY IN L'APRÈS-
MIDI D'UN FAUN,
1912.
PHOTOGRAPH,
MUSÉE D'ORSAY, PARIS.

Above
LEAD DANCER NICHOLAS LE RICHE
IN THE PRODIGAL SON,
CHOREOGRAPHED BY GEORGE
BALANCHINE.
OPÉRA NATIONAL DE PARIS.

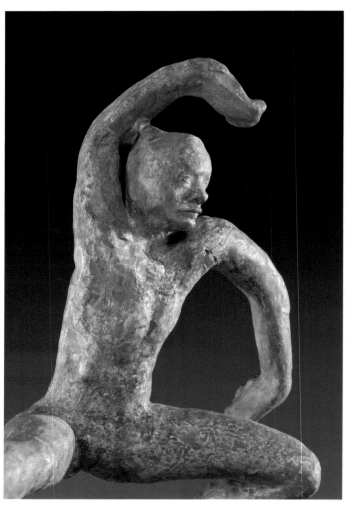

DANCE MOVEMENT F, C. 1911.
PLASTER,
10 ½ × 10 ¼ × 5 ¾ IN.
(26.8 × 26.2 × 14.5 CM).

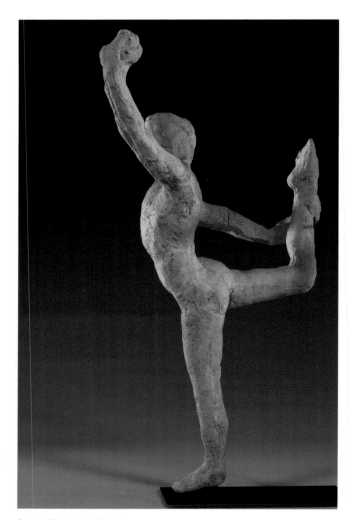

DANCE MOVEMENT E, C. 1911.
TERRACOTTA,
14 ¾ × 4 ¾ × 10 ¼ IN.
(37.5 × 12.2 × 26 CM).

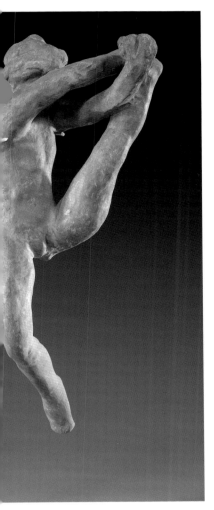

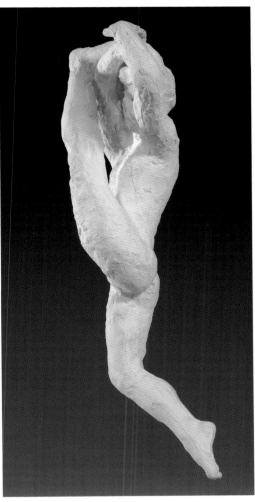

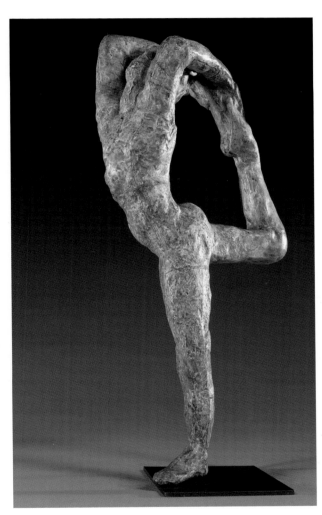

**DANCE MOVEMENT, CALLED
PAS DE DEUX B, UNDATED.**
PLASTER,
13 ¼ × 4 ¼ × 4 ¾ IN.
(34 × 11 × 12.5 CM).

DANCE MOVEMENT G, C. 1911.
PLASTER,
12 ¾ × 4 ½ × 3 ¼ IN.
(32.5 × 11.5 × 8.5 CM).

ADANCE MOVEMENT A, C. 1911.
PATINATED PLASTER,
12 ½ × 3 × 6 IN.
(31.5 × 8 × 15.7 CM).

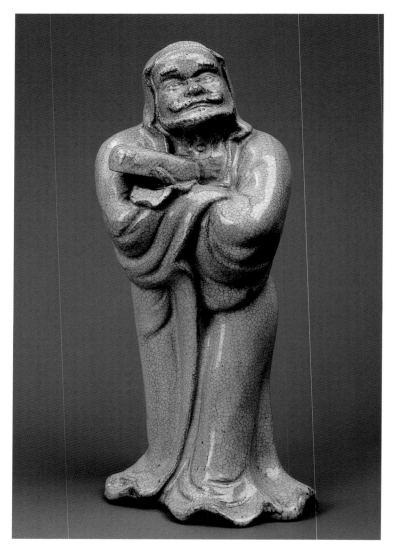

for aesthetic quality alone, independently of any fashion for the picturesque or the exotic. Above all, Rodin liked to immerse himself in a completely unsystematic blend of diverse influences, thereby provoking unlikely encounters that were conducive to new inspiration.

The grounds at Meudon thus featured a Buddha that impressed Rilke, and that seemed to watch over a world of ancient stone and other vestiges. The Japanese objects collected by Rodin were also very diverse: masks from the Noh theater, pottery, cloisonné enamels, and some two hundred prints and stencils. An admirer of Japanese prints, he bought van Gogh's *Portrait of Old Tanguy* partly because the background featured ten such prints. These works even inspired Rodin to alter his way of drawing, slowly abandoning details for line and for a style that he himself described as "Japanese art with Western methods." This Oriental influence was noted by art critic Roger Marx, who in 1896 wrote that Rodin's "graphic skill . . . is today. . . more summary, condensed; this synthesis can be seen in a series of drawings done not from memory, but from a life model sometime around the summer of 1896; they could be fairly accurately called snapshots of female nudes, which means getting the outline of a contour in a single a stroke, freehand, finely sketched on card; which means

defining a nude through that outline then modeling it with a light drop of watercolor; which means grasping a hundred unconscious, transient poses, recording the most fleeting aspect of beauty. Purely external similarities have sparked a comparison between these high-lighted drawings and Japanese woodcuts."

Rodin also displayed a sustained interest in Indian art. In a 1912 issue of *Ars Asiatica*, he published his comments on photographs of Indian bronzes in a museum in Madras. These texts were written at the request of Victor Goloubeff, a member of the École Française d'Extreme-Orient, whose wife had posed for Rodin in 1905–06 and whose bust he executed.

Rodin, Women, and Eroticism

The art of Japanese printmaking and its handling of the human body certainly influenced Rodin's style, but we should not forget that this already represented familiar ground for the sculptor. Indeed, the female body was his main source of inspiration, and he claimed that women understood him better than men. Women naturally occupied pride of place in his sculpture, and it was by tirelessly modeling women that Rodin went furthest in his handling of the human body, seeking to grasp its most complex and most

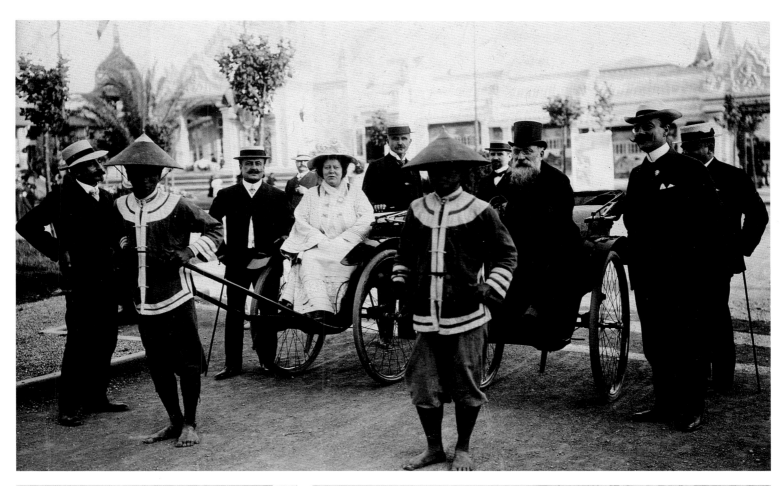

Facing page, left
**FIGURE OF DARUMA
(BODHIDHARMA) FROM
RODIN'S PERSONAL
COLLECTION,**
JAPAN, 19TH CENTURY.
CERAMIC,
12 1/4 × 5 3/4 × 4 3/4 IN.
(31.3 × 14.5 × 12.5 CM).

Facing page, right
**SIGNED LETTER FROM
RAINER MARIA RILKE
TO RODIN, NOVEMBER 19, 1905.**
9 × 5 3/4 IN. (22.8 × 14.5 CM).

Top
**RODIN AND LOIE FULLER IN
RICKSHAWS AT THE COLONIAL
EXPOSITION IN MARSEILLE, 1906.**
GELATIN SILVER PRINT,
4 1/2 × 6 1/2 IN. (11.7 × 16.7 CM).

Bottom left
**AN ISSUE OF ARS ASIATICA,
THIRD VOLUME OF STUDIES
ON SHIVAITE SCULPTURE
IN INDIA, 1912.**
13 3/4 × 10 3/4 IN. (35 × 27.5 CM).

Bottom right
**AN ALBUM OF PERSIAN
MINIATURES FROM
RODIN'S COLLECTION.**
ILLUMINATED MANUSCRIPT,
13 1/2 × 16 1/2 IN. (34.5 × 42 CM).

extreme possibilities. Works such as *The Martyr, Crouching Woman,* and *Iris, Messenger of the Gods* reflected these explorations and projected a sensuality sometimes bordering on eroticism, as does the group called *Eternal Idol,* a clear allegory of Rodin's abiding admiration for female genitalia.

Thanks to his experience and success, in the 1890s Rodin thus began to draw the female body without constraint—no longer models simply adopting a pose, but the body in constant movement. His technique evolved to the point where he could draw without looking at the paper, the better to concentrate solely on the figure he was studying. The perceptible development in his style, especially following the drawings for *The Gates of Hell,* owed more to Michelangelo than to Rembrandt and testified to his tireless exploration. Many of Rodin's contemporaries, unaware of his personal quest, viewed the hundreds of erotic drawings that he did as the work of a libidinous old man, "in full satyr mode," as Goncourt put it when referring to Rodin's uninhibited enthusiasm for his own collection. The chronicler

Below and facing page
ETERNAL IDOL, 1889.
PLASTER,
28 ¾ × 23 ¼ × 16 IN.
(73.2 × 59.2 × 41.1 CM).

Right
IRIS, MESSENGER OF THE GODS, 1895.
BRONZE (CAST BY A. RUDIER PRIOR TO 1916),
32 × 21 × 24 ¾ IN.
(82.7 × 69 × 63 CM).

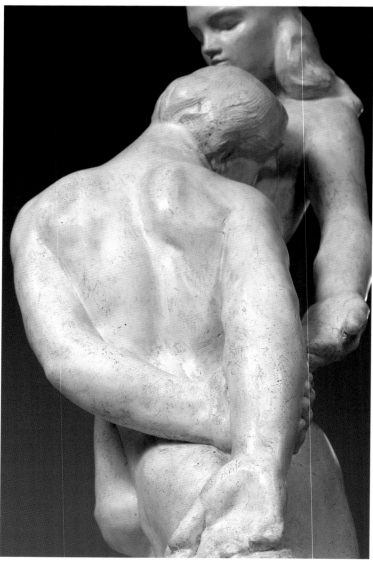

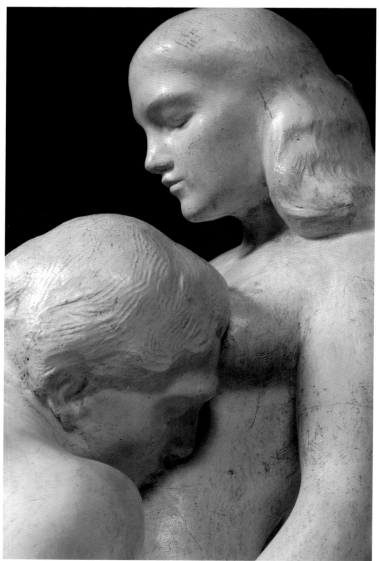

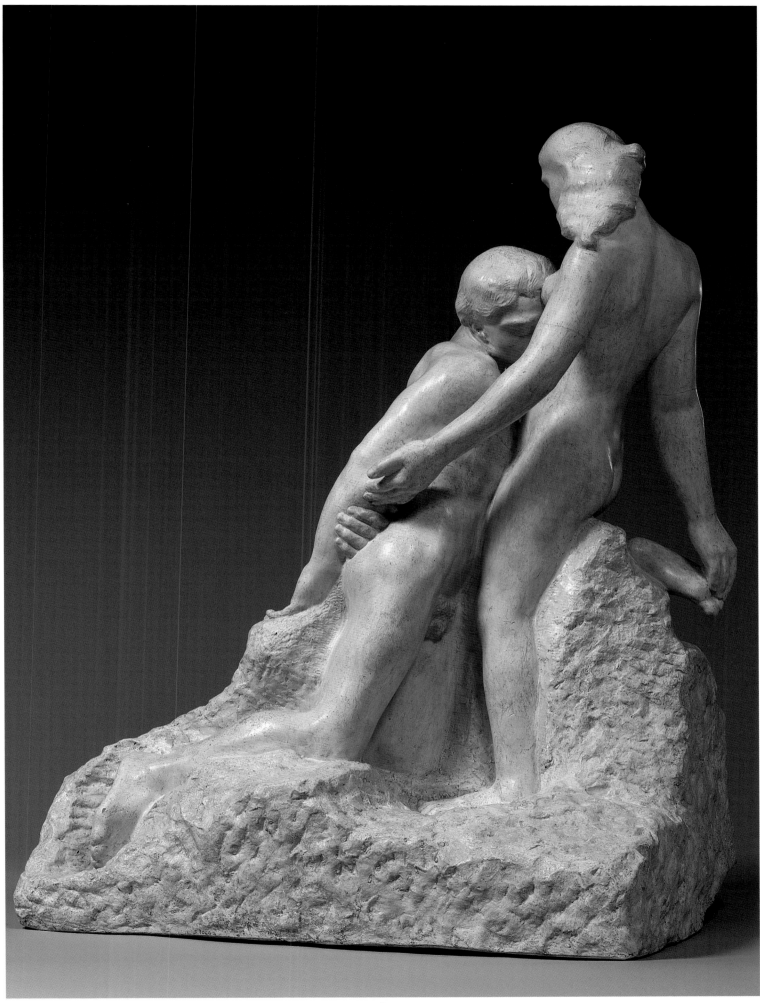

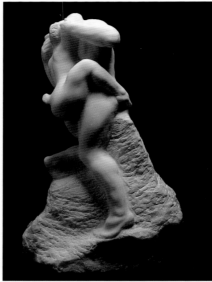
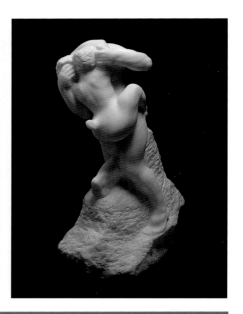

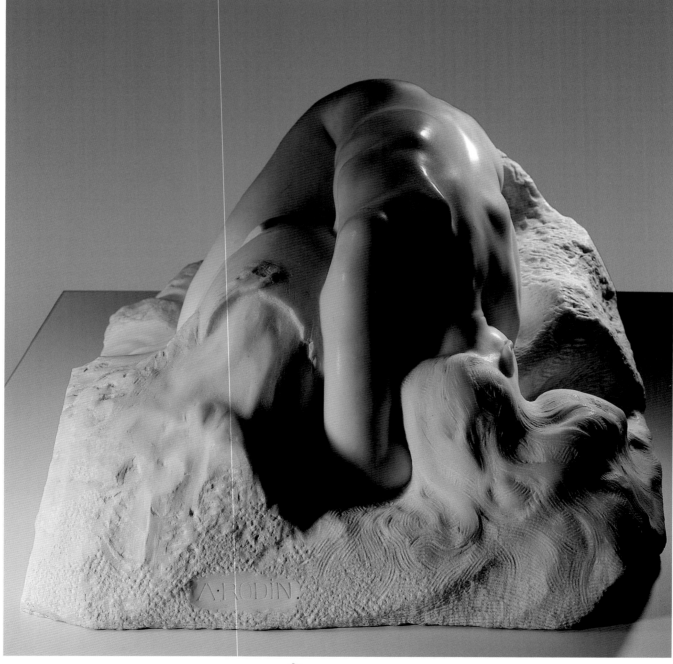

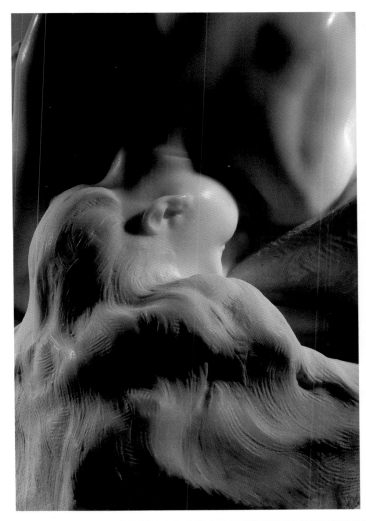

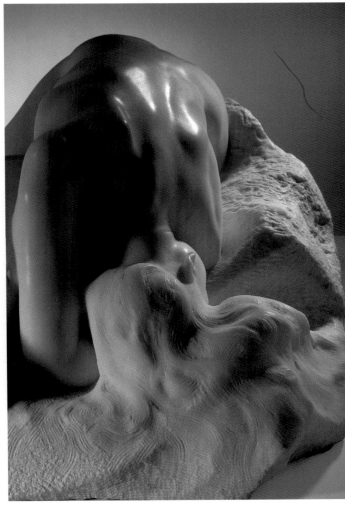

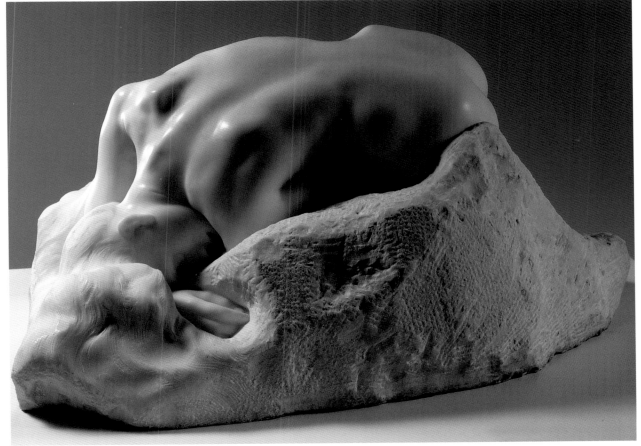

Facing page, top
SIN, UNDATED.
MARBLE,
24 ¾ × 15 ¼ × 12 IN.
(63 × 39 × 30.5 CM).

This page and
facing page, bottom
DANAID, UNDATED.
MARBLE,
14 × 27 ½ × 21 ¼ IN.
(36 × 70 × 54 CM).

noted the sculptor's "wonderment before the downward spill of all these women with their legs in the air, all these heads thrown back, all the wiry, flailing arms and clenched feet, all this voluptuous and frenzied reality of coitus, all these sculptural weavings of bodies entwined and commingled in a spasm of pleasure." Goncourt was not the only person to contribute to Rodin's reputation for raciness; scandal was constantly simmering and sometimes exploded in violent eruptions, as in 1906 when Count Harry Kessler, director of the grand-ducal museum in Weimar, was forced to resign after having exhibited Rodin's drawings of nudes. Things even took a frankly silly turn when, in 1912, the press debated whether Rodin should or should not be allowed to remain at the Hôtel Biron, since it had formerly been a religious institution. Gaston Calmette, the editor of *Le Figaro*, reminded his readers that "contrary to all propriety, [Rodin] is exhibiting a series of libidinous drawings and shameless sketches in the former chapel of the Sacred Heart and in the rooms of the Hôtel Biron vacated by the nuns."

Rodin left an impressive corpus of drawings of nudes that glorified the female body, lovingly caressed in pencil. Aware, however, that these drawings might shock an unprepared—or poorly prepared—public, he declared in 1910, "I don't say that my drawings should be announced with the sound of trumpets. To the contrary, they should be gently protected so that the public doesn't rise up in revolt." Affected by the harsh attacks made against him, he defended himself once more in 1912 to journalist Raoul Aubry: "Today people attack the morality of my pencil and accuse me of licentious ideas! I have never exhibited certain drawings that were purely personal work, private research, studies done for my use alone and which never left my boxes. . . . As to drawings that have been shown many times, they are anything but licentious." In fact, the sculptor's friends and

admirers unanimously defended Rodin against the charges of immorality laid against him. The loyal Judith Cladel, who was responsible for drawing up an inventory of his drawings at the end of his life, suggested two possibilities.

During the inventory process in Meudon, there was not a single [sculpted] figure or group that could really shock the modesty—so often insincere—of Western eyes. As to the drawings and watercolors. . . at most some thirty very fine watercolors and some twenty pencil drawings, plus the same number of sketches, are private in nature. Are they simply studies that, stripped of their status as art, would be filed under the heading of gynecological plates? . . . Or, on the contrary, are they the proof of a satyric obsession, of what has been called 'Rodin's erotic madness'? . . . It is hard to decide.

Rather than coming down on one side or other, we will simply say here that, in every case, it is clear that a constant *odor di femmina* was essential to the expression of Rodin's creative genius.

Rodin and architecture

Rodin executed nearly two thousand architectural sketches and drawings, ranging from overall views to details of moldings and ornamentation. During his travels and outings he would sketch buildings from the past, with a predilection for old churches. Goncourt reported in 1888 that the artist "sometimes vanishes from home for a few days. No one knows where he has gone. When he comes back and we ask where he's been, he says, 'I've been looking at the cathedrals.'" Rodin's love of architecture never waned.

In his famous conversations on art with Paul Gsell, Rodin recounted how one of his early teachers, Constant Simon, had taught him the art of modeling by advising him to fashion the leaves of a capital

"not laterally, but always in depth, with the tip pointing toward you." Rodin's simple but precise draftsmanship still has the power to amaze. In just a few lines he was able to capture the essence of a building or the subtlety of a detail as demonstrated, for example, by his drawing of the Medici tomb in Florence. His notebooks contain hundreds of drawings of windows, gargoyles, pilasters, flame ornaments, and fireplaces, sometimes hard to identify. In his book on cathedrals, he even made an eloquent connection between sculptors and architects who, like himself, "knead and model." In Rodin's eyes, a sense of detail was crucial: details of pilasters, friezes, and capitals filled twenty-three of the hundred plates in his book *Cathedrals of France*, testifying to his fascination with architectural decoration.

When Rodin began *The Gates of Hell*, he was conscious of combining two arts: "I'm becoming an architect. I have to, because I will add what is lacking to my Gates." This conception of things became even more marked when he developed his model of *The Tower of Labor*, a huge project that was supposed to serve as a receptacle for the countless figures that had sprung from his imagination. Rodin thereby devised an architecture that was primarily designed to present his own work. *The Tower of Labor* inevitably invokes the notion of *gesamtkunstwerk*, the "total artwork" envisaged by another genius, the composer Richard Wagner, to whom Rodin has been compared.

It was Rodin's taste for architecture that also led him to give the title of *The Cathedral* to one of his famous works. Employing his assemblage technique to join two identical right hands, Rodin thus composed a surprising allegory of the Gothic arch, one with extraordinary symbolic power.

His veritable veneration of architectural heritage naturally led Rodin to object to the demolition of an eighteenth-century château at nearby Issy-les-Moulineaux, and then to save part of it, which he rebuilt on his estate in Meudon. And, like many other people outraged by the destruction caused by artillery during the First World War, he could not find terms harsh enough to condemn the barbaric fate that befell Reims Cathedral. Writing to Romain Roland from London, where he was staying at the time, Rodin complained, "Ignorance is so great everywhere that people think they can repair and redo a cathedral! But it's like burning the library in Alexandria, burning the temple in Jerusalem."

Page 188
RECLINING WOMAN, HALF NUDE, ARM OVER HER HEAD, UNDATED.
STUMPED GRAPHITE AND WATERCOLOR ON CREAM PAPER,
7 ¾ × 12 ½ IN. (20 × 31.1 CM).

Page 189
NUDE WOMAN WITH ANOTHER FIGURE (OF WHOM ONLY THE HAND IS VISIBLE) AND NUDE WOMAN IN PROFILE, HANDS CLASPED, UNDATED.
GRAPHITE AND WATERCOLOR ON TWO PIECES OF PAPER, CUT OUT AND ASSEMBLED,
12 ¾ × 8 IN. (32.5 × 20.6 CM).

Facing page
PORCH OF A CHURCH,
c. 1909–13.
GRAPHITE,
6 × 4 IN.
(15 × 10 CM).

This page, top
THE MEDICI TOMB, FLORENCE, UNDATED.
ALBUMEN PRINT INSCRIBED IN INK: MÊME MOTIF QU'À AMBOISE, PORTE CHARLES VIII (SAME MOTIF AS THE CHARLES VIII GATE AT [THE CHÂTEAU OF] AMBOISE),
3 ½ × 2 ¼ IN. (9.3 × 5.8 CM).

Right
THE MEDICI TOMB IN FLORENCE,
c. 1875–76.
GRAPHITE ON CREAM PAPER,
10 ¼ × 13 IN. (26.4 × 33 CM).

6584

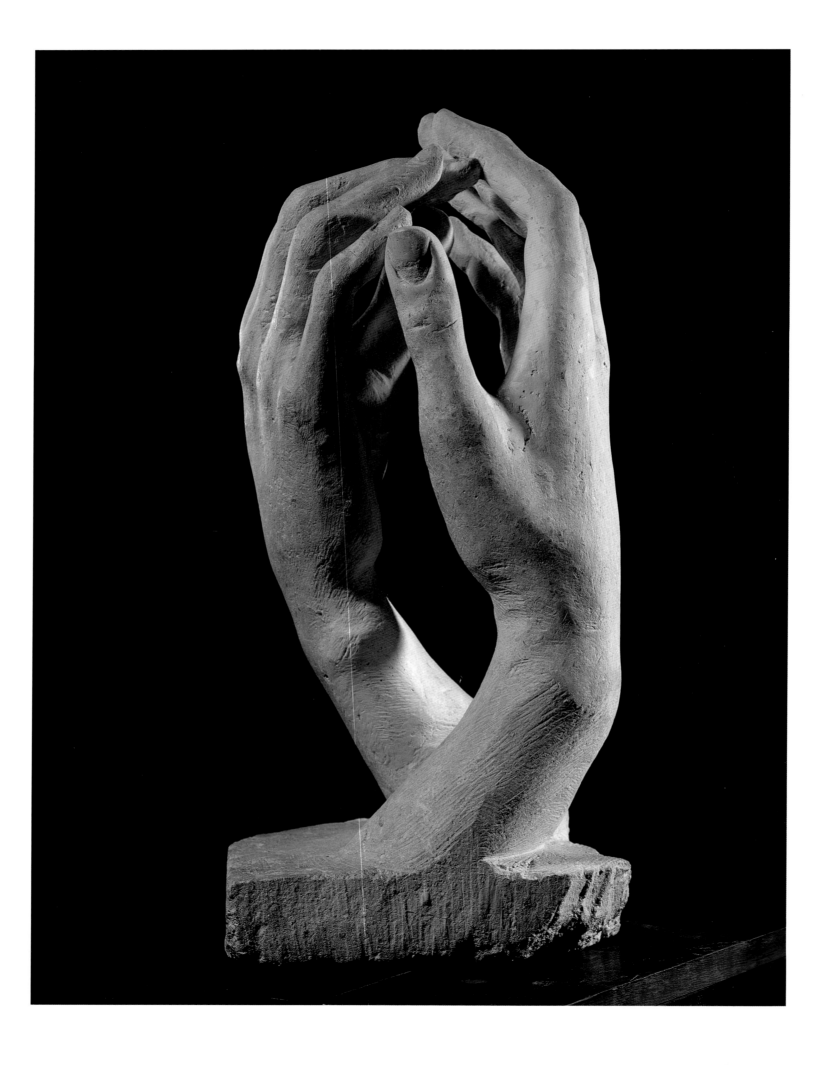

Top
**BELLTOWERS, SAINT-JEAN-DU-GRAY
IN ATHÉE-SUR-CHER AND
IN BEALIEU-LÈS-LOCHES; CHARLEMAGNE
TOWER IN TOURS, UNDATED.**
PEN AND BROWN INK,
9 ¾ × 6 ¼ IN. (25.1 × 16 CM).

Literature

"In my youth, I felt that reading a poem, for example, could help me understand my art." Like many artists, Rodin professed a taste for literature and poetry; yet he was primarily a serious-minded rather than enthusiastic reader of ancient authors such as Homer, Virgil, and Ovid, and of Romantic ones such as Hugo, Musset, and Lamartine. He delighted in other, more occasional reading, such as Dante. Edmond de Goncourt nevertheless questioned his ability to appreciate and judge literary works. "In the end," he noted in 1889 concerning *The Divine Comedy,* "the sculptor Rodin falls too much for the *antiquitous* side of old literature, and doesn't have Carpeaux's natural taste for modernity. In Rodin's uneducated, laborer's brain, Dante becomes a narrow, stupid religion, a fanaticism that excludes admiration for the present." This judgment is perhaps too severe when it comes to describing a man who could recite Baudelaire by heart.

Rodin's relationship to literature can be seen in different lights, depending on whether we consider the man or his work. The two are

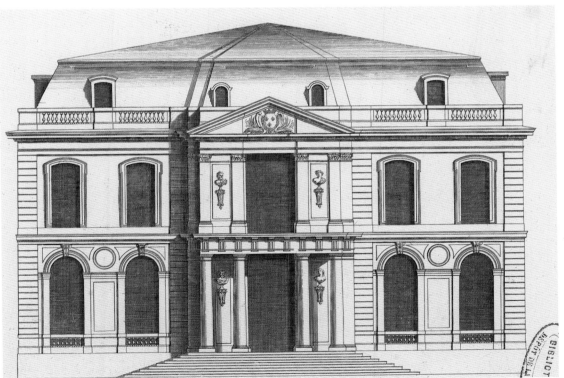

Bottom
JEAN MARIETTE,
**MAIN ELEVATION OF THE ENTRANCE FAÇADE
OF THE CHÂTEAU D'ISSY, BELONGING
TO MONSEIGNEUR THE PRINCE DE CONTY,
NEAR PARIS.**
ENGRAVED PLATE FROM L'ARCHITECTURE
FRANÇOISE, AN ANTHOLOGY OF FRENCH
ARCHITECTURE PUBLISHED IN PARIS IN 1727,
9 ¾ × 13 IN. (25.2 × 33.1 CM).
LIBRARY, SERVICE HISTORIQUE DE L'ARMÉE DE
TERRE, VINCENNES.

Facing page
CATHEDRAL, 1908.
STONE,
25 ¼ × 11 ½ × 12 ½ IN.
(64 × 29.5 × 31.8 CM).

sometimes linked: Rodin the portraitist produced busts of famous writers of his day, and with some of them he maintained relationships of mutual admiration and sometimes even mutual understanding. Worth mentioning in this context are Octave Mirbeau, Henry Becque, Anna de Noailles, George Bernard Shaw, and Gustave Geffroy. Furthermore, Rodin received an impressive number of books with dedications from the author, on highly varied and sometimes surprising subjects. The library at the Musée Rodin boasts some very fine dedications, such as the one in verse by Robert de Montesquiou in his *Hortensias Bleus*:

Vous avez pris des blocs des neiges éternelles,
Et vous leur avez dit : « que la lumière soit »
Les blocs ont pris des attitudes solennelles,
L'une s'est envolée, et l'autre se rassoit

Vous avez pris des pans énormes de ténèbres
Et vous leur avez dit : "Levez-vous et marchez!"
Et les ténèbres ont cessé d'être funèbres
Pour devenir de nobles sphinx aux sens cachés.

[You have taken blocks of eternal snow
and said to them: "Let there be light."
The blocks all adopted a solemn pose—
some soared high, others sat tight.

You have taken vast panels of darkness
and said to them: "Rise up and walk!"
And the darkness ceased to be cheerless,
becoming noble riddles that talk.]

The most moving dedication was certainly the one written by Rainer Maria Rilke on the first page of his collection of poems, *Der neuen Gedichte anderer Teil* (*New Poems*) published in Leipzig in 1908: "My finest efforts are trapped in a language that is not your own. I'm offering you a book that you cannot read. By inscribing your glorious name in it, I'm acknowledging that your immense example contributed greatly to my education in producing an intense, sincere work." These lines sum up the relationship between Rilke and Rodin, between boundless admiration and benevolent condescension.

In 1887, at the request of bibliophile and publisher Paul Gallimard, Rodin illustrated a copy of Baudelaire's *The Flowers of Evil*. His task was to illustrate each poem in the margins of this volume, which was none other than a highly rare copy of the first edition of 1857 (the publication of which caused one of the greatest literary scandals of the Second Empire). Rodin also added a few wash drawings on Japan paper, incorporated in a binding produced by Marius Michel. Already exceptional from a historical and artistic standpoint, this copy is also a priceless piece of bibliophilia, for it combines the names of Baudelaire, Gallimard (a major figure in French publishing), Rodin, and Michel (one of the most famous bookbinders of the day). It was purchased by the Musée Rodin in 1931, thanks to the generosity of D. David-Weill and Maurice Fenaille.

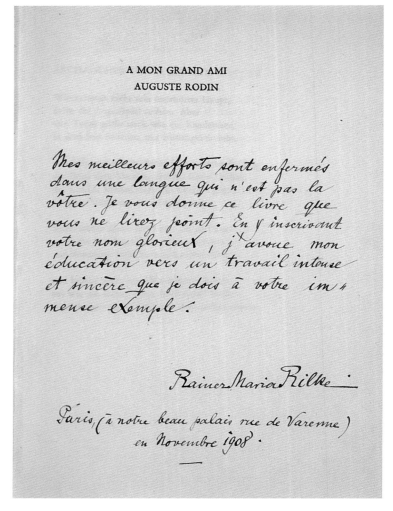

RAINER MARIA RILKE,
HANDWRITTEN DEDICATION TO RODIN
IN DER NEUEN GEDICHTE ANDERER TEIL, 1908.
7 ½ × 5 ½ IN. (19 × 14 CM).

For this project Rodin reused drawings initially done for his early research into *The Gates of Hell*, but he also drew on certain other works such as *Orpheus and Eurydice*, *Meditation*, and *The Thinker*. The remaining illustrations testify to his great knowledge of Baudelaire's poetry (he once considered sculpting a memorial statue of the poet). In 1918, a modern-book society known as the Société des Amis du Livre Moderne, whose president was none other than Paul Gallimard, published a facsimile edition of Rodin's illustrated version, limited to two hundred copies. Other editions would follow, the most recent dated 1983.

A second illustration project by Rodin involved a collaboration with his friend Octave Mirbeau, who had just completed a racy novel titled *Le Jardin des supplices* (*The Garden of Torture*). The friendship between Rodin and Mirbeau was based on a solid foundation of mutual admiration and empathy, to the extent that certain journalists claimed Mirbeau had "invented Rodin the way Zola invented Manet." Their collaboration progressed in stages. In 1897, Mirbeau wrote the preface to the first collection of drawings by Rodin to be published, now known as the Goupil Album after the publisher who produced

the lavish edition. The idea of working more closely with Mirbeau grew in Rodin's mind—he drew a portrait of Mirbeau on the cover of a copy of *Sébastien Roch* owned by Edmond de Goncourt. In 1899, Rodin illustrated the frontispiece of *Le Jardin des supplices,* published by Charpenter & Fasquelle. Given the popularity of the book, the publisher launched a subsequent luxury edition for which Rodin did twenty illustrations, lithographed by the highly talented printmaker Auguste Clot. This edition, financed by art dealer Ambroise Vollard, was finally published in 1902, comprising two hundred numbered copies on three different qualities of paper.

Just prior to the war, Rodin wanted to publish a book on cathedrals based on the ideas, personal notes, and sketches he had been gathering for many years. It was a risky gamble because the sculptor was a very shaky writer—studding his texts with grammatical mistakes and sometimes fanciful spellings—and had never published anything without calling on the services of colleagues to formulate correctly the ideas he wanted to express. But toward the end of his life, obviously listening complacently to the flatterers around him, he began to think that he could promote his own ideas, hastily and chaotically jotted down in a multitude of notebooks and datebooks. It is impossible not to acknowledge the platitudinous quality of most of his inconsistent and sometimes incoherent comments, penned by a man who of course displayed great sensibility but no skill whatsoever in the art of writing, which betrayed him more often than it served him. For that matter, Rodin sometimes disconcerted even sympathetic audiences. One day he was to give a talk on cathedrals to a society gathering; he listened to Judith Cladel read a text, then launched into an amazing monologue. As recounted by Comtesse de Pange in her memoirs, "Poor Judith read a banal text on medieval art, surely not written by Rodin, after which the *Maître,* stroking his long beard, stood up, having decided to add a few words. He launched into a strange, hour-long tirade, comparing the Gothic cathedral to a woman's body, employing the most highly sensual images. The effect on the gathering of pious ladies was appalling!"

In 1914, the Armand publishing house issued the first edition of *Les Cathedrals of France.* In a long monologue that lacked specific order, Rodin—aided by Charles Morice, who worked tirelessly to try to get the text into shape—let his thoughts wander on buildings he

**Rodin's frontispiece,
printed by Auguste Clot,
for Octave Mirbeau's
Jardin des supplices.**
Printed in Paris, 1899.
9 ¾ × 6 ¼ in. (24.9 × 16 cm).

**Galley proofs of
Les Cathédrales de France,
corrected by Rodin, c. 1914.**
12 ¾ × 9 ¾ in. (32.5 × 25 cm).

discussed in a manner more poetic that scholarly. The originality of the book resides above all in Rodin's illustrations—sketches that were vigorous and accurate, if done in a style totally unexpected for a publication of this type, at least as far as most critics were concerned. Despite a few fierce articles on "all the gibberish" it contained, Émile Mâle—then the leading authority on medieval art—wound up endorsing this unusual book, whose true significance he was one of the few to grasp. "Don't expect to find the history of cathedrals, nor their laws of equilibrium, nor an explanation of their encyclopedia of stone. These are quivering notes, noble thoughts, fine metaphors." Although packed with errors and approximations, the text is revealing of Rodin's sensibility, and even contains interesting details on his conception of art and on the development of his taste. In this respect, it remains a rich source for acquiring an understanding of the artist.

Rodin's personality nevertheless emerges more fully in his correspondence, which he often wrote with the help of his long string of secretaries. A few private letters, addressed notably to Rose Beuret and Camille Claudel, show a man of simple tastes and sometimes

clumsy yet sincere thoughtfulness, such as a note written in Rome in 1915: "My darling Rose, I send you my kindest regards, and I guess you'll open my letter in the garden, in the sunshine, and you'll be eating strawberries. Thinking of you, your loving friend." Much better than pompous, bombastic, empty phrases destined for the gallery or motivated solely by commercial considerations or propriety, these words can still move us, because they were written by a man whom success had placed in a social situation for which he was clearly not made, yet which he did not have the courage—or desire—to give up.

Rodin and music: An unlikely encounter

Although sensitive to music, Rodin was not what we would call a musician. Music is nevertheless present—from near or afar—in much of his oeuvre. Highly conservative in this realm, Rodin always professed great admiration and a pronounced taste for classical composers, primarily including Mozart and above all Beethoven (whom Rodin once dubbed the "Dionysus of music"). Aware, however, of the importance of music and the inspiration it might provide him, he wrote—with a certain affectation—to his friend Hélène de Nostitz,

AUGUSTE RODIN

LES CATHÉDRALES
DE FRANCE

AVEC CENT PLANCHES INÉDITES
HORS TEXTE

Introduction par CHARLES MORICE

LIBRAIRIE ARMAND COLIN
103, BOULEVARD SAINT-MICHEL, PARIS
1914
Tous droits de reproduction, de traduction et d'adaptation réservés pour tous pays.

Left
**ONE OF THE HUNDRED PLATES
INSERTED IN THE FIRST EDITION OF
LES CATHÉDRALES DE FRANCE, 1914.**
11 ¼ × 9 ¼ IN. (28.7 × 23.5 CM).

Above
**FRONTISPIECE
OF THE FIRST EDITION OF
LES CATHÉDRALES DE FRANCE**
PARIS : ARMAND COLIN, 1914.
11 ¼ × 9 ¼ IN. (28.7 × 23.5 CM).

"Yes, like a generous wine, Music provides inspiration and I, a new Bacchus, harvest this wine on which humanity intoxicates itself."

Rodin's favorite composer was Beethoven, whose work he would stay close to all his life; one of his first projects was a medallion portrait of the German composer, commissioned by the Conservatoire Royal de Musique in Brussels, and completed in 1874—the sculpture can still be seen today on the façade of the conservatory. In 1905, the year the Société Beethoven was founded, Rodin was one of its members and probably attended the concert of string quartets performed in the hall of the Société de Géographie on rue Saint-Jacques in Paris. In 1913, the Opera organized a gala evening, attended by Rodin, to celebrate the imminent completion of a commemorative statue of the composer, commissioned by the government from sculptor Joseph de Charmoy. Only the base of the monument was completed, which can still be seen in the Bois de Vincennes. More revealing were the words uttered by Rodin after having heard a transcription for piano of Beethoven's Second Symphony: "God, how he must have suffered to compose that. And yet it was on hearing it for the first time that I 'saw' *Eternal Springtime,* just as I later produced it."

Given his sincerity and his aloofness from all notions of fashion and snobbery, Rodin displayed amazing eclecticism in his musical tastes. He did not disdain—far from it—folk music and even certain popular tunes. His reservations concerning the modern music of the day, which he clearly didn't understand, spoke volumes: "I don't like the music being written these days. Like most modern artistic creations, it reeks of effort and *convolutions*. When it doesn't deafen you, you realize, assuming you've heard some Mozart, that it has lost all sense of continuous movement, of liaison, of relief, of balance and shading." Yet Rodin must have been aware of the importance that Wagner's music had assumed among French intellectual circles. Like many artists, in 1897 he made the trip to Bayreuth; he returned disappointed after having heard *Parsifal,* which he described as "pointless din." Another time, he left the Paris opera house after the first act of *Tristan,* declaring, "I must go, I can't stand this music much longer—it's so beautiful it makes me want to die." Referring to the same piece, he also said, "It plunges me into a deadly angst, and prevents me from working." Nor did Rodin seem to appreciate the music of Claude Debussy, who came to play for him in Meudon. He was

Right
INVOICE FOR RECORDS BOUGHT BY RODIN FROM THE COMPAGNIE FRANÇAISE DU GRAMOPHONE.
6 ¾ × 6 IN. (17 × 15.2 CM).

Right
INVOICE FOR RECORDS BOUGHT BY RODIN FROM THE COMPAGNIE FRANÇAISE DU GRAMOPHONE.
6 ¾ × 6 IN. (17 × 15.2 CM).

Below
JEAN CASPAR RIENING,
PIANOFORTE OWNED BY RODIN, NOW IN MEUDON.
MAHOGANY, WALNUT, BRONZE. SIGNED:
JEAN CASPAR REINING,
RUE ST. MARTIN, NO. 245,
À PARIS, 1812.
31 ¾ × 60 ¼ × 22 ½ IN.
(81 × 153 × 57 CM).

Above
PROGRAM FROM THE CONCERT GIVEN IN HONOR OF RODIN AT THE RITZ HOTEL, PARIS, ON JUNE 28, 1910.
12 ¾ × 9 ¾ IN. (32.3 × 25 CM).

more inclined to share the infatuation displayed by some of his contemporaries for the rediscovery of Baroque and classical music. At that time, eighteenth-century music was just coming back into fashion, despite sometimes debatable performances (particularly concerning arrangements). The nineteenth century's marked taste for pastiche was reflected in numerous compositions, both for the theater (the minuet in Offenbach's *Orphée aux Enfers;* Delibes's *Le Roi s'amuse,* the intermezzo of Tchaikovsky's *Queen of Spades*) and for the salon. Reynaldo Hahn, a composer whom Rodin saw frequently, was noted for many works that he based on music from earlier centuries (*Le Bal de Béatrice d'Este, À Chloris*).

While Rodin was not a musician himself, he liked to listen to music and even owned a record player—Rilke described the listening sessions at the Hôtel Biron under the aegis of Claire de Choiseul. The archives at the Musée Rodin still hold invoices for records purchased by Rodin, notably recordings of Gregorian chants "which no one [wants] and which only the pope—apart from the retailer—owns," joked Rilke. Rodin also acquired several pianos, including a Pleyel, for his studio on rue de l'Université. Delivered in 1909, the Pleyel was

damaged by the Paris flood of 1910 and was ultimately destroyed by the manufacturer.

Rodin also liked to summon musicians to Meudon, which Paul Gsell cited as an example of his search "for all the refined pleasures that might increase his artistic fecundity. Often he asked young virtuosi to come to his home in Meudon before he got up in the morning, in order to play old music: Bach, Gluck, Mozart, Beethoven. The little ensemble would head up to Rodin's bedroom while he was still in bed. Violin, double bass, flute, and clarinet would gather around his bed. And as soon as he requested it, they lifted his soul on ecstatic melodies."

Rodin also maintained a deep friendship with Wanda Landowska, a Polish musician who was then reviving the repertoire for harpsichord. Other musicians and artists were part of his universe: Delius, whose young wife Jelka Rosen carried on an important correspondence with Rodin; Louis Vierne, the organist at Notre-Dame Cathedral in Paris, whom Rodin sometimes went to see high in the organ loft; the singers Felia Litvine, Augusta Holmes, and Emma Clavé, as well as composers Ernest Chausson, Vincent d'Indy, and others. Augusta

Left
**MEMORIAL MEDALLION
FOR CÉSAR FRANCK, 1891.**
BRONZE,
21 ½ × 17 × 6 ¾ IN.
(55 × 43 × 17 CM).

Far left
**WANDA LANDOWSKA
PLAYING THE
HARPSICHORD IN FRONT
OF RODIN, 1908.**
GELATIN SILVER PRINT,
3 × 5 ½ IN. (8.1 × 13.9 CM).

Holmes, an opera singer and a composer of unpredictable temperament, carried on a long-term correspondence with Rodin and even dedicated to him a melody inspired by—and named after—*The Eternal Idol*. (For the record, the composer Edgard Varese was one of Rodin's last—and briefest serving—secretaries.)

When César Franck died in 1890, it was Rodin who was commissioned to sculpt a medallion to be placed on the musician's tomb. The funds were raised at the initiative of Chausson, d'Indy, and Holmes (a former pupil of Franck). We do not know whether Rodin was familiar with Franck's music, or how he may have perceived it. Following the completion of the medallion, plans were discussed for a statue of the composer to be placed in the basilica of Sainte-Clothilde, where Franck had long been the organist, but nothing became of them.

Rodin also executed a bust of Gustav Mahler that is sometimes called *Mozart*, the sculptor having commented that "Mahler's head was a blend of Franklin, Frederick the Great, and Mozart." Rodin was interested in the special use that musicians, like dancers, made of their bodies, as witnessed by his hands of pianists and his sketches of Hélène de Nostitz playing her instrument. As with the other arts, Rodin took from music an aesthetic pleasure that allowed his own genius to blossom. Did Rodin and music ever really connect? Clearly, they met only in the realm of pure sensibility and emotion.

Indeed, Rodin sought inspiration in an intuitive, almost disordered fashion. His ever-present curiosity focused only on those things—whether seen, read, or heard—that might immediately feed into his work. It might be regrettable that he remained aloof from the people and movements that shaped his era, but his irrepressibly frenzied creativity and his solitary genius disqualified, once and for all, anything that might seem superfluous or might distract him from his work and his art.

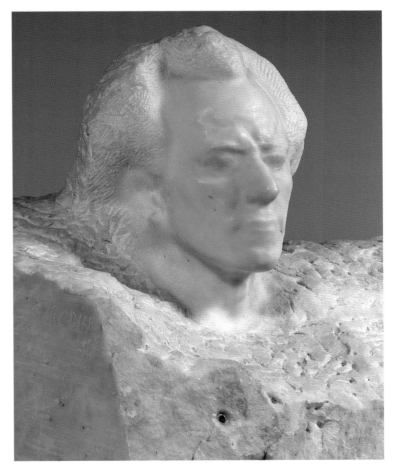

Above
**MOZART, (OR PORTRAIT
OF GUSTAV MAHLER), 1911.**
MARBLE,
23 ½ × 39 ¼ × 22 ¾ IN.
(50.9 × 99.7 × 58 CM).

"I am giving to the Nation my entire oeuvre in plaster, marble, bronze, and stone,
my drawings, and the collection of antiques that I was fortunate to collect for the apprenticeship
and education of artists and workers. And I am asking the Nation to maintain all these collections in the Hôtel Biron,
which will become the Musée Rodin, and to allow me to live there for the rest of my life."

Rodin to Paul Escudier, late 1909

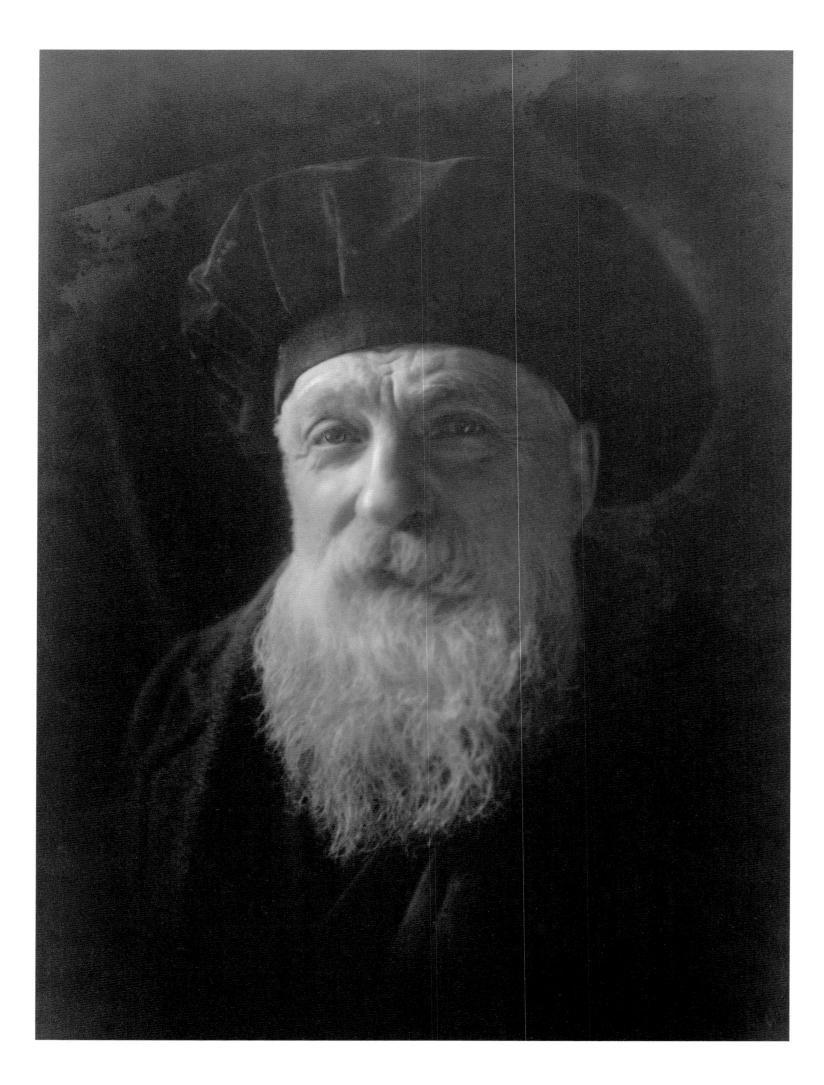

THE FINAL YEARS

When the French nation became the owner of the Hôtel Biron in 1911, all the tenants except Rodin, who benefited from a reprieve, were evicted. The sculptor then began taking steps to save the residence and to promote a national museum devoted to his work. Surrounded by faithful friends and admirers, he launched into major negotiations with the government. The elaboration of the bequest became lengthy and laborious. An encouraging petition made the rounds. His face etched by life, the "great faun" was engaged in his last battle—Rodin was progressively worn down by the harshness and injustice of his contemporaries, even though he managed to retain his patriarchal dignity. Once again he ran up against red tape, hostile envy, and stubborn reticence; this time, however, advancing age made him vulnerable.

Already plagued by uncertainty and disappointment, Rodin's troubles were not yet over. The First World War was about to break out, setting a miserable stage for the final years of his life.

"I want to go to Rome to hear the bells!"
Rodin's notebook

The declaration of war prompted Rodin, who was then very weak, to leave Paris as soon as possible. He wandered through France until, with Rose Beuret, he fled first to England and then to Italy. "I'm in Rome for my health, in a place where, even at my age, I'm still studying," he replied with some annoyance when Armand Dayot urged him to return to Paris. In Rome, Rodin enjoyed a pleasant lifestyle, revisiting the beauties of the Eternal City with undimmed emotion. He finally set up a studio at Latour's, one of the greatest pastry chefs in Rome, in a pavilion of the old Palazzo Colonna, where he worked at leisure in a mystical twilight. As his days were drawing to a close, Rodin spent almost all his time drawing, ceaselessly exploring human flesh for its splendors and deformities. His final graphic style was perfectly illustrated by the drawings he did based on his Italian model, Assunta Petricca—bodies full of health, with a lively, determined appearance, edges softened through use of a stump. But his stay was marred on New Year's Eve by an earthquake that hit Rome and devastated the environs. Worried about Rose's health, Rodin soon put an end to his exile and returned to France.

One month later, a last trip to Rome—his final stay abroad—started off as the consecration of his career. It began on April 8 1915, at

Facing page
CLAUDE HARRIS,
**PORTRAIT OF RODIN WEARING
A VELVET BERET,**
1914.
GELATIN SILVER PRINT,
10 ¾ × 6 ¾ IN. (27.5 × 17 CM).

Above
JOHN MARSHALL,
**RODIN ON JOHN MARSHALL'S
TERRACE, WEARING A BERET,**
ROME, DECEMBER 1914.
GELATIN SILVER PRINT,
4 ¼ × 5 IN. (10.9 × 12.4 CM).

the Vatican, where Rodin had gone to execute a bust of the newly elected Pope Benedict XV. Several of Rodin's friends who were close to the Vatican, such as the musician Livio Boni, managed to obtain authorization for him to execute the bust while Albert Besnard was painting a portrait of the Holy Father. When the sculptor arrived, Besnard was just finishing the full-length figure for which he had negotiated four sittings, instead of the three initially scheduled. On Rodin's instructions, one of his employees had dispatched a modeling stand, clay, and tools to Rome; yet on April 20 Rodin had still not begun to work—the pope, in mourning for his father, had suspended the project. The sittings finally began on April 26, in the presence of a small group of dignitaries required by protocol. It was Monsignor Richard Sanz de Samper, chamberlain to His Holiness, who introduced Rodin to the pope. The sculptor had to be content with three sessions, during which he felt that his sitter was very distant. "The pope is very busy and preoccupied," Rodin complained to the press.

Facing page
POPE BENEDICT XV,
1915.
BRONZE,
10 × 7 ½ × 9 ¾ IN.
(25.3 × 19.1 × 24.7 CM).

Below
RECLINING WOMAN WITH GARMENTS THROWN OPEN.
STUMPED GRAPHITE ON CREAM PAPER,
12 ½ × 8 ½ IN. (31.7 × 21.7 CM).

Right
STANDING NUDE, FACING RIGHT, ARMS BEHIND HEAD,
CHRISTMAS 1914.
STUMPED GRAPHITE ON WATERMARKED CREAM PAPER,
17 ¼ × 23 IN. (44 × 58.5 CM).

"He works from morning to night and could only grant me three sittings. I would have needed twelve. . . . He was visibly preoccupied, and didn't pose very well, so I could record only hasty impressions of his interesting face. . . . Although short, the pope seems tall. You sense in him a man of breeding, of fine Italian or even Roman breeding, although he's Genoese. His features are very pure and fine. There is something of the head of Emperor Augustus about him, with a somewhat more aquiline nose. He wears glasses, but judging by his gaze and the liveliness of his features, you sense his great intelligence. That's all I could grasp from the few minutes of silent, anxious posing that he deigned to grant me."

The pope was uneasy with Rodin's approach, which involved turning slowly around his sitter to observe the successive profiles. The pope tried to turn at the same pace as the sculptor, obstinately facing him. After three sittings Benedict wearied, dismissed Rodin, and gave the sculptor a series of photographs to help him continue his work. A disappointed Rodin left the Vatican and decided to quit Rome immediately, accompanied by Boni de Castellane, who dispatched the incomplete bust to Meudon. There, Rodin, thanks to his still-fresh memory of the pope's features, went back to work. "I've saved the bust," he wrote to a friend. "I was back at work at seven o'clock on Monday morning and continued into the evening and throughout the next six days. The bust is incredible, there's a likeness in it but as you can imagine, it's a long way from the masterpiece that could have emerged with patience." The lean, austere handling of the modeling produced a severe face accentuated by the diagonal bridge of the solidly anchored nose, reminiscent of the portraits of ancient Egyptian pharaohs. The powerful shape projects such an obvious expression of sovereignty and aristocratic haughtiness that one might expect the sitter to be pleased. And yet Rodin never overcame the reservations of a pope who was stubbornly disappointed with the outcome.

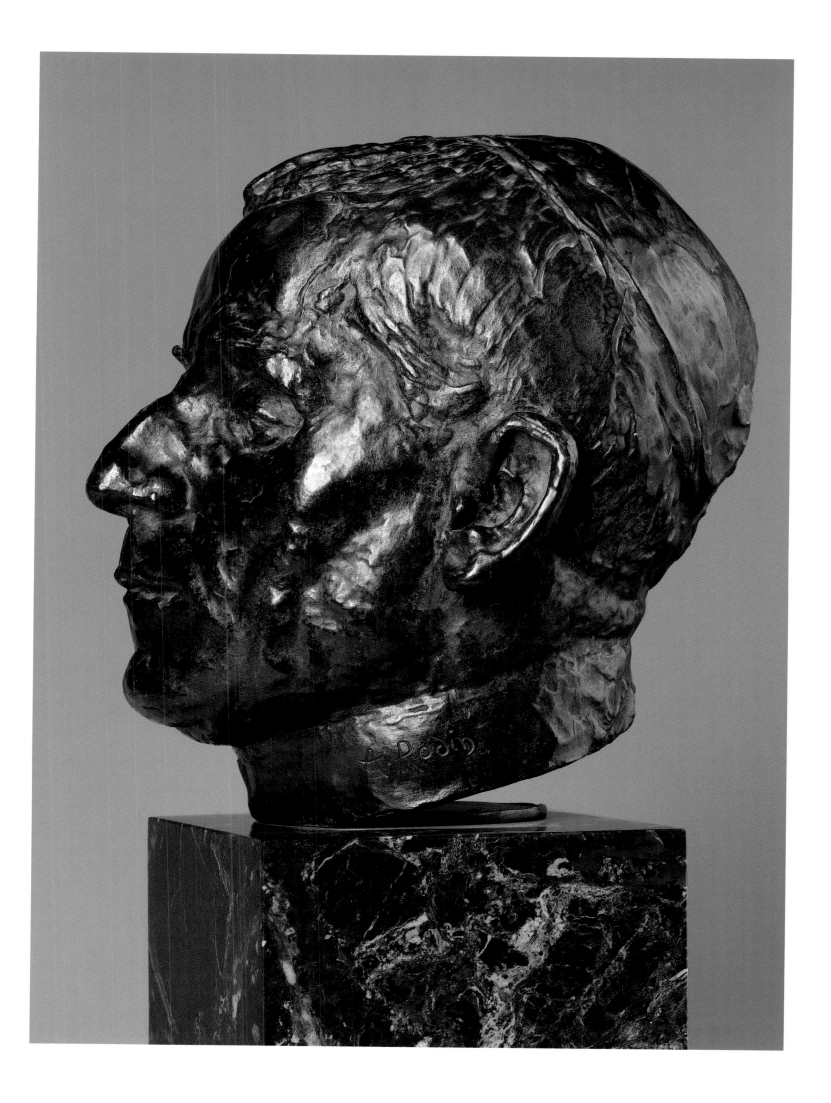

"This character, this undefinable quality of affection, attention, and anxiety in the gaze, as though constantly questioning."

Léonce Bénédite on Rodin

The outbreak of war and the dread of tragic consequences spurred Rodin to summon his son, then aged about fifty, to Meudon. Auguste Beuret had a colorful companion, Eugénie Dorée—better known as Nini—who did not display the slightest restraint or propriety. Rodin knew his son lacked character, being proud and sensitive, indeed highly touchy and very lazy, although talented. He had turned his hand to every trade, from ragpicker to engraver to draftsman, before becoming custodian of the villa in Meudon for his father. Octave Mirbeau described him to the Goncourt brothers as "a strange son with an extraordinary gaze and glowering face, who never says a word and spends his entire life on fortifications, drawing the backs of soldiers, backs that his father says sometimes display genius. . . . The son appears only at mealtimes, then vanishes." The proximity of son and mistress,

who lived in a dilapidated house next to the Villa des Brillants, sometimes led to incredible scenes, prompting Rodin to withdraw silently to meditate in one of his studios, where by candlelight he would draw inordinately or study intensely, with great feeling, the antiques in his collection. In a swift, all-embracing style based on strokes of graphite sometimes modeled with a stump, he would set down on paper a woman's body or a bold gesture with an energetic handling from which suddenly would emerge the mark of genius.

A dismayed Rodin bemoaned the war's destruction and disfigurement of buildings. The future of the museum was put on hold, while brand-new "friends" bustled and conspired around him, taking advantage of every opportunity to remove works, ravage the studios, and grab a piece of the heritage. Fortunately, Rodin also had important contacts who defended his interests, such as Étienne Clémentel, the powerful minister of trade, industry, post and telegraph, who skillfully intervened on several occasions to bring the negotiations to a conclusion. Clémentel's role was crucial, and Rodin expressed his gratitude by doing his portrait. "Busts executed free for friends and

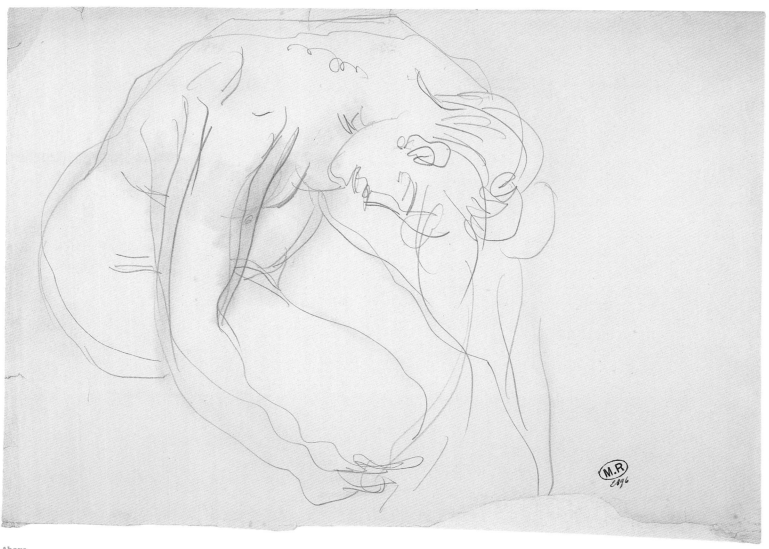

Above
Seated Nude, Facing Right, Leaning Toward her Knees.
Stumped graphite on cream paper,
9 ¼ × 12 ¾ in. (23.5 × 32.5 cm).

relatives are the best," he explained. "Not just because the artist knows much better a sitter that he regularly sees and cherishes, but above all because his free donation of labor gives him the freedom to do it entirely as he pleases." Clémentel endured many sittings. Faithful to his working method, Rodin packed the profiles densely, spinning his modeling stand and circling around the sitter until the miracle occurred: a blend of physical likeness and personal psychology. The noble, frontal pose faithfully conveys the minister's normal appearance. The lines are bold while small balls of clay subtly disperse the play of shadow and light. Expressive eyes and forehead convey an intelligent man concerned about his heavy responsibilities and the outcome of the war. This last work now seems particularly moving, for it demonstrates the dexterity and boldness with which Rodin was able to articulate a bust even at the end of his life; in July 1916, however, he suffered a stroke that incapacitated him and prevented him from completing the piece. The attack irreversibly weakened him. The titan of sculpture henceforth assumed the appearance of a sick old man, physically diminished, weary, and touchingly docile.

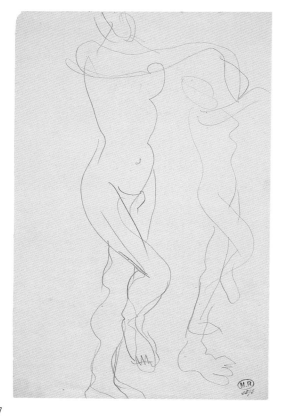

Left
Nude Woman, Right Arm and Leg Crossed to the Right.
Graphite on cream paper, 12 ¼ × 8 in. (31.2 × 20.1 cm).

An offering to the nation

It thus became urgent to act, to shield Rodin from all the quarrels and especially from the "unsavory" ambitions of the schemers surrounding him.

Rodin bequeathed the totality of his collections to the state in three successive donations on April 1, September 13, and October 25, 1916. Finally, at the height of the war and after bitter debate—whether through fear of creating an unfortunate precedent, or whether against the "decadent" and "subversive" artist and his immoral works—the donation was accepted by the French parliament on December 24, 1916, followed by the Senate. The representatives then voted to found a national Rodin museum in the Hôtel Biron. At the time, people did not realize that the delays provoked by war would prevent Rodin from seeing his dream come true—attending the opening of the museum—perhaps the only thing in his long life that might be regretted.

It also became urgent to protect the heritage by legally joining the old couple in matrimony, an idea cherished by Judith Cladel. The private ceremony took place at home, on January 29, 1917, during a grim wartime winter. Coal shortages created a cold and inhospitable setting in the villa. This strange event united two lives almost at the very moment they would be separated forever. "Rodin and his fiancée, huddled together with a blanket over their laps, resembled the little parrots known as lovebirds," recounted Rodin's secretary, Marcelle Tirel. "They were freezing to death. The following days were a fine sight: they remained in bed from morning till night since neither the minister nor friends were able to send an ounce of coal to those poor old people who were freezing to death. Yet they held hands, from one bed to another, smiled and talked about their life of poverty, of their youth. It was a fairly eccentric picture of a honeymoon."

Two weeks later, in a fit of violent coughing, Rose Rodin died from complications of pneumonia.

Below
PIERRE CHOUMOFF,
**AUGUSTE RODIN AND ROSE BEURET ON THEIR WEDDING DAY, FLANKED BY AUGUSTE BEURET,
M. AND MME ÉTIENNE CLÉMENTEL, LÉONCE BÉNÉDITE, JOANNY PEYTEL, ALBERT DALIMIER, AND JUDITH CLADEL,**
JANUARY 29, 1917. GELATIN SILVER PRINT, 6 ¾ × 8 ¾ IN. (17 × 22.5 CM).

Facing page
BUST OF ETIENNE CLÉMENTEL,
1916.
BRONZE, 21 ¾ × 21 ½ × 12 IN. (55.4 × 54.8 × 30.2 CM).

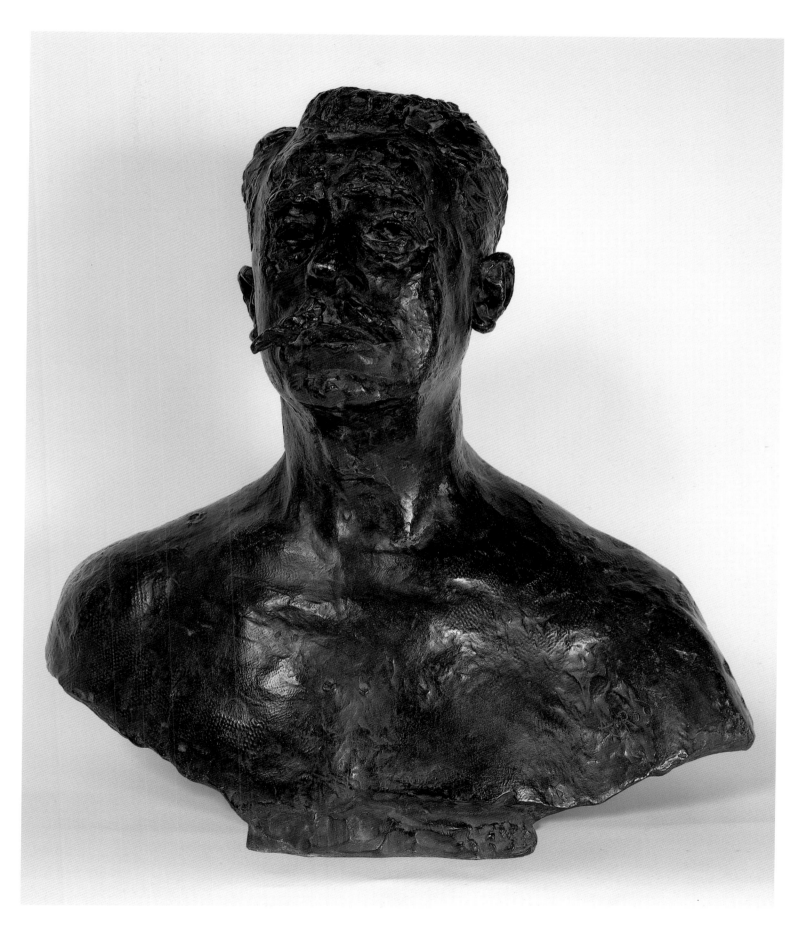

"I'll lay myself down in the wilderness and won't regret a thing."

Rodin, quoted by Gustave Coquiot, 1917

Widowed—and perhaps even more, orphaned—Rodin survived Rose by less than a year. Sorrowful and silent, his mind enfeebled, sadly indifferent to his surroundings, he awaited the death that "in his last days of lucidity he called 'my new friend.'" He worked no more, and hardly left Meudon, content to take short walks near the house. In Meudon, he was looked after by his cousin Henriette Coltat; visitors were rare, apart from the faithful Judith Cladel and the man he appointed executor of his estate, Léonce Bénédite (then curator of the Musée du Luxembourg, and the future curator of the Musée Rodin). Shortly before Rodin's death, Bénédite asked that a studio assistant make a cast of the sculptor's hand. Although skillfully executed, the hand is frozen and lifeless. It holds a small torso of a woman.

Thin and almost inert, it is the feeble, halting hand of an old man, so similar yet so alien to the powerful, proud hand of the creative artist.

Rodin never wearied of admiring a polychrome *Christ on the Cross* in the Italian style, which occupied the full height of a wall in his bedroom. He would gaze at it for hours. He spent his seventy-seventh birthday in oblivion—his seriously weakened body suffered congestion of the lungs. He finally died, peacefully, at four o'clock on the morning of November 17, 1917.

"On the linen-draped bed, high as a state bier, in a gown of soft ivory, he lay in repose, sovereign—like an emperor who had donned a monk's habit out of contrition," recalled Cladel. Although the press hinted that a national funeral might be organized for Rodin, the government immediately rejected the idea at a time when the nation was wracked by war. The ceremony was held on November 24, drawing all those who knew him to the hills of Meudon, down the path they had usually taken with the master. The many official speeches included an improvised, emotional farewell by the writer Séverine (Caroline Rémy), delivered on the steps of Château d'Issy, opposite the tomb that would henceforth be crowned by *The Thinker*.

The mourners knew that posterity would rank Rodin among the greatest. They recalled the modest, hard-working life of a laborer who was simultaneously driven and contemplative, they recalled a powerfully sensual life, they recalled the troubled twilight years, but above all they recalled a solitary man who pursued a constant, diligent quest, indifferent to both praise and denigration. "He loved sculpture with a love that demanded everything of him—heart and mind," observed Gustave Coquiot coldly. "We should not flatter ourselves with even a brief friendship between such a man and the likes of us—it couldn't exist."

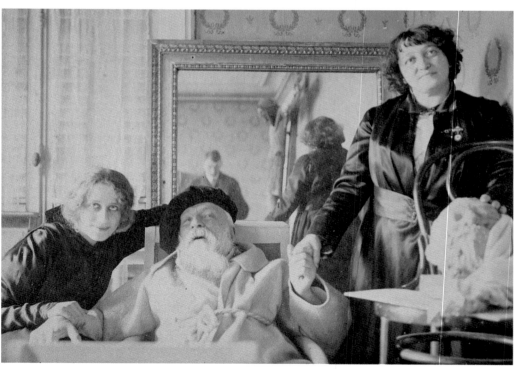

Top
HAND OF RODIN HOLDING A SMALL FEMALE TORSO.
PLASTER,
6 × 9 × 4 ¾ IN. (14.9 × 22.9 × 11.8 CM).

Left
ANONYMOUS,
AUGUSTE RODIN IN HIS BEDROOM, SEEN WITH HIS NURSE, ANNA GAMBEZ, AND HER DAUGHTER. IN THE MIRROR IS THE CHRIST ON THE CROSS,
MARCH 21, 1916.
GELATIN SILVER PRINT,
3 × 3 ½ IN. (7.8 × 8.9 CM).

Facing page
HARRY B. LACHMAN,
RODIN ON HIS DEATHBED,
NOVEMBER 1917.
GELATIN SILVER PRINT,
6 ¼ × 4 ½ IN. (15.7 × 11.6 CM).

Pages 212–213
PIERRE CHOUMOFF,
SÈVERINE SPEAKING AT RODIN'S FUNERAL,
NOVEMBER 24, 1917.
GELATIN SILVER PRINT,
6 ¾ × 8 ¾ IN. (17 × 22.5 CM).

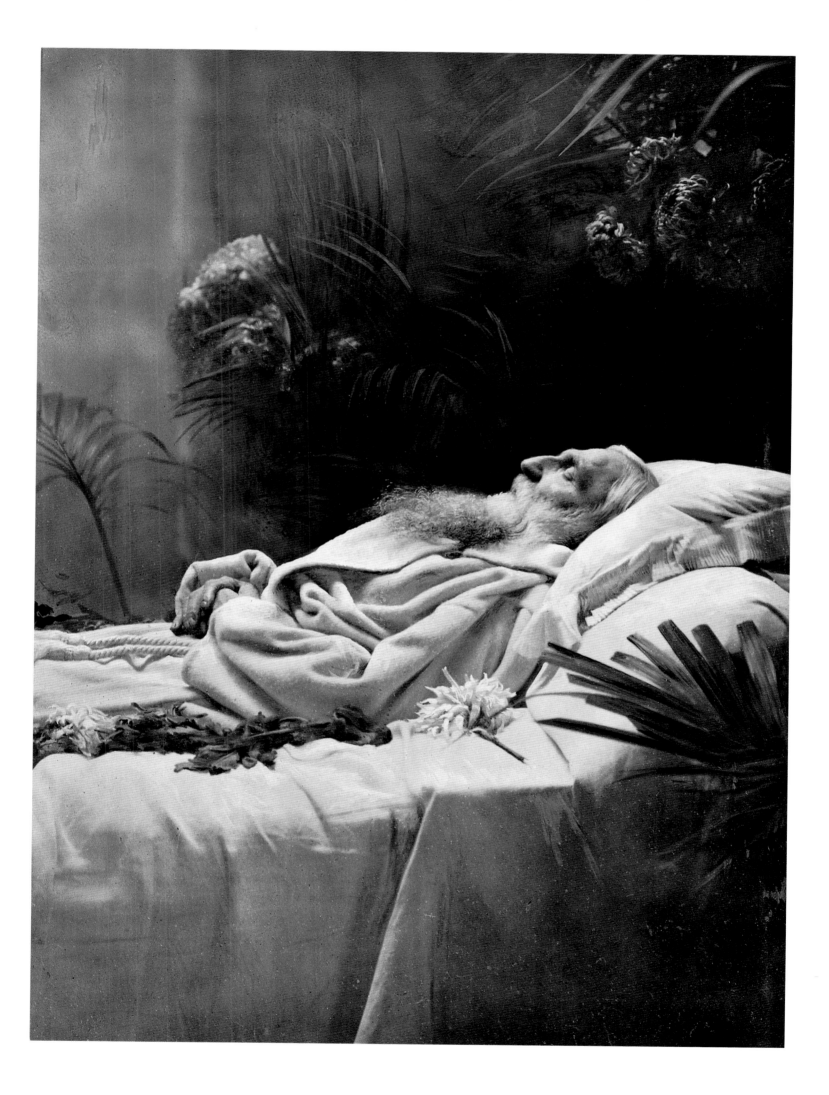

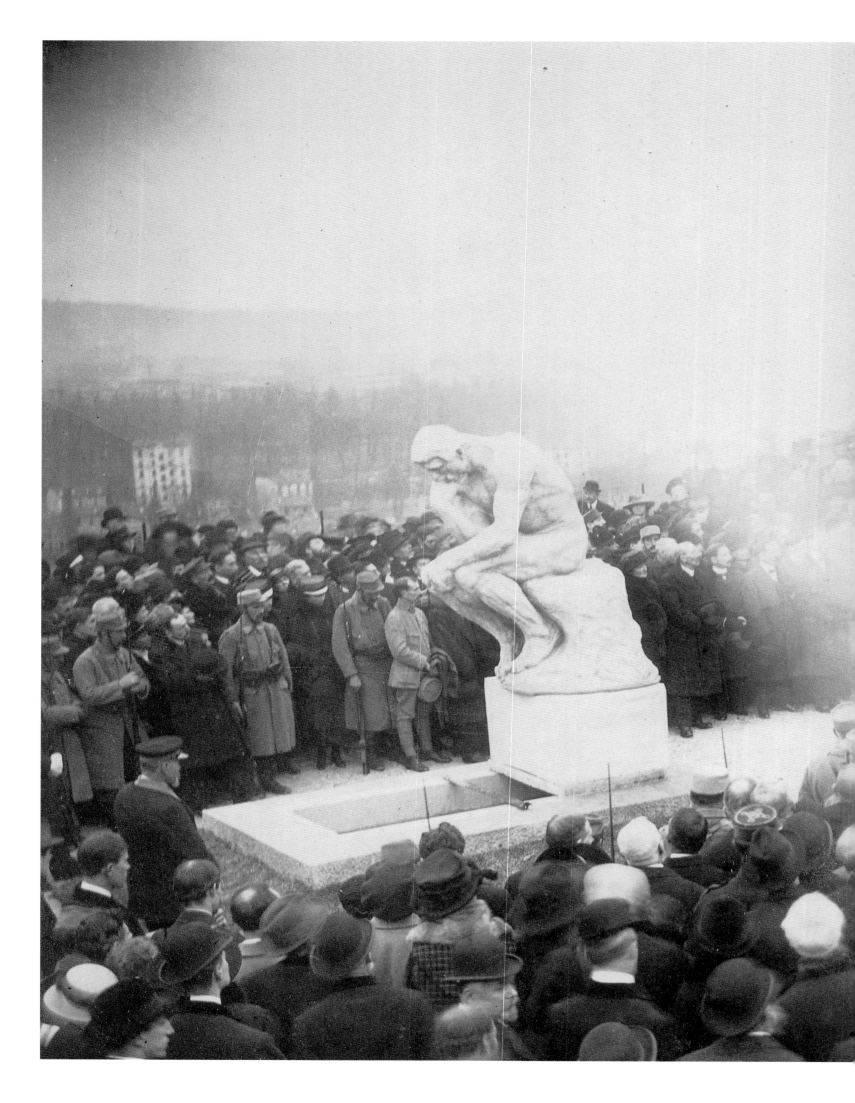

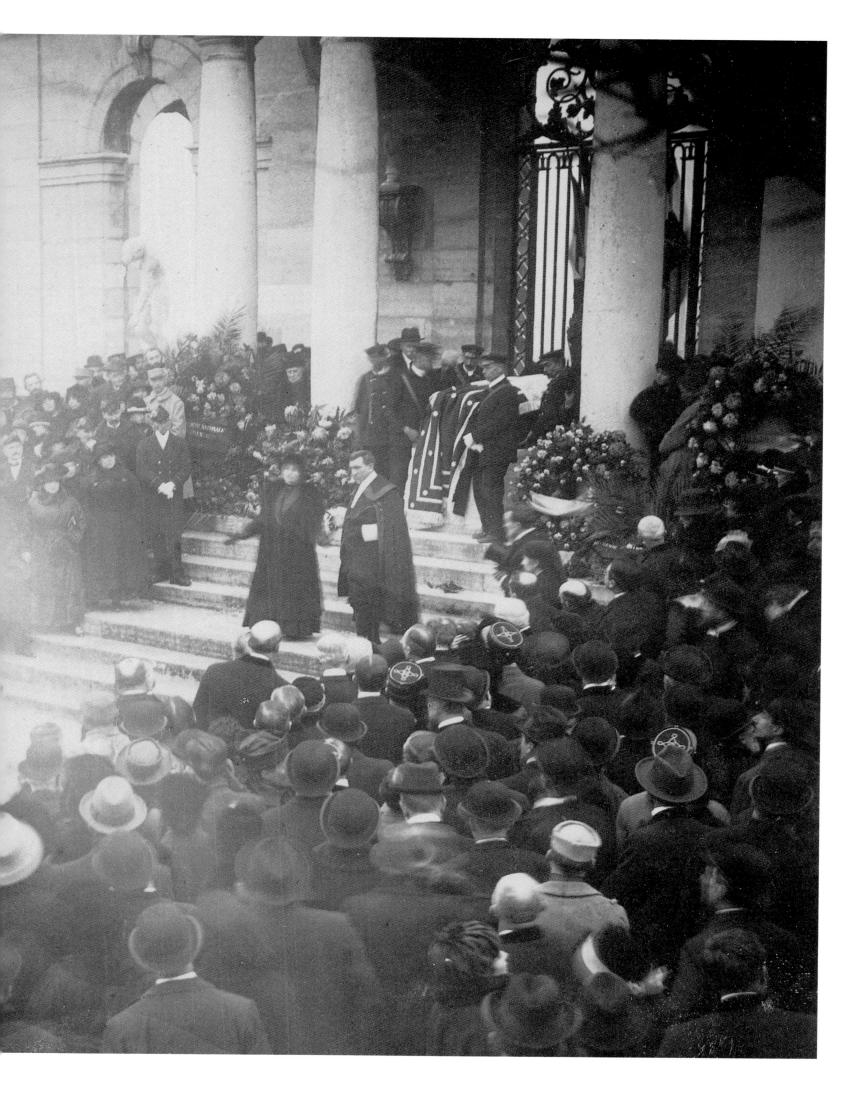

"The main concern of all Rodin's friends should be to ensure that he receives the greatest possible recognition during his own lifetime. The signs of admiration they are making around him are merely modest gestures aimed at posterity. Rodin's fame is now irrevocable. It would thus be fitting that he lay his eyes, before they close forever, upon the finest proof of enthusiasm we could offer him, which would be . . . to present him with a historic building where his entire oeuvre might stand."

Émile Verhaeren

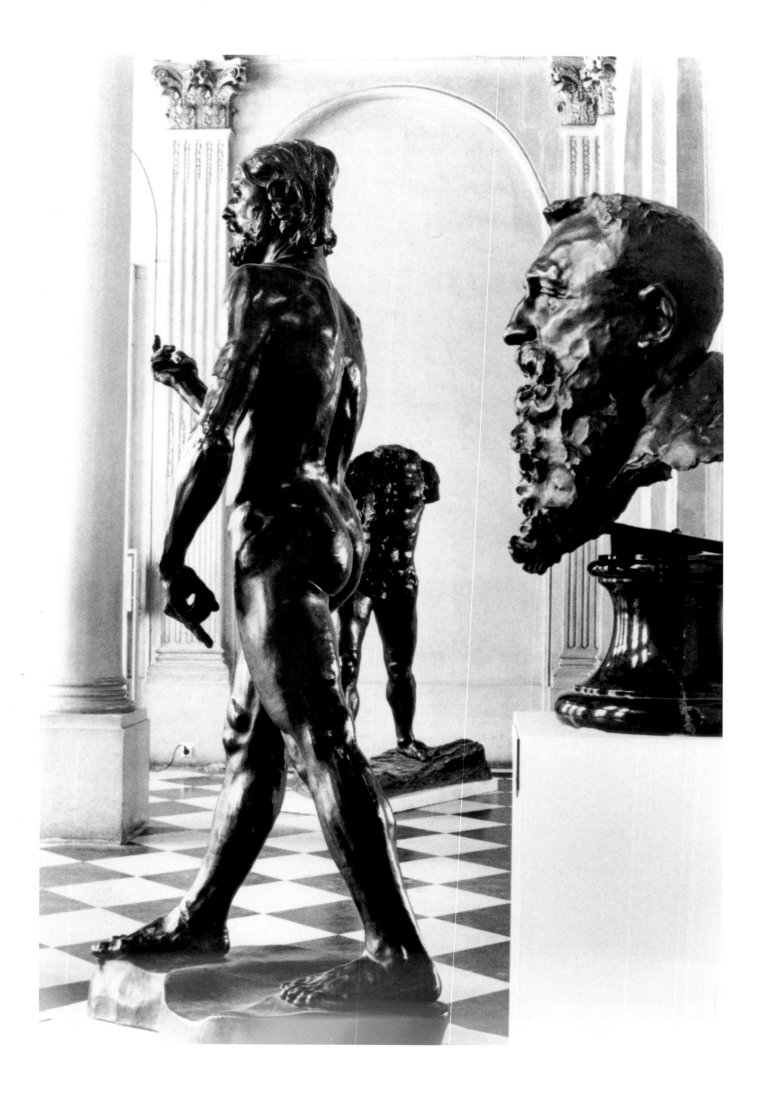

THE MUSÉE RODIN FROM 1919 TO THE PRESENT

The Musée Rodin opened on Monday, August 4, 1919. The glamorous residence known as the Hôtel Biron housed the marbles, bronzes, plasters, and drawings, as well as items from Rodin's own art collection (paintings, antiques, furniture), while the chapel of the former convent was devoted to a display of plaster casts of monumental pieces including, for the first time, a complete presentation of *The Gates of Hell* (now in the Musée d'Orsay). What remained of the grounds of the estate (truncated back in 1911 of their southern sections, allocated to Lycée Victor Duruy), were deliberately left in the state in which Rodin had known and loved them, even though some people wanted to turn the site into a public square adjacent to boulevard des Invalides. The museum's first curator, Léonce Bénédite, who was also curator of the Musée du Luxembourg and, more significantly, one of the executors of Rodin's estate, was able to reconcile his curatorial concerns with a desire to maintain the special, lively atmosphere of an artist's dwelling. Overall, despite a few criticisms, the press and public responded enthusiastically to the inauguration and arrangement of this new museum exclusively devoted to Rodin's work.

Fortunately, for the preservation of the site, plans to extend the residence by erecting lateral wings and buildings around a main courtyard (inspired by the courtyard at the Hôtel de Soubise), intended to house a museum of contemporary art, never left the drawing board—nor did the idea, around 1920, of adding a special pavilion to house Monet's *Waterlilies*. Yet it was not until June 12, 1926, that the residence and grounds were finally listed as historic monuments. The original decoration had been disfigured by the nineteenth-century dispersion of sections of the wood paneling and certain wrought-iron features. In the days when nuns lived at the Hôtel Biron, some of the paneling had been acquired by the Rothschild family and reinstalled in their residences in Waddesdon, Buckinghamshire (Baron Ferdinand), Vienna (Baron Albert), and Paris (Baron Edmond). Later, the Hôtel Biron slowly recovered items of its original decoration, notably some of the wood paneling and, more recently, some of the over-door paintings done by François Lemoyne. Replicas have been made of some lost ironwork, such as the wrought-iron banister that

Facing page
HELENA VAN DER KRAAN,
**ENTRANCE HALL, MUSÉE RODIN,
1995.**
GELATIN SILVER PRINT,
11 ¾ × 7 ¾ IN. (30 × 20 CM).

Above
PIERRE CHOUMOFF,
**LÉONCE BÉNÉDITE IN THE STUDIO
OF VILLA DES BRILLANTS, MEUDON,
1917.**
GELATIN SILVER PRINT,
9 × 6 ¾ IN. (22.8 × 17.2 CM).

A HISTORIC RESIDENCE FOR RODIN

Originally from Le Vigan in the Cévennes region of France, Abraham Peyrenc represents a good example of the swift and heady rise of speculators during the ancien regime. In 1720, the future Marquis de Moras began his career as counsel to the regional *parlement* in Metz, and was appointed master of petitions in 1722. Soon he became one of the directors of the French East India Company, a banker, a royal counselor, who sat on all the king's councils, and chief counselor to the dowager Duchesse de Bourbon (Louise-Françoise de Bourbon, Louis XIV's legitimized daughter by Madame de Montespan).

The *hôtel particulier,* or private residence, that Peyrenc de Moras built on rue de Varenne was his third Paris home. It was designed by architect Jean Aubert (who also built the stables at the Château de Chantilly) on plots of land bought between 1727 and 1732. The land was on the edge of the city, which explains the vast size of the grounds around the residence. The layout of the building was a compromise between a standard Parisian *hôtel particular*—set between front courtyard and back garden—and a country-style château.

Peyrenc de Moras hardly had time to enjoy his new home, for he died in 1732. The Duchesse de Maine (Louis XIV's daughter-in-law), widowed in 1736, decided to move into the Moras residence, which she rented for life from Peyrenc's widow, as recorded in a lease dated August 1, 1736. When the *duchesse* moved into the building, she had Aubert draw up an inventory of all the furnishings and decorations—now an invaluable reference source, notably for identifying the overdoor paintings that Peyrenc de Moras commissioned from François Lemoyne for the ground-floor rooms, probably painted between 1729 and 1730. Two other ground-floor rooms featured paintings by Nicolas Foucher and Noël Coypel, plus copies of mythological scenes after Antoine Coypel and Louis de Boullogne. When the *duchesse* died on January 23, 1753, Peyrenc de Moras's son, François-Marie, sold the property to Louis-Antoine de Gontaut, the fourth Duc de Biron. The residence thus acquired its current name, Hôtel Biron. The duke undertook numerous renovation works, taking great care to enlarge and enhance the garden, which in its day was often described as one of the most beautiful in Paris.

The property was handed down several times until, in the early nineteenth century, the Duchesse de Charost rented it to various tenants (such as Cardinal Caprara, the papal nuncio, and Prince Kurakin, the Russian ambassador), then sold it in 1820 to the religious congregation of the Sacred Heart of Jesus, headed by Sophie Barat (canonized in 1925). The Hôtel Biron thus became a reputable boarding school for young ladies who notably included Marie d'Agoult (French writer and Liszt's lover) and Eugénie de Montijo (the future Empress Eugénie). This was nevertheless a sad period for the residence, steadily stripped of its decoration (woodwork, overdoor paintings, ironwork), which the nuns sold off; the grounds also suffered, disfigured by outbuildings and semi-neglect. After the separation of church and state in France, the congregation was dissolved by the French government on July 10, 1904, and the school closed the following October. The premises were evacuated by August 1907. In 1908, Rodin moved into several rooms, and his name has been permanently associated with the Hôtel Biron ever since.

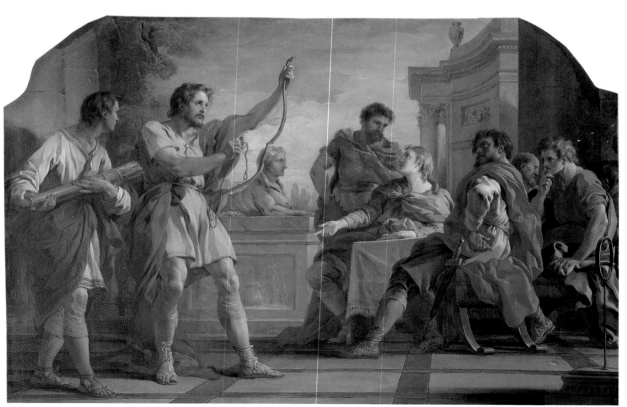

plan des cours et jardins de l'hôtel de Biron

rue de varenne

20 30 40

has now replaced the modest handrail used by the nuns after the original banister was sold.

The Second World War

In 1940, curator Georges Grappe, following the example of other national museums, sought a safe place for his collection, given the threat of war. The Rodin collections were thus transferred to the center of France: the marbles went to the Château des Rhuets, near Vouzon, while the terracotta pieces went to the Château des Aisses, near La Ferté-Saint-Aubin, and the molds were divided between Rhuets and the Château de la Chesnaie, near Rhuets. The bronzes, meanwhile, were placed in the Hôtel Biron's cellars in Paris. Drawings, paintings, tapestries, and archives were handed over to the national museum administration and shipped to Chambord. In June 1940, the molds in Chesnaie were damaged by the Germans, so those remaining were transferred to Rhuets. One month later, to forestall a requisitioning of the Hôtel Biron by the Germans, Gabriel Cognacq, chairman of the board of directors ordered—in the absence of Grappe—that the museum be reopened. A year later, Cognacq recounted the scene to his board:

One day in July, I received a phone call from the warden, announcing that a German high officer had turned up at the museum and declared that it would a perfect place for his offices. He said he'd return later to discuss details. The warden demurred without a word, but as soon as the officer had left he telephoned the news to me. I told him that I would come over and, two hours later, I decided to reopen the museum. The bronzes were brought up from the cellars; I recalled the plaster models—which were still in Meudon—of the marbles shipped to the provinces. And so we opened with the materials at hand, confronting the covetous officer with a fait accompli. Since then, we've managed to remain open and struggle along.

The collection was reassembled in Paris in 1945, and the museum opened its doors again on November 17 of that year. Meanwhile, in 1942 and 1943 Meudon had been hit by Allied bombardments, further delaying the opening of that branch of the museum, which had been awaiting its day since 1919.

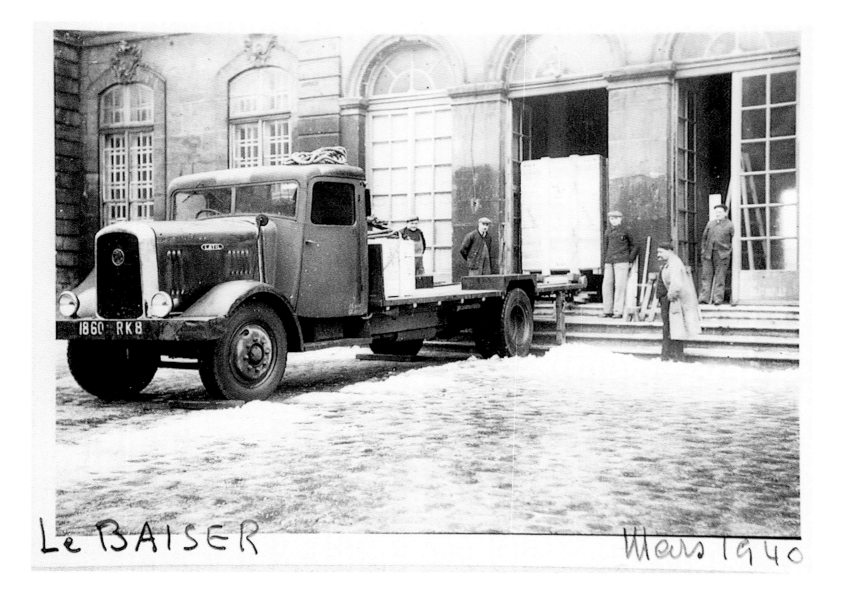

Le BAISER Mars 1940

Meudon

The plan to open Rodin's Meudon estate to the public dates back to the founding of the museum, but the project was long in coming. As mentioned above, Meudon had been a must-see for Rodin's admirers even during his lifetime. This "Bayreuth of sculpture" had been regularly visited by celebrities (such as King Edward VII), art lovers, and interested amateurs who wanted to meet the great sculptor and see his studio. After the museum opened in 1919, Bénédite wanted to complement the Hôtel Biron with a visit to Meudon, "a place of pilgrimage for all those who wish to enter more deeply into the study of the man and his work." It was also the site of his tomb. The major problem was the poor condition of the buildings—the museum, housed in the former Alma Pavilion, was on the verge of collapse. Having abandoned plans to restore the building as too risky and above all too costly, in 1926 curator Grappe asked architect Henri Favier to design a replacement building. The Favier proposal, for which the museum holds not only the plans but also a fine plaster model, displayed a certain nobility in its striking echoes of the Petit Trianon. Lack of available funds unfortunately obliged Favier to revise his plans, and to build, next to the façade of the Château d'Issy, the

Right
BRUNO DELAMAIN
**STORAGE OF
PLASTER CASTS IN
MEUDON: ADAM,
CARYATID WITH
URN, SHADE, 1996.**
GELATIN SILVER
PRINT,
15 ¾ × 12 IN.
(40.3 × 30.3 CM).

**Facing page
STORAGE OF
MOLDS, MEUDON.**

**Pages 224–225
INTERIOR OF THE
MUSÉE RODIN IN
MEUDON.**

current hall that has housed the works of the former museum since 1931. At that point the Alma Pavilion was ruthlessly demolished—only a recently produced model provides any record of that temporary structure.

It was not until two years after the war that Meudon was officially opened to the public. Then, in 1953, the ground floor of the villa was also opened. The estate was finally listed as a historic monument in 1972. In the late 1990s, major works were carried out to create a vast underground complex of restoration workshops and storage space (housing objects not normally on display, such as plasters, molds,

furnishings, and paintings). These galleries link the villa to the museum—set lower on the hill—on several levels. Today the museum in Meudon not only exhibits large plaster casts of monumental works but also provides valuable insight into the various creative methods employed by Rodin.

The Hôtel Biron at the dawn of the twenty-first century

Magnificently set in a gem of an eighteenth-century building, the Musée Rodin nevertheless has problems coping with an increasingly

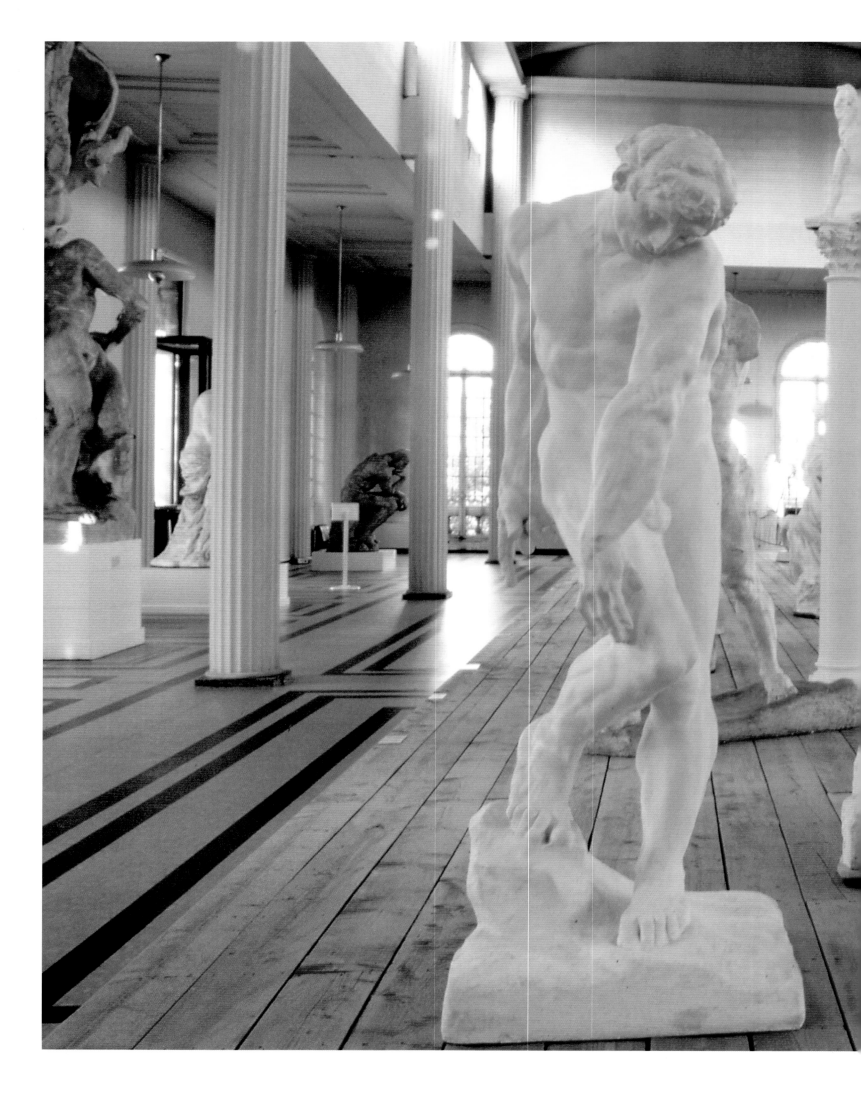

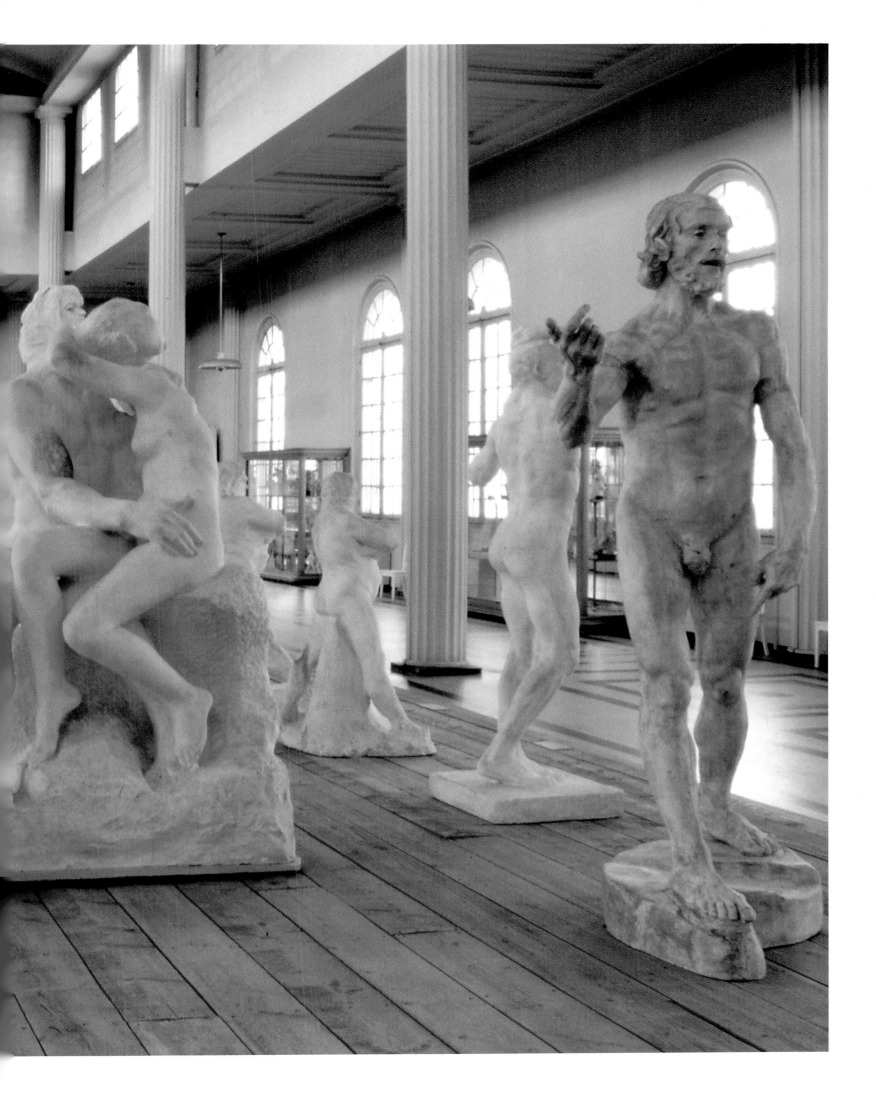

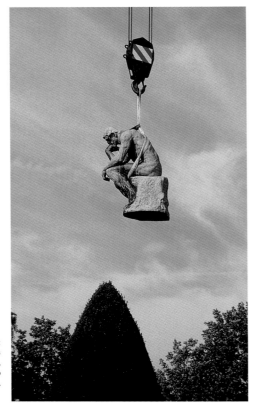

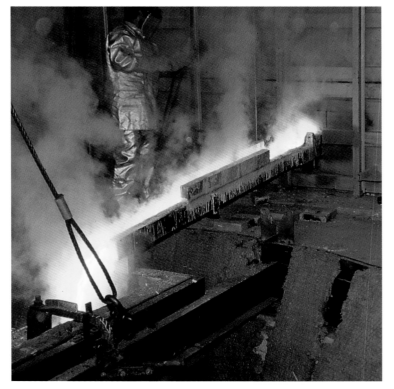

drastic lack of space. The outstandingly rich collection is regularly enhanced by the acquisition of additional sculptures, drawings, photographs, and archive material, whose abundance and appeal cannot be properly presented to the public due to lack of exhibition space. Although administrative offices were long ago moved to the outbuildings of the former convent chapel, the museum shop and workshops must share the limited space of the residence itself, to the detriment of the artworks and the public.

Thus at the dawn of the twenty-first century a vast renovation of the chapel will eventually permit it to house all the museum's various offices, as well as providing a temporary exhibition space and a boutique that opens on to rue Varenne. The archives and library, currently squeezed into the attic and mezzanines of the residence, will be endowed with considerable storage space and a large reading room. The museum itself can then be entirely restored, opening new exhibition spaces to the public. This ambitious project, fully justified by the universal appreciation of Rodin's work, is largely indebted to the master's own foresight in having bequeathed his oeuvre to the nation and allowing the state to encourage its preservation and ever wider appeal to a growing public. The Musée Rodin, as ever, continues to carry out its mission to enrich and disseminate the heritage left to humanity by the great artist nearly a century ago.

"I would like . . . my works that exist only in plaster . . . to be cast in bronze so as to give my oeuvre a definitive feel."
Rodin to Léonce Bénédite, September 1916

The Musée Rodin's statutes have always given it a special status within the national museum network—its finances depend largely on the marketing of Rodin's work. Following three successive bequests to the nation by Rodin, a decree dated March 12, 1919, established the new museum as a public institution from an administrative standpoint yet enjoying its own legal status and financial autonomy. The Musée Rodin therefore acts as Rodin's heir and assumes responsibility, in the name of the French government, for his bequest. Endowed, as per Rodin's instructions, with a board of directors that met for the first time on March 26, 1919, the museum is financed by revenues from admission charges and above all from reproduction rights. Rodin's oeuvre was exploited through the casting of bronzes, thereby following a practice Rodin himself had inaugurated, either by dealing directly with occasional buyers or by signing licensing contracts with bronze founders for the unlimited sale of mechanical reproductions of his works; the new museum canceled such contracts as early as 1919, in order to exploit reproduction editions on its own behalf. Only in 1946 were limitations imposed on the number of copies and their systematic numbering, finally enshrined in 1968 in a French law covering the casting of all bronze artworks.

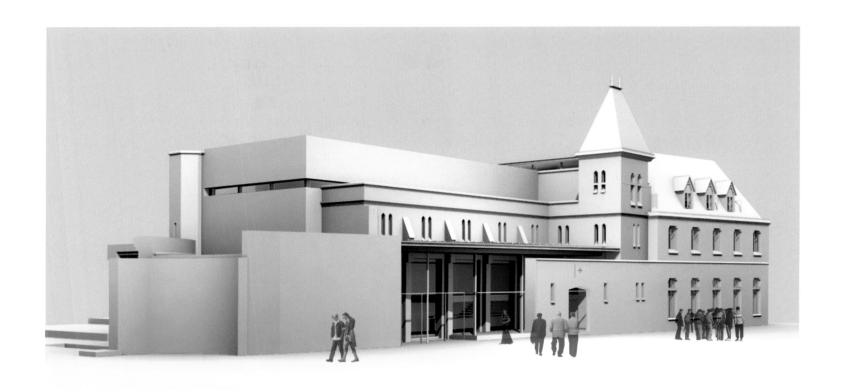

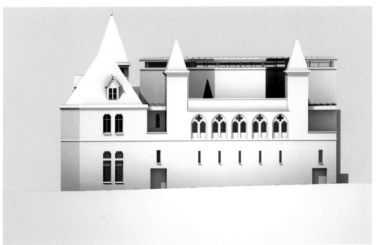

Pierre Louis Faloci, architect,
**Proposal for renovating the
chapel of the Hôtel Biron, 2003–05.**
Elevations of the rue de Varenne
façade and perspective views.

Major foreign collections of Rodin's work

At a very early date, Rodin's work aroused an enthusiasm that led private collectors, cultural institutions, and even national governments to purchase bronze casts. Three large collections were assembled during Rodin's own lifetime at the Ny Carlsberg Glyptothek in Copenhagen (at the instigation of Carl Jacobsen), the Metropolitan Museum of Art in New York, and the Victoria and Albert Museum in London. A major Japanese collector, Kojiro Matukata, head of the Nagasaki shipyards, began assembling a large number of works by Rodin in 1916 and in 1925 commissioned the first casting of *The Gates of Hell*; these works were nevertheless blocked in France by the outbreak of the Second World War, and were only dispatched to Japan in 1959. In the meantime, the *Gates* had been shipped to Philadelphia; it is therefore the third cast that is now on display in Tokyo's Museum of Western Art.

Philadelphia, Pennsylvania

In 1923, movie mogul and philanthropist Jules Mastbaum (1872–1926) visited Paris, where he first saw Rodin's work. Mastbaum's immediate enthusiasm led him to assemble a collection of sculptures and sketches by the master, which he offered to the city of Philadelphia with the goal of founding a Rodin museum there. In 1929, just ten years after the founding the Musée Rodin in Paris, the new Philadelphia museum was inaugurated in the presence of Paul Claudel, the French consul to the United States. In order to evoke the sculptor's environment in Meudon, a copy of the façade of the Château d'Issy was built. In fact, Rodin's connection with Philadelphia went back many years; in 1876 he exhibited eight works at a show in Fairmount Park, Philadelphia, during celebrations of the United States' centennial.

The Cantor collection

In 1945, it was Gerald B. Cantor's turn to discover Rodin's legacy and to begin collecting the sculptor's works. Over the years, Cantor and his wife Iris managed to assemble the largest private collection of Rodins, including sculptures, drawings, printed material, photographs, and diverse items. Through its exhibitions, its bequests to American museums, and its Rodin Research Fund at Stanford University, the Cantor collection has greatly contributed to the dissemination of Rodin's oeuvre on the American continent and beyond.

Shizuoka, Japan, and Seoul, Korea

On March 23, 1994, the regional museum in Shizuoka inaugurated a Rodin wing—containing facsimiles of drawings and photographs, educational display cases, and thirty-two bronze sculptures, including

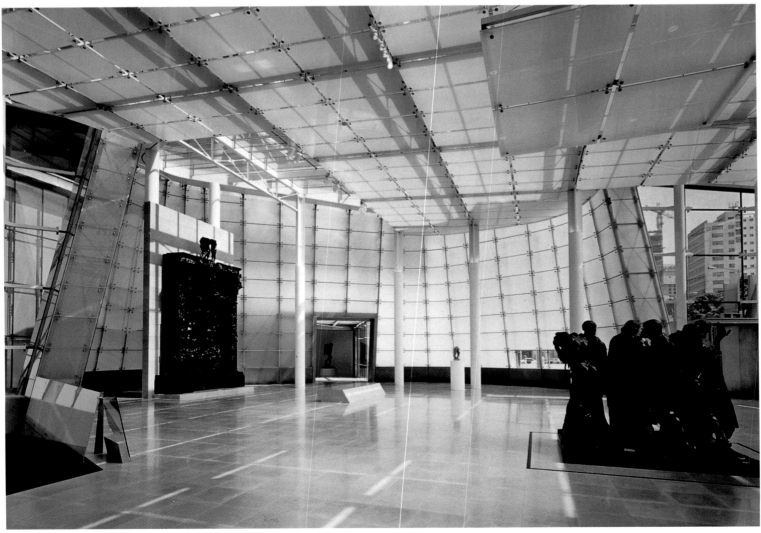

The Burghers of Calais with its six figures, *Claude Lorrain, Bastien–Lepage, The Muse of Whistler, The Spirit of Eternal Repose,* and, most importantly, the sixth casting of *The Gates of Hell,* exhibited indoors for the first time.

In Seoul, a Rodin Museum was founded in 1999 at the Ho-Am Museum, with support from the Samsung Foundation; it features a collection of bronzes that include *The Burghers of Calais* and *The Gates of Hell.*

Salvador de Bahia, Brazil

The idea of founding a Rodin museum in Brazil was sparked by the enormous enthusiasm surrounding an exhibition of his work in Rio de Janeiro in 1995. The project was launched by Emanoel Araujo, a Brazilian sculptor. The French ministry of culture and the Musée Rodin soon lent their support to the project, whose originality resided in the display of bronzes commissioned for the proposed tropical garden as well as original plasters placed on loan by the Paris museum.

In May 2002, France and the state of Bahia signed an agreement covering the temporary loan of works; the opening of the museum, housed in the Palacete Comendador Bernardo Martins Catharino, is scheduled for 2006.

Facing page
HO-AM ART MUSEUM.
SEOUL, KOREA.

Bottom left
THE FUTURE RODIN MUSEUM IN COMENDADOR BERNARDO MARTINS CATHARINO PALACE.

Bottom right
THE HÔTEL BIRON SEEN FROM THE END OF THE GARDENS.

Below
RODIN WING, SHIZUOKA PREFECTURAL ART MUSEUM., JAPAN
SHIZUOKA, JAPAN.

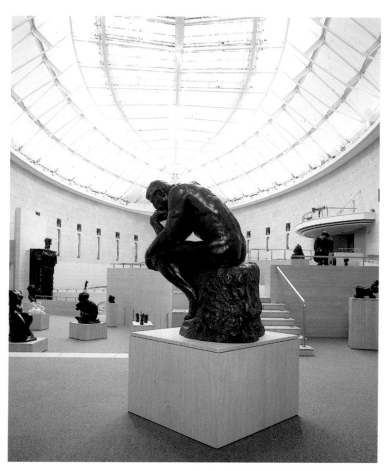

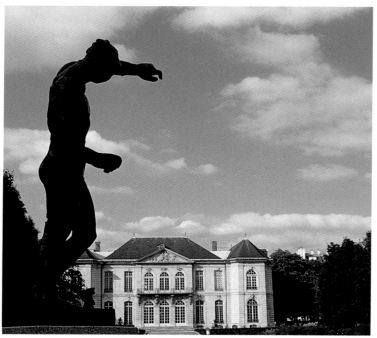

CHRONOLOGY

1840
Birth of Auguste Rodin on October 12 at 17, rue de l'Arbalète, Paris.
Birth of Claude Monet.
Birth of Georges Clemenceau.
December: Napoleon's ashes return to France.
Ingres paints *Odalisque and Slave*.
Delacroix paints *The Entry of the Crusaders into Constantinople*.

1848
Rodin enters a Catholic primary school.
Revolution sweeps across Europe. The French monarchy falls in February;
the Second Republic is declared.
Death of Chateaubriand.
Dumas publishes *The Lady of the Camellias*.

1850
Rodin begins to draw.
Death of Balzac.
Courbet paints *A Burial at Ornans*.
Bouguereau paints *Dante and Virgil in the Inferno*.
Universal Exposition held in Paris.
Wagner composes *Lohengrin*.

1854
Rodin enrolls in the École Spéciale de Dessin et d'Architecture (known as the
"Petite École").
Carpeaux wins the Prix de Rome.
Liszt composes *The Preludes*.
Crimean War breaks out.

1856
Rodin wins a drawing prize at the Petite École.
Death of David d'Angers.
Death of Chassériau.
Death of Schumann.
Victor Hugo publishes *Contemplations*.
The Treaty of Paris puts an end to the Crimean War.

1857
Rodin leaves the Petite École and applies to the École des Beaux-Arts; he passes the
drawing test but fails the sculpture test.
Flaubert publishes *Madame Bovary*.
Baudelaire publishes *The Flowers of Evil*.

1858

Once again, Rodin fails to gain admission to the École des Beaux-Arts.

1859

Third and final failure to win entry to the École des Beaux-Arts.
Gounod composes *Faust*.
Millet paints *The Angelus*.

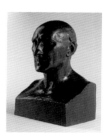

1860

First surviving sculpture by Rodin, a bust of his father, *Jean-Baptiste Rodin*.
August 11: date of earliest surviving letter by Rodin, to his mother.

1861

Rodin avoids military conscription by drawing a favorable lottery number.
Carpeaux, in Rome, sends a plaster cast of his *Ugolino* to Paris, where it is exhibited in the École des Beaux-Arts.
March: Wagner's *Tannhauser* is performed in Paris.
December: Maria Rodin enters the convent of Saint-Enfant-Jésus (she will take her vows on September 11, 1862).

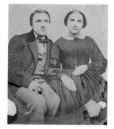

1862

December 8: Maria Rodin dies of smallpox.
Late December: Rodin joins the Order of the Blessed Sacrament as a novice, remaining there until June 1863.
Carpeaux completes his sculpture of *Ugolino*.
Hugo publishes *Les Misérables*.
Berlioz composes *Beatrice and Benedict*.

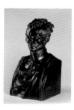

1863

February: Rodin sculpts a bust of *Father Pierre-Julien Eymard*.
Death of Delacroix.
The Salon des Refusés is organized in opposition to the official Salon.
Ingres paints *The Turkish Bath*.

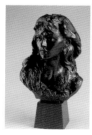

1864

Rodin sets up a studio at 20, rue de la Reine Blanche.
Rodin accepts a job with Carrier-Belleuse, for whom he would continue to work until 1872.
Corot paints *Souvenir of Mortefontaine*.
1864–65: Rodin works on the decoration of the Théâtre des Gobelins and meets Rose Beuret.
Birth of Camille Claudel.

1865

Rodin and Rose Beuret begin living together.
Rodin's *The Man with a Broken Nose* is rejected by the Salon.
He works on the decoration of the Paiva residence on the Champs-Élysées.
Manet paints *Olympia,* which creates a scandal at the Salon.

1866

Birth of Rodin's only child, Auguste Eugène Beuret.
Manet paints *Le Déjeuner sur l'herbe*.
Verlaine publishes *Poèmes saturniens*.

1867

Rodin works as technical assistant for various ornamental sculptors.
Universal Exposition held in Paris.
Death of Ingres.
Courbet and Manet organize independent exhibitions at Place de l'Alma.
Death of Baudelaire.

1869

Carpeaux sculpts *La Danse* for the façade of the new Paris Opera.
Degas paints *The Orchestra at the Opera House*.
Manet paints *The Balcony*.
Deaths of Lamartine and Berlioz.

1870

Carrier-Belleuse sends Rodin to Brussels for the Brussels Salon.
September: France's Second Empire collapses and the Third Republic is proclaimed in Paris
on September 4.
September 27: Rodin joins a National Guard battalion as a corporal to defend Paris against the Prussians.
Deaths of Mérimée and Dumas.

1871

March 1: Rodin, demobilized, returns to Carrier-Belleuse in Belgium, where he would remain
until 1877.
First show of Rodin's work (Brussels or Antwerp).
Rodin begins working with Joseph van Rasbourgh.
Rodin is fired by Carrier-Belleuse, who returns to Paris.
May 10: The Treaty of Frankfurt obliges France to surrender Alsace and much of Lorraine to
Prussia, and to pay reparations of five billion francs.
August 23: Death of Rodin's mother.
Rimbaud publishes *Le Bateau Ivre*.

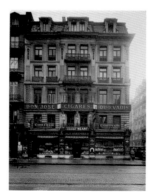

1872

Rodin works on allegorical figures for the Brussels Stock Exchange, on decorations for the throne
room of the Royal Palace, and on façades along boulevard Anspach.
Portrait of Rose Beuret (oil on canvas).
Death of Théophile Gautier.

1873

January: Rodin participates in an international exhibition in London.
Rodin and van Rasbourgh form an official partnership.
The Brussels Stock Exchange sculptures are unveiled.
The city of Antwerp commissions a monument to J. F. Loos.
Rimbaud publishes *A Season in Hell*.

1874

Rodin executes a figure of Beethoven for the Brussels Conservatory.

Executes allegorical groups representing Science and Art for the Palais des Académies.

An exhibition of "Impressionist" artists is held on Nadar's premises in Paris.

Victor Hugo publishes *Ninety-Three*.

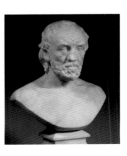

1875

Rodin exhibits a marble version (executed by Léon Fourquet) of *The Man with a Broken Nose* at the Salon.

October: Meets Auguste Neyt, who poses for *The Age of Bronze*.

Toward the end of the year Rodin travels to Italy, where he discovers the work of Michelangelo.

Garnier's new opera house is inaugurated in Paris.

Bizet's *Carmen* premieres at the Opéra Comique.

Death of Corot.

1876

August: Rodin's *Monument to Loos* is unveiled.

Renoir paints *Le Bal du Moulin de la Galette*.

Death of George Sand.

Construction begins on Sacré Coeur basilica in Paris.

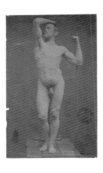

1877

Rodin exhibits *The Vanquished One* at the Cercle Artistique et Littéraire in Brussels.

The same statue (now titled *The Age of Bronze*) is presented at the Salon in Paris, involving Rodin in a violent polemic.

October: Rodin and Beuret move back to Paris (rue Saint-Jacques).

Rodin reestablishes contact with Carrier-Belleuse, who has since been named artistic director of the Sèvres Porcelain Factory.

Death of Courbet.

Autumn–winter: Rodin makes a tour of the cathedrals in central France.

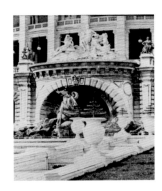

1878

Universal Exposition held in Paris.

Rodin works for ornamental decorators; helps to decorate the fountains at the Trocadéro exhibition site.

Rodin begins *Saint John the Baptist Preaching*.

Brahms composes his *Concerto for Violin and Orchestra*.

1879

The head of *Saint John the Baptist* is exhibited at the Salon.

The City of Paris launches an open competition for a "Monument to the Republic."

The regional council launches an open competition for a monument to the "Defense of Paris."

Rodin works for Léon Fourquet on the decoration of the Palais des Beaux-Arts in Marseille.

Rodin spends time in Nice (where he works for Charles Cordier on the decoration of the Villa Neptune) and Strasbourg.

Rodin begins working for the Sèvres porcelain factory.

Death of Daumier.

Telephones begin appearing in Paris.

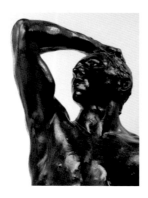

1880

The French government purchases a bronze cast of *The Age of Bronze*.
Turquet reforms the Salon selection system, leading to the founding
of the Société des Artistes Français.
July 6: France adopts Bastille Day (July 14) as the republic's national holiday.
The government commissions *The Gates of Hell* (official decree of August 16).
July: Rodin moves into a government studio in the Dépôt des Marbres
at 182, rue de l'Université, where he would continue to work until his death.
November 19: The City of Paris commissions *D'Alembert* for
the Hôtel de Ville.

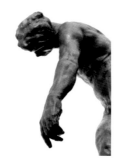

1881

Rodin exhibits *Adam* at the Salon under the title of *Creation*.
He goes to London in the summer, remaining there until August. His friend Alphonse Legros
teaches him engraving techniques, while Rodin begins a bust of Legros.
Sculpted portraits of Legros, Henley, and Laurens.
Rodin's first provincial show takes place in Dunkirk.

1882

The Union Générale bank fails.
December: Rodin ceases working for the Sèvres factory.
Meets Camille Claudel.
Exhibits his bust of Laurens at the Salon, where Laurens shows his oil portrait
of Rodin.

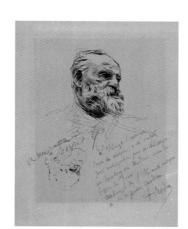

1883

Rodin meets Hugo, whose bust he had always wanted to do.
Bust of Victor Hugo.
February–March: First known exhibition of Rodin's drawings (at the Cercle des Arts Libéraux).
March: First show in the Netherlands, at the Universal Exposition in Amsterdam.
August: First show in Germany, at the International Exhibition in Munich.
Death of Wagner.
Death of Manet.
October 27: Death of Rodin's father, Jean-Baptiste.

1884

Bust of Madame Roll; *Bust of Rochefort* (first version); *Bust of Madame Vicuña*.
Summer: First show at the Georges Petit Gallery.
The City of Calais approaches Rodin about sculpting a memorial to the patriotic surrender
of the town in 1347.

1885

Calais officially commissions *The Burghers of Calais*.
June 1: Death of Victor Hugo, who is given a national funeral. Dalou is appointed
to execute the death mask.
Rodin receives the commission for a *Monument to Bastien-Lepage*.
Rodin meets Octave Mirbeau.
He exhibits his *Bust of Antonin Proust* at the Salon.
Pasteur develops a rabies vaccine.

1886
Rodin travels to England.
Another show at the Georges Petit Gallery.
The Impressionists exhibit as a group for the last time.
Rodin commissioned to design monuments to *Vincuña-Mackenna*
and *General Lynch* (Chile).

1887
Rodin is awarded the Légion d'Honneur.
December: Rodin is appointed to a subcommittee for the Universal Exposition of 1889.

1888
The government orders a marble copy of *The Kiss* for the Universal Exposition.
The same year, it purchases a marble *Bust of Madame Vicuña*.
October (?): First public display of *The Thinker* as a small plaster version in Copenhagen.

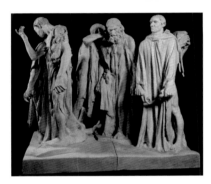

1889
Eiffel Tower inaugurated for the Universal Exposition in Paris.
The Musée Guimet opens.
April 8: Rodin receives the commission for the *Monument to Claude Lorrain.*
July–August: A plaster of *The Burghers of Calais* is shown at the Georges Petit Gallery as part of a
joint exhibition with Monet.
July: Rodin tours the Loire chateaux.
September 16: Receives the commission for a monument to Victor Hugo for the Pantheon in Paris.
September 29: Rodin's *Monument to Bastien-Lepage* is unveiled in Damvillers.
Dalou unveils his *Monument to the Republic* on Place de la Nation in Paris.
Rodin is a founding member of the Société Nationale des Beaux-Arts.

1890
Clément Ader flies the first heavier-than-air craft.
April and September: Rodin travels again to the Tours and Angers regions.
May 15–June 30: First Salon organized by the Société Nationale des Beaux-Arts.
June 11: Unveiling of the *Monument to Jules Castagnary*.
July 19: Rejection of Rodin's second proposal for the Hugo monument in the Pantheon.

1891
June 19: Rodin is told he must modify his *Victor Hugo* for the Pantheon,
but that his original version will be bought for a museum or public park.
July: The Société des Gens de Lettres commissions a statue of *Balzac*.

1892
Receives a commission for a monument to Baudelaire (never executed).
June 6: *Monument to Claude Lorrain* unveiled in Nancy.
June 19: Rodin is promoted to the rank of Officer of the Légion d'Honneur.
The Panama scandal rocks the government of the Third Republic.

1893
Monet paints his series of *Cathedrals*.
Late 1893: Rodin rents the Villa des Brillants in Meudon.

1894

Rodin meets Cézanne at Monet's house in Giverny.

Dreyfus is found guilty of espionage, dismissed from the army, deported, and imprisoned in Guyana.

October–November: Rodin's *Balzac* causes a crisis within the Société des Gens de Lettres.

November 30: Buenos Aires commissions *Monument to President Sarmiento* (unveiled in 1900).

Affair with Camille Claudel is definitively over.

1895

April: The first Venice Biennale opens.

June 3: *The Burghers of Calais* is officially unveiled.

December 19: Rodin purchases the Villa de Brillants in Meudon.

December 29: The Lumière brothers project the first moving picture (*A Train Entering the Station of La Ciotat*).

1896

February 2–13: A major Rodin/Puvis de Chavannes/Carrière exhibition at the Rath Museum in Geneva where, for the first time, photographs of works are also displayed.

1897

Gide publishes *The Fruits of the Earth*.

May 4: The Bazar de la Charité burns down.

Rodin travels to Bayreuth, where he attends a performance of *Parsifal*.

Maurice Fenaille finances an album of photogravure reproductions of 142 drawings by Rodin, with a preface by Octave Mirbeau (known as the Goupil album, after the name of the publisher).

1898

January 13: Zola publishes *J'accuse* in defense of Dreyfus.

Rodin exhibits *The Kiss* in marble and a large plaster version of Balzac at the salon of the Société Nationale des Beaux-Art. When his Balzac is rejected by the commissioning institution (the Société des Gens de Lettres), a polemic erupts.

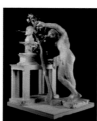

1899

Death of Puvis de Chavannes.

The French president pardons Dreyfus.

Rodin receives the commission for a *Monument to Pierre Puvis de Chavannes*.

First one-person show of Rodin's work in Brussels, Rotterdam, Amsterdam, and The Hague.

1900

Rodin mounts his own exhibition on Place de l'Alma during the Universal Exposition.

Women admitted to the École des Beaux-Arts for the first time.

The Paris Métro (subway) is opened.

Rodin is awarded Belgium's Ordre de Léopold.

1901

Rodin's Alma Pavilion is dismantled and rebuilt in Meudon.

1902

Bust of Mrs. Simpson.
A subscription is organized to buy *Saint John the Baptist* for the Victoria and Albert Museum in London.
Death of Jules Dalou.
Debussy's *Pelleas et Mélisande* premieres at the Opéra Comique.
May–June: Rodin makes a triumphal tour of Germany, Bohemia (Prague exhibition), Moravia, and Austria.
September: Rodin meets Rainer Maria Rilke.
Meets Isadora Duncan.
Death of Zola.
Rodin illustrates Octave Mirbeau's *Jardin des supplices.*

1903

Busts of George Wyndam, Eugène Guillaume, and Mrs. Potter Palmer.
May 20: Rodin is promoted to the rank of Commander of the Légion d'Honneur.
June 30: A celebration and banquet, presided by Émile Bourdelle, are held in Vélizy in honor of Rodin.
November: Rodin is elected to succeed Whistler as president of the International Society of Sculptors, Painters, and Gravers in London.
Women are able to compete for the Prix de Rome for the first time.
The first Tour de France bicycle race is held.

1904

February 8–15: Rodin in London to be officially installed as president of the International Society of Sculptors, Printers, and Carvers.
April 8: A Franco-British treaty inaugurates the Entente Cordiale.
July 7: Catholic religious orders are banned from teaching in French public schools, which sparks great local resistance and leads to a break in diplomatic relations between France and the Vatican.
Rodin meets Claire de Choiseul; their affair lasts until 1912.
The large *Thinker* is displayed for the first time at the International Society Exhibition in London, then in Paris at the Salon of the Société Nationale des Beaux-Arts.
Major Rodin exhibitions take place in Germany (in Weimar, the drawings create a scandal).

1905

July 3: A French law officially confirms the separation of church and state.
Rodin is named a member of the Conseil Supérieur des Beaux-Arts.
Receives an honorary doctorate from the University of Iena.
August Thyssen begins commissioning works from Rodin.

1906

Dreyfus is exonerated and reinstated into the army.

Busts of George Bernard Shaw, Howard de Walden, Marcelin Berthelot, Anna de Noailles, Georges Leygues, Victor de Goloubeff.

January: Rodin is awarded an honorary doctorate from the University of Glasgow.

February–March: Rodin goes to London.

Death of Eugène Carrière.

April 21: *The Thinker* is unveiled in front of the Pantheon in Paris.

May: Rodin is elected to Berlin's Academy of Fine Arts.

July: Rodin goes to Marseille for France's Colonial Exposition.

December 31: Delivers the marble version of the *Monument to Victor Hugo* (finally unveiled in 1909 in the gardens of the Palais Royal).

December–January 1907: Rodin travels to the region west of Paris to study its cathedrals.

Receives a commission from London for a monument to Whistler.

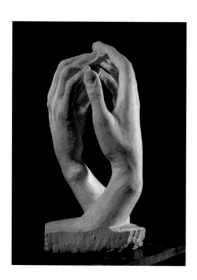

1907

Busts of Madame Elisseieff and Joseph Pulitzer.

March: Rodin goes to Strasbourg for an exhibition of French art (March 2–April 7).

May: Rodin is granted an honorary doctorate by Oxford University, where he visits in June.

October: Major exhibition of over 300 drawings at the Bernheim Jeune Gallery in Paris.

Picasso paints *Les Demoiselles d'Avignon*.

1908

Busts of Claire de Choiseul, J. Winchester de Kay, and Lady Warwick; also sculpts Mrs. Merrill and her daughter, a medallion of Stendhal, and *Cathedral*.

January: A show of Rodin's drawings is hosted by the Photo Secession (Gallery 291) in New York.

January 7–March 8: Eighth International Society Exhibition held in London, followed by *Fair Women*.

March 6: King Edward VII visits Rodin in Meudon.

April 23: Rodin organizes a Czech reception in Meudon.

Late May: Rodin goes to Belgium.

June 1: *Monument to Henri Becque* is unveiled in Paris.

September: A Rodin–Zuolaga exhibition is held in Frankfurt.

October 15: Rodin moves into rooms in the Hôtel Biron.

October 19–November 15: A show of Rodin's drawings and watercolors is held at the Devambez Gallery.

December: Rodin travels through Burgundy.

1909

Busts of Renée Vivien, Barbey d'Aurevilly, Edward H. Harriman, Gustav Mahler,
Thomas F. Ryan, the Duc de Rohan, and Napoleon; *The Secret.*
June 1909: It is announced that the Hôtel Biron will be sold, prompting Rodin to consider
making a bequest to the nation in order to save the building—the birth of the plan to found
the Musée Rodin.
September 30: *The Monument to Victor Hugo* is unveiled at the Palais Royal.
October: A Rodin exhibition at the Devambez Gallery includes 135 drawings
and four photographs of *Balzac* by Bulloz.
November: Second announcement of plan to sell the Hôtel Biron.
November 28: *The Monument to Barbey d'Aurevilly* is unveiled in Saint-Sauveur-le-Vicomte.

1910

Spring: Rodin goes to Blois and Tours.
March: *The Thinker* and drawings are exhibited at the Photo Secession (Gallery 291)
in New York, along with photographs by Edward Steichen.
April 27: Mrs. Theodore Roosevelt visits Meudon.
October: Exhibition of drawings in the salons of the review *Gil Blas.*
August 14–15: A huge fire ravages the Brussels International Exposition,
but the French art display is spared.

1911

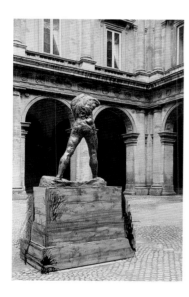

Busts of Professor Gabritchewski, Georges Clemenceau, Mozart (Mahler). Publication
of Rodin's *Art: Conversations with Paul Gsell.*
January 1: Rodin moves into another three rooms of the Hôtel Biron, including two upstairs rooms.
January–March: Exhibition in Berlin's Royal Academy of Fine Arts. Kaiser Wilhelm II refuses
to award Rodin the Order of Merit.
February 26: The French government commissions Rodin to execute a bust of Puvis de Chavannes
for the Pantheon.
March 31–November 30: *Walking Man* (large bronze version) is exhibited in the French pavilion
of the International Exposition in Rome.
May: *Walking Man* is collectively purchased by Grunbaum, Golubeff, Fenaille, and Peytel,
who present it to French embassy in Rome (Palazzo Farnese).
July: The Sourrisseau monument (*Broken Lily*) is unveiled at the Saint-Acheul Cemetery in Amiens.
October 13: The French government buys the Hôtel Biron; tenants are told they must vacate
the premises by January 1, 1912.
November: England buys *The Burghers of Calais* and places it outside Westminster.
December: Plans are made to publish *The Cathedrals of France,* written in conjunction
with Charles Morice.
December 23: *The Walking Man* is installed in the Palazzo Farnese in Rome.

1912

Rodin sculpts *Nijinsky*; does studies for a monument to Eugène Carrière.
January: Rodin travels to southern France and Rome.
February: Rodin exhibition in Tokyo.
May 2: The Metropolitan Museum in New York inaugurates its Rodin collection.
May 3: The *Monument to Champlain* is unveiled in New York.
May–June: The municipal library in Lyon hosts a show of Rodin's drawings
and engravings.
May 29: *L'Après-midi d'un faun* premieres at the Théâtre du Châtelet in Paris.
Summer: Demolition of outbuildings that had been grafted onto the Hôtel Biron.
August: Rodin breaks with Claire de Choiseul.

1913

Bust (plaster) of *Lady Sackville*.
Camille Claudel is confined to an asylum.
March: An exhibition on physical and athletic education at the medical school
in Paris includes the first public display of Rodin's collection of antiquities.
March–June: Exhibition of the first Rome Secession.
March–April: Exhibition of Rodin's drawings and sculptures in Tokyo.
May–October: International Exposition held in Ghent.
May–June: Rodin goes to London to supervise installation of *The Burghers of Calais*
in the gardens at Westminster.
June–October: 9th International Exhibition held in Munich.
The premiere of Stravinsky's *Rite of Spring* causes a scandal in Paris.

1914

Dante; *Lady Sackville* (marble).
February–March: Sojourn in the south of France, notably with Renoir
in Cagnes-sur-Mer.
March 6: Publication of *The Cathedrals of France*.
June–July: Rodin goes to England for the show of his work at Grosvenor House,
home of the Duke of Westminster.
September: Rodin donates eighteen works to Great Britain, which are installed
in the Victoria and Albert Museum in London.
August 3: Germany declares war on France.
August 11: France declares war on the Austro-Hungarian Empire.
November: Rodin and Beuret travel to Rome.
Sacha Guitry films Rodin in the Hôtel Biron and incorporates the footage into a film
called *Ceux de Chez Nous*.

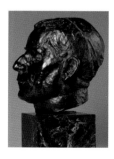

1915

Pope Benedict XV.
January: *The Burghers of Calais* unveiled in front of parliament at Westminster.
April 8–May 11: Rodin is received by Pope Benedict XV in Rome in order to execute a bust.
June: The Panama–Pacific International Exposition is held in San Francisco.
September: Sixteen of the eighteen works donated to Britain are exhibited at
the Royal Scottish Academy in Edinburgh.

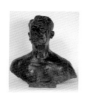

1916
Rodin's final work: *Bust of Étienne Clémentel*.
March: Rodin falls seriously ill.
April 1: Rodin makes his first bequest to the nation for a future Rodin museum in the Hôtel Biron.
September 13: Second bequest to the nation.
September 15: The French Assembly accepts the bequest by a vote of 379 to 56.
October 25: Third bequest to the nation.
November 9: The French Senate accepts all three bequests by a vote of 209 to 26.
December 15: The Assembly votes to found a Musée Rodin in the Hôtel Biron (recorded in the *Journal Officiel* of December 24).
December 26: Rodin commissioned to execute a memorial to the defense of Verdun.

1917
January 29: Rodin and Beuret are married in Meudon.
February 14: Beuret dies.
March 3: Exhibition at the Georges Petit Gallery.
November: Retrospective exhibition at the Haussmann Gallery.
April 25: Rodin draws up his will.
November 15: Adds a rider to his will.
November 17: Rodin dies.
November 24: Rodin's funeral is held in Meudon. A memorial service is also held in London in the presence of Queen Alexandra.

1919
March 12: A statute confirms the establishment of the Musée Rodin (recorded in the *Journal Officiel* of March 14).
August 4: The Musée Rodin opens its doors to the public.

1934
Death of Rodin's son, Auguste Beuret.

1943
Death of Camille Claudel.

1947
The Meudon branch of the Musée Rodin opens.

SELECT BIBLIOGRAPHY

It would be very risky to attempt to compile an exhaustive bibliography on Rodin. Rather than presenting a list of titles organized in alphabetical or chronological order, the authors have decided to propose a select bibliography divided into thematic groups based on some of the issues discussed in this book, so that interested readers will be able to pursue further study into a specific aspect of the artist or his work.

OVERVIEWS OF RODIN'S LIFE AND WORK

Among the many general books on Rodin, it is worth mentioning:

Descharnes, Robert and Jean-François Chabrun. *Auguste Rodin*. Lausanne: Edita/Paris: Vilo, 1967.

Le Normand-Romain, Antoinette. *Rodin*. Paris: Flammarion, 1997.

Pinet, Hélène. *Rodin: les mains du génie*. Paris: Gallimard, 1988.

RODIN ON RODIN

Two volumes in the form of interviews offer valuable insight into Rodin's artistic opinions:

Rodin, Auguste and Paul Gsell. *Art: Conversations with Paul Gsell*. Translated by Jacques de Caso and Patrica B. Sanders. Berkeley: University of California Press, 1984.

Dujardin-Beaumetz, Henri Charles-Etienne. *Entretiens avec Rodin*. Paris: Imprimerie Paul Dupont, 1913. Translated in Albert E. Elsen, *Auguste Rodin: Readings on His Life and Work*. Engelwood Cliffs, N.J.: Prentice-Hall, 1965.

On Rodin's taste, it is also worth noting:

Rodin, Auguste. *Cathedrals of France*. Richmond, Va.: Black Swan, 1981.
> The only book written and published by Rodin, with original illustrations.

Beausire, Alain, ed. *Correspondance de Rodin, 1860–1917*. 4 vols. Paris: Musée Rodin, 1985–92.
> Some 1,500 letters by Rodin, held at the Musée Rodin, have been retranscribed and placed in chronological order. A substantial index facilitates research.

BIOGRAPHIES

Rodin's life is sometimes eclipsed by his vast oeuvre. For readers who wish to get a better grasp of the man and his times, here are a few key works:

Rodin viewed by his contemporaries:

Cladel, Judith. *Rodin, sa vie glorieuse, sa vie inconnue*. Paris: Grasset, 1936.
> The first biography of Rodin, by a witness to his final years. This collection of several texts, which Cladel began publishing in 1903, represents one of the prime sources on Rodin.

Rilke, Rainer Maria. *Rodin and Other Prose Pieces*. Translated by G. Craig Houston. London: Books Britain, 1986.
> Rodin viewed through the Austrian poet's boundless admiration and affection.

Coquiot, Gustave. *Le vrai Rodin*. Paris: Jules Tallandier, 1913.

Coquiot, Gustave. *Rodin à l'hôtel Biron et à Meudon*. Paris: Ollendorf, 1917.
> The section on the history of the Hôtel Biron is not necessarily reliable.

RECENT BIOGRAPHIES

Grunfeld, Frederic V. *Rodin: a Biography*. New York: Henry Holt & Co, 1987.
> The most complete biography of Rodin, employing a great deal of original archive material. Indispensable.

Butler, Ruth. *Rodin: The Shape of Genius*. New Haven: Yale University Press, 1993.
> This key reference work presents a major synthesis of Rodin's life and work. Richly illustrated.

Schmoll, J. A. *Rodin-Studien: Persönlichkeit, Werke, Wirkung, Bibliographie*. Munich: Prestel-Verlag, 1983.

Delclaux, Marie-Pierre. *Rodin: éclats de vie*. Paris: Musée Rodin, 2003.

On Rodin's relationship to institutions and his role as official sculptor, it is always worth consulting:

Martinez, Rose-Marie. *Rodin, l'artiste face à l'État*. Paris: Séguier, 1993.

A good study on Rodin in Meudon:

Le Normand-Romain, Antoinette and Hélène Marraud. *Rodin à Meudon: la villa des Brillants*. Paris: Musée Rodin, 1996.

Sculpture in Rodin's day

Pingeot, Anne, ed. *La Sculpture française au XIXᵉ*. Paris: Ministère de la culture et de la communication/Réunion des musées nationaux, 1986.
> This overview makes it possible to situate Rodin's sculpture in its historical context.

RODIN'S SCULPTURE

Tancock, John L. *The Sculpture of Auguste Rodin*. Philadelphia: Philadelphia Museum of Art, 1976.

Barbier, Nicole, ed. *Rodin sculpteur*. Paris: Musée Rodin, 1992.

Kausch, Michael, ed. *Auguste Rodin: Eros und Leidenschaft*. Milan: Skira, 1996.

RODIN AT WORK

Elsen, Albert E. *In Rodin's Studio*. Ithaca, N.Y.: Cornell University Press, 1980.

Pingeot, Anne, ed. *Le Corps en morceaux*. Paris: Réunion des musées nationaux, 1990.

Judrin, Claudie and Hélène Pinet. *Los Arrepentimientos de Rodin: colección del museo Rodin*. Barcelona: Fundación la Caixa, 2003.

RODIN THE DRAFTSMAN

Judrin, Claudie. *Rodin: l'Enfer et le Paradis. Un dessin de sculpteur*. Paris: Musée Rodin, 2002.

Major Rodin collections througout the world
Musée Rodin

Vilain, Jacques, ed. *Le musée Rodin et ses collections*. Paris: Scala, 2001.
 A history of the Musée Rodin and an introduction to its collection.

Judrin, Claudie. *Inventaire des dessins*. 5 vols. Paris: Musée Rodin, 1984–92.
 The key work for grasping the Musée Rodin's collections of drawings—each work is reproduced in the form of a vignette.

Barbier, Nicole. *Marbres de Rodin. Collection du musée*. Paris: Musée Rodin, 1987. (Out of print)
 An inventory of the Musée Rodin's collection of marble sculptures.

Garnier, Bénédicte. *Rodin: l'antique est ma jeunesse. Une collection de sculpteur*. Paris: Musée Rodin, 2002.
 A book on Rodin's personal collection of antiquities.

OTHER COLLECTIONS

Elsen, Albert E. and Rosalyn Frankel Jamison. *Rodin's Art: the Rodin Collection of the Iris & B. Gerald Cantor Center for Visual Arts at Stanford University*. New York: Iris and B. Gerald Cantor Center for Visual Arts at Stanford University with the Oxford University Press, 2003.

Caso, Jacques de and Patricia B. Sanders. *Rodin's Sculpture: a Critical Study of the Spreckels Collection, California Palace of the Legion of Honor*. San Francisco: The Fine Arts Museum, 1977.

Le Normand-Romain, Antoinette, ed. *Rodin. Les marbres de la collection Thyssen*. Paris: Musée Rodin, 1996. (Out of print)

Fonsmark, Anne-Brigitte, Flemming Johansen, Henri Loyrette, and Anne Pingeot, ed. *Manet, Gauguin, Rodin ... Chefs-d'oeuvre de la Ny Carlsberg Glyptotek de Copenhague*. Paris: Réunion des musées nationaux, 1995.

RODIN AND FOREIGN LANDS

Keisch, Claude. *Rodin dans l'Allemagne de Guillaume II: partisans et détracteurs à Leipzig, Dresde et Berlin*. Paris: Musée Rodin, 1998.

Le Normand-Romain, Antoinette and Claudie Judrin. *Rodin et la Hollande*. Paris: Musée Rodin, 1996.

Le Normand-Romain, Antoinette, ed. *Vers « L'Âge d'airain ». Rodin en Belgique*. Paris: Musée Rodin, 1997.

Le Normand-Romain, Antoinette, ed. *Rodin et l'Italie*. Rome: De Luca, 2001.

RODIN'S MAJOR WORKS
The Burghers of Calais

Judrin, Claudie, Monique Laurent, and Dominique Viéville. *Auguste Rodin: le monument des Bourgeois de Calais, 1884–1895, dans les collections du Musée Rodin et du Musée des Beaux-Arts de Calais*. Paris: Musée Rodin/Calais: Musée des Beaux-Arts, 1977.

Haudiquet, Annette and Antoinette Le Normand-Romain. *Rodin: les Bourgeois de Calais*. Paris: Musée Rodin, 2001.

The Gates of Hell

Elsen, Albert E. *The Gates of Hell by Auguste Rodin*. Palo Alto: Stanford University Press, 1981.

Le Normand-Romain, Antoinette. *Rodin: la Porte de l'Enfer*. Paris: Musée Rodin, 1999.

The Thinker

Elsen, Albert E. *Rodin's Thinker and the Dilemmas of Modern Public Sculpture*. New Haven: Yale University Press, 1986.

The Kiss

Le Normand-Romain, Antoinette. *"The Kiss" by Rodin*. Translated by Lisa Davidson and Michael Gibson. Paris: Réunion des musées nationaux/Musée Rodin, 1995.

Balzac

Le Normand-Romain, Antoinette, ed. *Le « Balzac » de Rodin*. 1998.

The Monument to Victor Hugo

Butler, Ruth, Jeanine P. Plottel, and Jane Roos. *Rodin's Monument to Victor Hugo*. London: Merrell Holberton Publishers, Ltd. and the Iris and B. Gerald Cantor Foundation, 1998.

Le Normand-Romain, Antoinette and Frédérique Thomas-Maurin, eds. *Victor Hugo vu par Rodin*. Besançon: Musée des Beaux-Arts, 2002.

Molinari, Danielle, ed. *D'ombre et de marbre. Hugo face à Rodin*. Paris: Somogy/Paris-Musées, 2003.

Meditation

Georget, Luc and Antoinette Le Normand-Romain, eds. *Rodin: la Voix intérieure*. Marseille: Musée des Beaux-Arts, 1997.

Whistler's Muse

Judrin, Claudie and Antoinette Le Normand-Romain. *Rodin, Whistler et la Muse*. Paris: Musée Rodin, 1995.

EXHIBITIONS DURING RODIN'S LIFETIME

Beausire, Alain. *Quand Rodin exposait*. Paris: Musée Rodin, 1988.
 A remarkable overview that covers all the exhibitions in which Rodin showed, along with a list of works displayed. An indispensable reference work.

Le Normand-Romain, Antoinette, ed. *Rodin en 1900: l'exposition de l'Alma*. Paris: Réunion des musées nationaux, 2000.

Vilain, Jacques, ed. *Claude Monet – Auguste Rodin: centenaire de l'exposition de 1889*. Paris: Musée Rodin, 1989.

CAMILLE CLAUDEL

Laurent, Monique and Bruno Gaudichon. *Camille Claudel*. Paris: Musée Rodin, 1984.

Le Normand-Romain, Antoinette. *Camille Claudel et Rodin: le temps remettra tout en place*. Paris: Musée Rodin, 2003.

Paris, Reine-Marie. *Camille Claudel re-trouvée*. Paris: Aittouarès, 2000.

Pinet, Hélène and Reine-Marie Paris. *Camille Claudel: le génie est comme un miroir*. Paris: Gallimard, 2003.

Riviere, Anne and Bruno Gaudichon, eds. *Camille Claudel: correspondance*. Paris: Gallimard, 2003

Rivière, Anne, Bruno Gaudichon, and Danielle Ghanassia. *Camille Claudel: catalogue raisonné*. Paris: Adam Biro, 2000.

INDEX

Numbers in bold refer to pages with illustrations

PHOTO CREDITS